MONUMENTS MAN

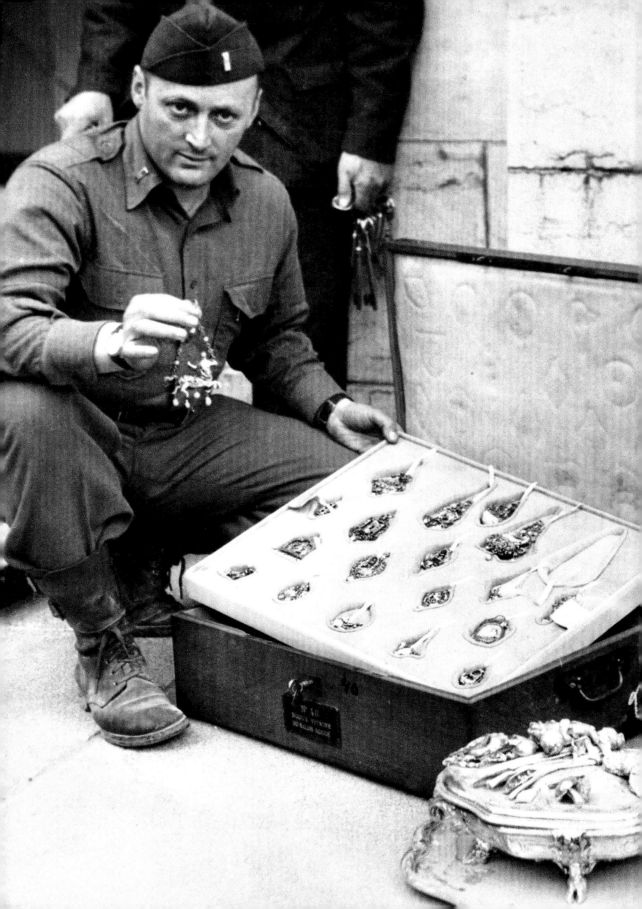

MONUMENTS MAN

THE MISSION TO SAVE VERMEERS, REMBRANDTS, DA VINCIS, AND MORE FROM THE NAZIS' GRASP

JAMES J. RORIMER
with Louis and Anne Rorimer

Foreword by Lynn H. Nicholas

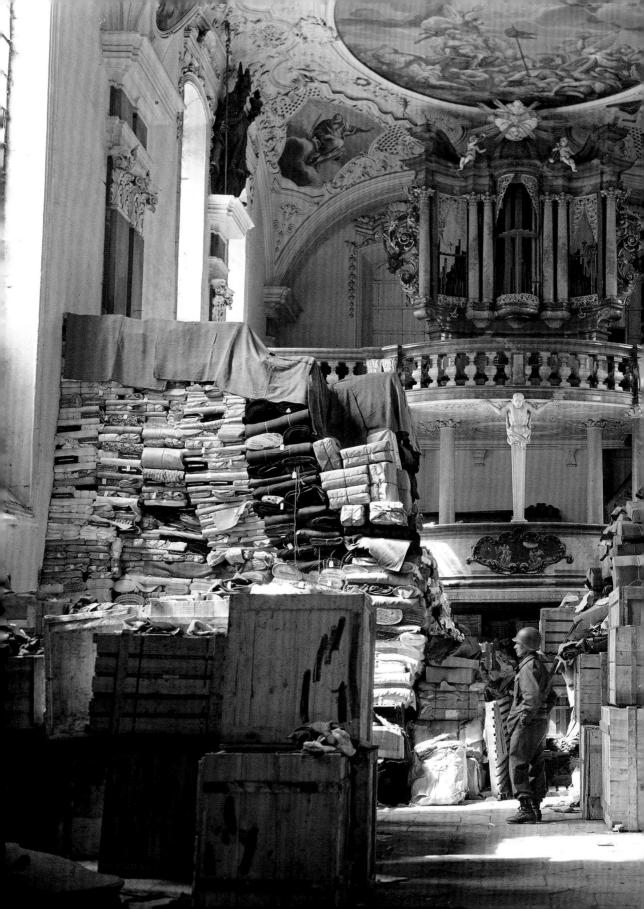

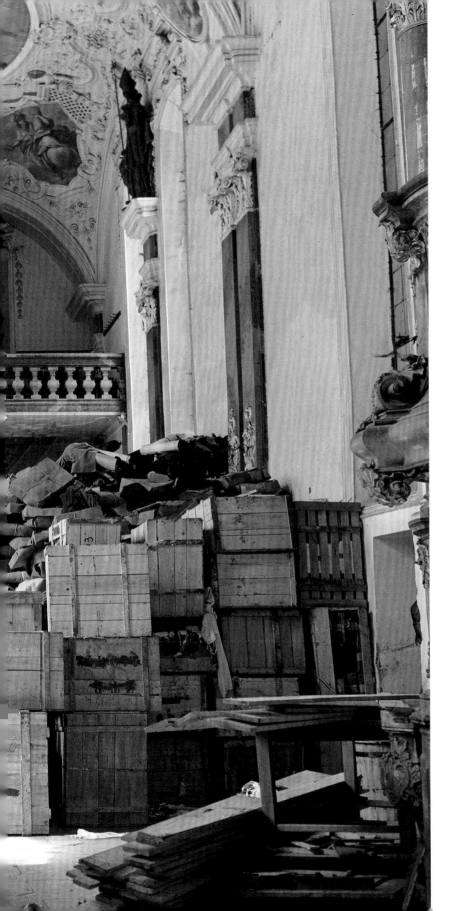

Dedicated to the memory of Captain Walter J. Huchthausen and to the British Major Ronald E. Balfour, monuments officers killed in action, spring 1945.

PREVIOUS SPREAD
The author displays Renaissance jewelry from the collection of Meurice de Rothschild that was recovered at Neuschwanstein Castle.

LEFT
An American GI guards piles of crates and other confiscated property in a church in Ellingen, Germany, April 24, 1945.

FOLLOWING SPREAD
Lieutenant Dale Ford (left) and Technician Fourth Grade Harry Ettlinger display a Rembrandt self-portrait in the Heilbronn mine in spring 1945.

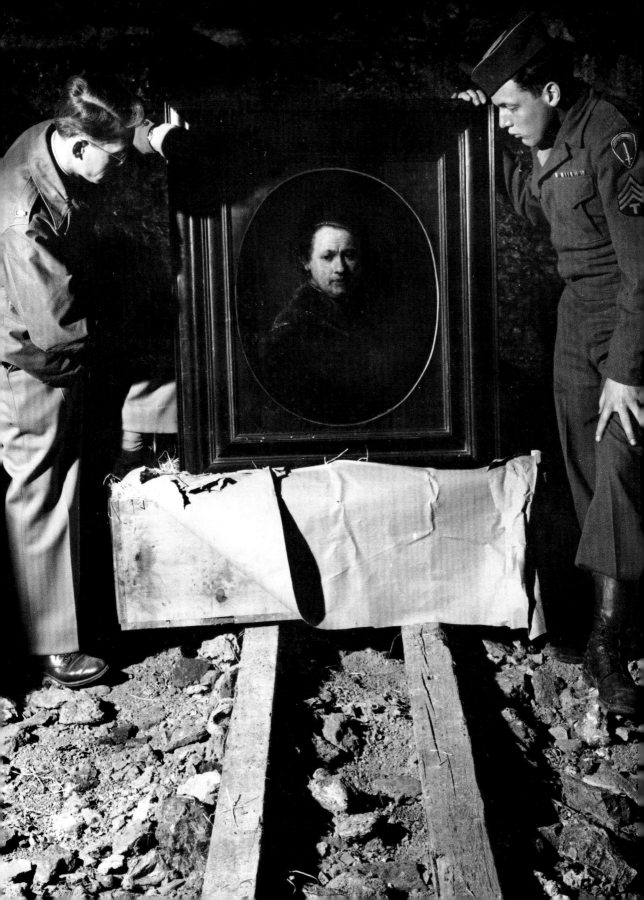

CONTENTS

Foreword

BY LYNN H. NICHOLAS

In the fall of 1980, while living in Belgium, I happened to read the obituary of Rose Valland in the *International Herald Tribune*. Mlle Valland, a lowly curator at the Jeu de Paume Museum who had kept her position throughout World War II, had been a heroine of the French resistance and had not only risked her life numerous times, but had saved or recovered some 60,000 works of art for France. As a former museum employee, I knew that 60,000 works of art was a lot. The National Gallery of Art in Washington, for example, now has about 4,000 paintings in its collections.

This revelation made me wonder what, in fact, *had* happened to works of art in World War II. It was not, in 1980, a subject I had ever heard mentioned during my time spent in museums. A few inquiries of museum officials I knew in Belgium produced astonishment. Did I not know of people like James Rorimer, and the many others who served during the war as Monuments, Fine Arts & Archives officers? Did I not know of the heroic actions of museum officials, both Axis and Allied, to save their collections, and basically the entire patrimony of the western world, from destruction? I had indeed met many of these art professionals, but I knew nothing of their experiences or of the massive displacement of works of art that had resulted from the Nazi attempt to create and adorn its Thousand Year Reich in accordance with Nazi ideology.

I began my research in Europe, but it was not until I returned to the United States in 1984, that I was able to learn the truly massive scale of Nazi confiscations, forced sales, and sequestration of collections from museums, galleries, and individuals with large private art holdings. I also discovered the amazing achievements of what are now called the "monuments men" of many nations who, while putting their lives at great risk, found, secured, and returned millions of movable works of art to the countries from which they had been taken, and, at the same time, tried to prevent further damage to the great monuments located in war zones. As was true of so many veterans of World War II, those who had used their expertise to salvage Europe's treasures did not talk much about their exploits, but came home, proud to have done their duty and ready to move on, so that by the 1980s the subject had largely been forgotten in the United States.

The research sources available were, to my surprise, enormous. At the National Archives in Washington, D.C., are millions of captured enemy documents that include very detailed records of the Nazi looting organizations and of the dealers who serviced them. A presidential commission set up to deal with displaced art during the war had had its headquarters at the National Gallery of Art. The Library of Congress has such things as Goering's photo albums, and much more. I would spend ten years happily sifting through all this, by hand, competing for the copying machines at the National Archives, as my work was mostly done before the general use of computers and the extraordinary amounts of data now available online.

But more important than all the documents would be the personal stories of those involved. Only a few of the monuments men had published their memoirs just after the war. By the 1980s, these volumes

were no longer in circulation. It was quite daunting to think of approaching these heroes, who were, by now, at the pinnacles of the art world. Many of them, when I wrote to them requesting interviews, were hesitant. One, fearing I might be a troublemaker, even set up a huge reel-to-reel tape recorder in the interview room to protect himself. But after a time he relaxed, and after lunch and quite a lot of wine, he told his extraordinary tales at length and showered me with photographs and documents. Once their surprise that there was any interest in their wartime achievements had worn off, the Monuments Men became more and more eager to have their stories accurately told.

By the time I had reached the interviewing stage, sadly, James Rorimer had died. There were numerous documents and reports by him in the archives, and I had found and read his memoir, *Survival: The Salvage and Protection of Art in War*, but I was curious to know if there might be more. It was through the good offices of his colleague Craig Hugh Smyth, who had run the Munich Central Collecting Point in Germany at the end of the war, that, in June of 1986, I received a letter from Kay Rorimer, James Rorimer's widow:

> *In going through my late husband's letters here...I have come across many letters and reports from the field...You would benefit, I think, from checking out these hundreds of papers weighing many pounds which I hesitate to entrust to the mails and which need intelligent assortment...If you had the time and interest, you would be most welcome to study this important material here (in Cleveland)....You might even look on visiting my files as a semi-holiday bringing your swim suit, bird binoculars and hiking shoes.*

I did not hesitate to accept this invitation and would spend a delightful few days with Mrs. Rorimer, copying documents, finding mutual friends, and exploring the Ohio countryside. Kay also gave me many photographs taken by James Rorimer during his service in Europe (somewhat the worse for wear having been used in his book and other publications) and later would send me even more documents. I met her several more times in New York, and I will be forever grateful for her trust and friendship.

By the mid-1990s, a series of events had prepared the way for a revival of interest in the displacement of art in the World War II era: the Soviet Union had imploded, revealing the locations of a plethora of works from both Germany and the Allied nations that had long been thought to have been lost; the 50th anniversary of the end of the war; the development of the field of Holocaust studies; and the fall of the Iron Curtain all brought renewed awareness of these losses and of the possibility of recovering them. The losses were not only of art: interest in recovery of real estate and insurance was also revived. There were claims for compensation from former prisoners of the gulags and slave laborers in both the Soviet and Nazi systems. Since that time, the issue of wartime looting has captured enormous public attention. Major

Katherine Rorimer on the porch of the family home in Ohio.

conferences in Washington, in 1998, and Prague, in 2008, have set out new standards for the restitution of works of art, and the courts of many nations continue to sift through and deal with claims.

Few people today have any real concept of the difficulties faced by the small group of art professionals from every affected nation, who, in the chaos of the end of World War II, were tasked with securing what amounted to the entire patrimony of Western civilization. This book gives us a vivid picture and a vital record not only of James Rorimer's determination, courage, and expertise in the most daunting of circumstances, but also that of so many of the monuments men who worked by his side.

Kay Rorimer had hoped that *Survival* would be re-published one day, and it is with the greatest pleasure and gratitude to her, and to Anne and Louis Rorimer, that I write these words to applaud the fulfillment of her wish.

Lynn H. Nicholas
Washington, D.C.
February, 2021

Introduction

BY LOUIS AND ANNE RORIMER

CAST OF PRINCIPAL CHARACTERS IN THE EUROPEAN THEATER OF OPERATIONS, WORLD WAR II

This memoir is James J. Rorimer's account of his role in the international effort to protect architectural monuments in France and Germany during World War II, and to rescue works of art and other property confiscated by the Nazis from public and private collections throughout Europe.

While in the line of duty as a monuments officer assigned to France and Germany, the author recorded his wartime interaction with a broad spectrum of people affiliated with the Allies (the U.S., Great Britain, France, and Russia) on one side, and the Axis powers (Germany, Italy, and Japan) on the other. The far-reaching endeavor to protect and wrest from hiding places much of the cultural heritage of Europe that had been plundered and sequestered by Nazi officials was played out against the backdrop of a horrific war framed by the crimes of the Holocaust.

When the author originally published his book in 1950 under the title *Survival: The Salvage and Protection of Art in War*, the wartime experience was still fresh and many of the individuals in this book were well-known public figures. The following biographies provide brief sketches of some of those players along with others that Rorimer encountered during his quest to help save many of Europe's greatest treasures from Hitler's grasp.

THE NAZIS

Adolf Hitler (1889–1945) After initially attempting to pursue a career as an artist in the early 1900s, Hitler enlisted in the German infantry in World War I. Shortly after Germany's defeat in 1918, he settled in Munich and began his rise to power. During this time, he applied his oratorical talent to stirring up postwar grievances among demobilized German troops, who had become frustrated by the terms of the peace agreement imposed on Germany by the Treaty of Versailles. He also stoked fears of the international Communist movement then emanating from Russia (and the rest of the Soviet Union). From the outset, Hitler blamed Germany's troubles on its Jewish citizens, whom he alleged were fomenting a secret plot to take over the world.

The Nazi movement he championed started in Munich in the southern German State of Bavaria, not far from the mountainous border with Austria. There, in 1923, Hitler and his partisans instigated an uprising known as the Beer Hall Putsch, for which he was arrested and jailed. While in prison, he codified his platform of anti-Semitism, and his plans for European domination, in his widely distributed autobiography, *Mein Kampf*. Several of his co-conspirators from the Beer Hall Putsch remained his steadfast supporters and leading henchmen throughout his career.

After release from prison, Hitler worked to expand public support for the Nazi party, while deploying increasing levels of violence to eliminate his rivals. By 1933, when the party gained over 35 percent of the

German popular vote, Paul von Hindenburg, the ailing president of Germany's democratic republic, was convinced that he had no choice but to appoint Hitler as Chancellor of the Reich. Hitler quickly grasped supreme command of the German government in Berlin, adopting the position of Leader (or Führer) and Chancellor of the Reich, under which he pursued his dreams of domination. Despite all the efforts of France, Great Britain, and the Soviet Union to appease him with limited annexations of Germany's neighbors, they were eventually forced to meet the threat of Nazi expansion militarily, culminating in World War II. The U.S. joined the Allies in Europe after the bombing of Pearl Harbor by Japan on December 7, 1941.

After launching a program in the 1930s to purge German museums and other institutions of contemporary art that he labeled "degenerate," Hitler pursued his master plan to establish and build a new seat of German culture, the so-called Führermuseum, which was to be part of a cultural complex in Linz, Austria, near his birthplace. During the war, he used his power to confiscate (or destroy) the cultural legacy of the countries he invaded on a massive, unprecedented scale.

Hermann Goering (1893–1946) Second in influence to Hitler, Hermann Goering played an outsized role not only in Nazi governmental and military decision making, but also in art looting throughout Europe. Well recognized for his success as a fighter pilot during World War I, Goering exerted his influence through both his build-up and command of the German air force (the Luftwaffe) and his control over a variety of other segments of the German economy. His voracious appetite for art, which he displayed primarily at his elaborate hunting lodge near Berlin known as Karinhall (named after his first wife), inevitably brought him in direct competition with Hitler. On one occasion, Goering's private train left Paris under Luftwaffe escort in 1941 with 19 crates of masterpieces marked for delivery to "H," and 23 crates for "G."

Bruno Lohse (1911-2007) Bruno Lohse came to Goering's attention in 1941 while working for Kurt von Behr (1890–1945), the Paris head of the Einsatzstab Reichsleiter Rosenberg (ERR) (see page 46), the German agency charged with art confiscation. Lohse had operated a minor art dealership from his home in Berlin before the war and spoke fluent French. While taking advantage of Goering's influence, Lohse played a variety of roles. In the process of confiscating art from Jewish dealers and collectors in Paris, he funneled it not only to Goering, but also to Hitler and many others, and possibly to himself. As the Allies approached Paris, Lohse and his colleague, Günther Schiedlausky (1907–2003), left the city, eventually making their way to the perceived safety of rural Bavaria before the liberating Allied troops arrived there in 1945.

Walther Andreas Hofer (1893–1971) and **Beatrice Fritsch** (dates unknown) Another leading art advisor to Goering, Walther Andreas Hofer had been an independent art dealer in Berlin. He began working with

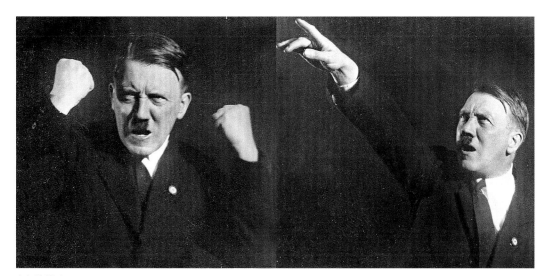

Adolf Hitler

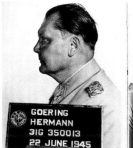

Hermann Goering, 1945

Bruno Lohse (right) with Goering, c. 1945

Walther Andreas Hofer, 1945

Heinrich Hoffmann, 1945

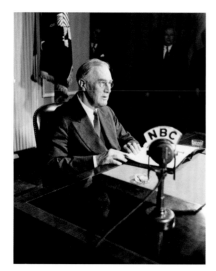

Franklin Delano Roosevelt, 1944

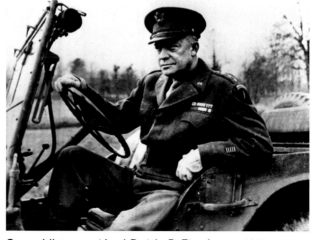

General (later president) Dwight D. Eisenhower, 1944

General Alexander M. Patch, 1945

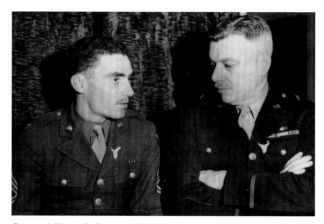

General Pleas B. Rogers (right), 1943

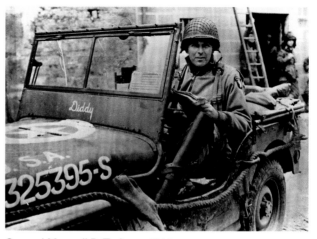

General Maxwell D. Taylor, c. 1944

Goering in 1936 and became the director of Goering's art collection. Hofer's wife, Bertha Hofer-Fritsch, was well regarded as an art conservator. At war's end, the Hofers de-camped to Berchtesgaden.

Heinrich Hoffmann (1885–1957) As Hitler's official photographer, Heinrich Hoffmann was part of Hitler's inner circle. Among other things, he introduced Hitler to Eva Braun (1912–1945), who became Hitler's last companion in life and who, on the eve of their deaths on April 30, 1945, became his wife.

THE AMERICANS

Franklin Delano Roosevelt (1882–1945) President Roosevelt influenced every aspect of America's involvement in World War II. In December 1941, shortly after the Japanese attack on Pearl Harbor, he encouraged the formation of the Second Roberts Commission, which engendered the military unit in which the author served. This unit became known as the Monuments, Fine Arts & Archives (MFA&A) section of the U.S. Army. Its members are commonly referred to as the monuments men.

Dwight D. Eisenhower (1890–1969) General (later President) Eisenhower was Supreme Commander of the Allied Expeditionary Force in Europe. A few days before D-Day, he issued the order formally directing his armies to "protect and respect" monuments and other cultural property whenever possible (see page 23). This order gave military clout to the guidance of the monuments men, who were typically lower in rank than the commanders they worked with in the field. Eisenhower became publicly associated with the work of the monuments men when he appeared in a photo capturing his inspection of looted art and hidden gold reserves in the Merkers mine in Germany (see page 22).

Brigadier General Pleas B. Rogers (1895–1974) As the head of Seine Section, Rogers was responsible for the overall administration of Paris after its liberation by Allied troops in August 1944. From there he directed the work of the monuments men in the city and surrounding regions.

General Alexander M. Patch (1889–1945) "Sandy" Patch was a senior U.S. Army officer who served in both World Wars. He was commander of the U.S. Seventh Army in Germany in 1945.

General Maxwell D. Taylor (1901–1987) Maxwell Taylor graduated from West Point in 1922. After an early posting in the 1930's as a military attaché to Japan during the Sino-Japanese War, he took command of the newly formed airborne unit of the 101st Division in 1944 when its senior general fell ill just before D-Day. Under Taylor's command, the division parachuted into German-held territory deep in France the night before the Normandy landing, successfully securing the areas in-

land from Utah Beach. He continued to lead the 101st during a year of bitter fighting in France and Germany, eventually earning assignment to the prestigious mission to secure Berchtesgaden at the end of the war. The division is known as the "Screaming Eagles" and has a bald eagle's head on its shoulder patch.

Monuments Men and Women

It is estimated that around 350 individuals were among the monuments men and women who served during World War II. At any one time, however, there were typically only about 15 American monuments officers active on the ground in Europe. Those who figure most prominently in the events described in the author's account on these pages are described below. About 25 others, including British and Australians, are introduced elsewhere in the book.

Paul J. Sachs (1878–1965) Paul Sachs was arguably the original inspiration for the monuments men. After first working at Goldman Sachs, his family's investment banking firm, he began volunteering at the Fogg Art Museum (now part of the Harvard Museums) in 1911. Before long, he left investment banking and became assistant director of the Fogg, as well as a renowned educator at Harvard. His famous museum course defined the nascent field of professional museum studies. He trained the author and many of the other museum experts he recommended for assignment in the wartime effort.

George L. Stout (1897–1978) In the late 1920s, George Stout became a pupil of Paul Sachs while pursuing a master's degree at Harvard. Upon graduation he joined the art conservation department at the Fogg and remained there until the war. Stout is recognized as the founder of the modern science of art conservation. It has been reported that he was the first person to propose the idea of sending a team of art professionals to serve in the path of the war in Europe. Ubiquitous in Europe after D-Day, he was personally involved in all aspects of the art salvage and conservation effort.

Mason Hammond (1903–2002) Third in the trio from Harvard who shaped the effort to preserve European art during the war, Mason Hammond was trained as a classical scholar and was an historian of ancient Rome. During the war, well before D-Day, he was assigned to serve as the first monuments officer on the ground, traveling to North Africa to prepare for the invasion of Sicily and southern Italy. He later served throughout Italy and Germany as a senior official helping to oversee the monuments operation.

Ralph W. Hammett (1896–1984) A professor of architecture at the University of Michigan before the war, Ralph Hammett was the author's superior in the Army chain of command during the war. While serving in that role at Supreme Headquarters Allied Expeditionary Force (SHAEF) in England and on the continent, he managed and coordinated much of the work of the monuments men in the field.

Paul J. Sachs

George L. Stout

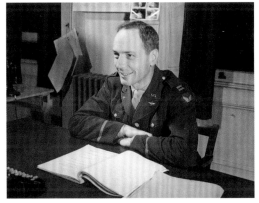

Mason Hammond, c. 1944

Ralph W. Hammett, c. 1944

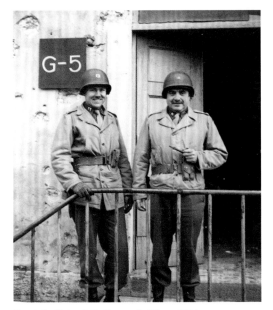

Captain Robert K. Posey (left), c. 1944

Edith A. Standen, 1946

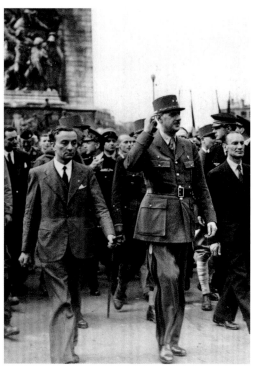

General (later president) Charles de Gaulle (right),
1944

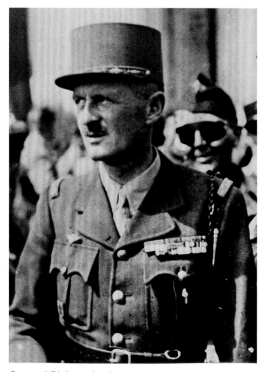

General Philippe Leclerc, 1944

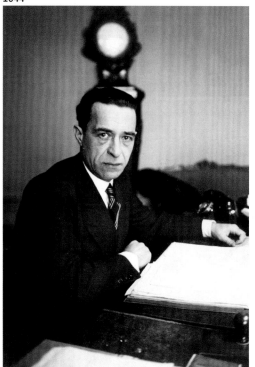

Jacques Jaujard

Rose Valland

Robert K. Posey (1904–1977) An architect from Alabama, Posey was assigned initially to serve as the monuments officer for General Patton's Third Army in western France. Later, his fortuitous interview with a German dentist led him to Hermann Bunjes (1911–1945), a German art historian who had become one of Goering's assistants. Information supplied by Bunjes led Posey to discover the hiding place of the *Ghent Altarpiece* and other masterpieces hidden in the Altaussee salt mine, marking a turning point in the unfolding recovery of major looted treasures.

Edith A. Standen (1905–1998) Edith Standen came to the attention of Paul Sachs while she was volunteering at the Fogg Art Museum and subsequently joined his museum course. In 1943 she enlisted in the U.S. Army Women's Auxiliary Corps, later known as the Women's Army Corps (WAC). She was eventually posted to work with Mason Hammond as a member of the monuments team. She later collaborated with French art expert Rose Valland in the tracing and restitution of looted art. She also took part in the critical work at the Wiesbaden Collecting Point in Germany, where recovered works were assembled for sorting and repatriation.

THE FRENCH

Charles de Gaulle (1890–1970) General (later President) Charles de Gaulle is mentioned only once in the narrative but stands behind the action as the outspoken and controversial leader of the Free French in Exile during the war. From his base in England, he championed the Free French as the opponents of the regime of Philippe Pétain (1856–1951), a hero of World War I who, in 1940, formed a collaborationist government in the French city of Vichy under Nazi control. De Gaulle was constantly at odds with the Allied leaders but ultimately convinced Roosevelt and Eisenhower of his value as champion of the noncommunist French factions. He joined Philippe Leclerc in a triumphal march through Paris after liberation in August 1944.

Philippe Leclerc (1902–1947) Philippe François Marie Leclerc de Hauteclocque shed his ancestral name and identity to protect his family when he left conquered France to join the resistance. Known simply as Leclerc, he led a variety of expeditions against the Axis forces. He features in the author's account as the leader of the first French division to enter Paris upon liberation who also, though not mentioned by name, leapfrogged the Americans to become the first to arrive at the Nazis' Bavarian stronghold at Berchtesgaden at the end of the war.

Jacques Jaujard (1895–1967) As early as 1932, the French fine arts administration began to develop contingency plans for protection of the Paris museums. The following year it appointed Jacques Jaujard, previously an insurance salesman and a journalist, to prepare the museums for war. Later becoming director of the Louvre Museum

and general director of the French National Museums, Jaujard, together with his curator of paintings, Germain Bazin (1901–1990), worked tirelessly throughout the Nazi occupation of Paris to hinder and delay German efforts to loot the French collections. Among other things, he clandestinely collaborated with resistance member Rose Valland to monitor, and partially foil, Nazi looting operations based at the Jeu de Paume Museum.

Rose Valland (1898–1980) Belatedly recognized as a heroine of French culture, Rose Antonia Maria Valland, the daughter of a blacksmith, was born in a small town in southeastern France. She showed promise at an early age and pursued a double curriculum in art history at the Paris École des Beaux-Arts and École du Louvre, followed by further study at the College de France. When the war began, Valland was a volunteer assistant curator at the Jeu de Paume Museum in Paris. After the museum's director left due to illness, leaving Valland effectively in charge, the site became the center of the Nazis' art sorting operation for France. During this time, she quietly observed and recorded the depredations of Goering, Lohse, and others, clandestinely reporting details of Nazi activities every few days to Jacques Jaujard. Her dangerous resistance operation ultimately proved vital to Allied efforts to locate and collect looted property, as well as to postwar restitution efforts.

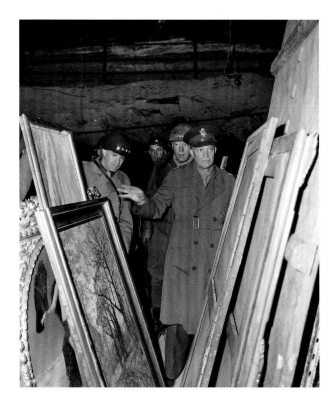

General Eisenhower visits the Merkers mine on April 12, 1945. Behind Eisenhower are Lt. Gen. Omar N. Bradley (left), and Lt. Gen. George S. Patton, Jr. (right).

ALLIED FORCE HEADQUARTERS

Office of The Commander-in-Chief

2512

AG 000.4-1 29 December 1943

SUBJECT : Historical Monuments

TO : All Commanders

Today we are fighting in a country which has contributed a great deal to our cultural inheritance, a country rich in monuments which by their creation helped and now in their old age illustrate the growth of the civilization which is ours. We are bound to respect those monuments so far as war allows.

If we have to choose between destroying a famous building and sacrificing our own men, then our men's lives count infinitely more and the buildings must go. But the choice is not always so clear-cut as that. In many cases the monuments can be spared without any detriment to operational needs. Nothing can stand against the argument of military necessity. That is an accepted principle. But the phrase "military necessity" is sometimes used where it would be more truthful to speak of military convenience or even of personal convenience. I do not want it to cloak slackness or indifference.

It is a responsibility of higher commanders to determine through A.M.G. Officers the locations of historical monuments whether they be immediately ahead of our front lines or in areas occupied by us. This information passed to lower echelons through normal channels places the responsibility on all Commanders of complying with the spirit of this letter.

DWIGHT D. EISENHOWER,
General, U. S. Army,
Commander-in-Chief.

DISTRIBUTION:
"C"

U.S. CONFIDENTIAL EQUALS BRITISH CONFIDENTIAL

Letter from General
Eisenhower, re-issued
on May 26, 1944, just
before D-Day.

The Mission

AUTHOR'S PREFACE TO THE FIRST EDITION

Toward the end of 1942 American educators and museum personnel became increasingly alarmed about the fate of the art in the path of the war. William B. Dinsmoor, president of the Archaeological Institute of America; Sumner McKnight Crosby, president of the College Art Association;[1] Francis Henry Taylor, director of the Metropolitan Museum of Art; and David E. Finley, director of the National Gallery of Art in Washington, D.C., proposed to the chief justice of the Supreme Court of the United States the creation of a governmental commission. With the encouragement of President Roosevelt and his secretaries of state and war, the Department of State announced on August 20, 1943, the establishment of what was to become the American Commission for the Protection and Salvage of Artistic and Historic Monuments in War Areas. It has been generally referred to as the Roberts Commission, as it was under the chairmanship of the Honorable Owen J. Roberts, then a justice of the U.S. Supreme Court.[2] The commission benefited from the preparatory work of the American Defense–Harvard Group and the American Council of Learned Societies.

The British War Office had an adviser, Sir Leonard Woolley, on questions of protection, and the Macmillan Committee was founded in May 1944 as a counterpart to the American commission, although its interest was limited primarily to problems of restitution and reparations.[3]

In May 1940 the German High Command had established the Kunstschutz, professedly for the protection of art in occupied countries. While great credit is due the efforts of well-trained and courageous German officials whose chief concern was the preservation of cultural properties, it must be remembered that the Nazis envisaged complete subjugation of western Europe. They wished to preserve everything that was to be part of the culture of "Greater Germany." In eastern Europe they systematically looted and burned.

In the European Theater of Operations, with which we are here concerned, a letter signed by General Dwight D. Eisenhower, supreme commander of the Allied Expeditionary Forces, was issued on May 26, 1944, a few days before D-Day. It is the key to all subsequent instructions concerning the preservation of historical monuments and cultural objects in Europe. The letter stated:

> *Shortly we will be fighting our way across the Continent of Europe in battles designed to preserve our civilization. Inevitably, in the path of our advance will be found historical monuments and cultural centers which symbolize to the world all that we are fighting to preserve.*
>
> *It is the responsibility of every commander to protect and respect these symbols whenever possible.*
>
> *In some circumstances the success of the military operation may be prejudiced in our reluctance to destroy these revered objects. Then, as at Cassino,[4] where the enemy relied on our emotional attachments to shield his defense, the lives of our men are paramount. So, where military necessity dictates, commanders may order the required action even though it involves destruction to some honored site.*

But there are many circumstances in which damage and destruction are not necessary and cannot be justified. In such cases, through the exercise of restraint and discipline, commanders will preserve centers and objects of historical and cultural significance. Civil affairs staffs and higher echelons will advise commanders of the locations of historical monuments of this type, both in advance of the front lines and in occupied areas. This information, together with the necessary instruction, will be passed down through command channels to all echelons.[5]

The military personnel chosen to expedite such instructions were for the most part selected by the War Department on the advice of the Roberts Commission's Committee on Personnel, headed by Professor Paul J. Sachs of Harvard University with W. G. Constable of the Boston Museum of Fine Arts as adviser.

As the Monuments, Fine Arts & Archives officer[6] with (1) Advance Section, Communications Zone, in Normandy; (2) Seine Section in Paris; and (3) the Seventh Army/Western Military District, U.S. Zone, in Germany, I was directed to do what I could to help preserve monuments and other cultural objects from the tip of the Normandy peninsula across large and artistically important areas of France into Germany and Austria.

Without the continued assistance of my wife, Katherine Serrell Rorimer, this book would never have been written. Gilbert Rabin has molded a long and difficult manuscript into its present form. Among many colleagues who have given help are Dietrich von Bothmer, Marshall Davidson, Dudley T. Easby, Charles Kuhn, Jane A. Mull, Charles de Noailles, Vera K. Ostoia, Theodore Rousseau Jr., and Edith A. Standen.[7]

NOTES

1 Sumner McKnight Crosby (1909–1982) was an assistant professor at Yale University before the war, specializing in medieval architecture. After service as special adviser to the Roberts Commission from 1943 to 1945, he returned to teaching and scholarship at Yale, where he pursued his lifelong dedication to innovative study of the abbey of Saint-Denis outside Paris.

2 This commission may also be referred to as the Second Roberts Commission. An earlier commission had been appointed under the chairmanship of Justice Roberts in 1941 to investigate possible negligence leading to the Pearl Harbor attack.

3 The full name of the British committee was the British Committee on the Preservation and Restitution of Works of Art, Archives and Other Material in Enemy Hands. It is to be distinguished from the unrelated British committee formed to investigate the causes of the financial crash in 1929, which was also known as the Macmillan Committee and produced an influential report, largely written by John Maynard Keynes.

4 Prior to the battle of Monte Cassino (January–May 1944), German forces in Italy held out doggedly along a defensive line running through Monte Cassino, the ancient hilltop abbey that housed an important library and works of art. After vigorous internal debate, the Allies reluctantly decided to bomb the abbey, reducing it to rubble. The Allies eventually broke the German line, suffering extensive loss of life, but discovered belatedly that the Germans had entered the abbey to set up defenses only after it had been destroyed.

5 Eisenhower had previously issued an order to similar effect on December 29, 1943 (see page 23). For organizational purposes, the Army typically placed monuments officers on its "civil affairs" staffs, which were charged with supplying government and municipal services to the civilian population immediately after the end of hostilities. These "military governance" services included the provision of food, medicine, and shelter, as well as security and policing. Protection of the art and heritage of Europe fell within this mandate.

6 Although originally identified simply as members of the army's Monuments, Fine Arts & Archives unit, or "monuments officers," the author and his colleagues have been referred to more recently as "monuments men," the latter term being used notwithstanding the noteworthy contributions of women on the team. References in this book have been modified, where context allows, to reflect current usage.

7 Several of these individuals were among the monuments men and women or colleagues of the author. Dietrich von Bothmer (1918–2009): curator of Greek and Roman art at the Metropolitan Museum of Art, who served in the Pacific in World War II; Dudley T. Easby Jr. (1905–1973): secretary of the Metropolitan and expert on pre-Columbian metalwork; Charles L. Kuhn (1905–1985): monuments man; Jane A. Mull (1915–1990): writer for *Fortune* magazine and monuments woman; Charles de Noailles (1891–1981): French patron of the arts; Vera K. Ostoia (1904–1988): curator of medieval art at the Metropolitan; Theodore Rousseau Jr. (1912–1973): curator of paintings at the Metropolitan and monuments man; Edith A. Standen (1905–1998): curator of textiles at the Metropolitan and monuments woman.

World War II Timeline, 1938–45

This book describes the participation of author James J. Rorimer in the events of World War II, and for the most part, his progress unfolds in chronological order. The timeline below follows the author's travels through France and Germany in the context of the larger global conflict.

YEAR	THE AUTHOR AND THE ALLIES	HITLER AND THE AXIS POWERS
1938	The Cloisters opens to the public	**March:** Germany annexes Austria (the "Anschluss") **September:** Hitler agrees, at the Munich Conference, to refrain from further territorial expansion upon surrender of the Sudetenland region of Czechoslovakia to Germany
1939	**September:** Britain and France declare war on Germany: World War II begins in Europe	**September:** Germany invades Poland
1940		**May:** Germany invades the Netherlands and Belgium **May:** Re-establishment of the Kunstschutz for "protection" of art **June:** Germany invades France and occupies Paris
1941	**December:** The United States declares war on Japan and Germany	**December:** Japan bombs Pearl Harbor
1942	Fogg Museum holds preservation conference at Harvard The Metropolitan Museum transfers selected works to the Stotesbury mansion, outside Philadelphia, for safekeeping	
1943	**June:** Author enlists in the U.S. Army; basic training at Ft. Dix (NJ) and Ft. Wheeler (GA) **August:** Establishment of the Roberts Commission **November:** Author transferred for military governance training at Ft. Custer (MI) and Boston University	

YEAR	THE AUTHOR AND THE ALLIES	HITLER AND THE AXIS POWERS
1944	**May:** Macmillan Committee formed in Britain	**May 22:** Nazis transfer Strasbourg stained glass to Heilbronn mine
	May 26: Publication of Eisenhower Order on Protection of Art	
	June 6: D-Day	
	August 3: Author crosses the Channel from England to France	
	August 25: Liberation of Paris; author arrives in Paris	
	December (and early 1945): Rose Valland agrees to release her records of Nazi looting to the author	**December:** Battle of the Bulge, the final German offensive
1945	**March:** Seventh Army crosses the Rhine into Germany	**March:** Hitler orders evacuation of Prussian State Museums in Berlin
	April: Discovery of gold and art in the Merkers mine, Germany	**April 30:** Hitler commits suicide
	April: Author arrives at the Kochendorf mine	
	May 4: French troops occupy Berchtesgaden in southern Germany	**May 2:** German garrison surrenders Berlin to the Soviets
	August: Hungarian Crown of St. Stephen discovered in Germany	**May 8:** Germany surrenders
	August 6: United States drops atomic bomb on Hiroshima, Japan	
	August 9: United States drops atomic bomb on Nagasaki, Japan	
	November 4: Strasbourg stained glass returned to cathedral. Author receives French Legion of Honor	**September 2:** Japan surrenders

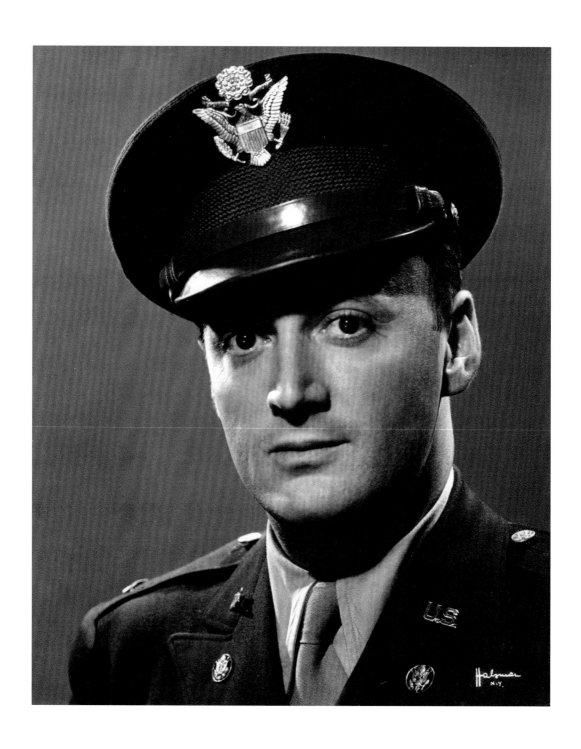

The author in uniform
by photographer
Philippe Halsman, 1944.

AUTHOR'S ROUTE DURING THE WAR, 1944–45

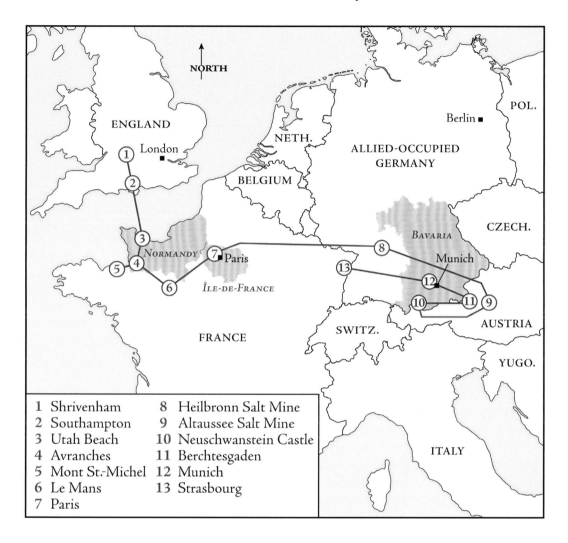

NORTH

ENGLAND

London

NETH.

BELGIUM

NORMANDY

Paris

ÎLE-DE-FRANCE

FRANCE

BERLIN ■

POL.

ALLIED-OCCUPIED
GERMANY

BAVARIA

CZECH.

Munich

SWITZ.

AUSTRIA

YUGO.

ITALY

1	Shrivenham	**8**	Heilbronn Salt Mine
2	Southampton	**9**	Altaussee Salt Mine
3	Utah Beach	**10**	Neuschwanstein Castle
4	Avranches	**11**	Berchtesgaden
5	Mont St.-Michel	**12**	Munich
6	Le Mans	**13**	Strasbourg
7	Paris		

Basic Training

LEAVING THE METROPOLITAN MUSEUM OF ART TO JOIN THE ARMY

1

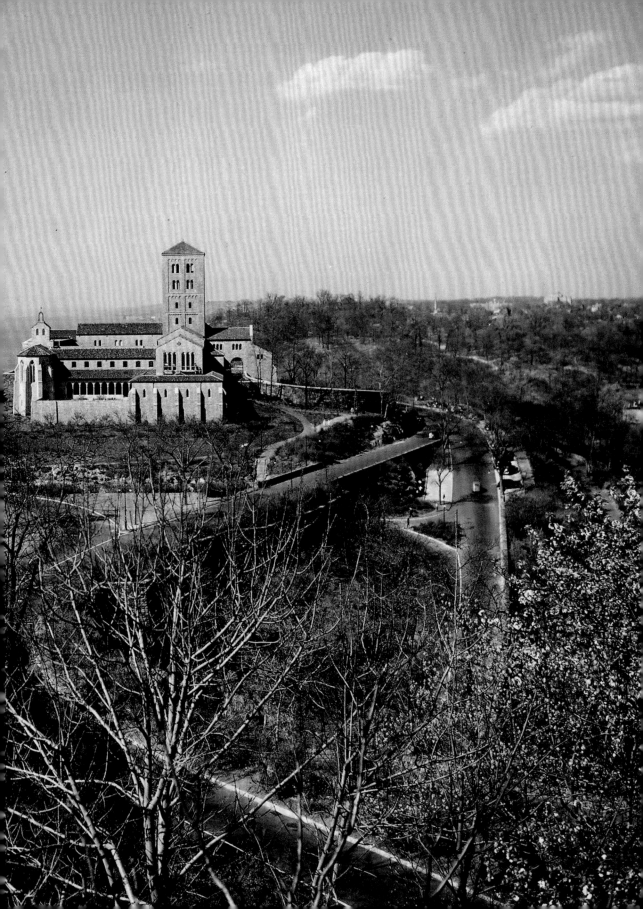

AUTHOR'S BASIC TRAINING IN THE U.S., 1943–44

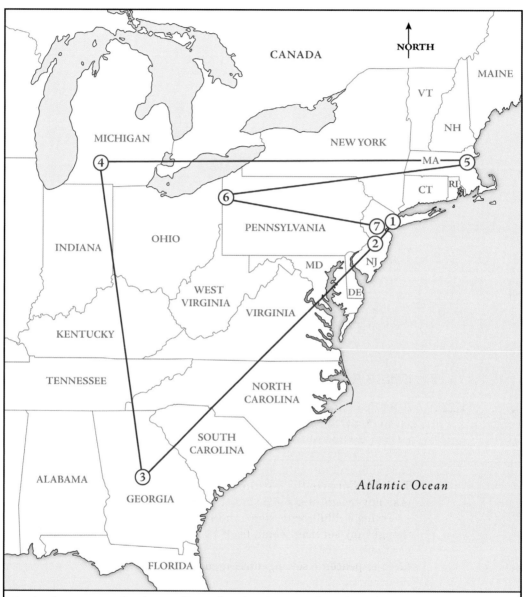

1 Author reports for duty at Penn Station, New York City, on June 9, 1943
2 Initial processing at Fort Dix
3 Basic training and promotion to officer at Camp Wheeler
4 Training in civil affairs at Fort Custer
5 Specialized training in military government at Boston University
6 Transfer camp at Camp Reynolds
7 Staging area at Camp Kilmer before shipping out to England in mid-1944

James J. Rorimer was born in Cleveland, Ohio, on September 7, 1905. His father, Louis Rorimer, also a Cleveland native, founded Rorimer-Brooks Studios, an interior design firm that decorated and furnished many homes and institutions in the Cleveland area and elsewhere. His paternal grandfather, Jacob Rohrheimer, had immigrated to Cleveland from Lorsch, Germany, in 1848. His mother was Edith Joseph Rorimer, whose father had emigrated from Germany to Cincinnati, where he founded a hide and fur trading business in 1863, later switching to scrap metal recycling.

James attended University School in Cleveland, except for intervals of study in Paris, before graduating in 1923. He received an undergraduate degree in fine arts from Harvard in 1927 and went to work at the Metropolitan Museum of Art in New York City. With the unexpected death of the curator of the Medieval Department, the author suddenly found himself responsible for completion of the design and construction of the Cloisters in northern Manhattan. Collaborating closely with John D. Rockefeller Jr., whose contributions funded the project, Rorimer oversaw completion of the Cloisters in 1938.

Just before joining the U.S. Army in 1943, the author married Katherine Newton Serrell, who was then working in the library of the Metropolitan Museum of Art after graduating from Wellesley College. During the war she worked on aerial maps designed to help Allied aviators flying over Europe avoid targeting cultural heritage sites.

ENLISTMENT

After Pearl Harbor[1] and the adoption of Selective Service[2] I volunteered for intelligence work. Had I known as much about the army in 1941 as I learned subsequently, I might have made the most of opportunities to knock at a few doors in Washington. General Marshall[3] rightly assured me that my year of infantry training as a boy in the Student Army Training Corps in the last war was of no particular value, and I failed to take advantage of his offer in these early days to get me "started."

Irving J. Phillipson, commanding general of the Second Corps Area,[4] thought my services would be of value. He had found occasional relaxation at the Cloisters, as had other visiting celebrities who enjoyed that unique, peaceful setting untainted by the ever-increasing activity of their wartime careers.

I was rejected for the army by the omnipotent doctor on the draft board,[5] which had to give the go-ahead signal. A physical technicality, later proved erroneous, changed my plans. By 1943 I had managed by digging on the family farm, chopping wood, bicycling to work at the museum, and playing tennis to convince myself and the army that I was eligible for unlimited service. With the draft board hurdle finally overcome, I set off for basic training.

At the Pennsylvania Station[6] (June 9, 1943) I joined as motley a group of draftees as ever entered the U.S. Army. An old suit—the oldest I owned—

35

as well as a hat with a Harvard twist[7] and a hole poked in the crown, might have betrayed me to my traveling companions; most of them wore no hats at all. I wanted to be like every other man in that mob. I had taken my toothbrush with me as recommended in the sheaf of instructions. Otherwise I had left behind all of my earthly possessions except for my American Express checks, the onetime open sesame of the seasoned traveler.[8]

There were few occasions to use money in the ensuing months. Whatever we received was sufficient for our immediate needs, although some of us were now earning less than a few percent of what we had earned as civilians. We had little use for one fellow who managed to send for his roadster and avoided KP[9] by indulging the sergeant in trips to town and paying other soldiers to take his turns at unpleasant duties.

ARRIVAL AT FORT DIX, NEW JERSEY

No one cared about such matters when we paraded into a large wooden structure on the first night of our arrival at Fort Dix.[10] We were given our general classification tests without private secretaries and filing clerks, or the help of capable associates, or the advice of seasoned lawyers and statisticians. The hundreds of participants in that room were for the most part fresh from the classroom and had little hesitation at the prospect of another examination. I had not had an examination for years,[11] and the thought of counting boxes in a pile at breakneck speed, or working out a simple problem in algebra or geometry, was cause for misgivings.

During the examination it was my lot to be seated in a corner of the room where some dozen youths found it amusing and descriptive of their feelings about the procedure to emit catcalls and sotto voce remarks. I was included in the reprimand of the group. This was my first of several experiences in the army of having a finger pointed at "you, and you, and you."[12] The blemish was forthwith scribbled in pencil on my record card— "disorderly conduct." It was never inked in, or, as the police say, "on the blotter." I looked about the room and saw small cards, THINK THINK, and I thought some more. I was supposed to think about the absurdity of my present position, or was it the Radio Aptitude Test? As the dots and dashes[13] sounded through the room, I marked Xs and checks indiscriminately. The sounds came to me like noises in a swound.[14] I could hardly be more than 50 percent wrong. THINK. Think I must. The president of International Business Machines, respected Thomas J. Watson, was responsible for those THINK signs.[15] He was chairman of the Committee of Medieval Art at the Metropolitan Museum; I was the curator on leave. THINK. I hated to think that his machines standing in the corner of the room to adjudge my thinking by the release of a button might be my undoing.

My first practical thinking came the following morning when I had to explain to the examining officer, a bright young lad who had studied 18 months of psychology, why my card showed more than an average rating and yet I had been gigged for making ghoulish noises the previous evening. I explained simply that it just so happened that I was seated

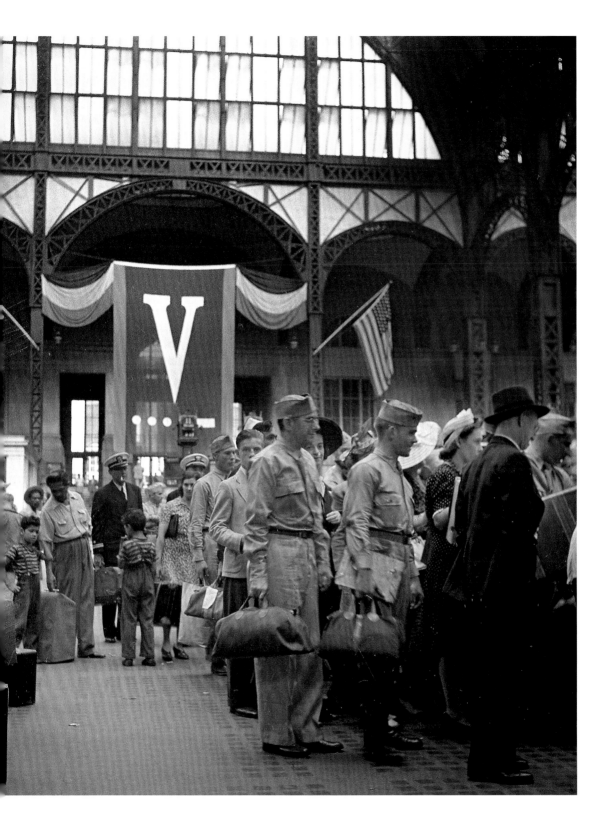

in that part of the room where the rumpus arose, but that I had been industriously THINKing through the whole performance.

Two Haircuts and Crushing Rocks

Satisfactory conferences with intelligent inquisitors across individual tables were not the rule in the army. An inspecting officer took joy in proclaiming his displeasure and that of the service in open ranks. I had my first GI haircut on my arrival at Dix. In the afternoon at the first of many inspections the major stopped in front of me, looked me straight in the eye, loudly cursed, and had my name taken for hair that was too long to meet regulations. "You'd make swell pickins for the Japs,"[16] he said. Ten minutes later I was standing in line for the second haircut of the day. Little by little, in fact pretty damned fast, I became accustomed to the ways and expectations of my superiors.

KP was too proud for the crowd of hoodlums I came to be associated with as army justice was meted out by the numbers and we were marched off to do heavy duty working on a road gang. I was crushing rocks when a colonel, the first and last I was to talk to for many months, asked me why I was doing that kind of work. "The corporal's orders, sir." The colonel implied that such labor was only for prisoners and that he was not too pleased that new inductees should be handled in this manner. I wonder what my army career would have been if I had told him then and there about lunching two days before with our mutual friend, the former commanding general of his Fort Dix. I stood in awe of our sergeant and decided that if I knew what was good for me, I had better just take things as they came. Three days of continuous guard duty at an abandoned area, with time out to sleep on the floor of one of the orderly rooms—we took turns bringing food from our own tent area a couple of miles away—produced weariness of a kind I had never experienced.

CAMP WHEELER, GEORGIA

It was a relief to entrain for our next destination, albeit unknown. Three of us shared a double berth that night. It became increasingly evident that it was officially thought that if we could have our spirits broken, we would be a little more manageable. We arrived at Camp Wheeler, near Macon, Georgia, for our basic training. This place had been described by Walter Winchell[17] as having all the attributes of a concentration camp except for the barbed wires. Our gang, to which I seemed irrevocably attached, had originated at a draft board just south of Harlem in Upper Manhattan. We were destined for a heavy weapons company where apparently brawn counted above-brains. In this heavy weapons outfit I labored mightily for two weeks. One day 200 of us were cubicled for interviews with officers on the hunt for talent for the cook and bakers school, and four platoons to receive special training in message center, wire, radio, and intelligence work. The warrant officer in cubicle 6 looked at my qualification card and then at me. He was very young.

"What are *you* doing here?" he asked irritably. "Why weren't you screened out of this mess before they sent you here?" From the way he glared I sensed he was feeling sorry for himself, not me. "With your special knowledge you should be . . . And look at me. I wasn't allowed to finish at Yale. They needed psychologists, and here I sit punching holes in these cards. I've been doing it for a year. When the war is over, I bet I'll still be doing it."

Who was I to give encouragement to this keen young man who should have had the world before him? I wasn't doing so well myself.

The result of our conference was that in due course, after the usual routine of delay and being forgotten, I started training all over again, this time in the intelligence and reconnaissance platoon. For four months we had training in radio, message work, map drawing, airplane recognition, motor school, and camouflage, in addition to the usual instruction in weapons and other requisites of the modern infantry soldier. Our hikes were long, our classes intensive, and the physical training strenuous. The average age in the platoon was 22. I was turning 38 and I found it essential to give all that I had to give. I learned a great deal about my fellow men and a way of life I had never known before. Others have written about 14 hours at a stretch at KP, hikes under the Georgia sun where 35 men dropped in their tracks, digging slit trenches, scrubbing floors and everything else in sight. There were fine fellows and there were loathsome ones. All these incidents were shared by others and can be passed over without further elaboration.

A Telegram from the Metropolitan Museum of Art

One hot night, stripped to my shorts, I was on all fours scrubbing more than my share of the wood floors of our barracks with GI soap and brush so that I could get off early and go to town to answer a telegram I had received with the day's mail. It was from Francis Taylor, director of the Metropolitan Museum. It read something to the effect that my "definitive and immediate decision was wanted about the purchase of an object of art for 250 grand." Our corporal had been confined to quarters, so he decided none of the men would go to town that night. He told me to telephone the answer to my telegram. Without showing him the telegram I insisted that it was confidential and important and that I couldn't answer it by telephone; if he wouldn't give me permission to send an answer from the telegraph office I would see the duty officer. Telegram in hand I walked boldly out of the barracks and over to the orderly room. The young lieutenant in charge thought this the best racket he had heard yet for getting to town to see one's girl.[18] He signed my pass.

The first sergeant produced my qualification card in the morning, and he and the lieutenant had a couple of good laughs. It was not long before the corporal found an excuse to have me do an extra turn of KP in the officers' mess. The corporal had been a private on a desert island in the Pacific and his eyes were badly damaged by sun. To get him off the island, he was promoted to PFC.[19] In California he had made T5[20] to be on the shipping schedule and had made corporal to get in the training battalion.

By this time the first sergeant knew more about me than I did myself. He singled me out to the commanding officer of our company, First Lieutenant Robert P. Armstrong, as a likely prospect for Officer Candidate School (OCS). The latter passed my papers along with a gratifying endorsement to the young major commanding our battalion, and he in turn, through channels, approved the application and wrote: "It is the understanding of the undersigned that present plans contemplate the use of certain individuals with a background and experience in museum work to be trained in the school of military government and sent abroad, and to occupied countries to rehabilitate the art work in those countries. While this man is slightly over the ideal age for troop leadership, it is believed that he can readily complete the course of instruction at the infantry school and that following this course, he might be detailed to attend the school of military government." The officer in charge of our platoon had also "recommended with enthusiasm," answering "yes" to 39 form questions, and added other attractive remarks so congratulatory as to be embarrassing.

If I had seen these papers at the time I would have understood the question asked me at the regimental board hearing: "Do you not think that you know too much to be an officer?" I was passed for OCS because I had sense enough to answer this question with the thought that knowledge is of no value unless put to good use, and that I had needed basic training in order to be better prepared for army service.

Maneuvers were to give us a foretaste of the long hours demanded by the necessities of a war of movement. The oft-repeated nightmare of the war for so many of us was "put 'em up, knock 'em down." We were forever establishing something and then moving on to something else. Whether it was a tent on a bivouac in Georgia or headquarters at Augsburg, some higher echelon always managed to have orders sent out to keep army units on the move. Granted that the exigencies of war require mobility and constant shifting, but it is hard to understand the motives behind the training program in the United States, which, according to one report, resulted in the average GI traveling 4,500 miles during six trips from camp to camp.

After four months of basic training, and being given three different types of instruction, I was on the final two-week bivouac. We had not been to bed for two days. I was aroused after less than an hour's sleep at the end of a grueling day. "Go away," I said peevishly, forgetting I was in the army. "Okay, okay," said the messenger, "but you've got orders from Washington."

Our sergeant thought it wise to get me back to camp immediately. I was to collect as many of my belongings as I could and return with the chow truck to camp. That moment I learned a valuable lesson: never spread out any more equipment than essential to the immediate moment. Groping in the dark for miscellaneous paraphernalia, and finding the extra shoes or a canteen in my half of the pup tent, was to prove child's play compared with moving the supplies and equipment of a monuments officer from headquarters to headquarters.

By ten o'clock the next morning I was in the neatest uniform we could muster from the supply room. I appeared before the colonel of our regiment to receive instructions.

"You are to be an officer as soon as you can be sworn in. Here's the adjutant now. Sign this paper."

I read the paper with mixed feelings. Apparently the Civil Affairs Division of the War Department, after finding my lost papers, had decided that I was to be a second lieutenant. As a private there was a certain distinction in having put my previous career in the background and in trying to be as good as the next fellow; as an over-age-in-grade shavetail[21] accepting a direct commission from the ranks I thought that the powers that be had failed to give the needed rank to a man who in the coming months would have to meet many challenges in helping preserve the art of Europe.[22]

I signed the paper and was sworn in as an officer. However, pending further instructions from Washington I was still a private. This anomalous position of being an officer on inactive duty and a GI at one and the same time embarrassed the other officers more than it did me. My real friends were among the enlisted men, and messing and rooming in the officers' quarters offered little attraction. I could easily understand why in general practice the army preferred to have newly appointed officers divorced from their old units.

The Long Wait

A month passed. I became restless as no further orders came from Washington. I was anxious to begin my military government schooling. Nothing worked. The only way to get action was to force the issue. To attract attention, I put on my officer's uniform, without insignia, and waited for the expected to happen. At Camp Wheeler the uniform was the most important part of a soldier, and regulations were explicit and enforced to the letter.[23] Within less than 15 minutes someone reported to regimental headquarters that one of the men in our company was out of uniform. I was summoned to the orderly room, explained the situation, and went from there to battalion and regimental headquarters.

I took a tongue lashing from the portly master sergeant whom I had previously known only when I served him in state at the officers' mess. He not only ran the mess, but the regimental headquarters and the colonel. After his harangue failed to make the proper impression on me and I had three times explained my situation, the colonel breezed into the outer room. He seemed to have forgotten that he had told me to wear my officer's uniform if I wanted to and that he had even offered me some of his own. The sergeant thought he had won another battle with an insignificant private just about the time the colonel told him to call camp headquarters to see where my papers were. To judge from the conversation, the sergeant really took hell.

"Is that fellow still in camp? He should have been sent out of here weeks ago. These were Do Not Delay orders with red margins, 24-hour action required. What do you mean by gumming the works! These were not Camp Wheeler orders; they came from Washington."

The telegram that arrived that same week could hardly have been an answer to our general's request for information about what to do with me. In it he was instructed to have "Lieut. Rorimer arrive at Fort Custer in Michigan to attend the Provost Marshal's Military School beginning 24 November." This order could not be complied with as it was already November 25, and I still had not been discharged from the army as a private. I was rather amused by the clause in the instruction, "If Rorimer has already been shipped overseas notify this office."

I was sorting mail at battalion headquarters when I received my orders. I telephoned our sergeant and asked him to send someone to fetch the mail. I didn't want to lose time pushing the mail cart back to our company down the hill, and perhaps I was already conscious of not doing anything "unbecoming an officer." It seems to be an unwritten rule in the army that any unnecessary menial work must be done by an enlisted man. In practice I was to learn that the way to get things done often included doing anything and everything oneself, just as it is in civilian life. With the help of the all-purpose bicycle assigned to our headquarters and appropriated by our sergeant, I covered miles about the camp and was ready for drinks with the officers who gave me a farewell send-off.

Two of my enlisted friends insisted on carrying my baggage to the bus. It is one of the regrets of life that acquaintances among the real people one meets in one's travels must of necessity be so fleeting. My most sympathetic friend during these arduous months of basic training, a cousin of the secretary of war, had left some weeks before to attend ASTP School.[24] Although we met again briefly in Paris, and when I returned home I was in time to be at his wedding, the close comradeship will never be again as our lives go their separate, involved ways.

FORT CUSTER, MICHIGAN, AND BOSTON

At Fort Custer I began studying the history of and rules for civil affairs and military government in the past. We learned about the various police systems of the world, in particular the former German and Nazi organizations, public health, public welfare, fire protection, and other requisites of civil administration. We had classroom problems to solve and were addressed by experts of all kinds. Specialists described Allied Military Government operations in Italy. Our course, which lasted four weeks—I missed the first week due to my late arrival—included marching, pistol practice, map reading, first aid, and other basic instruction familiar to soldiers with infantry or similar basic training.

The majors were segregated in their own course and lived in separate barracks. The lieutenants and captains had the identical training given the majors. It was a great pity that at the start of military government work officers were thought of in terms of rank rather than on the basis of their merits for carrying out either special functions or administrative duties. A young air corps major, an artillery captain, or a directly commissioned college professor was ordinarily not qualified for

his future work and responsibilities commensurate with his brass. The British system of giving a man temporary rank according to his responsibility of the moment had great virtue in such specialized operations as military government. The regular army system of promotions in the United States was ill adapted in many cases known to everyone who had contact with military government specialist officers.

At Boston University, one of several schools to which military government officers were sent after the preliminaries at Fort Custer, I found this differentiation by rank very noticeable. Here, unlike Custer (a purely military installation with its fine record for training army policemen), academic standards were set for military government officers. Our instructors included well-trained men in the field of government and related subjects. Former chancellor Brüning of Germany and other men on the Harvard teaching staff supplemented the valued services of those on the Boston University faculty. We brushed up on our German or French, whichever was the weaker, if we had proficiency in both languages. Some of the officers, particularly the older ones with the rank of major or lieutenant colonel, had not studied languages since school days, and it was as amusing as it was pathetic to see them struggle with a foreign tongue. Even their command of English was at times disheartening.

We had a growing library with some of the most recent publications on Germany and the Nazis. Many of our group of about a hundred officers were in deadly earnest about their studies, spent long hours poring over the OSS[25] summaries about specialized conditions under the Nazis, and found enlightenment in current Baedekers[26] and periodicals spirited out of Germany. Had not the Germans kept abreast of our work? Later in Germany, among Professor Dr. Louis Dede's books at Zwingenberg Castle on the Neckar, I noticed the *General Electric Review* and *Proceedings of the Cambridge Chemical Society* dating well into 1944.

SHIPPING OUT

Before the end of the training we were alerted for overseas shipment. As we learned later there had been serious thought that Germany might collapse in the spring of 1944 and it would be necessary to have the 2,000 military government officers to help establish peace and order at a moment's notice.

We were herded together from out of the classrooms to Camp Reynolds, once more euphoniously called Camp Shenango. At this godforsaken place near Sharon, Pennsylvania, we waited several weeks for shipping space. Here we got to know one another better than anywhere else. We organized ourselves into classes, complained about the lack of organization of military government, and lived in old wooden barracks with red-hot stoves. The spirit of camaraderie that developed from lieutenant colonels washing their clothes in the same basin as everyone else—normally four of us at a time—was admirable. We were like benumbed soldiers undergoing the hardships of basic training.

THE BAEDEKER RAIDS

In April and May of 1942 the German Luftwaffe targeted several historic British cities, including Exeter, Bath, Norwich, York, and Canterbury, in retaliation for Britain's aerial bombing of the German city of Lübeck, which had been the seat of a medieval trading coalition known as the Hanseatic League. The raids on British cities became known as the Baedeker Raids, or the Baedeker Blitz, when a German propaganda staffer remarked that Germany planned to bomb every city in Britain that had earned top ratings (two stars or higher) in the eponymous Baedeker guides, which were then popular throughout Great Britain and the continent.

Karl Baedeker founded the innovative German publishing company bearing his name in 1827. Designed to be comprehensive yet compact and portable, the guides served as the constant companions of world travelers until 1948 and later. This explains why the author's American colleagues in Boston, in 1944, were scrutinizing the guides for Germany (page 43).

LEFT
Baedeker's guide for Great Britain, edition from 1910.

BELOW
Advice for visitors to Mont Saint-Michel in the *Baedeker Handbook for Travellers in Northern France*, 1909. Baedeker recommends the hotel then known as Etablissements Poulard Réunis (United Establishments of Poulard), later called La Mère Poulard (Mother Poulard), where the author stayed while visiting this site in 1944. La Mère Poulard is still in operation, and omelets remain a specialty.

Mont St. Michel. — Hotels. *Etablissements Poulard Réunis, R. 3½, déj. 2½, D. 3 fr., omelettes a specialty; Duguesclin, R. 2, déj. or D. 2 fr. Rooms should be engaged in advance in summer. — Cafés. *Café Veuve Poulard; Café des Remparts.* — Visitors should time their visit so as to see the tide come in (tides approximately as at St. Malo or Granville). On Sun. and holidays the Mont is overcrowded with excursionists.

The end of waiting came. We spent a few days at such modernized army installations as Camp Kilmer, were divided into groups, and were sent to various ports in England on every kind of conveyance, from the largest transports down to LSTs,[27] the landing craft being ferried across the submarine-haunted seas. We were assembled at the American School (European Civil Affairs Training Center) in Shrivenham, Berkshire.

A PAUSE TO REFLECT

During those unbelievable days as our armies crossed France and Germany, I could not help thinking back to the restless days when I had paced the floor of my spacious office at the Cloisters wondering about the fate of the art of Europe. A field desk or a trunk was quite different from the walnut desk with a black Bakelite top designed for me by my father with loving thought and discrimination.[28] I had traded a thick beige carpet for the rough planking of a barn or the bare ground. Instead of three telephone outlets for one person who liked to shift the apparatus around the room as he moved from chair to chair, there was one phone for many people and the lines were always either busy or out of order. The peaceful view from the tower with windows on four sides looking out over the Palisades and the Hudson River and parts of New York was almost forgotten in scarred Europe, where the scene was never twice the same.

Accustomed to being coddled in the snug security of this ivory tower, I had learned in the summer of 1943 to prepare myself for the foxholes of Europe. Russian princes had driven taxis in Paris after the Revolution of 1917, successful businessmen were reduced to a life of chores and poverty after the Wall Street crash of the late 1920s, and college professors were now in the army doing manual labor they had never dreamed of in their most harassed moments. As I looked back over 16 years of service on the staff of the Metropolitan Museum of Art, I believed that the experiences and duties of a thus far rich and eventful career should make it possible for me to contribute to the vast responsibility we had as a civilized nation preparing for all-out war. Where could I be most useful?

I had come to know works of art under varied conditions, in their natural settings and in museums. In my laboratory I had examined them with microscopes and under ultraviolet rays.[29] In Europe I had climbed many a church tower, roamed the vast subterranean substructures of venerable buildings, visited and studied in museums in many places, and learned to love the cultural objects of other countries. I had known many people who concerned themselves with the relics of the past and modern artists whose challenging contributions gave vitality to our generation. My travels and studies had familiarized me with the customs and languages of many lands. It had been my good fortune from the time I graduated from Harvard until World War II to help build up the collections of medieval art at the museum, and with the support of John D. Rockefeller Jr., as he said at the opening of the Cloisters in 1938, to "brood over every detail of design, construction, and arrangement" of this unique museum.

ART LOOTING AND THE HOLOCAUST

The history of Nazi looting dovetails with the larger story of the Holocaust. In Germany, France, Belgium, and the Netherlands before the war, Jews had been especially prominent in the art world as collectors, art dealers, and curators. Hitler's early adoption of anti-Semitism as a political tool served not only as a narrative with which to inflame his followers, but also as a strategy to justify the seizure of works of art. By "Aryanizing" Jewish businesses and declaring that any art owned by Jews was "ownerless property" after they had been imprisoned or forced to flee, Hitler's agents were able to confiscate all manner of art at dramatically depressed prices or simply for the taking.

The looters and their collaborators were connected to art markets throughout the world through Switzerland, Spain, Liechtenstein, and other technically neutral jurisdictions. This network, which included many museums, offered ready pathways for Nazi looters to dispose of so-called degenerate art and artworks they simply did not want. The hard currency gained from art sales helped fund the German war effort and was a source of profit for high-level individuals. They often acquired especially valuable works by trading pieces they had confiscated.

Overseen by Alfred Rosenberg, the Einsatzstab Reichsleiter Rosenberg (ERR) was the primary organization charged with seizing Jewish and other cultural properties in occupied countries during the war. Beginning in 1942, it expanded its looting operations to include systematic pillaging of Jewish homes for furniture and other household goods. Rosenberg originally intended the so-called Möbel-Aktion ("Furniture Action") to furnish German administrative offices in the East, but most of it wound up in German households, or was destroyed or abandoned.

Nazi looting is often presumed to have been systematic—pro forma compliance with Nazi laws, detailed recordkeeping protocols, and professional administration in the field all fit with the model of German order and efficiency. In reality, redundancy and competition among the several German looting organizations (including the ERR and Kunstschutz) and collaborationist governments, combined with skimming by individual perpetrators and random acts of pillage, resulted in a free-for-all that vastly complicated the restitution efforts of the monuments men and remains a thorn in the side of their successors to this day.

RIGHT
Monuments man Robert Posey surveying books taken from Dutch synagogues.

FAR RIGHT
Gustav Klimt, *Portrait of Adele Bloch-Bauer I*, 1907. Neue Galerie, New York. The painting was stolen by the Nazis in 1941, restored to the family, and now is part of the collection at the Neue Galerie in New York, which was founded by Ronald S. Lauder and Serge Sabarsky. The diamond choker in the painting was said to have been confiscated and later worn by Goering's second wife, Emmy.

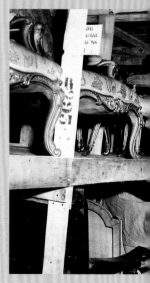

RIGHT
Furniture confiscated by the Nazis from the Rothschild family in storage at Neuschwanstein Castle. When this cache was discovered by the author and others, it was stacked to the ceiling in these specially constructed racks.

FAR RIGHT
Chaplain Samuel Blinder examines one of the hundreds of Sifrei Torah (sacred scrolls), July 6, 1945.

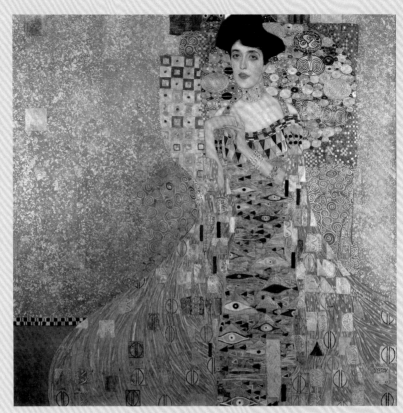

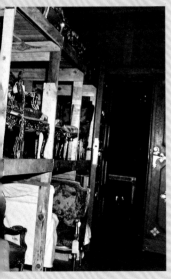

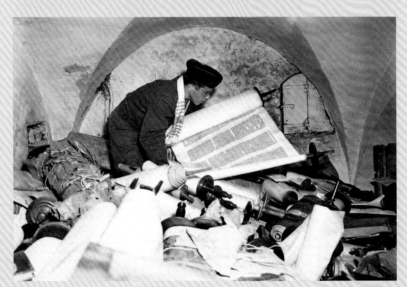

Safeguarding Art in New York During Wartime

Now our prized possessions had to be safeguarded during time of war. The *Unicorn Tapestries*, that fabulous series of unparalleled works of art at the Cloisters, had survived the vicissitudes of civilization and must have continued protection. They had been taken from the Rochefoucauld castle in southern France during the French Revolution and used to protect potatoes from freezing. When an edict of 1793 ordered that all tapestries having royal insignia be destroyed, the insignia were cut out, and the tapestries were preserved for the joy and enlightenment of future generations. These tapestries had been acquired by John D. Rockefeller Jr. in the early 1920s; he then gave them to the Metropolitan Museum of Art for the Cloisters when we opened to the public in 1938.[30]

Even though I had been reassured by Sir John Dill, the British field marshal on the Combined Chiefs of Staff at Washington, when he visited the Cloisters with me in 1942, that the possibility of the Germans' bombing of New York was remote, I preferred to send such works of art to the Stotesbury mansion outside Philadelphia.[31] There the museum had set up a superb repository under the supervision of the late William Chapman, for many years our superintendent of buildings. High fences, interior and exterior guards, fire protection, control of humidity, and periodic inspections by the experienced staff of the museum afforded ideal conditions. Three of us from the Metropolitan had gone to Harvard University for ten days of conferences and demonstrations conducted under the auspices of the Fogg Museum.[32] Representatives from other American institutions were there to pool specialized knowledge on the emergency protection of works of art. From Britain Sir Ronald Storrs, former governor of Cyprus and Palestine, wrote me asking if we could give safe harbor to one of his favorite tapestries. We decided that the risk of an Atlantic crossing in time of war was more perilous than leaving the tapestries in one of the many British repositories scattered over the entire island.

We placed our works of art of great intrinsic value—gold, silver, and jeweled objects—in vaults below New York's rock foundations. Glass and ceramics might be swept from the shelves of the museum's showcases by the shock from a single bomb in a token raid. Stained glass in the windows at the Cloisters, which I had gathered with untold difficulty during prewar European travels, might be shattered by an exploding ammunition barge on the Hudson River or an attempted sabotage of the George Washington Bridge.[33] All these precautions in troubled times might avail nothing, but the possible loss of even a single item was of great concern; its security was worth the expected sarcasm should the American shores come through the war without mishap.

In a luxurious chauffeur-driven Cadillac limousine, I rode from New York to Philadelphia with a convoy taking the treasures to safekeeping. How different were my experiences on the Continent, where in inclement weather I drove my own open jeep; in the trailer or in a tin box at my side there were often irreplaceable paintings, once the proud possessions of Hitler and Goering or their satellites.

ABOVE
Aerial view of the Met Cloisters in Fort Tryon Park, in upper Manhattan, 2017. The George Washington Bridge is visible in the distance at right. During the war, it was feared by authorities that the bridge would become a possible target.

LEFT
The furnishings in the author's former office atop the Cloisters tower include his desk with a Bakelite top designed by Rorimer-Brooks Company in Cleveland, Ohio.

50

NOTES

This chapter was not published in the first edition of *Survival: The Salvage and Protection of Art in War*. Additional unpublished materials are on file in the Archives of American Art, Smithsonian Institution and the National Archives in Washington, D.C.

[1] The attack on a U.S. naval base at Pearl Harbor, Hawaii, on December 7, 1941, precipitated entry of the United States into World War II. Britain and France had already been fighting Germany for more than two years.

[2] The Selective Training and Service Act, adopted on September 16, 1940, was the first peacetime draft in U.S. history.

[3] This reference is apparently to General George C. Marshall Jr. (1880–1959), who was then serving as army chief of staff. After the war, as secretary of state (before becoming secretary of defense), he was credited with devising the Marshall Plan for the rebuilding of Europe, among other accomplishments.

[4] Major General Phillipson (1882–1955) served as commander of the army's Second Corps Area, an administrative unit consisting primarily of New York, New Jersey, and Delaware, with headquarters on Governors Island, just off the southern tip of Manhattan.

[5] Under the Selective Service System, local draft boards are responsible for many of the administrative details of conscription.

[6] The original 1910 Penn Station was a New York architectural landmark designed by McKim, Mead and White. Objections to its demolition in 1963 were largely responsible for the rise of the early historic preservation movement.

[7] The "Harvard twist" refers to a technique for prolonging the useful life of felt hats, the standard headgear for American professional men before the 1960s, by twisting the section where a hole had developed from repeated creasing.

[8] Before the prevalence of credit cards, "traveler's checks," issued by American Express, were the preferred (safest) way to carry cash when traveling.

[9] Kitchen Patrol, a euphemism for peeling potatoes and washing dishes.

[10] Fort Dix is located near Trenton, New Jersey.

[11] The author was nearly 38 years old at the time of his enlistment.

[12] For a notorious example of collective army punishment, which made nationwide headlines at the time, see Chapter 4, note 5, about General "Yoo-Hoo" Lear.

[13] This test evidently tested the soldier's ability to understand and translate (or "copy") Morse Code, consisting of sequences of short and long signals ("dots" and "dashes") representing individual letters of the alphabet.

[14] From the epic poem *The Rime of the Ancient Mariner* (1798) by Samuel Taylor Coleridge (1772–1834): "The Ice was here, the Ice was there / The Ice was all around: / It crack'd and growl'd, and roar'd and howl'd— / Like noises in a swound."

[15] THINK signs had been at the time a ubiquitous feature of office environments for many years. The slogan was reportedly coined in 1910 by Thomas J. Watson (1874–1956), founder of IBM and a Metropolitan Museum benefactor, with whom the author worked closely after returning from the war.

The Unicorn Rests in a Garden (from the Unicorn Tapestries), c. 1495–1505. Metropolitan Museum of Art.

[16] Although not widely recognized by Westerners as offensive before World War II, this term is today an ethnic slur.

[17] Walter Winchell (1897–1972) was a print, radio, and eventually television journalist and commentator who rose to prominence and popularity in the 1930s.

[18] When retelling this story to his family years later, the author added that the "girl" in question was the bronze sculpture known as the "Barbet *Angel*," c. 1475, which is now in the Frick Collection in New York City.

[19] Private first class. The order of ranks mentioned in this passage is listed here in descending order. Lieutenant: a junior commissioned officer, either a first or second lieutenant; first sergeant: a senior enlisted rank, just below sergeant major; corporal: a mid-level enlisted rank between private first class and sergeant; private first class: a junior enlisted rank, two grades up from private.

[20] "T5" stands for technician fifth grade, a rank used for specialists during World War II and almost equivalent to corporal.

[21] "Shavetail" is army slang for a newly commissioned second lieutenant. The term refers to unbroken pack mules, whose tails were shaved to distinguish them from seasoned, more reliable animals.

[22] The author's sensitivity to army rank structure prevailed throughout his military career. Those who have served in the military can appreciate the chasm between officers and enlisted men on the one hand and between senior and junior members of the officer corps on the other. The author emphasizes the difficulties he encountered in protecting monuments from the objectives and whims of senior officers who vastly outranked him. The postwar report of the Roberts Commission expresses similar concerns.

[23] Being "out of uniform," which includes even the most minor deviation from prescribed details of costume and insignia, is considered a cardinal sin in the military. This passage demonstrates the author's readiness to dispense with army protocol to achieve results required by his mission, a characteristic that served him well in the field as a monuments officer.

[24] An abbreviation for Army Specialized Training Program. This program, in effect only during World War II, selected highly qualified individuals for specialized training in technical fields such as engineering, foreign languages, and medicine at land grant colleges. Among other postwar benefits, it exposed large numbers of capable soldiers to college who might otherwise not have attended.

[25] The Office of Strategic Services, predecessor to the CIA.

[26] In 1827 Karl Baedeker founded the innovative German publishing company bearing his name, which issued world travel guides in several languages. See page 44 for more information

[27] The abbreviation for a common type of amphibious assault support vessel. The letters stand for Landing Ship, Tank.

[28] Bakelite was an early form of plastic, commonly used to make radios and other household appliances. It was also used contemporaneously by the forger Han van Meegeren as an ingredient in paint to give an authentic-looking craquelure to his paintings, which were purportedly done by the 17th-century Dutch artist Johannes Vermeer. See Jonathan Lopez, *The Man Who Made Vermeers: Unvarnishing the Legend of Master Forger Han Van Meegeren* (Orlando: Houghton Mifflin Harcourt, 2008). Rorimer-Brooks Studios, the Cleveland interior design firm founded by the author's father, furnished his office at the Cloisters. The same furnishings remain in the director's office today. A full history of the studios appear in Leslie Piña, *Louis Rorimer: A Man of Style* (Kent, Ohio: Kent State University Press, 1990).

[29] In 1931 the Metropolitan Museum of Art published the author's groundbreaking research into the use of ultraviolet rays to establish the identity of artworks and to help recognize fraud and repairs. George Stout, then in charge of technical research at the Fogg Art Museum, was among his collaborators, which included experts in Paris and Vienna. James J. Rorimer, *Ultra-Violet Rays and Their Use in the Examination of Works of Art* (New York, NY: The Metropolitan Museum of Art, 1931).

[30] A Rorimer family story has it that before the Cloisters opened, the author guided the philanthropist to a large, empty gallery. When Mr. Rockefeller asked what the space was for, the author explained that it was designed to fit the *Unicorn Tapestries*. Initially taken aback because he had not yet made up his mind to part with these treasures from his collection, Mr. Rockefeller ultimately decided to make the donation. Today the *Unicorn Tapestries* are among the most popular exhibits at the Cloisters.

[31] The Stotesbury estate, known as Whitemarsh Hall, was the third-largest private residence in the United States when it was built. It was commissioned by Edward T. Stotesbury (1849–1938) and his wife, Eva, as a country residence around 1920 on the recommendation of the art dealer Joseph Duveen (1869–1939), to house their expanding collection. Stotesbury was a banking partner of J. P. Morgan (1837–1913) and later president of the investment firm Drexel Company. A portion of the Stotesburys art collection is now in the Philadelphia Museum of Art.

[32] The Fogg Museum in Cambridge, Massachusetts, is now part of the Harvard Art Museums.

[33] This vital New York transportation artery is within walking distance of the Cloisters. For examples of collateral damage to historic structures as a result of attacks on targets on the Seine River in France, see Chapter 4.

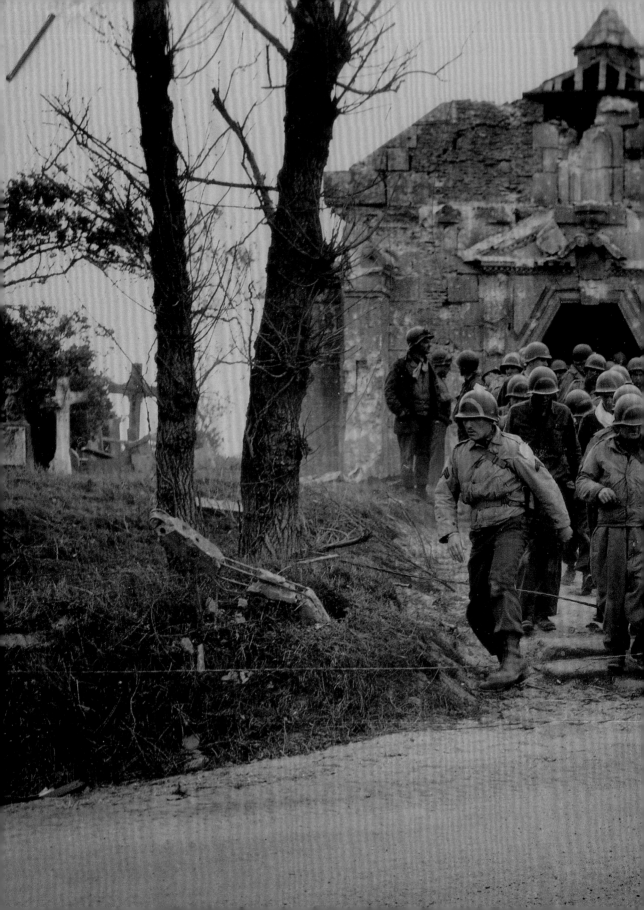

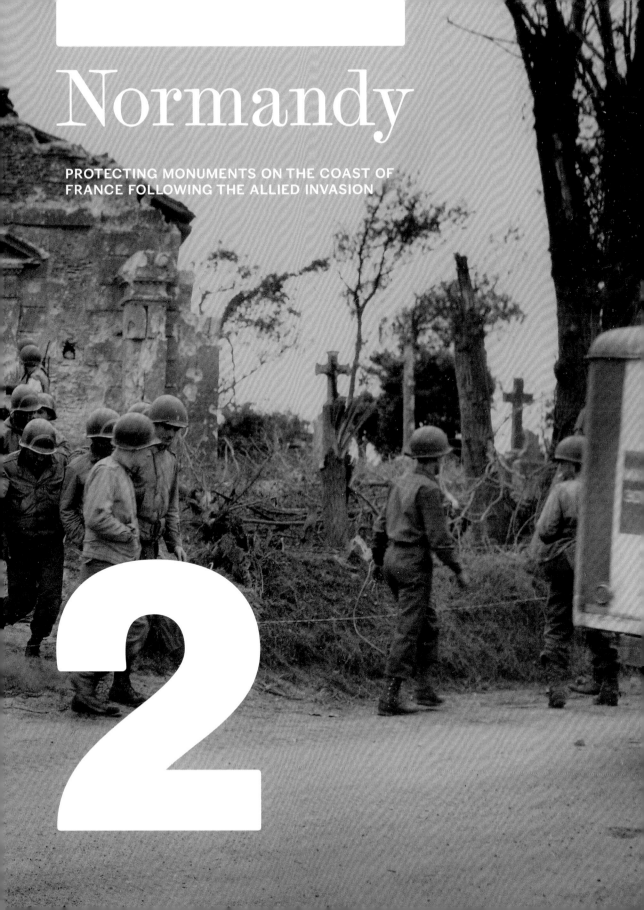

Normandy

PROTECTING MONUMENTS ON THE COAST OF
FRANCE FOLLOWING THE ALLIED INVASION

2

NORMANDY, 1944

English Channel / La Manche

NORTH

Cherbourg
Valognes
Montebourg
Saint-Sauveur-le-Vicomte
Fontenay-sur-Mer
Sainte-Marie-du-Mont
Dieppe
UTAH BEACH
La-Haye-du-Puits
Carentan
GUERNSEY
Catz
Le Havre
OMAHA BEACH
Colleville-sur-Mer
Rouen
CHANNEL ISLANDS
MANCHE
Bayeux
JERSEY
Caen
Lisieux
Cerisy-la-Forêt
Lessay
Saint-Lô
Coutances
NORMANDY
Mont Saint-Michel
Vire
Saint-Malo
MANCHE
Avranches
Pontorson

BRITTANY

Mayenne

Bonnétable
Rennes
Sourches
25 MILES
Laval
Le Mans
25 KILOMETERS
SARTHE
Le Grand-Lucé
Chardonneux
LOIRE

PREVIOUS SPREAD
GIs exiting the
Sainte-Madeleine
Chapel, near
Normandy's Utah
Beach, shortly after
D-Day. This was
the first monument
the author surveyed
after landing
in France a few
months later.

The region of Normandy is perhaps best known as the home of William the Conqueror, who crossed the English Channel to conquer England at the Battle of Hastings in 1066. The Bayeux Tapestry *(see page 116) portrays these events.*

Normandy is today subdivided into five departments, including the Department of Manche, which the French call the English Channel. The name is purportedly derived from the French word for "sleeve" because of its shape. Most of the towns mentioned in this chapter and shown on the map are in the Manche Department.

Just to the west of Normandy lies Brittany, defined by the peninsula that protrudes into the Atlantic Ocean at the east end of the Channel. It takes its name from the British settlers who populated the area in the 9th and 10th centuries.

FIRST IMPRESSIONS IN NORMANDY

The ravaged towns near Normandy's rugged and dangerous coastline were ghostlike. Before and during battle a historic monument was no more sacred to the Germans than any military installation. Again and again they used church towers as observation posts, and snipers fired from them at our advancing troops. As in the First World War, the Germans had disregarded the Rules of Land Warfare.[1] All the proclamations and notices in the world could not have saved these buildings for civilian use or art lovers of the future.

Normandy, with its famous walled towns and fertile fields, is rich in historical monuments of every kind.[2] Almost every Norman town has its ancient church spire or tower and has shared in the artistic pride of France's culture. Monasteries and private châteaux attest to the wealth of past generations. To these remote parts of the provinces the Nazis brought hordes of slave laborers from the east[3] and brutally all but enslaved the French, many of whom, devoid of every material possession, grieving their families, and victims of terror in each aspect of their daily lives, lived only in the hope of eventual liberation.

There were few vestiges of the hotly contested beachhead.[4] The Atlantic Wall we had been led to expect was even more a myth than the Siegfried Line.[5] Naturally, the Germans had not been able to build thousands of miles of concrete wall around "Greater Germany." Their pillboxes and other fortifications had been blown wide open. Many of their hidden land mines had been either rendered harmless or detonated. Still, for weeks afterward every new mine explosion made us wonder if the engineers were at work or if some Norman peasant or American GI had come to grief. Damaged Allied vehicles and equipment of all kinds were usually removed to dumps soon after battle had passed on, but everywhere the wreckage of fortifications was grotesque evidence of the growing German failure. The German 88s and tanks were more numerous where battle had been hardest or where their concentrations had been shattered by our air forces.[6]

The mere recording of the damage done to monuments and other art treasures would be a thankless task, trying in the extreme even to a hardened archaeologist devoted to gathering fragments and attempting to piece them together in an effort to restore a semblance of the past. The attempt to record this damage amid the many gaping craters and fire-swept hulks of buildings would be like trying to scoop up wine from a broken keg. The hardy Normans would need encouragement and direction almost as much as building supplies and transportation. An architect or inspector who had tenderly protected and reinforced a hundred decaying buildings in peacetime would now be confronted with countless problems that the centuries to come would not be able to solve. A few roof tiles on a cathedral used to need repair each year; now all of these tiles might be dislodged by shell blasts and piled almost beyond salvage on the floor of the nave or the pavement of adjoining streets. As the armies pressed on more quickly, the destruction became less irreparable but more widespread.

Crossing the Channel to Utah Beach

It was just two days since I had been in Southampton. When I learned that a telephone call from the office of United States high command had prepared the way for my arrival, I began to feel like I was part of a highly fluid, well-organized army that could adapt itself to unusual circumstances. This bubble of confidence burst when I learned that the ship on which I was supposed to make the Channel crossing had already sailed. The transportation officer was out, but he had left word with his corporal to take me around and allow me to pick out any of the Liberty ships then in port.[7] Hoping I had made a good choice, I boarded one loaded with French troops from the Italian and African campaigns sent to England for complete equipping with American supplies.[8] I had an idea that I would like to land on French soil with French troops.

We zigzagged[9] for a couple of days far from the usual peacetime courses of Dover–Calais and Folkestone–Boulogne, and landed on the bleak Normandy coast at Utah Beach, one of the initial landing spots on D-Day. From there I thumbed my way to the headquarters building of beach operations, where I telephoned to the Advance Section Communications Zone and spoke to my new commanding officer.

MONUMENTS WORK BEGINS

While waiting for transportation I made my first notes on the destruction a few hundred yards from the beach. Here was a small chapel not mentioned in any of our lists. "Chapel called Ste.-Madeleine," I wrote. "Fr. McAvoy has posted a sign calling for daily services at 1700. Good 16th-century Renaissance architecture in Maison Carrée style.[10] Fragments that can be used for restoration are in and about the immediate area off the highway. Main portal damaged by fragmentation from the south or west. One Lierne rib damaged.[11] Wooden roof with stones is in good condition except for minor damage." Then I took a photograph for the record.

LIBERTY SHIPS

The so-called Liberty Ships were not regular, armed naval vessels, but transport ships built on an emergency basis to ferry supplies across the Atlantic during the war. With so many men at the front in Europe, women were brought into the factories to help manufacture the vessels. While ship assembly by welding, rather than rivets, initially caused structural problems, these were overcome, and the moniker Rosie the Riveter was adopted by the U.S. government to help recruit women to the workforce to aid in the war effort. In time, the ships came to be valued for their durability and classic design.

Three women at work in a Navy shipyard in the U.S., 1942.

Getting Oriented

My transportation arrived and we drove inland to the Advance Section headquarters area, near Avranches.[12] Its installations were spread out for miles in every conceivable kind of farm building and tent. The signing-in process required going several miles between G-5,[13] the adjutant general's office,[14] the Finance Section office, and the headquarters building. I scurried about, made contact with the Signal Corps photographic service,[15] arranged for flying my negatives to London,[16] and then tried, with little success, to provide transportation for myself. The unit commander, Colonel C. I. Dennis, put me on guard about booby traps and mines, which had been discovered in such unheard-of places as tempting official safes, church pulpits, and carcasses awaiting removal.[17] With almost paternal regard the colonel assured me that a dead monuments officer would be of no use to him at all.

During the next three weeks our area of responsibility constantly enlarged, and the difficulty of securing transportation became more and more pronounced. Our position was at the rear of First Army territory. Third Army had not yet started the daring tank thrusts that would soon be made possible by the Saint-Lô engagements of General Omar Bradley. Our area would soon stretch from Cherbourg in the north to Le Mans on the route to Berlin, the common goal. Reports about damages and buildings used by military personnel were conflicting and spasmodic at best, and it was difficult to keep abreast of the maps showing the latest information from the front. I studied lists of important buildings and marked my maps so that I would know my targets when I went into the field. It was difficult to decide what to do first. Directives had to be prepared and sent out to the Civil Affairs detachments[18] under our jurisdiction, and the important buildings I had indicated on my maps had to be visited, as only a firsthand inspection could produce the desired information for our reports.

Convincing a General with No Time for Monuments

A monuments officer who objected to the use of a fine château as a military installation, or the use of rubble from a church as road fill, was anathema to men such as General Ewart Plank,[19] commander of Advance Section, whose only interest was supplies. His record for getting them to the front was superb, and in retrospect I can, of course, understand his insistence on having the Civil Affairs Section get the civilians to cooperate in repairing supply routes, rebuilding bridges and railroads, and doing other tasks. If it had not been for the reports I brought back about the good work being done by the monuments officers with other units of the American and British armies, and for the directives and requests for information handed down from Supreme Headquarters Allied Expeditionary Force (SHAEF)[20] and Communications Zone headquarters, with which I remained in closest contact through their respective monuments officers, there would have been no Monuments, Fine Arts & Archives work at our headquarters. Civilians, it appears, have no monopoly on keeping up with the Joneses.

THE MONUMENTS MEN ASSEMBLE A TEAM

A meeting was arranged near Saint-Lô between the intrepid George Stout of First Army; Bancel La Farge of Twenty-First Army Group; the jovial Ralph Hammett of European Theater of Operations, U.S. Army; Robert Posey of Third Army, who had impressed headquarters with his work with the Corps of Engineers in Alaska; and myself. The purposes of this gathering of monuments officers were to discuss our mutual problems and exchange information. Stout came in his captured, rakish German Volkswagen, Hammett and I begged a ride with colleagues from headquarters, La Farge drove up in a small British car, but Posey was unable to get transportation and didn't make it.[21]

The cooperation resulting from this meeting and subsequent ones was invaluable and helped avoid duplication of work. It was difficult to know just what work another monuments officer had done unless he communicated with those who might follow. Our orders sanctioned just such cooperation, and in the months to come almost all of the monuments men recognized their responsibility to other operators as well as to higher headquarters. But at best it took weeks and weeks for information to go back to SHAEF and then come down again to the field in consolidated reports. Speed in getting these reports through was to be particularly important in Germany, where we would be dealing with enemy personnel and their records.[22]

CHALLENGES FACED BY THE MONUMENTS MEN

For the most part, however, we had to operate quite independently. In Normandy I had no assistant. In Paris it took weeks before I could borrow the part-time services of a clerk from higher headquarters. In Germany I was aided by a corporal until the last days of hostilities, when I was gradually able to build up a staff that was efficient though small in numbers. The army had a stock reply to my frequent requests for more men: the monuments commission in Washington should have arranged adequate tables of organization and equipment.[23] The commission, on the other hand, explained that the army would not brook its interference. Our constant clamor finally resulted in our receiving more help, but when it did come, redeployment was already underway.[24]

The cyclonic shifting in the war picture defies description. Except for certain key personnel, even higher headquarters rarely knew how and if jobs were being done. Frequently a monuments officer would be assigned to a given unit by command of General Eisenhower, and much later we would learn that either he had not received his orders, he had not been released by his commanding officer, or perhaps he was doing a totally different job in some far-off place. It took me weeks to locate one of our officers who had been assigned to help me. His colonel had sent him off

JEEPS AND TRENCH COATS

The monuments men relied heavily on Army jeeps, the forbears of today's Jeep Wranglers. The original Jeeps were designed for the War Department by Willys-Overland Motors in 1940. Though the author spoke both French and German fluently, he sometimes had a driver, who also served as all-purpose field assistant and translator.

One driver was Frank Glazer, who later became a celebrated concert pianist. Born in Wisconsin to Jewish immigrants in 1915, Glazer had traveled to Berlin to study piano with Artur Schnabel in 1932. Although initially assigned to be a drummer in the Army band, his German language skills eventually earned him a place on the monuments team. After the war, he enjoyed a long career as a piano soloist, TV host, and educator. Never publicly recognized as a "monuments man," he modestly insisted until his death in 2015 that he was "only a jeep driver" for the author. The German Harry Ettlinger was another driver (see page 190).

After the war, the author always kept a Jeep on his farm in Ohio and continued to wear the trench coat to work in New York City. After becoming director of the Metropolitan Museum of Art in 1955, he would wear his combat boots on occasion. As the writer Jonathan Petropoulos put it, "The sound of his army boots echoing in the halls of the Met serv[ed] as a symbol of his vigilance."

BELOW LEFT
American soldiers survey the damaged Berlin Cathedral in August 1945.

BELOW RIGHT
The author (in trench coat) with another monuments officer, possibly George Stout, next to a Dodge WC-56 Command car, c. 1944.

BOTTOM
Jeep passengers John Walker, who became director of the National Gallery of Art, and monuments man Mason Hammond, c. 1944.

to do liaison work with the French. There were other officers holding monuments positions assigned without the knowledge of SHAEF, which was supposed to control the assignments of all such personnel.

Perhaps the bit of fouling-up that disturbed me the most resulted from the confused orders of a wandering British major who was attached one moment to a British unit and the next to an American one. None of his reports ever reached me until it was too late for them to have any value. I would make an all-out effort to get to a bombed-out building, only to find that he had already been there on one of his peregrinations. One day at the request of SHAEF, I made the long trip to Colleville-sur-Mer near Omaha Beach. It was a particularly trying journey and I resented the time it consumed. When at last I reached my objective, a Romanesque church in need of immediate attention, I found that my friend had already administered first aid. A fine portal remained un-harmed and some of the elements of the solid stone architecture had not fallen, including the tower and the vaults. My predecessor had planted a huge sign of his own device. It looked like a billboard and warned:

ALLIED FORCES:
It Is forbidden to Remove Stone or Other Material
from the Site of This Church.
HISTORICAL MONUMENT: CIVIL AFFAIRS.

The posting of a sign always gave a feeling of accomplishment. Our directive indicated that we should, whenever possible, get the French to do this for us. Generally, that was not too difficult. The directive did not mention age, and there was always a French child who, in the nature of small boys everywhere, was more than willing to fight off his friends for the privilege of holding the thumbtacks and glued tape.

We wanted printed posters prepared before we left England, but apparently General de Gaulle[25] made a particular point about not wishing to have this done, any more than he wanted us to print invasion francs, about which there was so much friction before we ever landed in France.[26] He seemed to be wary of another invading army storming through France, even if it were friendly. We did, however, have thousands of signs made in France (see page 81), and these announced:

OFF LIMITS
to all military personnel
HISTORIC MONUMENT
Trespassing on or removal of any materials
Or articles from these premises is strictly forbidden.
By Command of the Commanding General

The French version, placed at the right, substituted "Le Commissaire Régional de la République" for "Command of the Commanding General."

DEVELOPING PRIORITIES FOR PROTECTING MONUMENTS

With these signs peppered about, the commanding officers and their troops would be informed about monuments to be spared. This was particularly important in the supply sector.[27] In combat, it was possible only to single out a few of the all-important buildings in the path of the armies, and then their disposition would depend to a great extent on the actions of the enemy. Obviously, one or even two officers could not see to the protection and recording of all the monuments on the official lists when they accompanied a swiftly moving army, and particularly when this army's area became very large. In Normandy, with our troops waiting for the Avranches breakthrough, I was able to cover most places that had not been visited by other monuments officers about to move forward. The nearer we came to Germany, the more I found trying to cover my sector like trying to clear the woods of acorns.

If transportation had been more readily available, I could have made my trips in a logical sequence based on urgent priorities and coverage of the places I listed at night and marked on my road maps. While every Civil Affairs officer was supposed to have a copy of the lists and directives regarding historic monuments, it usually required the special training of the monuments officer to see that emphasis was put on the most important work. With dead to be buried, communication systems to be repaired, and all the other "firsts," it required the enthusiasm and perseverance of a devout lover of the arts to accomplish anything beyond posting signs and recording damage. Even these requisites were rarely attended to without the gadfly promptings of a monuments officer.

Sometimes the damage was so great that there was painfully little one could do. When a church was as badly damaged as the one in Montebourg, or the commune of Sainte-Marie-du-Mont,[28] of which the tower had suffered several direct hits and the roof had been hit squarely by three shells, about all that one could hope to accomplish at first was to take a few notes, record the damage on film, and then entrust Off-Limits signs to a stray Civil Affairs officer, local priest, or town official.

Stout Uses White Tape

Sometimes a little ingenuity went a long way to compensate for our lack of men, time, and materials. At Lessay, known for its particularly fine church—an unusual example of Romanesque architecture—George Stout feared for the safety of the carved fragments heaped about the parts still standing. He arranged for the engineers to stretch white tape around the courtyard, figuring that no one would venture into an area marked as though it were known to be mined. We learned that the Germans had used the church for various purposes, including housing troops. A jovial shopkeeper in a café across the street told me that an American lieutenant in charge of the combat troops did not want the church fired upon, but when the Germans refused to vacate it, he had no choice but to tell his men to open up on it.[29]

Throughout Normandy we heard similar tales, often accompanied by eulogies for the Allied policy. The Germans had used the church tower at the abbey of Cerisy-la-Forêt, once a flourishing monastic center, as an observation post, and they had stored horse fodder against the 13th-century frescoes in the abbot's private chapel. Other parts of the historic buildings were used for various military purposes. When our troops displaced the Germans, the tower was again used for its excellent prospect of the surrounding country, and 45 of our tanks were deployed about the abbey. A newly arrived American general promptly changed these arrangements.[30] This officer, who understood and loved old monuments, gave orders that signs be posted proclaiming the immunity of the abbey, and thereby earned himself an unenviable reputation with his troops. But it was men like him who commanded the respect of the French.

FURTHER MONUMENTS WORK IN NORMANDY

Destruction of the Abbey of Saint-Sauveur-le-Vicomte by U.S. Bombers

SHAEF requested a special report on the situation at the abbey of Saint-Sauveur-le-Vicomte. My report, dispassionate as it was, nevertheless gave facts that could be used by the Psychological Warfare Division as one more type of enemy crime to add to an already horrendous list. On July 14, 1940, the Germans took over the grounds and all the buildings except the church and main dormitory. In the days that followed, every sort of military equipment was concentrated here, and when mobile units were brought up in quantity, this active citadel was a target for our bomber raids on the nights of June 12 and 13, 1944.

We could not know from the air that 56 children and 35 sisters had taken shelter here. Our bombs left vast craters and seriously damaged the abbey church and adjoining buildings. The nuns and children miraculously escaped this fearful pounding unharmed. Because all their lives had been spared, Mother Superior Aline de la Croix accepted the material losses philosophically. The sisters remained in residence, exhibiting the very special type of courage characteristic of many French women, and almost immediately began to plan to piece together what remained of their physical world. Their church had been destroyed before, once in the 13th century and again in the 19th, and each time it had been restored. What had been done before could be done again. Fragments of stained glass could be rescued from the embers, the fine altar frontal could be shielded from the elements, the stones still standing could be protected.

When our troops arrived they shared their rations with the children and the sisters. They were considerate and sympathetic, but it was small recompense for the damage we had inflicted. Our soldiers, rugged and hard in combat, could be wonderfully gentle when the occasion demanded.

Salvaging the Church at La Haye-du-Puits

Flying over La-Haye-du-Puits between D-Day and June 8, our forces were

unable to locate the emplacement of a heavy German gun. This gun was set up in the nave of the Gothic church on the main square of the town. The center of the town was subjected to precision bombing in our effort to silence the German artillery. As a result of the pounding it took in this bombing, the church was in a precarious state. In spite of the danger, though, the townspeople consistently returned for prayer in what had always been their haven for worship. I tried to impress upon the overworked mayor, who had himself twice moved from one wrecked house to another, that this was a dangerous structure and that the people should be forbidden to enter it. The vibration of the heavy Long Toms[31] rolling past the church might easily be enough to set the trembling tower crashing through the church or into the street. By all odds it should already have happened. Rubble from the narrow street had been pushed into the church grounds, and heavy weapons and equipment had difficulty making the sharp turn. The local Civil Affairs detachment was moving up that afternoon nearer the front and had no time to give to this situation.

I started to climb into my vehicle when I noticed that my driver, who had twice fallen asleep at the wheel, was in the midst of a well-earned sleep, comfortably screwed into the front seat. I backed out quietly and then walked to the less-damaged suburbs to look for the curate. With his help, and that of the MPs, I was able to dislodge the more insistent and indignant worshippers. The need was urgent for immediate first aid, if only as a safety precaution. But it was beyond my power to render it, except to make suggestions to a few gaping inhabitants.

Saving the Church Spire in Carentan

The spire of the famous church of Carentan was used by German snipers, who once again disregarded the Rules of Land Warfare.[32] Our guns, pinpointing the target, weakened it with several direct hits. I had time only to check the damage through binoculars and advise that the tower, although seriously defaced, was not in danger of falling and menacing passersby. The departmental architect came from Cherbourg and clambered into the structure, in spite of his advanced years, to ascertain the extent of the damage and to prepare for the minimum of reinforcement work that had to be done.

Destruction of the Church in Valognes

The road from the beachheads and Cherbourg in the north to hotly contested Carentan and Saint-Lô in the south was all-important.[33] The route had to be clear and as direct as possible. The main artery that was built contributed to the speed of the victories that drove the Germans from French soil. But it was not easy to explain to the irate people of Valognes why their church of Saint-Malo had to have the highway run right

The vaults of this medieval abbey in Saint-Sauveur-le-Vicomte collapsed when a bomb exploded behind the apse.

through it. Four-fifths of the edifice had been destroyed by our bombing, and most of the stones had been pushed by bulldozers into the nave. With the road going through it, there was little hope that reconstruction would ever be attempted. The most difficult part for the townspeople to understand was the need for the bombing at all.[34]

U.S. Bulldozer Tackles the Château at Fontenay-sur-Mer

The historic château of the comte de Germigny at Fontenay-sur-Mer was another victim of the need for rapid routes and for road fill. This château had been described by Major Lord Methuen, one of our British colleagues, in a most useful list of lesser-known but important châteaux of northern France. It had caught fire following its bombing as a German headquarters, and I sorely regretted not having been able to get there sooner. There was a certain amount of destruction following the bombing that I might have been able to prevent.

As I drove up, one of our bulldozers was just about to push in the last of the walls. The stone from this building afforded the most readily accessible source of fill for road construction at the neighboring airfield. I stopped the driver of the bulldozer from pushing in the last wall, part of the chapel containing two handsome, 18th-century statues and a few fragments. I asked to see the officer in charge of the operation. As a staff officer I had no authority to give orders; my capacity was purely advisory.[35] I told the lieutenant the château's value as a historic monument and suggested that private property had to be respected. My remarks didn't take effect, however, until I emphasized that I had photographed the part of the building still standing for an official report, and that if he pursued his destruction further, I would do my utmost to see that he would be replying by endorsement all the days of his life.[36]

"Okay," he conceded grudgingly. "But this is a helluva way to fight a war." He went off muttering something about screwballs who didn't know there was a war going on.[37]

The contents of this château suffered in varying degrees. Objects that had been given safekeeping by the local curate were recovered. Others placed in farm buildings were, on the whole, undamaged except for the effect of rain pouring through roofs loosened by bombings. I was told that much of the fine furniture had been burned by the Germans when their own overstuffed pieces, designed to fit their particular shapes and tastes, arrived from Germany. The many other pieces shipped to Germany will probably never be returned, but what was taken by the local peasants may someday find its way back to their rightful owners.

Arrangements at Saint-Lô

The story of the Saint-Lô breakthrough and the almost complete destruction of the town has been told variously in light of different experiences. The fact remains that this beautifully situated, picturesque town suffered perhaps more in actual percentage than any other—even more than the often bombed and contested cities of Germany. The Germans had built their trenches and underground cement forts amid the hallowed monuments. When their positions were shattered, they fought hand-to-hand battles from building to building, and the destruction to these buildings, which should have been immune, was horrific.

I spent hours with a photographer assigned to General Eisenhower who had all the assurance of a Hollywood cameraman (and for all I know might have been one). He had been sent to record the terrifying impact of

American shell fire drove the German snipers from their positions atop the church in the town of Carentan.

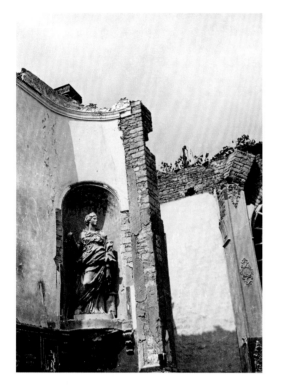
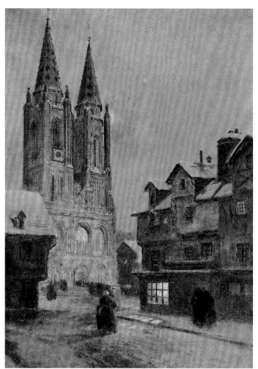
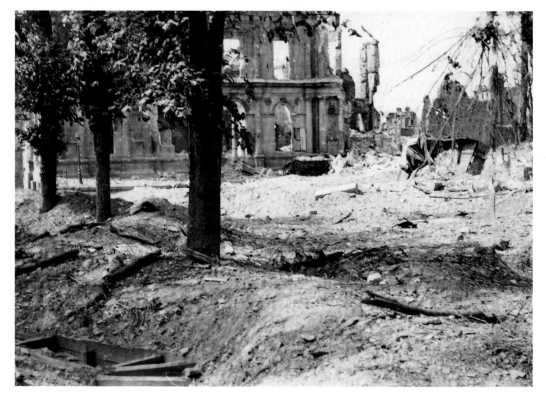

our might on the sturdily built buildings. The Hôtel de Ville,[38] with its library of rare manuscripts including a charter of William the Conqueror and others from Mont Saint-Michel, was completely gutted by fire. The museum might just as well have been reduced to powder. Only the church of Sainte-Croix withstood the barrages and skirmishes. The famous church of Notre-Dame was a shambles, almost beyond repair. It was filled with grenades, smoke bombs, ration boxes, and every conceivable sort of debris. There were booby traps on the pulpit and altar. At the entrance a stick of dynamite was attached with string or wire to a piece of masonry wall that had fallen.

When I returned to headquarters to report the seriousness of conditions at Saint-Lô, the general feeling there was that I had probably been working too hard and blown my top. The next day our colonel in charge of civil affairs made his own inspection. He returned with a vastly changed attitude. Several of the townspeople who revisited their annihilated dwellings, ignoring posted notices and the warnings of the all-too-few deputized civilians, had lost their lives. Yet amid all this suffering, with the dead, homeless, starving, and thirsty everywhere in evidence, the aged architect of the city had time to go about with me to plan for first aid for the historic buildings. He directed me to the general secretary of the Society of Archaeology and Natural History in the Manche department, who, he said, would be able to give me more information about the destruction in Saint-Lô. This official, then in German-occupied territory, was later able to write me a descriptive letter that must be read to understand the singleness of purpose of a gentleman and scholar under the most extreme stress of war. The letter, documented without bitterness or incrimination, was dated "Coutances, August 14, 1944."

The bombardment of June 6 and 7 of the city of Saint-Lô with explosive and incendiary bombs entirely destroyed our repository of archives which contained some of the very great historical riches and documents of greatest interest. All the cartularies[39] of the abbeys of the Department of the Manche were the prey of flames. Certain of them dated back to the eleventh century and were remarkable illuminated manuscripts. This is an irreparable loss for the historians of our region. . . .

A few weeks before the bombardment we had removed the library of our society, which was in the museum Rue Havin; we had placed our archaeological documents in the repository of the departmental archives for safekeeping, as we thought. Nothing of these remains. . . .

The old ceramics in the cellar of the archives building are under a pile of about fifty tons of debris.

In going around the archives building I noticed that in the annexes there are still a number of bundles and documents that were not burned. If one takes the necessary precautions when removing the

debris, it will be possible to disengage quite a few things. It is imperative that the work be undertaken as soon as possible and that it be supervised by qualified persons. . . .

There were numerous private collections containing artistic master-pieces of the first order which have disappeared completely. I myself was victim of this bombardment in which my house was reduced to ashes, as well as my collections, my library, and my personal studies on the history of the region.

This letter reached me in Paris and I gave several copies of it to the French authorities so they would send experts to salvage whatever they could. Badly charred paper is one of the most difficult materials to handle. It is like dandelions gone to seed and requires consummate patience.

The Cathedral at Coutances

The desolation of the next objective, Coutances, was equally moving. There was no use in attempting to mollify its saddened old bishop. Tendering him sympathy would not restore a town in which 300 buildings were destroyed by fires resulting from our bombardments. He could not cease lamenting his personal loss in the destruction of his home, with its fine Louis XV ceilings and furnishings. And he had no words to express his feelings at the death of some of the sisters when a neighboring convent was destroyed. To find his cathedral—one of the finest, most serene examples of Gothic architecture in the world—comparatively undamaged was some solace. Could there be any doubt, with the rest of the town in such utter ruin, as to the precautions taken to save the cathedral and the nearby church of Saint-Pierre? Had the cathedral been saved by special briefings of our pilots to preserve historic buildings? Every effort had been made by the American Commission for the Protection and Salvage of Artistic and Historic Monuments in War Areas to supply the fighting forces with maps indicating the locations of buildings that should be immune from war damage. I wanted desperately to believe that Coutances was evidence of the Allied consideration for great monuments. Later information indicated that the town had been shelled by heavy naval guns. Perhaps the navy had also been informed of the importance of sparing the cathedral.[40] The town is only a few miles from the shore and was undoubtedly as visible from the water as the water is from the church towers, which afford an unparalleled view of Saint-Malo and the Island of Jersey.

With the morale of the citizens at a low ebb, I feared it would be difficult to find laborers to begin repair work on the cathedral. I asked the bishop and young men from the seminary to aid by gathering up some of the rubble, but they refused. It was imperative that rubble be gathered up from the south portal before it was taken for road fill at the square. A temporary shelter over the lantern[41] had to be erected at once. The lead roof had melted and the supporting timbers had been consumed by fire. Guards were needed to protect the frescoes, liturgical vessels, and church furniture. It was highly improbable that signs by themselves

Damaged Church of Notre-Dame at Saint-Lô, June 1944.

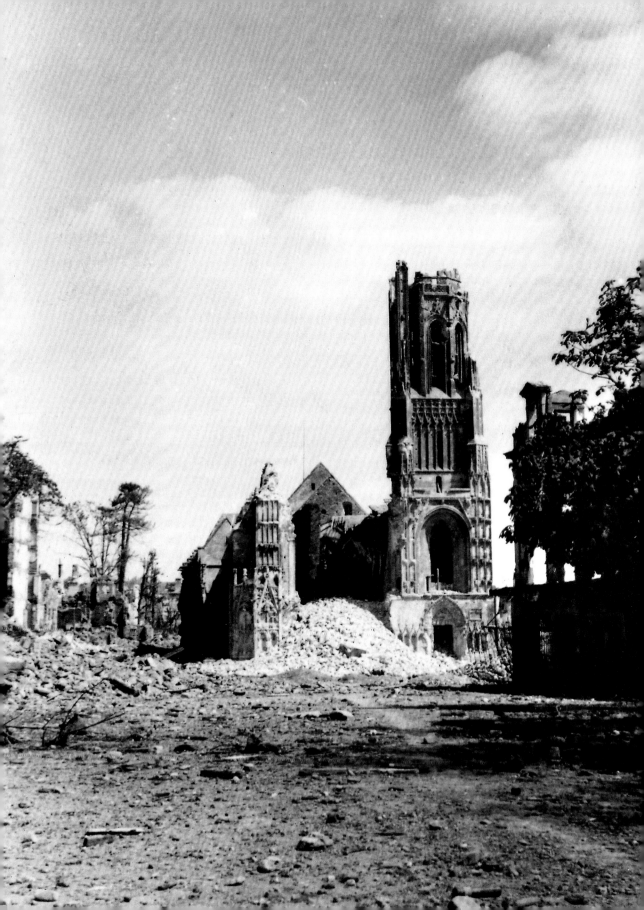

would prevent looting by displaced persons, bands of marauders, or the citizens themselves, who were desperately clinging to a few possessions rescued from the holocaust[42] and did not always resist appropriating their neighbor's property, or even the property of the church. Finding help turned out to be a comparatively simple matter, however. Within a few hours workmen who previously had been employed at the cathedral under the Administration of Fine Arts were carrying out my suggestions.

What may have been looted by the Nazis from Coutances before the bombardment was unfortunately not a matter of record. There was strong evidence that it had been considerable. While I was heating my rations in a corner of what remained of a once tiny restaurant, I met J. A. Agostini, magistrate of the tribunal at Coutances, who was anxious that I know more about the hated Boche.[43] Emboldened by something stronger than Normandy cider, which he produced from under the table, he told of the German looting seven days before the air raids. On his card he scrawled in French, "I certify also that German military personnel used Red Cross trucks for pillaging and that sometimes they were accompanied by their officers."

I went over to the small museum situated in what had once been a fine public garden. The main door was open and I walked in. Plaster from the ceilings and walls had fallen everywhere, and casts, prints, furniture, and medieval sculptures were collecting dust. Some of the shutters had been hastily closed when the windows were blown out, but it did little good as others were gone completely. Fearing vandalism and citizens coming here seeking wood to rebuild their refuges, I hunted for a curator or janitor. I found no one. Later the caretaker materialized and explained that he had been trying to salvage his garden. We arranged to close the museum.

By the time the caretaker located the disheartened curator, we had brought back the packing cases stored under German direction in the damp basement of the city hall. Although the curator had been in charge of the museum for more than 20 years, the Germans had permitted him to see the stored cases only once in the four years since they had been put away. We unpacked the paintings, drawings, and tapestries. They were covered almost completely with layers of mold. Everything looked more like Camembert cheese than works of art. We found a dry gallery and put the things there to dry slowly, lest there be further damage. From this experience I learned more about the damage caused by excessive moisture than in all my previous handling of works of art. In a few days' time we ascertained what had been irretrievably eaten away by mold, but before the mold could be completely cleaned away I had to be in a dozen other places. This was one of many instances when I had no time to identify objects; merely enough to render first aid.

AN EXCURSION TO MONT SAINT-MICHEL

At this point, First Army had cleared the Germans from Saint-Lô and Coutances, and Third Army had cut off the Brittany peninsula before

ABOVE
The late Gothic church of Sainte-Pierre, seen in the distance, was the only important building in Coutances, besides the cathedral (see at right), to escape almost complete destruction. Six or seven of the 16th-century stained glass windows were destroyed.

74

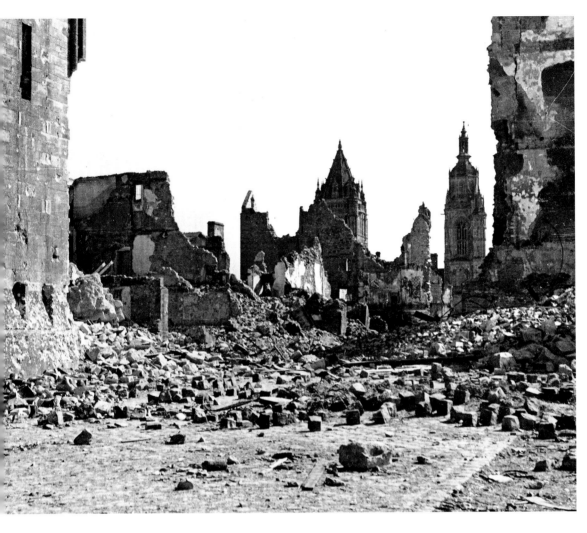

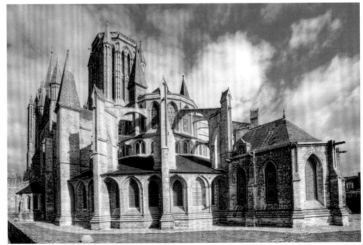

RIGHT
The cathedral at
Coutances, 2011.
It was comparatively
undamaged by the
war, because
U.S. naval gunners
received targeting
guidance to
minimize damage
to structures with
cultural significance.

sweeping north from Le Mans around the southern flank of the Germans' Normandy positions. I tried to contact Captain Posey, Third Army's monuments officer, to get information on conditions in Mont Saint-Michel. I was told at Twelfth Army Group that he had been hampered by lack of transportation and had probably been unable to go there. The architect of Saint-Lô had recently been there, and he told me that unlike the historic walled town of Saint-Malo, a few miles farther along the coast, this medieval town had not been used by the Germans as a resistance point. The tides, mines, and other obstacles placed along the uncertain quicksand beaches had been sufficient bulwark against an Allied landing from the sea. History had proven maritime operations in these waters to be hazardous in the extreme.

The high tide, which recedes for a distance of more than 7 miles and rolls in faster than a horse can gallop, makes driving on the sands impossible. Its inaccessibility had given the abbey a sense of security in the past, helping to induce calmness of thought and profundity on the part of its scholar monks. As early as the 12th century, it was known as the City of Books because of its collection of manuscripts. What a pity that many of these books were removed to archives at Saint-Lô where they were destroyed, when they would have been spared if left at Mont Saint-Michel.

I wondered if this inaccessibility would continue to be the town's salvation. Transportation methods had changed to such an extent that natural obstacles could easily be overcome in the air. What if the 13th-century cloister, the church, and the large Salle des Chevaliers, with its pointed vaulting supported by a triple row of columns, should be used for military installations and become the objective of enemy fire? Even a single plane might wreak irreparable havoc if it were thought that the ramparts, with their commanding view of land and sea, harbored a lookout post—as indeed the abbey did for a few hours when an American artillery unit moved in—or that the buildings were used for billeting troops. I decided that I would have to go to Mont Saint-Michel as soon as possible.

Transportation in Short Supply, and the Colonel Grumbles

Mont Saint-Michel was not easy to reach. It stood about a hundred miles from our headquarters at Catz, at the far end of Advance Section headquarters. There were rumors that we would be moving our headquarters at almost any time, and these served to tie up transportation even more seriously than usual. I momentarily forgot Mont Saint-Michel's remoteness from the main road when I suggested to my new commanding officer that I could walk there from the main Avranches–Rennes highway, over which we were busily moving mountains of supplies coming into Normandy at an ever-increasing rate now that the seas had subsided.

"You idiot," the colonel said irritably. "This is 20th-century war. Who gives a damn about medieval walls and boiling pitch?" Then he momentarily relented, probably recalling that there was a long list of names of people filling the description I could throw at him, not the least of whom was our commander in chief. "All right," he said gruffly. "Get going. But let me tell you, Rorimer, you'd better get there in a hurry and come back

fast. If you get left behind. . . ."

He left the sentence unfinished, but I had the feeling he would have liked to have ended it with, "that would be no loss."

Early the next morning our CO [commanding officer] left for Le Mans to establish advance headquarters, and I knew that once we were that far east, I would never be able to get transportation for Mont Saint-Michel and its vicinity.

The colonel had forgotten to leave instructions, although he had promised to authorize my trip. I appealed to his deputy, Lieutenant Colonel Osborne, who recognized the importance of the abbey. "I've heard there's wine and food down that way," he said. "Get there any way you can."

I pointed out that hitchhiking was forbidden in our area. Osborne laughed. "So what? You can talk your way out of trouble. You know you can't get anything done without breaking a rule or two along the way." He looked at me with one eyebrow cocked and a half smile on his face. "Or ought to," he added. "Take off. I'll worry about the responsibility for your going without a vehicle."

The colonel shot a series of injunctions at me as I was leaving. "Use your own judgment in Mont Saint-Michel. Better go to Avranches first. That's the seat of the provincial French government and we have a Civil Affairs detachment there. I haven't been able to contact them by phone. They just switched them over to us from Third Army. Tell them to try to contact us when we get to Le Mans. See if they need anything. Don't forget to take a set of directives for them. They weren't under us when we sent out the last lot."

Travel to Mont Saint-Michel by Foot and Thumb

I had no trouble getting as far as Avranches. The roads were alive with GI vehicles. Once there I contacted Lieutenant Colonel Barnes, an able British public safety officer on the Civil Affairs detachment. Avranches itself had suffered seriously, and the duties of his office provided the most hectic assignment conceivable for the colonel. He was delighted that I had come to investigate conditions at Mont Saint-Michel. It was too far from his office for him to supervise it adequately, and he was much disturbed on that account. He had written a report outlining the situation, but it had neither been acted upon nor reached my desk at headquarters.

Transportation here was no problem by reason of its being almost nonexistent. I got an occasional ride, but for part of the way I was a reluctant foot soldier. I soon realized that I would never make it before dark unless I got a ride, and I hailed a civilian car. The driver had lost all his possessions except this car, which he had just retrieved from under a hay mound on a friend's farm, following the long siege of Saint-Malo. The Germans had surrendered there just a few hours before. He dropped me at the end of the causeway outside of Mont Saint-Michel.

Allied Troops Partying Out of Control

I had visited this stronghold of the Middle Ages when I was a boy. I had

many recollections of the small village built on the sides of the curiously isolated rock formation connected with the mainland by an almost mile-long causeway built in the 19th century. I walked the plank bridge over the sands leading to the unguarded gateway. Three Off-Limits signs were completely ineffectual. The scene was one of almost indescribable bedlam. This was the one place on the Continent that was unguarded, undamaged, and open for business as usual. Even a British brigadier had found haven in one of the rooms of the hotel for himself and his lady companion. Each day more than a thousand soldiers came, drank as hard and as fast as they could, and, feeling the effects, became boisterous beyond the power of local control. The shopkeepers had at first thought that American soldiers would not loot. They hadn't counted on these soldiers being drunk.

Passing beneath heavily fortified archways, I clambered toward the picturesque abbey topping the mount. Streets winding beneath the windows of the old houses led up to the fine, seemingly interminable flight of steps to the Benedictine abbey. Neither time nor tourists had, until now, been able to dispel its air of serenity mixed with grimness and its self-sufficient solitude. In the short time at my disposal, I posted warnings, locked all the doors leading to dangerous parapets, shut off some of the rooms where further damage could be done, and advised returning to the regular opening and closing hours set by the Beaux-Arts,[44] instead of the endless hours demanded by carousing soldiers.

The chief custodian of the monastery and one of the guards had been taken as prisoners to Germany. The custodian's wife and a one-armed guard had done their best to maintain order. Among the hundreds of soldiers, the only officer I could find who might have authority to control the situation was an air corps MP captain who was investigating the facilities for bringing troops on pass from an airfield in the vicinity. He told me that the air corps had no interest in or control over ground troops. I was to discover that this was not the case when I had further dealings with him the following morning.

That night, I stayed at the hotel of La Mère Poulard.[45] Before dinner at a conference with the mayor of Mont Saint-Michel, I was authorized by the subprefect from Avranches to decide after further investigation whether the town should be entirely closed to troops. Apparently a passing provost marshal had thought that troops shouldn't be here any more than in other French towns that had been placed off-limits. He was the one who had put the signs in the town. The mayor owned the large and, until recently, well-stocked local curiosity and souvenir shop. He was no longer prejudiced by the prospect of unprecedented business—his shelves were almost completely empty. The restaurants and cafés no longer had enough supplies to meet the demands of the American military personnel streaming here from all over the peninsula on all kinds of junkets. We weighed the matter during dinner and just before bedtime decided that Mont Saint-Michel, with its poetic, historic, and artistic atmosphere, must, in spite of some good arguments to the contrary, remain open to our troops.

Air Corps Captain Mistakes Author for a German Spy

Early the next morning the air corps MP I had met the preceding day approached me in the hotel dining room and asked to see my papers. He had obviously been dwelling on the fact that the authority I seemed to have was incompatible with my rank of second lieutenant and, furthermore, I had arrived without a vehicle. This latter fact was too much for him. He found it inconceivable that any officer would travel without his own personal transportation.

He concluded that I must be a German spy and, envisioning a hero's reception for himself, carted me off to his headquarters, where I was obliged to sign oaths and papers of every description while copies were made of my papers. It was finally necessary that we go back to Pontorson, where we found a Civil Affairs officer who identified me and cleared up the matter for the disappointed captain.

HEADQUARTERS MOVES SOUTHEAST TO LE MANS

That same day, I arrived back at my outfit. When I reached headquarters I found my belongings already on a truck. We were to make an early start the next morning for our new headquarters 200 miles away at Le Mans. Now more than ever, distances would be a serious problem in planning a day's work.

I perched precariously on a folding camp chair on the back of an open two-and-a-half-ton truck so that I could estimate war damage as we rode. I didn't count on our one-eyed colonel urging the driver at the head of the convoy to greater and greater speed. It was all I could do to cling to my seat. Whizzing through Vire, Mayenne, and Laval in rapid succession, I could not possibly make a survey or do anything at all about damaged buildings. My desire to return to this area never materialized. George Stout had been through here with the rapidly advancing First Army and had reported that there was little that a lone monuments officer could do in this region.

The Cathedral at Le Mans Is Intact

Le Mans was a great art center, and in its neighborhood were some of the richest repositories for French art treasures. It had been victim to more than 20 sieges from the time it was first occupied and fortified by the Romans, through the vicissitudes of the Anglo-French War and German invasions. It was a happy day when the Germans left this chief city of Sarthe[46] and made a hasty retreat. Luckily our bombings of the railroads and the Germans' of the bridges, in a last desperate attempt to slow our advance, had not affected any of the favorite spots within the confines of the old city. The magnificent cathedral and the church of Notre-Dame de la Couture, with its sculptured portal, were untouched. Here at least we could gaze with pleasure upon the creations of the past. If the modern glass had been shattered, we were thankful that it was

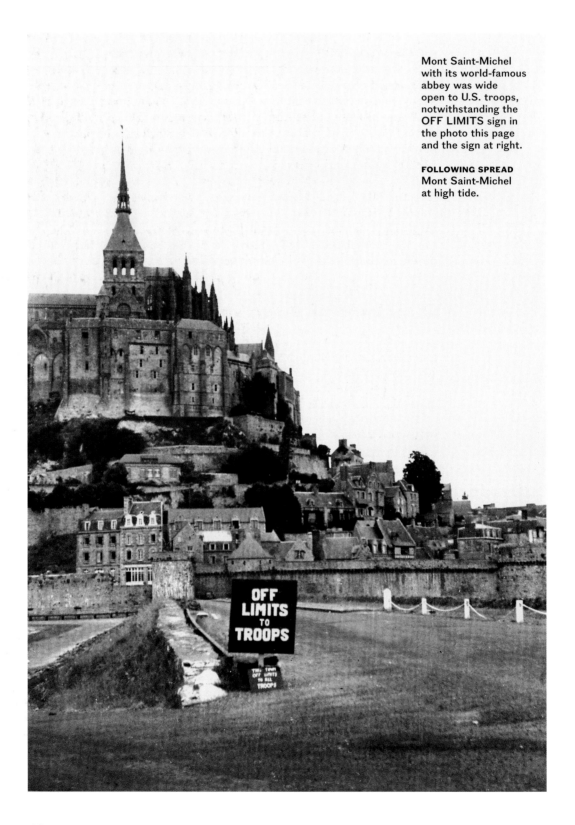

Mont Saint-Michel with its world-famous abbey was wide open to U.S. troops, notwithstanding the **OFF LIMITS** sign in the photo this page and the sign at right.

FOLLOWING SPREAD
Mont Saint-Michel at high tide.

OFF LIMITS TO TROOPS

THIS TOWN OFF LIMITS TO ALL TROOPS

OFF LIMITS

To all military personnel and civilians

HISTORIC MONUMENT

Trespassing on or removal of any materials or articles from these premises is strictly forbidden.

By Command of the
Commanding General.

this glass and not the irreplaceable stained glass. The latter had been safely stored. The cathedral architecture looked as heroic as ever before. Bold outlines made by the unfiltered light stood out theatrically against the rays of the setting sun.

I was standing in rapt contemplation in the cathedral when I was joined by Geoffrey Webb, Slade Professor of Architecture at Cambridge, now a colonel and chief of the SHAEF Monuments, Fine Arts & Archives program.[47] He had just returned from an inspection tour. We needed no conversation to express our delight at seeing this noble structure unharmed, undesecrated. We just stood there and drank it all in. There were no monuments-related problems here to detract from our enjoyment. No signs would be needed to prevent a sacrilege. In the First World War, some of our troops had playfully inscribed their names on buildings, but now this practice rarely had to be guarded against. Perhaps we had learned during our stay in England to respect venerable stones when they had not already been dislocated by war.

Further Arrangements at Le Mans

At Le Mans, Lieutenant Bonilla, the post, telephone, and telegraph officer of the local Civil Affairs detachment, devoted as much time as he could to carrying out monuments-related directives, including instructions issued through channels from my desk. His love and enthusiasm for art were fanned by the passionate devotion to French treasures evidenced by Paul Cordonnier-Détrie, the curator of the Le Mans Museum of Antiquities.[48] Cordonnier-Détrie had trained for years in Paris before settling down in Sarthe. He had helped other officials from the French National Museums establish excellent repositories in this region, and he had taken the rarest objects from Le Mans and placed many of them in his country home. He and his wife had taken turns day and night for four years personally guarding the 12th-century enamel plaque of Geoffrey Plantagenet.[49]

Cordonnier-Détrie and the regional architect of historic monuments were eager to cooperate with our suggestions. We obtained gasoline to run the firefighting apparatus and other equipment badly needed in the repositories. Then we formed a party of local French representatives and American officers and set out to visit the château repositories at Chardonneux, Le Grand-Lucé, Bonnétable, and Sourches. On the way, children ran out from farmhouses and offered us cordials, freshly picked fruits, and other tokens of their excitement and delight at seeing their allies. In this area the damage to property was unusually negligible. The invading armies had obviously moved forward without meeting great resistance.

Germain Bazin, curator of paintings at the Louvre, was in charge of the Sourches depot.[50] In enormous letters, the words "musées nationaux" had been placed on the lawn to announce to aircraft the use to which this great château had been put. At the time of the invasion it contained the Rubens canvases from the Medici Gallery in the Louvre, superb Goyas from one of the provincial museums, most of the large-sized paintings by Delacroix, Courbet, Ingres, Le Sueur, Poussin, and others from the Louvre collections. A Veronese painting measuring 16

by 36 feet had been taken with others to the basement storage vaults. Open charcoal fires were kept burning in the damp cellars to help control the humidity.

My recent experience in the cellars at Coutances made me fear that mold growth would attack these paintings if they remained in their present locations. The relative humidity in the basement at Sourches ranged from 79 to 85 percent, and we considered 40 to 60 percent proper. If the local authorities would not be able to handle the removal of the largest paintings, it would be essential for Bazin to go to Pairs as soon as possible to see Jacques Jaujard, director of French National Museums, and arrange for assistance. The Louvre had done a superior job of preparing storage with proper light, ventilation, temperature, and humidity, and now the need for temporary shelter in the damp cellars had passed. French technicians had once made monthly visits to these repositories, but under combat conditions four months had passed since they had been able to get to this region.

TRANSFER TO PARIS

I felt that my activities in the Le Mans region were an interlude. Most of us desperately hoped that our outfits, or we as individuals, would be moved to Paris, the liberation of which was expected momentarily. Higher headquarters began to show an even greater interest in the accomplishments of the Civil Affairs Section. My colleagues and I left the field for a couple of days to prepare our respective reports on Monuments, Fine Arts & Archives, refugees, public safety, and the feeding of inhabitants. There was beginning to be much talk of new assignments. Captain Ralph Hammett, with whom I had traveled about Normandy, was going over preliminary notes I had made and documents I had gathered. At this point his chief, Brigadier General Cuthbert Stearns, assistant chief of staff, G-5 for ETOUSA[51] and Communications Zone, bellowed my name from down the hall.

I hopped to answer, wondering what I was going to get chewed out about.

"Hammett has told me of your qualifications," he said, without further ceremony, "your Paris connections and background. You've got the Paris post. Get there as soon as you can. Our troops will be there sooner than you think."

I was on my way to Paris, the greatest art center on earth.

NOTES

1 Although the Rules of Land Warfare then in effect specified that churches must be avoided during a bombardment, there was no specific prohibition on using them to shoot from. A comprehensive discussion of the problem in a modern context, as applied to U.S. forces in Iraq, appears in Geoffrey S. Corn, "'Snipers in the Minaret—What Is the Rule?': The Law of War and the Protection of Cultural Property; A Complex Equation," *Army Lawyer*, no. 7 (July 2005): 28–40. This article concludes that use of a religious tower as a sniper's vantage point is permissible only when "no other feasible alternative [is] available for achieving what is presumptively an important military objective."

2 Saint-Malo is an example of a walled Normandy town.

3 Hitler claimed that the natural resources in targeted regions should be used for the benefit and advancement of a "superior" German race. Nazi racial theory considered the Slavic peoples they conquered in Czechoslovakia, Poland, and other eastern European countries to be members of an inferior race, thereby justifying mass deportations to open up *lebensraum* (living space) for Germans and supplying slave labor for the German war machine.

4 Note that the author arrived in Normandy about nine weeks after D-Day (June 6, 1944), reflecting the extended period of combat before he was authorized to land.

5 Although the Germans had in fact built extensive fortifications on the Atlantic coast, Nazi propaganda had greatly exaggerated the strength of the so-called Atlantikwall. Similarly, the "Siegfried Line," a chain of fortifications on the western border of Germany, had by this time in the war proved the veracity of General George Patton's reported remark that "fixed fortifications are monuments to man's stupidity."

6 The term "German 88s" refers to Germany's famous 88-millimeter antiaircraft guns, which many consider the most effective gun used by either side in World War II. One of their unique characteristics was the ability either to be deployed as antiaircraft guns or to be trained on surface targets. They are sometimes called "flak" cannons, a shorthand term for *Flugzeugabwehrkanone*, literally, "airplane defense cannons." The wartime operation of an 88 at the nearby coastal town of Saint-Malo is described in Anthony Doerr, *All the Light We Cannot See* (New York: Scribner, 2014), pp. 8, 408, 432, 437.

7 Liberty ships were transport ships built during the war to ferry supplies across the Atlantic. They were noteworthy for the high proportion of women engaged in their manufacture. See page 59.

8 Early Allied success against Germany and Italy, particularly in North Africa, had freed up troops to join the British and Americans for the invasion of Europe.

9 Zigzagging is a common wartime naval maneuver designed to make it more difficult for submarines that might be lurking in the area to calculate a fire-control solution for launching a torpedo.

10 The Maison Carrée is a well-known surviving Roman temple at Nîmes in southern France, the style of which inspired French Neoclassical architecture.

11 Literally, a "binding" rib, a term that refers to a particular kind of stone rib used typically in Gothic architecture. A binding rib links two other ribs designed to work in combination to support the ceiling vault of the church or other building. The author had extensive experience in structural stonework as a result of his work on the construction of the Cloisters. See James Rorimer, *Mediaeval Monuments at The Cloisters, as They Were and as They Are* (New York: Metropolitan Museum of Art, 1941), which documents the reconstruction of several medieval stone monuments and their sculptural elements.

12 Avranches is a region of Normandy that was heavily defended by organized German resistance. Although the Allies secured Avranches by July 31, 1944, fighting continued elsewhere in Normandy well into August.

[13] The meaning of G-5: an army force typically includes, in addition to fighting troops, staff personnel responsible for various administrative functions. G-5 is the abbreviation for the staff unit (or officer) responsible for the interactions between the military and civilian populations.

[14] The adjutant general is the chief administrative officer of a staff unit in the U.S. Army.

[15] Many of the photographs included in the first edition were taken by this service.

[16] For a description of the role of negatives in wartime photography, see Chapter 5, note 4.

[17] The film *Monuments Men* includes a scene in which Matt Damon's character becomes aware that he is standing on an unexploded land mine in one of the German salt mines. The reference here to the wide range of booby traps left behind by the retreating German troops may have inspired the scene in the movie, but there is no wholly corresponding scene in the author's writings. See also page 331.

[18] These detachments consisted of army personnel responsible for civilians in the occupied territory.

[19] Brigadier General Ewart Gladstone Plank (1897–1982) was later awarded the U.S. Army Distinguished Service Medal "for exceptionally meritorious and distinguished services to the Government of the United States, in a duty of great responsibility as Commanding Officer Advance Section, Communication Zone, North West Europe, from 1944 to 1945." The discussion here presents the first of several cases in which the author expresses frustration with the difficulty of protecting monuments in the midst of an active military conflict. General Plank undoubtedly had received little, if any, introduction to these preservation concerns prior to deployment. Such interactions between the monuments officers and regular members of the fighting force help to explain the author's last chapter—Chapter 9—in which he advocates for education prior to deployment.

[20] Supreme Headquarters Allied Expeditionary Force (SHAEF) was the top Allied military authority, which at that time was based in London and to which the monuments officers reported. SHAEF was later moved from London to Versailles (August 1944–May 1945) and then to Frankfurt (May–July 1945).

[21] This paragraph introduces several key European monuments officers. Comprehensive biographies of all the monuments men can be found at http://www.monumentsmenfoundation.org/the-heroes/the-monuments-men. See also pages 17–21.

[22] For an example of these communication problems, see Chapter 8, note 33.

[23] At one point the author's typewriter was lost or stolen. In several of his letters home, he begged his family to send a replacement.

[24] The 1946 *Report of the American Commission* states that the average number of Monuments, Fine Arts & Archives officers in the field was ten individuals for the major part of operations.

[25] Charles de Gaulle (1890–1970), the de facto commander of the Free French and later president of France (1959–69). See page 21.

[26] Invasion francs were the paper currency issued by Allied governments to pay soldiers, beginning with the D-Day invasion, in order to avoid the inflationary effect that would otherwise result from payment to soldiers by means of U.S. dollars or British pounds.

[27] This term evidently refers to the area behind the lines of advancing troops, where noncombatant personnel charged with supplying the front could thoughtlessly, or intentionally, damage cultural properties without timely direction.

[28] Both of these churches have been restored. For modern photos, see http://fr.wikipedia.org/wiki/Église_Saint-Jacques_de_Montebourg; and https://en.wikipedia.org/wiki/Sainte-Marie-du-Mont,_Manche#/media/File:%C3%89glise_de_Sainte-Marie-du-Mont_06.JPG.

29 For prewar photographs of the 11th-century Abbey Church at Lessay, see Henry LaFarge, ed., *Lost Treasures of Europe: 427 Photographs* (New York: Pantheon, 1946), figs. 225–26.

30 This reference is undoubtedly to Eisenhower, who (with General Omar Bradley) visited Cerisy-la-Forêt on July 2, 1944.

31 The term "Long Tom" refers to several varieties of large, famously heavy mobile canons employed on both sides during the war.

32 See note 1 above for a discussion of the Rules of Land Warfare and the particular problem of the use of religious towers by snipers.

33 See Stephen E. Ambrose, *Band of Brothers* (New York: Simon & Schuster, 1992), for a dramatic account of the taking of Carentan and securing of nearby territory by paratroopers of the U.S. Army's 101st Airborne Division before the arrival of monuments men.

34 The 13th-century church at Valognes has not been rebuilt. Interior and exterior views are included in LaFarge, *Lost Treasures of Europe*, figs. 223–24.

35 The author is focusing on a distinction between "staff" officers, who fulfill primarily administrative functions in the army, and officers who command regular combat troops.

36 A "reply by endorsement" is a form of military correspondence in which a senior person requires a junior person to explain in writing why the junior person did something they were not supposed to do, or why they failed to do something they should have done.

37 Notwithstanding the author's intervention, the château remains in ruins today. See http://www.plagesdu6juin1944.com/blog/on-a-dormi-sur-l-air-field-7-de-fontenay-sur-mer.html.

38 This French term is equivalent to city hall in English.

39 The term refers to various types of medieval manuscripts, particularly those containing official copies of documents for establishing ecclesiastical institutions or compilations of public records.

40 The author's wife, Katherine Serrell Rorimer, who had an MA in art history from the Institute of Fine Arts, New York University, participated in the work of preparing these maps while her husband was away at war.

41 The lantern of a church is the tall tower with many windows designed to let in light over the place where the arms of the cross intersect the central aisle below.

42 Although the capitalized term "Holocaust," which is derived from Greek for "burnt up as a whole," is now commonly used to refer to the Nazis' mass murder of European Jews, it probably had no well-developed meaning when this narrative was originally written. Winston Churchill reportedly used the term to refer to the Armenian genocide, the principal campaigns that occurred between 1915 and 1917. By the time of the trial of Adolf Eichmann for war crimes in 1961, the term was used regularly to refer to the Nazi genocide. In the present context, the author is using the term to refer to wartime destruction in general.

43 This slang term was used by the French to refer to Germans in both world wars and is considered offensive.

44 The Académie des Beaux-Arts is an omnipresent French administrative organization founded in 1815 that continues to maintain religious buildings and public art in Paris.

45 La Mère Poulard, in operation since 1888, is still open for business today. It is well-known in culinary circles for its extremely light omelets made with eggs from local free-range hens.

46 The Sarthe Department of France, of which Le Mans is the capital.

47 Geoffrey Webb (1898–1970) was a British monuments officer.

[48] This reference is undoubtedly to the Musée de la Reine-Bérengère, whose collection today focuses on historical objects and art of Le Mans.

[49] For an image of this plaque in the Museum of Archaeology and History, see https://en.wikipedia.org/wiki/Geoffrey_Plantagenet,_Count_of_Anjou#/media/File:Geoffrey_of_Anjou_Monument.jpg

[50] Germain Bazin (1901–1990), a renowned art historian, author, and curator of the Louvre from 1951–65, who was a longtime colleague of the author.

[51] European Theater of Operations, U.S. Army.

Paris Monuments Officer

ARRIVING IN PARIS AND SETTING PRIORITIES

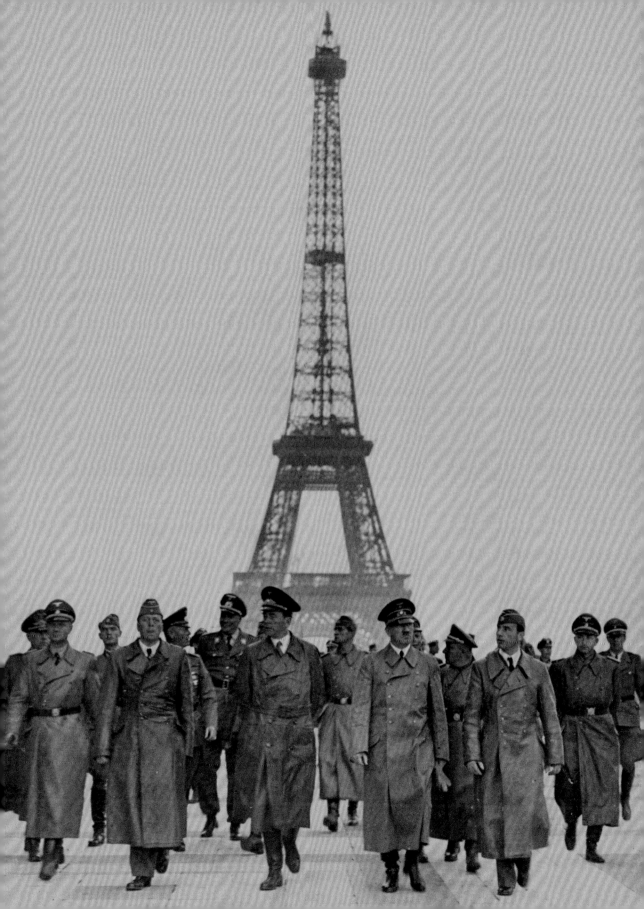

PARIS, 1944

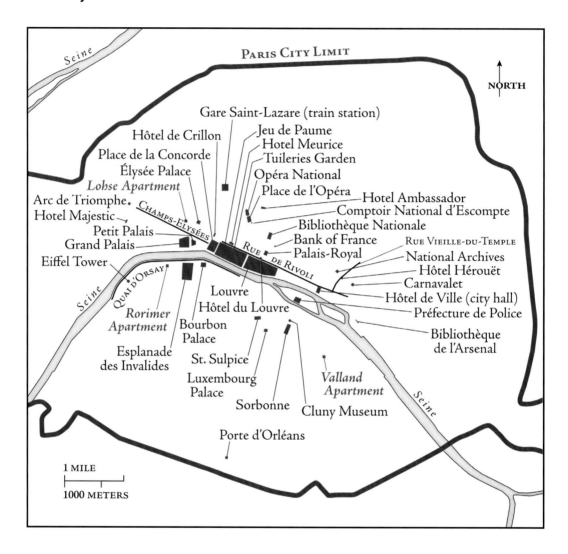

PARIS CITY LIMIT

NORTH

Seine

Seine

Seine

Gare Saint-Lazare (train station)

Hôtel de Crillon
Place de la Concorde
Élysée Palace
Lohse Apartment
Arc de Triomphe
Hotel Majestic
Petit Palais
Grand Palais
Eiffel Tower

Jeu de Paume
Hotel Meurice
Tuileries Garden
Opéra National
Place de l'Opéra
Hotel Ambassador
Comptoir National d'Escompte
Bibliothèque Nationale
Bank of France
Palais-Royal

CHAMPS-ÉLYSÉES

RUE DE RIVOLI

RUE VIEILLE-DU-TEMPLE
National Archives
Hôtel Hérouët
Carnavalet
Hôtel de Ville (city hall)
Préfecture de Police
Bibliothèque
de l'Arsenal

QUAI D'ORSAY

Louvre
Hôtel du Louvre
*Rorimer
Apartment*
Bourbon
Palace
Esplanade
des Invalides
St. Sulpice
Luxembourg
Palace
Sorbonne
*Valland
Apartment*
Cluny Museum

Porte d'Orléans

1 MILE

1000 METERS

By the time of the Allied invasion of Normandy in June 1944, the German army had occupied Paris for four years. Notwithstanding its pillaging and persecution of the populace, Germany had refrained from the wholesale destruction it wrought in the conquered cities of eastern Europe. In Paris, French collaborators governed the city under German control. German troops frequented its boulevards, theaters, and cafés. As the Allies advanced from Normandy and the defeat of Germany grew increasingly certain, pressure from the French resistance mounted within the city. Communist partisans within the resistance pressed for an armed uprising to preempt the advancing Allies and Free French under General de Gaulle from taking control of the city. The Allies, however, were actually planning to bypass Paris and proceed directly to the Rhine. Finally, the resistance staged an armed uprising beginning on August 19, 1944. The Americans changed their plans and, along with the Free French, went to the aid of Paris, where they were met by jubilant residents interspersed with lethal pockets of German defense.

ENTERING PARIS

What was the fate of the many historic buildings? Of the Venus de Milo, the *Mona Lisa*, and the myriad other art objects that had made Paris the most famous art center in the world? What had the Germans removed from France? Where were their repositories for confiscated objects? These were among the many questions on our minds on the night of August 25, 1944.

Brigadier General Pleas B. Rogers, anxious to be in Paris where he was to command Seine Section,[1] drove on ahead of our lumbering convoy in the last hours of our trip from Le Mans. In the near outskirts of Paris, at Saint-Denis and elsewhere, the shooting was still in progress. In the direct path of the struggle was the Basilica Cathedral of Saint-Denis, burial place of the kings of France.

We picked up our escort at the Porte d'Orléans, then entered the city. The streets had been barricaded and we had to follow a winding, twisting route to the Grand Palais on the Champs-Elysées, where we had arranged to meet the general. The Tuileries Garden and the Champs-Elysées had seen hideous combat. The bores of the guns ringing these areas were still hot from the last shells they had fired. The blaze at the Chamber of Deputies had been extinguished, and the Germans had just surrendered at the Luxembourg Palace, their last stronghold. Just before this, other Nazis had been either ousted or taken prisoner at the hotels Meurice and Majestic, and at the Comptoir National d'Escompte on the Place de l'Opéra.

The blacked-out murk following the fires was rendered the more mysterious as the shadows moved against an intermittent curtain of artillery fire in the environs of the city. When we arrived at our destination we found that the Grand Palais had been burned. For the moment we seemed safe enough with our trucks blacked out, but the sound of small-arms fire kept our nerves jumping. It helped little that the heavy artillery action was at some distance from us. We breathed more easily

when we finally discovered that corps headquarters was located in the Petit Palais across the street.

After checking in we were sent to the Hôtel du Louvre to spend what was left of the night. It was absurd, but here in the midst of destruction was this comfortable hotel with hot and cold running water and big, high-ceilinged rooms, each with French doors, drapes, and a balcony. Just for a moment it was like prewar Paris.

Surrounded by more comfort than I had seen for some time, I lay awake thinking. Two or three hundred thousand Germans had come to Paris, planning on 25 years of occupation. They dominated the French at every turn for their own selfish aggrandizement and that of their fellow countrymen. They did away with 75,000 men, women, and children—perhaps as many as 100,000—by the most atrocious means ever conceived of by human beings.

On this night most of us were ignorant of the growing efforts of the French resistance. We knew little of the undaunted exploits of millions of people living in France throughout those hateful years of organized domination. Children spurned the enemy's friendly overtures. Boys in their teens, prematurely old and wise in the ways of sabotage, quietly organized groups as daring as those of their elders, and if anything, even more cold-blooded. The resistance had patiently awaited the final signal to end the occupation, and until it came had duped and tricked the Germans at every turn. (Even still, the inevitable exceptions existed: relatively few, despised collaborators who thought not of France but of their own private enrichment and comfort.)

Even some of the enemy loved Paris. General Dietrich von Choltitz, as the Kommandatur in Paris, had refused to carry out the instructions from Berlin to blow the bridges across the Seine and to set off explosives strategically placed in important buildings and military installations. This was the one Nazi warlord who did not believe in destroying what you could not have for yourself.[2]

First Days in Paris

As the monuments specialist officer for Paris it was my responsibility to advise the commanding general of Seine Section and his assistant chief of staff, G-5, in all matters pertaining to the art and culture of this metropolis and the surrounding Île-de-France.[3] I had to promote our relations with the French, to see that they helped themselves, to get them to help carry out our program, and to report my findings and the actions taken by our command through technical channels to SHAEF. I knew I could count on the uncompromising cooperation of Captain Ralph Hammett, the Monuments, Fine Arts & Archives staff officer at Headquarters Communications Zone, who was to act as a buffer between the British-controlled sections at SHAEF and the SHAEF Mission to France. My own colonel, Bob Hamilton, a man of rare intelligence, and General Rogers could also be depended on.

Early the next morning I stepped out onto the balcony and breathed the almost palpable atmosphere of Paris. Below me stood the Louvre

and the Palais Royal. These buildings had served as palaces until the French Revolution; afterward they were used to house complicated, centralized national ministries, museums, the Théâtre Français, and the many government services that had contributed to the greatness of France even after the German invasion. The necessary functions of government would still be housed in these ancient buildings.

After breakfast General Rogers and his party went out scouting for a headquarters site and the many necessities of our strategic command post. I crossed the Rue de Rivoli for a walk through the Tuileries Garden to the Louvre. It was reassuring, but incongruous, to see an American tank unit bivouacked in the heart of Paris. The GIs had small fires burning on the street and were shaving and cooking their breakfasts. Not since the French Revolution had anything of this nature transpired so close to the Palace of the Louvre. Each hour brought more Parisians to the streets. By and large the rejoicing over our arrival was so real and unconditional that almost everyone, except those actively engaged in immediate combat problems, momentarily ignored the need for facing reality. Champagne flowed from bottles that had been artfully concealed from the Germans. We were witnessing a turning point in the fortunes of a great nation after four years of enslavement. For the French, August 26 is as memorable as the day that Joan of Arc rode into Orléans, or the day the French stormed the Bastille to bring to an end the many foibles and weaknesses of a dissolute monarchy.

JACQUES JAUJARD AND THE LOUVRE

In the offices of the Louvre nothing much seemed changed from the last time I had been there five years before, until I looked out of the window and saw hundreds of captured German soldiers corralled in the courtyard and American anti-aircraft equipment being set up on the grounds. Jacques Jaujard, general director of the National Museums, and his loyal deputy, Robert Rey, had never left their posts, day or night, during the German occupation. Our mutual greetings were heartfelt and enthusiastic. We had not seen each other since the start of the war. Jaujard, a truly heroic figure, had fought the German demands for France's national art treasures again and again with no weapon but courage and no defense but integrity. There were tears in his eyes now that he could tell his faithful, incredibly hardworking staff that the French would at least have the assistance of their allies in preserving their artistic patrimony. For them the prolonged period of Nazi-dodging was ended.

Although the Pétain government[4] had worked hand in glove with the Nazi regime, leaving resistance to those who valued France more highly than their own lives, we knew that there were individuals, unlike the vile Abel Bonnard, who had never stooped to the ignominious betrayal of their countrymen. Bonnard, who had been minister of education and who had controlled the General Direction of Fine Arts, had fled to Germany. It was he who had made possible the German removal of the

altarpiece belonging to Belgium and secreted in Pau under the strongest French guarantees of safety.[5]

Before his flight Bonnard tried to sway Jaujard, but the latter firmly opposed transactions of all kinds that might enable the Germans to benefit at the expense of the French public collections. Jaujard vitiated all German attempts to effect an exchange of German objects from France for French objects in Germany. Knowing that such an exchange would redound to the disadvantage of the French collections, Jaujard with firmness and tact reduced a long list of demands to ten. A series of complicated negotiations and delaying feints reduced that number to two: the central panel of a German 15th-century retable[6] and a 16th-century wooden female figure, also German, said to remind Goering of his wife.[7]

For months Jaujard delayed German efforts to acquire the *Bayeux Tapestry*, the 850-year-old embroidered pictorial of the conquest of England by William the Conqueror and one of Europe's most prized art treasures.[8] Finding it impossible to procrastinate further, he finally permitted them to copy it. The Germans subsequently insisted that the original be given up to them. A week before the arrival of the Allies, a special emissary came from Berlin with instructions to bring the tapestry back with him. The resourceful Jaujard contacted the underground to learn when the arrival of the Allied troops was expected. Hearing that it might be only a matter of days, he fought a final delaying action and succeeded in keeping the tapestry in its lead box in the subbasement of the Louvre.[9]

From the first the French had been unable to trust the German Kunstschutz[10] art historians, and they had their fill of the Nazi looters who had removed about one-third of the private collections of France to German soil. They spoke cordially of a few men like Professor Count Franz Wolff-Metternich,[11] who lost favor with the Hitler regime when he opposed the shipment of the Ghent Altarpiece from the repository at Pau.[12]

The French Wartime Repositories

The Germans had had lists of individual objects and knew where they were in the various repositories. Once we knew that the national collections, including such objects as the Venus de Milo and the *Mona Lisa*, were safely stored away in these repositories, our chief concern was the safety of the repositories themselves.

Complete information on the location of the French wartime repositories had never arrived in London, although some coded information had gotten through by radio. I impressed upon my friends at the Louvre that vital maps showing the locations of these repositories, and summary information on their contents, should be prepared at once for forwarding to the monuments officers with the armies in the field. Four days later they had the lists and maps ready. Information received at this time revealed that the Germans had mined the approach to the Château de Brissac, one of the greatest of all the French art repositories, and were threatening to blow it to dust. Our troops in the vicinity were warned of this intention by wire. The paintings stored in the damp cellars at the Château de Sourches would have to be removed immediately. We de-

Plaster cast of the Venus de Milo in the Louvre. The original was sent to a French repository for safekeeping, 1939.

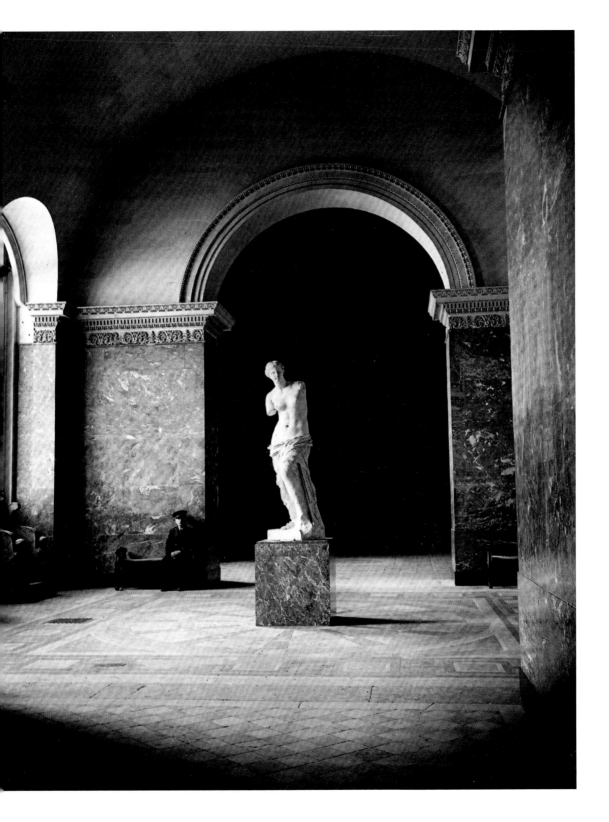

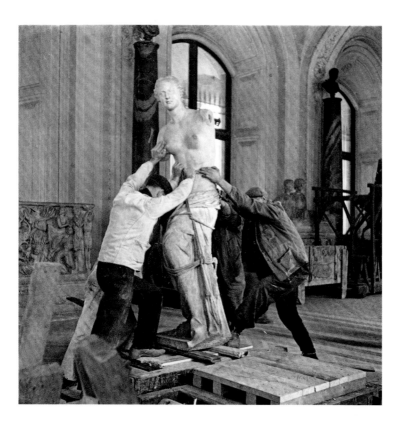

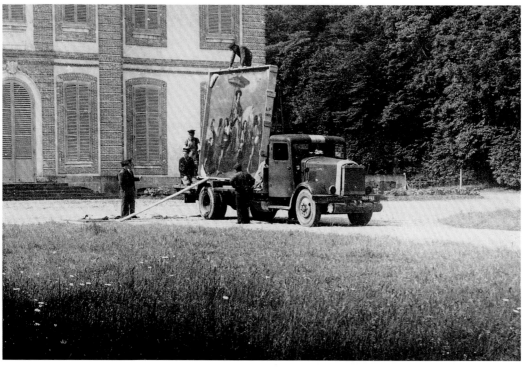

cided that workmen could be sent there on the return trip of the trucks already on their way to Paris with food for the famished populace.

Protecting the Louvre

The SHAEF Official List of Protected Monuments[13] would enable us to keep historic buildings from military use, and I was to be notified if there were any infringements of this ruling. I assured the Louvre authorities that their cooperation in certain spheres would not only be proper but was also much to be desired. They could, with little difficulty, give shelter to the men manning the anti-aircraft guns in the gardens. I felt it was only fair to warn them not to give too freely at this point; they might regret their openhandedness later if it might prove difficult to dislodge units from what, once used as a military position, might come to be considered a military necessity. Jaujard and some authorities from the Fine Arts Administration, remembering the pitched battle in the Tuileries Garden between a German tank unit and members of the French resistance, were concerned lest the anti-aircraft unit deployed in the gardens make the Louvre a target for German bombers. I assured them, with all the confidence I could muster, that the Germans would be repelled rather than attracted by the presence of this unit. Obviously this would have been no time to try to dislodge the outfit, even if I had thought otherwise.

For someone who had crossed a street in Paris to see an old friend, with no desire to do more than make a social call, I had given a great deal of advice. Seine Section was not yet operational and we were the guests of corps[14] for the sole purpose of reconnaissance. This visit, however, did prepare the way for nine months of daily contacts with my old French civilian colleagues. During this time we tried to keep in mind that we were not giving orders to the French, as would have been the case under a military government occupation, but were merely Civil Affairs officers smoothing over relations between our troops and the civilians. Frequently, however, in our desire for action it was difficult not to exceed our prerogatives.

SIDETRACKED FOR A WEEK

The next seven days pointed up the fact that, in a great army fighting a global war, a soldier is fortunate if he gets to do the job he is assigned to do at least part of the time. Since I knew Paris, spoke French, and had some of the other qualifications sorely needed by the understaffed nucleus of our headquarters contingent, I was ordered to help out with headquarters duties. I ran errands in the general's jeep, stood guard on the roof of the Hotel Ambassador during the bombing of Paris on the second night after our arrival, helped check our headquarters for explosives, and contacted the French officials and our own army officers, who began to stream into the building designated as Seine Section headquarters. Our building, the Comptoir National d'Escompte, on the Place

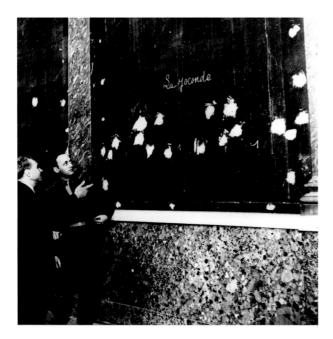

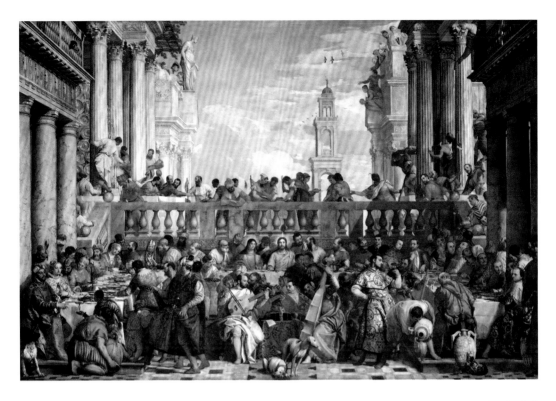

ABOVE
Paolo Veronese,
Wedding at Cana,
1563. Louvre Museum.
This was one of the
paintings removed for
storage in the French
repositories. It's
worth noting that
its dimensions
correspond closely to
the largest frame in
the photo opposite
below.

RIGHT
Francisco de Goya,
*Time and the Old
Women (El tiempo y
las viejas)*, c. 1810-12.
Palais des Beaux-Arts
de Lille, Lille, France.
Que tal? ("What's
up?") are the
mysterious words
Goya painted on the
back of the notebook
in the painting.

de l'Opéra, had been the German Kommandatur headquarters. The French had surprised the Germans here while they were at lunch, and the ensuing rough-and-tumble had thrown the premises into unimaginable disorder and clutter. Bottles, papers, weapons, office and army equipment, uneaten food, and dishes—everything that wasn't nailed down—were scattered through the rooms.

I found myself running the information desk, a trifle bewildered at this move but no more so than the representatives of French archives, libraries, museums, and other cultural institutions who had heard of my arrival and assignment to help them. I arranged for the hiring of a taxi driver who would be used to ease our transportation difficulties. I answered questions as well and as fast as I could as hundreds of civilians and army personnel filed by. I explained the status quo to dozens of high-brass visitors and provided for the arrest of hundreds of AWOL soldiers and 19 German officers and men whom I spotted dressed as French civilians. I left this bedlam only once, to find out why the Counter Intelligence Corps had been slipping up on some of the leads I had sent them. At lunch with them I discovered that I wasn't the only one with problems: the two American agents couldn't speak French, and their French liaison officer didn't know a word of English.

I worked late one night in the headquarters building. I felt jittery, thinking of the concealed entrances from tunnels and adjoining stores that hadn't been closed off. Hoping to reassure myself that the place was adequately guarded, I went to the main entrance to make certain that the two gendarmes who had been posted at that spot were still there. They were gone. I located them eventually at the police headquarters behind the Opéra National. They had walked off their post because their supply of ammunition was exhausted and they were understandably reluctant to face the possibility of being shot at without the chance of retaliating.

RETURN TO THE DUTIES OF MONUMENTS MAN

With many of the jobs for which I had been drafted more or less under control, I appealed to higher headquarters to permit my return to my duties as a monuments officer. The general granted my request, and I was immediately faced with the problem of where to begin. The Army Service Forces Manual, Civil Affairs Handbook, France listed 165 monuments in Paris and 52 on the Official List of Protected Monuments. In addition to the 154 private collections listed there were others of note requiring attention. At the Palais Royal I arranged for the cooperation of the architects and inspectors of the Direction of Fine Arts. Joseph Billiet, assistant director of French National Museums, was still in office, although he was later to be succeeded by his former chief, Jaujard. I had to proceed carefully for fear of upsetting the delicate political balance in the ramifications of bureaucratic relations. I relied in the main on such old friends as Jaujard, Georges Salles (curator of Asian art at

Bicycles and military equipment occupied the Place de la Concorde in the heart of Paris after its liberation in August 1944. Taxis and other civilian vehicles generally did not reappear for several days.

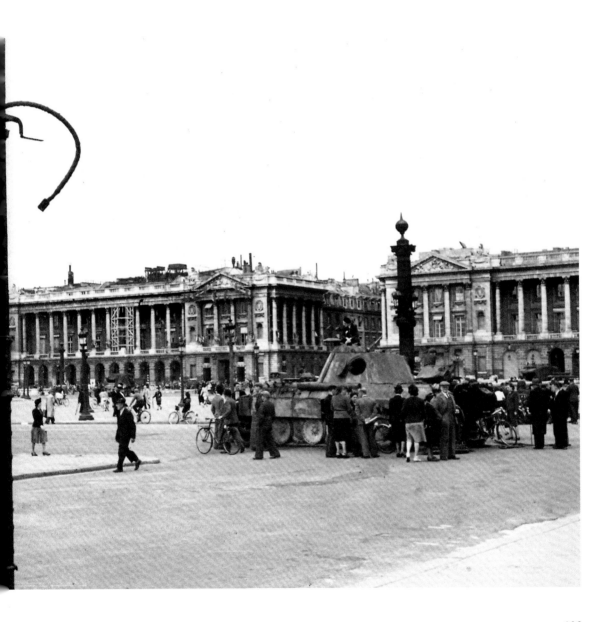

the Louvre), René Perchet (director general of architecture), Robert Danis (chief architect of historic monuments), Jacques Dupont (general inspector of historic monuments), Jacqueline Bouchot-Saupique (curator of drawings at the Louvre),[15] and the able François Sorlin (director, Office of Historic Monuments), who were to help in many a tight place. Captain Hammett and the Communications Zone group, with General Stearns and Colonel Greason—who always had a ready ear in spite of being tremendously busy with supplies from Cherbourg and other ports and with all of the other Civil Affairs business of northern France—gave incalculable aid and encouragement.

In the early days of September I chased around the city like a tourist who has but a few days to see Paris. I took photographs of the principal buildings that had suffered during the week of liberation. Occasionally there was comic relief: one Civil Affairs detachment followed a directive to the letter and counted bullet holes in the buildings at the Place de la Concorde and on the Rue de Rivoli, and tabulated hundreds of war-damaged holes in the stonework of the Louvre. Everyone had his angel and his pet project. Art dealers, architects, newspapermen, and earnest members of various art and protective committees added to the general confusion, which prompted a corporal in our office to label a mail basket, "In or out; don't make much difference."

PARIS PRIORITIES

National Archives

The Foreign Office on the Quai d'Orsay had been burned by the Germans, and all the important documents it contained had gone up in smoke. Some of the stately columns of the colonnade in front of the Hôtel de Crillon on the Place de la Concorde had been badly damaged and needed reinforcement. One of the German bombs landed near the National Archives building on the night of August 26. The structure was badly shaken and 700 windowpanes vanished with the explosion. The acting director of the Archives was in a disorganized state. He was greatly perturbed because a member of the resistance borrowed the army's prerogative and "liberated" his car and official Archives truck, which he wanted for collecting documents from many places in Paris.

We were trying to arrange for the rescue of vital records from the Saint-Lô debris and for contacting representatives at Caen, but my poor friend could not work in his windowless office where the *courants d'air*, of particular anathema to the French, were superseded by blasts of wind and rain. I suggested that he go to the Hôtel de Ville, or the Prefecture of Police, to recover his truck or to get a substitute, and to apply to the proper authorities for gasoline. As for his window glass and the unfortunate air currents, I suggested that he shut off several of the many rooms of the vast Archives building and transfer the undamaged glass from these rooms to the rooms where it was more essential. The British in London had found this transfer of glass to be most expedient.

Hôtel Hérouët

From the Archives building I walked down the street to the Rue Vieille-du-Temple. All that remained of what had once been a large flourishing department store was one lone, smoke-charred wall. The 1528 Hôtel Hérouët, one of the few remaining medieval or Renaissance houses in Paris, was in deplorable condition from the bomb, which had killed 35 persons. The house had always been one of my great favorites, and now, seeing its lamentable but not irreparable state, I decided to do what I could to help save it.

I jumped into my taxi, one of the 500 available for Seine Section headquarters, and started back to the Beaux-Arts at the Palais Royal. Detouring to avoid wreckage, we careened through the narrow streets, following the medieval pattern that Baron Haussmann had not changed in his city planning zeal a century before. When we arrived, I enlisted the sympathies of the city architect, who promised to begin at once to assemble the fallen stones of the Hôtel Hérouët and to prop into security those weakly in place. Photographs taken two weeks later showed that a starving Paris, beset by thousands of immediate, material problems, could nevertheless take time out to save its Hôtel Hérouët for posterity.[16]

Proceeding to Luxembourg Palace

The Élysée Palace, long the residence of the presidents of France, had not suffered during the German occupation, nor had it been despoiled during the frenetic period of liberation. I was curious to see its interior but decided that I could not spare the time. The Senate and Chamber of Deputies buildings, however, would require a visit. There were rumors that the former had suffered seriously and that there had been a fire in the library of the latter, which had caused untold damage. These buildings were not under the protection of the Administration of Fine Arts but were supervised by their own individual staffs.

On the way out to the Luxembourg Palace, which houses the Senate, I asked my French driver where all the bronze statues were that once had dotted the city's streets. "Melted down by the Boche," he replied. At the entrance to the Senate grounds, Carpeaux's memorable bronze figures *The Four Quarters of the World Supporting a Globe* were not in their fountain basin.[17] It was beginning to appear that none of the historic bronze monuments for which Paris was renowned had escaped the German melting pots.

Later I obtained a list of the monuments that were taken by the Germans to make instruments of war. It was a relief to find that the Carpeaux figures were not on the list. These, along with some of the other better sculptures, had been hidden by the French in stone quarries and in the strongly vaulted subterranean passageways of churches such as St. Sulpice. I located several heroically sized statues from the provinces in a foundry on the outskirts of Paris, under heaps of scrap metal where they had been secreted by the workmen. For some inexplicable reason the Germans left untouched all the statues in Paris commemorating Americans.

The Senate and Chamber of Deputies

In 1946 the Senate building was the scene of some heated disputes during the Paris Peace Conference, but they were nothing compared to the struggle put up by the Germans before their surrender there on the night of August 25, 1944. Many of the windows gaped at twice their original size from shells that had been sent screaming in both directions. The Germans had reinforced these buildings, which they had used as West European Air Command Headquarters. Three air raid shelters with mammoth concrete superstructures had been built beside the historic palace, and they were connected underground with passageways adjoining the Odéon quarries. This space had been used for storing vast amounts of explosives. There were a dozen German tanks and quantities of ordnance equipment scattered about the grounds. I had no desire to investigate these further because they looked too much like possible booby traps. Nor were the hastily erected and often overturned barricades nearby especially inviting.

In a nearby administration building I found the general secretary of the Senate, M. P. Miègeville, and the chief architect, Marcel Macary. Macary had cared for the palace for years and could be trusted implicitly. He had not left his post during the German occupation. One day he heard that Germans were placing mines under the buildings and in the gardens. He urged the prefect of the Seine to attempt to have this work stopped, but knowing that the prefect was a German collaborator, he also notified the Laboratoire de Paris officials.[18] Thereafter the Germans could not understand why their lights would go out repeatedly and for extended periods, long enough for the workmen to disconnect the mine fuses. The morning after the Germans surrendered, men were already at work removing those mines whose locations were known. The Garde Républicaine carted off 100,000 unused cartridges and 1,000 hand grenades. Four or five truckloads of other equipment were removed by the Paris firemen. The sumptuous halls were littered with grenades and potato mashers,[19] and any one of the 19 safes that had been used by the Germans looked as if it might be a repository for enough TNT to blow the place wide open. I advised the French not to poke about in them until they could be checked. My guess was wide of the mark. When these safes were checked later by our troops, they were found to be empty.

After returning to headquarters I first contacted a bomb disposal squad and then arranged for G-2 (Intelligence) examination of documents, maps, and other material that the Germans, in their haste to execute the navy maneuver known as "getting the hell out of there," had not had time to burn. The Germans had also left behind large presses and other printing material that would be of use.

On September 4 there was a lead article in *Le Figaro* stating that the Germans "under the eyes of Air Marshal Sperrle had left with clocks and paintings in their baggage" eight days before the surrender of the SS troops.[20] This was denied by the Senate authorities. It was not always possible to tell which report contained more truth. I do know that weeks later, when I was in the duchesse de Talleyrand's Château du

TOP
The Four Quarters of the World Supporting a Globe, 1867–74, by Jean-Baptiste Carpeaux was returned to its original location in Paris, the Jardin Marco Polo, south of the Jardin du Luxembourg in the 6th arrondissement of Paris, the so-called Fontaine de l'Observatoire. During the war, as a safety precaution, the French had hidden it.

BOTTOM
The Germans gathered bronze statues from all over France to melt down, probably for manufacturing weapons and ammunition. These were saved from the furnace by French workmen.

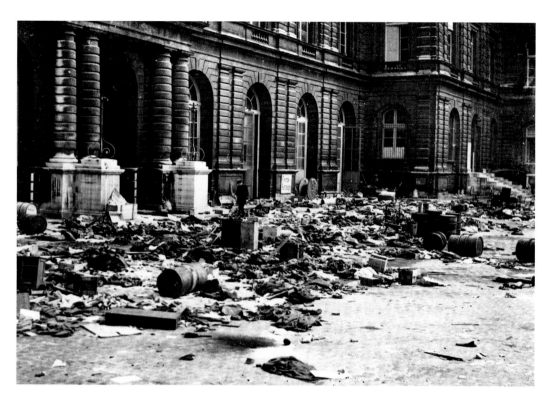

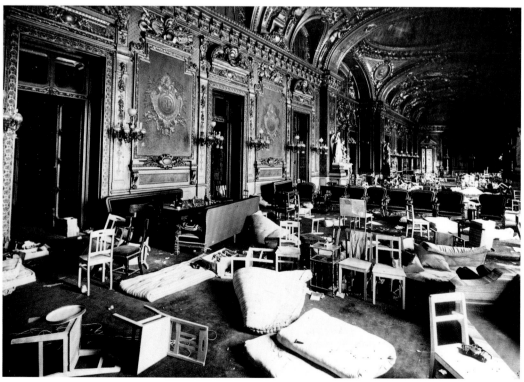

Marais,[21] which had been occupied by the Germans, I was shown one of the 19th-century lighting fixtures from the Senate, which certainly proved that some material had been removed.

The Chamber of Deputies was my next concern. For a time it was the seat of the German military administration of Paris. Later, these services evacuated the building, and troops brought here from Normandy moved in. Land mines had been planted about, and one misstep might bring a harvest of destruction to the Bourbon Palace. Although most of the damage was repairable, the fire that blazed in the palace from three o'clock until six on the afternoon of our arrival in Paris destroyed 50,000 volumes on theology, art, and science, and archives of the League of Nations.

EVENTS IN THE TUILERIES

Rescuing the Jeu de Paume from U.S. Army Requisition

Shortly after my visit to the palace our troops began arriving in ever-increasing numbers. One morning Jaujard called me in great excitement. He had discovered a placard affixed to the museum of the Jeu de Paume, in the Tuileries Garden, that stated that the

> *ARMÉE AMERICAINE BY ORDER OF THE COMMANDING GENERAL RESERVES THIS BUILDING FOR USE AS A BASE POST OFFICE BY FIELD FORCE REPLACEMENT SYSTEM.*

From this central exhibition building Goering had 20 times made his selections of confiscated art. It was my hope (later to be realized) that the Jeu de Paume could be used as a clearing center for misappropriated private treasures that belonged in France. My outspoken determination that it should serve no other purpose was but the first of many tests of the authority of a second lieutenant speaking for his commanding officer. Unhappily the Jeu de Paume was not on that magic SHAEF Official List of Protected Monuments, although the argument could be advanced that it and the Tuileries were part of the Louvre, which of course was on the list. Thanks to my close contacts with Paris activities when I sat for a week at the headquarters information desk, I had received General Eisenhower's command order of August 28. This order had been prepared by his deputy chief of staff and authenticated with the initials of General Rogers. The paragraphs that applied to the present difficulty were these:

> *Effective 12:00 hours, 28 August 1944, the Seine Section, Communications Zone, European Theater of Operations, is designated as the sole U.S. agency for administration of Paris and environs, in accordance with the terms of the agreement concluded between the French Committee of National Liberation and the United Kingdom and the United States on the 25th of August 1944.*
>
> *All authorized accommodations for all Allied agencies in the Paris*

area will be procured through the Seine Section, Communications Zone, European Theater of Operations.

Lieutenant Colonel Lawrence King, chief of the Real Estate Section of the Engineer's Office, had affection for the French. He understood the goodwill to be obtained by not asking the French military government in Les Invalides, formerly the Hôtel des Invalides, to requisition public buildings for the Allies, even though there had been a conflicting agreement permitting Allied use of any real estate used by the Germans. I obtained a copy of the long list of available buildings submitted by the French Ministry of War and reviewed it with Jaujard's deputy, Joseph Billiet. Not only was the Jeu de Paume returned to its prewar status, but the Pavillon Sully in the Palace of the Louvre, the Senate in the Luxembourg Palace, and the Chamber of Deputies in the Bourbon Palace were also declared off-limits to our troops and services.

The French themselves frequently made the task of aiding them more difficult. Their air of apparent helplessness had undoubtedly served them well during the German occupation, when infuriatingly polite delays were both a weapon and a defense. Now it appeared that, having once had long-staying houseguests who had no welcome at all to wear out, they were finding it difficult to adapt to more agreeable ones. I proposed that they print posters reading:

HISTORICAL MONUMENT: THIS BUILDING IS UNDER THE PROTECTION OF THE MINISTRY OF FINE ARTS

so that the character of these edifices would be perfectly clear. The French argued that this was an impossibility as there was no electricity to run the presses during the day. I told them that the presses could be run at night when the current was turned on for a few hours, or it could be turned on one afternoon as it had been in Cherbourg so that we could print similar placards. Eventually the posters were printed.

Rescuing the Gardens

Every day thousands of men and women walk across the serene paths of the Tuileries Garden, perhaps to catch a bus, to take the Métro, to ride the trams to the banlieue,[22] or to walk to their homes. Since the days of the last French kings these gardens have belonged to the public, and generations have relaxed here. They retain the same general aspect as André Le Nôtre's 1664 plans for Louis XIV. The terraces, trees, fountains, and sculptures offer serenity in the presence of beauty.[23]

No one who has strolled through these gardens, which connect the Palace of the Louvre and the Place de la Concorde, or looked up the Champs-Elysées toward the Arc de Triomphe or the Eiffel Tower, can fail to feel the significance of this cherished park. Its gardens mean more in historic association and daily convenience to Parisians than do Hyde Park to Londoners or Central Park to New Yorkers. I protested vigorously when it was recommended that the Tuileries be made a biv-

ouac area for the service troops for whom it was becoming increasingly difficult to find accommodations.

Now that it was fairly certain the Germans could not return to Paris and food supplies were beginning to come into the city, thousands of Parisians were returning to their homes. Other French citizens, some of whom had never seen the capital before, were arriving to do sightseeing or to visit families with whom they had not been in communication for a long time. Under these crowded conditions accommodations were badly needed, but I was determined that the Tuileries should not be subjected to slit-trench latrines and the other defacing necessities of an encampment. German tank units and the Division Leclerc[24] had come to grips here just before our arrival, but the area had come through practically unscathed. The Horses of Marly, the massive sculptural groups from the Place de la Concorde tucked away in boxes near the Orangerie, and the 18th-century marble benches and statues in the Le Nôtre gardens around the main water basins were all unharmed. I made myself vociferous and decidedly unpopular in their defense.

An unsatisfactory compromise was reached without my knowledge: the Tuileries would be used as the official Allied motor park for all the jeeps and 10-ton trucks plying their way from the ports through Paris to the front. In a short time half a dozen historic statues were damaged by the heavy trucks. The terra-cotta pipes sagged under the unaccustomed weight of these vehicles, and the old trees were damaged. I suggested that the large open area of the Esplanade des Invalides be used instead of the Tuileries. After many meetings with both American and French officials, at which we argued the case until I almost had to give in, it was fortunately agreed to use the Esplanade rather than the Tuileries as the motor park.

Security Concerns Gradually Subside

The Germans dropped four bombs in our vicinity before Christmas and one fell in the Tuileries. Their objective apparently was General Eisenhower's special train, at the time supposedly in the Gare Saint-Lazare. If the bombardier had turned them loose just an instant later, the one that landed in the gardens would have demolished a wing of the Louvre. It was a very near miss. The radio broadcasting men and equipment placed in the gardens had been moved at my suggestion to a less conspicuous part a few days before. The bomb exploded less than a hundred yards from their installations. The trees were blown limbless and leafless, but the men were miraculously unharmed.

In the early days following the liberation, security was still an important factor. We thought then that it was safer to keep many of the cultural institutions closed. It seemed the wisest course in view of the disorganization of the directing authorities, the continuing need for caring for objects that had been stored out of the city, and the fact that Paris had not yet been declared open to soldiers on leave. Somewhat later, however, it was decided that the vast artistic resources of Paris could be made available to the soldiers. Special Services officers,[25] in cooperation with the Red Cross and our Public Relations Section, prepared for the even-

tual opening of many institutions. As I recall, the Carnavalet was the first of the museums to open. François Boucher, its director, prepared an informative exhibition on the liberation of Paris. It included copies of the first newspapers published, German and French flags, pictures of German gun emplacements in Paris, and all kinds of things related to the historic day. It is typical of the French that in the midst of such confusion they could hold an exhibition and observe all of the protocol it demanded. Jefferson Caffery, the newly appointed American ambassador, attended, as did many other ambassadors and officials from every quarter.

The Louvre Exhibits the *Bayeux Tapestry*

The same afternoon, the Louvre opened an exhibition displaying the *Bayeux Tapestry* for the first time in Paris since 1804, when Napoleon had shown it to his generals. I was particularly glad to have helped arrange for this showing, as it would provide an opportunity for the services of the Historic Monuments and the National Museums to work out a joint undertaking that might lead to continued cooperation. Because of the personalities involved and a question of domain—both were under the Ministry of Education—they were continually at loggerheads on jurisdictional questions. Jacques Dupont, the clever young inspector of historic monuments, made his contribution to the scheme by bicycling the 165 miles to Bayeux to obtain the approval of the city officials for the loan of the tapestry.

An embarrassing discovery was made just as the minister of education arrived to greet the American, British, and French officials, including our General Rogers, with whom I particularly wanted to keep in touch regarding fine arts activities. The last line of the explanatory inscriptions on the tapestry reads, "The English Turned in Flight." In the interests of inter-Allied solidarity it was hastily decided that the last scenes of the tapestry would have to be artfully concealed. A new edition of the descriptive pamphlet omitted "In fuga verterunt Angli" altogether.

FATE OF THE LIBRARIES OF PARIS

The libraries of Paris on the whole did not fare badly. Throughout the occupation students had continued working at the Bibliothèque Nationale. Jean Larran was now the general administrator. His predecessor, Bernard Faÿ, one of the most despised men in France, had been imprisoned as collaborator. Julien Cain, the prewar administrator, was a prisoner in Germany. This dignified, charming old man was later released and given a hero's reception in Paris.

In January 1944, 300 cases of rare treasures, which had been sent to the Château d'Ussé by the French for safekeeping, were returned by the Germans in a special train to Paris. As the future of the war was by no means settled, 60 of the cases were put in the vaults of the Bank of France. Little, if anything, was removed to Germany. The Polish Library had been sent to Germany, but the Polish and Russian books in

the Byzantine Institute remained in Paris. They were secreted away and, in defiance of the Germans' demands, were not surrendered.

The American Library had suffered to a very minor extent. The famous Jewish Research Library, however, had been taken bodily to Germany for "research." The librarian at the Bibliothèque de l'Arsenal had more time to get his library in order once the entertaining but distracting influence of an American lieutenant and ten men from an AAA (Anti-Aircraft Artillery) unit billeted there was removed.

With the arts and the sciences again living openly and unafraid in France, the Institut de France arranged a solemn opening and the press acclaimed the newly elected members of the Academy of Letters. The Academy of Sciences reported the existence of a secret repository for its publications at the Château du Ry at Journet, in the [Vienne Department]. Stored here were 100 boxes containing the papers of the great chemist Lavoisier and others, and 60 cases of rare mineralogical specimens. It was imperative that the combat troops on their way to Germany from southern France be notified immediately to spare this repository if it was humanly possible.

OTHER PARIS BUILDINGS

Other buildings had been affected in varying degrees. Though the Grand Palais had been burned, its loss was not considered a serious blow to art. It was neither a thing of beauty nor especially noteworthy historically. Many were glad that a modern building might now replace it. The Germans had used the Petit Palais to billet troops and we continued to use it for the same purpose. The appeals of the Museums of the City of Paris that we discontinue this practice could not be granted. It was true that objects of art stored in the basements could have been made more available had our troops not been in the building. It was also undeniable that the water from the men's shower should have been diverted into the courtyard rather than onto these objects. On the favorable side, however, was the fact that the 1,300 troops using this building for barracks were very carefully disciplined. They treated the 18th-century paneled walls with utmost respect. Inspection disclosed that the steam from the showers was not damaging the 20th-century frescoed vaults over the colonnades, which had been boarded in to form the large latrines.

Military Use of the Hôtel de Crillon

It was sometimes difficult to comply with official requests, no matter how high-pressured. A letter from the general secretary of the French Ministry of War was particularly irritating. It requested that the Hôtel de Crillon be vacated, or that at least only senior officers dignify the rooms that had been host to so many distinguished foreign visitors, including President Wilson.[26] The Germans had given the hotel unusually hard wear and it was markedly run-down. The furniture, rugs, and old paintings, referred to as classified "Monuments Historiques" in the offi-

BAYEUX TAPESTRY

The *Bayeux Tapestry* remains one of the world's most renowned works of art. The tapestry commemorates William the Conqueror's victory over English forces at the Battle of Hastings after his French fleet crossed the Channel in 1066. The tapestry even includes a panel depicting Haley's Comet, which appeared in the sky that same year. It was likely commissioned by Bishop Odo, who was the half-brother of William the Conqueror, and was first presented to King William at the dedication of the Bayeux Cathedral in 1077. According to recent scholarship, its full 230-foot length was likely hung around three sides of the cathedral's nave for all to admire. The city of Bayeux, where the tapestry is currently displayed, is located near the D-Day landing beaches in Normandy, between St. Lô and Caen (see map page 56).

On August 22, 1944, as Allied troops moved to gain control of Paris, General Dietrich von Choltitz, the last Nazi commanding officer of occupied Paris, was in his office at the Hôtel Meurice when German SS officers arrived to inform him that they had been ordered to remove the tapestry from the Louvre and deliver it to Hitler in Berlin. The story goes that von Choltitz told the men that the Louvre was already in Allied hands and therefore he could not protect them during the tapestry's removal. This dissuaded them from taking it and saved it from almost certain loss or destruction.

RIGHT
A detail from the section of the *Bayeux Tapestry*, c. 1070, shown below.

BELOW
In this embroidered scene, English and French soldiers fall side by side at the Battle of Hastings. At center, Bishop Odo is depicted on horseback wielding a club, urging on the young soldiers.

HIC·ODO·EP̄S·BACVLV·TE[

4 55

BACVLV·TENENS ·CONFORT· HIC·EST· ·DVX· ·ELVS ·HIC·E·A[]·P·G·AN
 WILLE[]
 ·ПAT·
 ·PVE·
 ·ROS·

cial complaint, were inspected and found to be "expensive copies, which in the opinion of the undersigned [the author] would never be placed, as stated in the letter, in a French National museum." Finally, a typical army compromise was reached: in the future only officers of the rank of captain and above would be permitted to stay there.

THE FATE OF FRENCH PRIVATE COLLECTIONS

The Case of Robert de Galéa

Many a private French art collection had gone underground during the occupation. One such collection was called to my attention when its owner was notified that American troops from a civil censorship detachment were about to occupy his house. An excited, almost incoherent Frenchman, Robert de Galéa, came to my office following an urgent telephone call I received from the director of the Museums of the City of Paris notifying me of his imminent arrival. De Galéa told me that his family had works by Renoir, Cézanne, and Degas by the dozen in the small Villa Félix on the Île de Migneaux at Poissy, north of Paris. It was an incredible story and I dropped everything else to make an immediate check on it.

I secured a jeep and a driver and left almost at once on this bleak, bitter cold winter's day for the de Galéa summer home. The trip took several hours over icy roads and we were looking forward to a fire and perhaps some hot grog, or something equally warming, on our arrival. Instead, we were greeted in a cold, damp house by a group of frenzied Frenchmen who complained bitterly about the way they had been treated by the French mayor of Poissy. They said that he was a Communist "like all the other newly made mayors since the liberation." I had come to see paintings, and I insisted that they be shown to me immediately. I was cold and tired, and half convinced that I had been a fool for coming. A couple of the men rolled back two sliding doors and exposed a large room. The walls were covered with paintings—pinned up everywhere like wallpaper. There were at least a hundred canvases on the walls.

I recognized a few as well-known works. Others I had never seen before, not even in reproduction.

De Galéa was obviously pleased with the effect this display had on me. I listened, still awestruck, as he told me how these paintings had come into his possession. The celebrated painter and dealer Ambroise Vollard died in 1939 and bequeathed most of his great collection of paintings to Mme de Galéa, Robert's mother. Throughout the occupation the paintings had been stored in cases in the garage. They had been brought into the house only the day before. Now that our troops were to occupy the premises, de Galéa was concerned over the fate of these paintings. I returned to Paris convinced that the Poissy repository was no place to keep such an important group of paintings but undecided as to what could be done to safeguard them.

After thinking it over, I decided that the best safeguard would be to store the paintings in the Louvre for a time. I called de Galéa in the

morning and told him that arrangements had been made for the transfer of the paintings to the museum. A couple of hours later he returned my call to tell me that he had made other arrangements. There was no further explanation.

A few months later de Galéa arrived at my office a little before eight o'clock on a beautiful spring morning. It was the first time I had seen him when he was not flushed and fidgety. He seemed unperturbed, but his deathly white face belied his calm appearance. His voice was without emotion as he told me that his entire collection—the paintings I had seen and hundreds of others—was about to be destroyed.

He had placed the Vollard Collection in a hunting blind on a small island in a lake and swamp district near Chantilly. Our air force had closed off the district and was preparing to conduct air maneuvers and experimental bombing. De Galèa feared that it might even now be too late. Bombs might already have destroyed his paintings.

I put through a call to air force headquarters. After several wrong numbers, busy signals, and poor connections during which time we both began to despair, I finally contacted the local outfit. The bombing had not yet begun. Hurriedly I gave the reason for my call and the approximate coordinates of the island. The strain was ended: I was assured that the air force would not bomb the island.

A total of 819 paintings by Rouault alone were part of the possessions of the de Galéa family and were the subject of a court decision that returned the "unfinished" ones to the artist.[27]

ESTABLISHING A POLICY FOR RESTITUTION

During the early months in Paris a policy had not yet been formulated for returning Nazi-appropriated works of art to their rightful owners. We had visits from Francis Henry Taylor, Sumner Crosby, Henry C. Newton,[28] and others, who represented the Washington commission and the State and War Departments. One of their duties was the establishment of such a policy. Lieutenant Colonel Aeneas McDonnell,[29] the British monuments officer on the SHAEF Mission to France, came from London and set up his office in the old Chase Bank building with the other high-echelon officials who had meetings with French officials and coordinated intelligence reports in preparation for the days ahead in Germany.

The French authorities were so delighted with our arrival, so pleased that they had been able to prevent the Germans from taking their nationally owned treasures, and so tired of the political wrangling and double-crossing of the Germans and their collaborators that it was most difficult to enlist their aid in setting up future plans for large-scale operations. The French monuments officers who had been brought from Africa, and others from France itself, had difficulty getting established. For the most part these men were demobilized without having served a useful purpose. The Commission de Récupération Artistique under Albert Henraux, who had been acting president of the National Museums,

was set up in the Jeu de Paume and began to accumulate documentation about looted properties. There was no one who had a clear idea of the extent of confiscation of works of art. Traffic in such items even in normal times is often a clandestine business. I did not know what had been stolen, swindled, sold, bartered, or otherwise lost to France.

THE FATE OF OTHER FRENCH COLLECTIONS

It was some time before we gained even an impression of what had transpired. In general, public collections, which had been housed in banks or the basements of buildings or transferred to repositories in the country, were intact. Private houses had suffered in varying degrees depending on the character of their German occupants. The magnificent Robert de Rothschild home had all of its famous treasures intact in spite of the fact that it had been occupied by a German general. The other Rothschilds were not nearly so fortunate. Nothing remained at the homes of Henri and Édouard de Rothschild. Some of the fine things were left in the Meurice mansion, which later became a British Officers' Club. At the Boulogne château of Alexandrine de Rothschild some of the large paintings, including a fine Boucher, had been left behind, but the others had either been shipped to Germany or taken by the Germans to decorate the officers' dining room in their Marine School at the Lycée de la Fontaine, not far away. Those put to this latter use were subsequently recovered.

Private homes were subjected to vandalism in varying degrees. Generally those that suffered most were those left completely to the tender mercies of their German occupiers. Less despoiled were those staffed by faithful servants throughout the occupation. Next in line were those whose owners had not been forced to join the exodus and who resisted the Germans by every imaginable trick and stratagem in the effort to retain their art treasures. Least subject to vandalism were those homes whose collaborator owners had welcomed the Germans with open arms.

The Fate of Some Icons of Art History

The Germans had a plaster cast made of the Winged Victory of Samothrace and took that, and not the original, to Berlin. The *Bayeux Tapestry* and the 11th-century gold altar frontal from Basel in the Cluny Museum were not delivered over to the Germans, but many works of art "acquired" by the National Museums from Jewish owners for safekeeping were taken from the repositories. Marshal Pétain, extending his cooperation to another fascist neighbor, arranged for the return to Spain of the Visigothic material from the Cluny Museum, including the Crown of Reccesvinth and also the celebrated *Dama de Elche* from the Louvre. The relatively unimportant exchange of a painting and a sculpture between the Germans and the Louvre authorities probably benefited the latter more than it did the Germans—and these are now back in France.

Claude Monet, The *Parc Monceau*, 1878. Metropolitan Museum of Art. This painting was taken by the Nazis from the Lindon family in 1940 and removed from the Jeu de Paume Museum by Hermann Goering on November 25, 1942. Following restitution to the family, it was sold to the Metropolitan Museum of Art in 1959.

Gustav Klimt, *Mäda Primavesi*, 1912-13. Metropolitan Museum
of Art. The painting was seized by the Nazis around 1938 and
restituted to the Steiner family in 1951.

Lady of Elche, 5th–
4th c. BCE. National
Archaeological
Museum, Madrid.
The so-called Lady of
Elche had been
discovered in Spain in
1897 and purchased
by the Louvre shortly
thereafter. The Vichy
government returned
it to Spain during
World War II.

Votive crown of
Recessvinth, as found
in the treasure of
Guarrazar, Spain,
7th century. National
Archaeological
Museum, Madrid.
The gold crown of
the Visigothic King
Recessvinth was
discovered near Toledo,
Spain, in the mid-19th
century as part of
a larger trove. It had
been in the collection
of the Cluny Museum
in Paris, but under
Nazi occupation, the
Vichy government
returned the crown
to Spain.

LEFT
Gregor Erhart, *Saint Mary Magdalen*, c. 1515-1520, also known as *La Belle Allemande*. The Louvre relinquished this sculpture to Goering. The statue was said to have been much admired by Goering because it reminded him of his first wife.

BELOW
Basel Antependium, c. early 11th century. Musée de Cluny, Paris. The French were able to avoid giving over this gold altar frontal to the German occupiers.

NOTES

[1] The army staff unit responsible for Paris. The section's G-5 staff oversaw interactions between the U.S. military and the civilian population of Paris.

[2] Von Choltitz (1894–1966) was hailed by some as the "Savior of Paris" for disobeying Hitler's order to destroy the city and was never charged with war crimes, notwithstanding almost three years in Allied prison camps after his capture and his admitted participation in atrocities earlier in the war. See Larry Collins and Dominique Lapierre, *Is Paris Burning?* (New York: Simon & Schuster, 1965).

[3] See map page 130.

[4] Marshal Philippe Pétain (1856–1951) was a military hero of World War I who was appointed head of the French collaborationist government that cooperated with Hitler after the German invasion. This administration was commonly known as the Vichy government, owing to the placement of its headquarters in the central French city of Vichy.

[5] The reference is to the *Ghent Altarpiece*, discussed in more detail in note 12 below. Abel Bonnard (1883–1968) was a French writer and politician who had served as minister of education under the Vichy regime. After escaping to Germany, he later found refuge in Spain, where he survived until 1968 following two French prosecutions for war crimes: one in absentia and one for which he temporarily returned to France. His formal title under the Vichy regime was Ministre-Secrétaire d'État de l'Éducation Nationale et de la Jeunesse (minister–state secretary for national education and youth).

[6] A structure or painting forming part of the assembly behind the altar of a church. The 15th-century example referred to here is probably the Louvre's painting *The Seven Joys of the Virgin*, created in Cologne by the Master of the Holy Kinship. See Gerri Chanel, *Saving Mona Lisa* (Heliopa Press, 2014).

[7] The wooden figure is *La Belle Allemande* (c. 1515–20), to which Goering specifically alludes in his post-capture interview, reported on page 260. The statue was returned to the Louvre after the war.

[8] Today, the *Bayeux Tapestry* is on display in a museum dedicated to it in the French town of Bayeux.

[9] Both the Collins and Lapierre book *Is Paris Burning?* (pp. 197–99) and the film version by the same name portray the visit of four SS officers to the office of General von Choltitz at the Hôtel Meurice on August 22. Von Choltitz had delayed carrying out Hitler's orders to destroy Paris in hopes that the Allied enemy would arrive in time to save the city. Expecting his SS visitors to arrest him for treason, von Choltitz was greatly relieved to learn that all they wanted was assistance in carrying out the order of Heinrich Himmler, head of the SS, to seize the *Bayeux Tapestry* at the Louvre and take it back to Berlin.

[10] This term, meaning "art protection," refers to a German military unit with roots in World War I that was theoretically responsible for the protection of art in wartime.

[11] Wolff-Metternich (1893–1978) was a German art historian appointed by Hitler to oversee art in occupied France, where he regularly found himself caught in the middle between his Nazi superiors and French museum professionals.

[12] The *Ghent Altarpiece* (also known as *The Adoration of the Mystic Lamb*), completed in 1432 by Hubert and Jan van Eyck (see page 202), is one of the great masterpieces of Flemish art. The monuments men ultimately recovered it from the mine at Altaussee, Austria. For the complete story of the many incidents of damage and theft the work has suffered over the centuries, see Noah Charney, *Stealing the Mystic Lamb: The True Story of the World's Most Coveted Masterpiece* (New York: Public Affairs, 2010).

[13] The Official List of Protected Monuments contained extensive maps of French cities and regions, with corresponding lists of cultural institutions. See Army Services Forces Manual M352-17A, Civil Affairs Handbook France Section 17A: Cultural Institutions:

Supplementary Atlas on Churches, Museums, Libraries, and Other Cultural Institutions in France, January 4, 1944.

[14] Corps here denotes the larger administrative unit responsible for military government in the region.

[15] Jacqueline Bouchet-Saupique (1893–1975) became the first woman to be appointed a curator at the Louvre on October 23, 1945. She was head of Cabinet des Dessins as the curator of drawings.

[16] See pages 106–107.

[17] This sculpture (1867–74) is once again in its original location, the so-called Fontaine de l'Observatoire in Paris. For a recent discussion see Laure de Margerie, "Fountain of the Observatory," in *The Passions of Jean-Baptiste Carpeaux*, by James David Draper and Edouard Papet exh. cat. (New York: Metropolitan Museum of Art; New Haven, Conn.: Yale University Press, 2014), pp. 156–67. Carpeaux's full-scale varnished plaster model is now in the Musée d'Orsay. See http://www.musee-orsay.fr/en/collections/works-in-focus/sculpture.html?no_cache=1&zoom=1&tx_damzoom_pi1%5BshowUid%5D=131560

[18] The Laboratoire Central de la Préfecture de Police (Central Laboratory of the Prefecture of Police, or LCCP) is a scientific organization that works to ensure health and safety in Paris and environs. During the war, chemists and physicists at the LCCP, among other resistance activities, worked to block German efforts to obtain the LCCP's research into the heavy water needed for the development of atomic weapons.

[19] Potato masher was the nickname for a type of German hand grenade with an explosive at the end of a stick. British soldiers gave it this name in World War I because it resembled the kitchen tool.

[20] After a long career in the Luftwaffe, Hugo Sperrle (1885–1953) had been removed from command of an important German air unit in France in 1941 owing to disagreement with Goering over strategy in the air war against Britain. He sat out the rest of the war in Parisian luxury and was one of only two senior officers acquitted by a U.S. military court in a separate Nuremberg trial of 14 members of the German High Command. Had Goering pursued Sperrle's strategy, to focus bomb attacks on British airfields instead of population centers, it is quite possible that the German plan to invade Britain would have succeeded.

[21] The Château du Marais is located in Le Val-Saint German, France. A masterpiece of Neoclassical architecture, it is open to the public.

[22] French for "suburbs."

[23] André Le Nôtre (1613–1700) served as the principal landscape gardener for Louis XIV (r. 1643–1715). He often worked with architect Louis Le Vau (1612–1670) and interior painter and theorist Charles Le Brun (1619–1690). Le Nôtre not only designed the gardens for Versailles, but also designed or improved the Tuileries and many other classic French formal gardens of the region.

[24] The reference is to the Second Armored Division, commanded by General Jacques Philippe Leclerc (1902–1947) and consisting of 16,000 troops (and 4,000 vehicles)—the first French forces to enter Paris in support of the uprising led by the French resistance.

[25] The Special Services was a unit of the U.S. Army that provided entertainment to the troops. The author's brother-in-law, Samuel Dushkin (1891–1976), was a prominent classical violinist who served in the Special Services. Dushkin had lived in Paris before the war. His Paris apartment was later the author's home base there; see Chapter 5 and map on page 92. The Special Services should not be confused with the U.S. Army Special Forces, better known as the Green Berets.

[26] The Hôtel de Crillon is a classic luxury hotel established in the early 20th century in a building dating to the mid-18th century. It is located on the Place de la Concorde, at the foot of the

Champs-Élysées. During the liberation of Paris, two American officers, who had known the elegant hotel before the war, reportedly repaired to the Crillon bar for a celebratory drink but were startled to find its lobby still occupied by 176 armed German soldiers. The Germans eagerly surrendered to the Americans on the spot, rather than risk the vengeance being wrought upon captured Germans by the Free French elsewhere in the city. See Collins and Lapierre, *Is Paris Burning?*, p. 303. Hôtel de Crillon is still in operation as a luxury hotel.

[27] In April 1949, following the court-ordered return of Rouault's works, the City of Paris filed suit against Vollard's longtime companion Madeleine de Galéa and his brother Lucien, the principal beneficiaries of the late dealer's estate. The suit claimed that the city was entitled to more of Vollard's substantial collection than the four paintings he had bequeathed in his will to the Petit Palais. The court ruled in favor of Vollard's heirs. Members of the de Galéa family (Madeleine, Robert, and Robert's son Christian) consigned this inheritance to the art market over many decades, and works from the family's collection now appear in major museums and private collections. For more about the complicated history of Vollard's estate, see Maryline Assante di Panzillo, "The Dispersal of the Vollard Collection," in *Cézanne to Picasso: Ambroise Vollard, Patron of the Avant-Garde*, ed. Rebecca Rabinow (New York: Metropolitan Museum of Art; New Haven, Conn.: Yale University Press, 2006), pp. 259–62; and Lynn H. Nicholas, *The Rape of Europa* (New York: Vintage Books, 1995), pp. 304–306, 425.

[28] Brigadier General Henry C. Newton (1896–1981), served as a second lieutenant in the field artillery during World War I and continued as a reservist while teaching architecture at the University of California until called back to active service in 1940. After directing various aspects of the work of the monuments men during the war, he continued as an army officer and educator until his retirement in 1956.

[29] Aeneas J. L. McDonnell (1904–1964) was an art dealer and connoisseur, native to Australia, who served as a monuments officer with British forces in France. He returned to his native Australia after the war.

Paris and
Castle Company

SECURING PALACES AND CHÂTEAUX IN AND AROUND PARIS

4

CHÂTEAUX OF THE ÎLE-DE-FRANCE, 1944

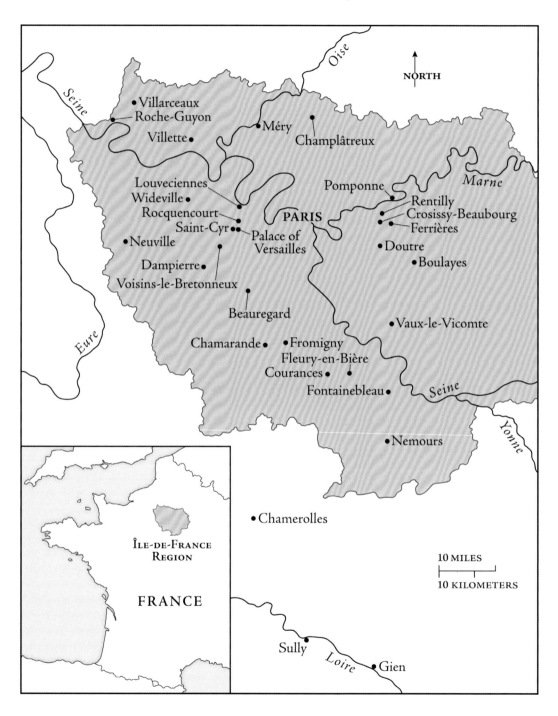

NORTH

Oise

Seine

•Villarceaux
Roche-Guyon
Villette•

•Méry

Champlâtreux

Marne

Pomponne

Louveciennes•
Wideville•
Rocquencourt•
Saint-Cyr•
•Palace of
Versailles

•Neuville

PARIS

Rentilly
Crosissy-Beaubourg
Ferrières

•Doutre
•Boulayes

Dampierre•
Voisins-le-Bretonneux•

Eure

Beauregard•

Vaux-le-Vicomte•

Chamarande•
•Fromigny
Fleury-en-Bière•
Courances•
Fontainebleau•

Seine

Yonne

•Nemours

•Chamerolles

ÎLE-DE-FRANCE
REGION

FRANCE

10 MILES

10 KILOMETERS

Sully•
•Gien
Loire

Île-de-France is a region of France with Paris approximately at its center that is surrounded by territory roughly corresponding to the historical seat of the kings of France. The name of the region, which means "Island of France," may be a sort of synecdochic connection to the entire territory by imperfect reference to the island in the Seine River known as the Île de la Cité, which is at the center of Paris.

Several of the châteaux visited by the author in this chapter share connections with Kings Louis XIII, XIV, and XV, and members of their circles, who inhabited these châteaux at various times when they were not at court in Paris.

STAFFING THE PARIS OFFICE

Just as soon as I began to check on the damage done to the palaces and castles of France, my office in Paris was besieged with broken-down countesses, German sympathizers, and compassion-seeking victims of German brutality, all as difficult to deal with as the exacting American officers who also had complaints to register. It soon developed that the enlisted men in the outer office were no match for the exasperated art collectors and château owners whose wild, gesticulating, and deafening presence gave my office all the aspects of a madhouse.

I was virtually chained to my desk when it was more important that I be free to check on the damages and occupations of the palaces and châteaux of the Île-de-France and some adjoining areas. I would probably be there yet, except for a very fortunate occurrence. I finally acquired the services of a French Red Cross lieutenant who knew Paris and its environs as foreigners rarely do. And of even greater importance to me was the fact that she was familiar with the people, too. It may be that she was overly suspicious of my visitors' motives, but she handled all situations with skill and finesse. I will always be indebted to this rosy-cheeked, blonde Frenchwoman—who looked more Swedish than French—for the work she took off my hands. It left me the time and the energy to go out into the field and to visit these places.

SECURING THE PALACE AT VERSAILLES: PRIOR HISTORY OF THE PALACE

Twelfth Army Group,[1] soon to be followed by the Forward Echelon of Supreme Headquarters, was scheduled to move into the Palace of Versailles. It was here that mobs seized King Louis XVI and Marie-Antoinette and took them to a prison in Paris during the French Revolution. The furniture was sold shortly afterward and the paintings the palace had contained were transferred to the Louvre. The deserted palace itself narrowly escaped being sold. In the 19th century Louis-Philippe I developed Versailles into a great national art gallery. It was in the renowned Hall of Mirrors that King William I of Prussia was proclaimed German

emperor in 1871, and here too that the Allies and Germany signed the fateful Peace Treaty of 1919.

After World War I Versailles was restored with the aid of American funds, and visitors could again see the palace of "Le Grand Monarque"— Le Roi Soleil (Louis XIV)—the gardens of Le Nôtre, the architecture of Le Vau and Mansart, and the paintings of Le Brun, with much of their former lavish grandeur reinstated. Like an enormous mirror, the cruciform grand canal, 68 yards wide and over a mile long, reflects the skies and the green along the banks. The leveling of the ground for the construction of the aqueduct that brings water from the Eure River was said to have kept 36,000 people and 6,000 horses at work for ten years. The palace could house 6,000 people.

The Threat of German Air Attack

Lieutenant (USNR) George Stout had told me that Twelfth Army Group would use none of the historic buildings except the so-called Small and Large Stables across the square from the palace. I was not so much worried about the damage the occupation itself might cause as I was by the possibility of a German attack on Versailles now that it was a major Allied headquarters. If the Germans were to bomb it as a military objective, as we had bombed the nearby Saint-Cyr, there would probably be nothing left of Versailles. I took scant comfort from the old bromide claiming that offensive armies never destroy each other's headquarters. Our anti-aircraft and air corps units appeared to be much better restraining devices.

The Risks from U.S. Troops

When I arrived at Versailles, the frantic architects of the palace and the curator of the museums referred all problems that were outside the scope of their experience to me. The Special Services shows were creating special problems. Soldiers were coming from everywhere in vast hordes and were trampling across the grounds to view the performances on the steps of the Grand Trianon. The entertainers were using the elaborate period rooms as dressing rooms and creating a fire hazard by smoking in them. Trucks were driving up on the lawns with troops and equipment.

The French officials had sanctioned the use of a small space for one tent for a British signal outfit. Having secured permission for just this one tent, the British then moved aerials, six trucks, and other equipment in front of the palace. They used the statues in the 17th-century Le Nôtre gardens for the suspension of camouflage nets to conceal the trucks. When I tried to remedy this situation, I learned that the British are no mean buck passers. I was shifted from a sergeant to a lieutenant and all the way up to the group captain with a great show of polite interest but no results. A sympathetic bystander agreed with me that the installations should be moved. I learned that he was Air Vice-Marshal Strafford, and it may be that I was more impressed with his rank than was this British unit. At any rate, they didn't budge until word arrived from the front ordering them to move up closer to the lines.

Other difficulties were constantly arising. The web of cables and wires required by the SHAEF headquarters had to be strung along the walls of the palace. Ingenious loops and supports were devised to save the 17th-century stone and woodwork.

Art for Eisenhower's Office

The gossip at the breakfast table in our Paris headquarters was that works of art were being taken from the museum of the Palace at Versailles to furnish General Eisenhower's office. The general was moving into the home of Paul-Louis Weiller, which the Germans had systematically stripped of all its furnishings.[2] I called the town major[3] in charge of requisitioning real estate at Versailles to check on the story. Learning that it was true, I got in touch with Jacques Jaujard, who, as director of French National Museums, should be apprised of what was happening. He explained that he had been informed of the situation but that he had not called me because he knew I would do whatever I could to put a stop to it. He understood that the general, either in person or through his immediate representative, had made the "demand," and he did not like to refuse such a request. I suggested that there might have been some confusion over the French word *demander*, which means "ask for" rather than "demand."

The newly assigned Versailles town major, Captain O. K. Todd, was very proud of his feat. He had succeeded in borrowing the finest Regency desk by Cressent, a terra-cotta statue, seven engravings, and 11 paintings, including Van Dyck's portrait of Thomas of Savoy, two fables of La Fontaine by Oudry, and a duck hunt by Claude-Joseph Vernet. In addition, there were a handsome Persian carpet and other furnishings from the Mobilier National in Paris. I went to the general's prospective office when these objects were being installed and urged the workmen to handle them carefully. I suggested to Captain Todd that a busy general would want a modern, more utilitarian desk than the one chosen by his well-intentioned subordinates. I insisted that it was foolhardy to allow art objects such as these, all but one of which had been receipted for by the army, to be unprotected and unguarded. My argument was considerably strengthened by the fact that no one had questioned my presence either on the grounds or in the house. It was obvious, however, that I was making no headway. My arguments made no impression on Todd. A few minutes later I was told that Colonel Brown, General Eisenhower's two-fisted headquarters commandant, wanted me to come to his office immediately.

I was sure of my facts and of my position. I had previously given the Official List of Protected Monuments, which of course included the Palace of Versailles, to two former town majors, who had been less successful than Captain Todd in fulfilling the many requests of the SHAEF headquarters. I had checked earlier in the day to see that the list was on hand in their office.

In spite of this I had to talk fast and with as much assurance as I could muster. I contended that General Eisenhower would be personally embarrassed if it should leak out, as some of the story had already, that

Claude-Joseph
Vernet, *Duck Hunting
at Lake Patria near
Naples in 1746*, 1749.
Château de Versailles
et de Trianon,
Versailles, France.
This painting was
borrowed from the
palace at Versailles to
decorate General
Eisenhower's Paris
office but returned at
the author's urging.

he was using "protected" works of art for military purposes, contrary to orders signed by him. And wouldn't the German propaganda office have a holiday if it could report that General Eisenhower had appropriated art objects from Versailles for furnishing his own office? The eagle descended on the gold-barred lieutenant. His rage mounted steadily. Finally he seized the phone. "Let's see what your General Rogers[4] has to say about this," he insisted. The general could not be located.

I continued my badgering and finally Colonel Brown reluctantly decided to order the town major to remove everything from the Eisenhower office and return it to the palace. I left the room feeling as though I had taken a physical beating. The next morning those objects borrowed from Versailles were returned. But four years later the French government was still trying to locate furnishings borrowed from the Mobilier National, and my old friend Georges Fontaine, as general administrator, was being held responsible for their disappearance. On the day following the return of the artworks to the palace, Captain Todd was decorated by the City of Versailles; he was promoted to the rank of major a few days later.

A LOSING BATTLE AT FONTAINEBLEAU

The situation at Fontainebleau was comparable to that at Versailles, with one major exception. Albert Bray (1884–1959), the architect, was a watchdog of the first rank. It was an unaccustomed luxury for me to have a friend at court whose authority I could hide behind. Together we arranged for moving the troops bivouacked on the palace grounds to a more remote part of the forest, where they were less likely to do any damage. We also successfully opposed the use of the canals for amphibious demonstrations and practice. The old walls of these canals and the grounds were hardly fair prey for assault boats practicing for the Rhine crossing.

In spite of our combined efforts, however, two fires broke out in the Henry IV wing, which was occupied by troops of the Replacement System. (Later this command was euphemistically termed the Reinforcement Command to stimulate morale in view of our heavy losses at the front.) These fires started in fireplaces, which should not have been used. One such fire burned for a day and a half behind the thick walls before it was noticed.

It was at Fontainebleau that I fought a long, drawn-out, and bitter but losing battle in trying to prevent Colonel H. E. Potter, commanding officer of the Ground Force Training Center and the Ninth Replacement Depot Fontainebleau, from using the Louis XV wing of the palace. His requisition for the 32 rooms in the wing for an administration and headquarters building was turned down by General Rogers and by the French minister of education. Potter, however, was determined to get the wing "one way or another," as he expressed it. Apparently the one way or another was Lieutenant General Ben Lear, deputy theater commander. The colonel appealed to him and all orders were reversed. The entire army seemed to stand in awe of the general.[5]

The Château de La
Roche-Guyon was
used by Erwin
Rommel as Germany's
regional headquarters
in 1944. In the shelling
by the Allies, the
castle and its art
objects were seriously
damaged.

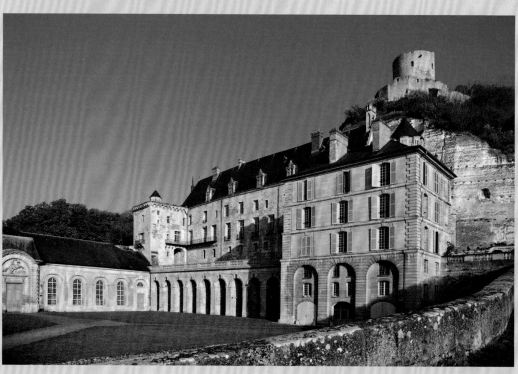

LEFT
Erwin Rommel wearing a scarf knitted by his daughter Gertrud, which he purportedly wore throughout the war.

BELOW
Restored Château de La Roche-Guyon with dungeon (castle keep) rising above it. Roche-Guyon, Île-de-France, 2014.

THE DESERT FOX

Few generals on either side in World War II were more admired by troops and the general public than Field Marshall Erwin Rommel.

Rommel earned his sobriquet, Desert Fox, for outstanding leadership of the German and Italian forces and for his cunning tactics while fighting against the Allies in North Africa, from 1940 to 1943. Allied troops ultimately overwhelmed the Desert Fox, a defeat that likely resulted from Hitler's refusal to send reinforcements from the Eastern front to his aid.

In 1944, realizing that an Allied landing was imminent, Hitler transferred Rommel to France to evaluate the coastal defenses. Rommel selected Château de La Roche-Guyon, the seat of the Dukes de la Rochefoucauld for centuries, as his French headquarters. Unlike many of his peers, and consistent with his reputation for thrift and respect for his enemies, he left the château unscathed.

After an inspection of coastal defenses, Rommel recommended concentrating Germany's efforts on planting the coast with land mines, and he advised giving up on inland tank strategies, where he knew that Allied air superiority could easily destroy them. Arguably, Hitler's refusal to follow Rommel's recommendation cost Germany the war. It has been asserted that if Rommel's mines had thwarted the D-Day invasion, Hitler might well have brought his troops back from the Eastern front to set the stage for a negotiated peace.

Just prior to D-Day, Rommel was badly injured when Allied aircraft strafed his military vehicle on a French road and was forced to return to Germany, where he became increasingly disenchanted with Hitler, who in turn became jealous of Rommel's growing popularity. On October 14, 1944, Hitler dispatched two German generals to Rommel's home. After allowing him to say goodbye to his wife and son, the generals forced him to commit suicide by cyanide pill.

SECURING THE CHÂTEAUX
OF THE ÎLE-DE-FRANCE

Although the dangers to these palaces from Allied occupation were potentially immeasurable, the actual damage was slight. The châteaux of the Île-de-France that dot the countryside for a 50-mile radius around Paris were far less fortunate. Unlike the châteaux of the Loire, these castles were little known before the war. They either were occupied by the descendants of the nobility or had passed into the hands of individuals with newly acquired wealth. Obviously it would have been impossible to inspect these buildings each time new troops arrived in the area. There were too many châteaux for such close checking, and troop movements were too frequent. I had to prepare a blanket plan that would serve for all of the castles. I prepared a list of the most important châteaux from information submitted by the Beaux-Arts officials, the Demeure Historique,[6] and several other societies and competent individuals. Letters were then sent to the owners of these châteaux. In the letter the unit was requested to notify our headquarters of the military necessity for using the château. In general, any building over 100 years old could be protected as a historic monument, and those containing rare works of art could fall into a similar category and be placed off-limits to Allied military personnel.

A great many of these châteaux had been used by the Germans as military installations. In spite of this, our bombers and artillery had done comparatively little damage to them. In the Department of Seine-et-Oise alone, the Germans had requisitioned 8,000 properties, including castles and villas. In the adjoining Department of Seine-et-Marne, 1,200 claims were received by the French authorities six months after the Germans had departed.

Arrangements at the Château de La Roche-Guyon

The damage to the Château de La Roche-Guyon was widespread and serious. In a progress report on French châteaux, dated January 12–February 15, 1941, the German Kunstschutz (Art "Protection" Squad) stated, "Only at La Roche-Guyon had damage worth considering been caused owing to the blowing up of the Seine bridge opposite the château by French troops."[7] The buildings, dating from the 13th through the 18th century, with a fine library and handsome tapestries and furnishings, suffered even more severely when the castle was again subjected to war damage. This was in 1944 when our planes scored several direct hits. The embittered residents of the adjoining village, which was hit hard during this same raid, claimed that the Germans had left their headquarters a few hours before the bombing.

If that was so, our intelligence had no inkling of it. The owner of the château, the duc de La Roche-Guyon,[8] had been imprisoned primarily for his involvement with the French fleet. His wife and children assisted me in moving their undamaged possessions to rooms where ceilings of-

fered some protection from the elements. They welcomed the suggestion of having their best things classified by the Beaux-Arts so that we could expedite the badly needed restorations of the roofs and make temporary enclosures for the windows. During the German occupation the château's chapel had been used as a storage place for the finest tapestries and tapestried chairs. It was very damp and mildew was beginning to add its debilitating effects to the other damages already suffered.

The Château de Villette

About 2,000 Germans had taken shelter in the woods near the Château de Villette, the home of Robert Gérard. We bombed the area on August 27, 1944, and damaged the chapel and the orangerie. Stores of ammunition, gasoline, and abandoned vehicles evidenced the Germans' haste in leaving the area. This château was said to have been the residence of Lafayette, and if I correctly recall a plaque I saw in the chapel, he was married there.[9]

Along the rivers, such as the Oise, Seine, and Loire, many castles were damaged or narrowly escaped damage, in spite of the fact that they were not targets for our bomber raids. They were near important bridges or other military objectives and suffered to a degree dependent upon their proximity to the targets and the accuracy of our bombardiers. The chapel of the Château de Méry-sur-Oise was damaged in this manner. The luxuriously furnished château of the comtesse de Ségur (Cécile Sorel, the great French actress)[10] narrowly escaped destruction. The Germans rarely remained behind in French châteaux as our troops advanced, and with few exceptions there was no bombing by our planes of isolated châteaux merely because they were being used for billeting troops or as headquarters. Further, I cannot recall a single instance when the Germans bombed an Allied installation in the castles around Paris, although in the Melun region there was considerable fear that the Germans, in bombing our airfields, might accidentally hit a château. It might also be said, with good cause, that the German air force had been weakened by this time to the extent that they had neither the planes nor the bombs to attack any but the most vital targets.

The Pavilion at the Château de Louveciennes

The Germans blew up an ammunition barge on the Seine, and in the ensuing blast, the pavilion at the Château de Louveciennes,[11] which had been given to Madame du Barry by Louis XV,[12] lost all of its windows and had some of its woodwork damaged. The Pavillon du Barry had been restored some years before by François Coty, of the well-known perfume family, with the fondest attention to detail. In this case the French authorities refused to aid in the restoration of the pavilion. The Beaux-Arts authorities, not having been called in for advice when the rebuilding was done, now declared that the need for repairing classified national monuments was of greater interest than, as they put it, "troubling with a rich man's folly." They left it to the Coty architect to look after the Pavillon du Barry.[13]

The Château de Sully and Château de Gien

The medieval Château de Sully, where Joan of Arc had been held prisoner, has a commanding view of one of the important Loire bridges.[14] The Germans caused some destruction here when they fired at the château in 1940; our air force added to the damage when they bombed the bridge in 1944. The roofs, plaster, windows, and window frames were knocked about by the blasts. By the spring of 1945 the departmental architect was at work here and at the beautiful Château de Gien, a few miles up the river.[15] That latter château, which had been used as the local tribunal, lost its roofs when a powerful bomb blast demolished the adjacent church. Our troops billeted here did not exactly endear themselves to the French: Four amorous GIs favored several of the women from the nearby town with objects of art from the château.

The Château de Vaux-le-Vicomte

One inexplicable case of German bombing occurred at Vaux-le-Vicomte, the greatest private château in France, built for Nicolas Fouquet, finance minister for Louis XIV. In the latter part of the 19th century M. A. Sommier restored the château and reconstructed the Le Nôtre gardens with the help of the remaining elements and engravings. When Sommier died in 1908 his son, Edme, the sugar multimillionaire, continued his father's work aided by his wife. The vast 17th-century rooms were restored and refurnished with taste and an understanding of their original atmosphere.

During the occupation the Germans enjoyed the splendor of the castle, and the Sommiers, who had treated their conquerors with cold disdain, were forced to live in the servants' buildings. The Germans remained there from 1940 to 1942 and returned in 1944 for eight days. They were careful of the property and apparently took nothing away. Then, on August 27, 1944, German planes bombed the château and made several hits in the gardens. The blasts blew out the windows and made a huge rent in the Le Brun ceiling. A bomb loaded with incendiaries fortunately failed to open during its descent. It landed harmlessly a few paces from the château.

The Sommiers were provided with off-limits posters, but they said they hoped they would never have to use them. Although the protection of Vaux-le-Vicomte meant everything to them, they shared their rooms of state with Allied guests, and on occasion the quarters in which they had lived during the German occupation were put at the disposal of military visitors. Mme Sommier worked with the Red Cross at Melun. She lived frugally, making no demands for butter and meat from her tenant farmers and neighbors beyond the small accepted ration allowances.[16]

I stayed at Vaux-le-Vicomte while investigating other châteaux in the vicinity. My room was a large one, possibly as much as 30 feet square. It seemed almost as high. Fortunately, the forests of Vaux were extensive; otherwise I would have been bitterly cold during my three-day stay. In this time more wood was consumed than I had used through the entire winter in my Paris apartment. Even with this prodigal expenditure I was

not overly warm. The experience gave me an understanding of the heating problem in these old châteaux that I had never secured from reading of life on a medieval barony. It is easy to lose sight of the vast complement of servants that made the life of a grand seigneur pleasurable.

We discussed the future of French châteaux one night at dinner. In any other wartime setting the food would have seemed wonderful but here, in a room that had once been famous for the pomp and splendor of its historic receptions, it was merely adequate. These châteaux could not all become museums, though reduced household staffs and incomes were making it difficult for private owners to maintain them. Monuments officers were frequently called to explain to châteaux-burdened individuals the extreme unlikelihood that Americans would provide funds for the restoration of their buildings, as had John D. Rockefeller Jr. for Versailles and Fontainebleau after World War I. The French fine arts authorities had no idea if they would ever be able to cope with the constantly growing burden of their patrimony. Whatever their ultimate use or disposition, it was essential that damage to these buildings be avoided.[17]

The Domaine de Villarceaux

A good many châteaux were never occupied by Allied troops. In others it was found necessary to curtail or prohibit altogether the military use of the buildings. In some châteaux only certain rooms and collections were placed off-limits. The château at the Domaine de Villarceaux was one of the few that had not been ravaged during the French Revolution. The paintings by Boucher and Oudry, the handsome suites of furniture, and the old hangings and other works of art, all described in an inventory of 1797, were for the most part still intact. As a slight measure of protection, but more in the spirit of deserved recognition, I arranged to have its collections added to the official French lists of classified historic properties.[18]

The château's owner had gotten along famously with the Germans. The marquis de Villefranche and his guests hunted together on the estate, and the obliging marquis sent 60 boars to Germany as a gift. I feared that some rash, misguided Frenchman might think that setting a torch to the château would square accounts for France. The marquis, his wife, and his son, Emanuel, had been jailed at Versailles as German sympathizers the day before my arrival. This made me all the more eager to have the town crier announce to the populace the immunity of this unparalleled estate.

Though the Russians were breaking up the Junkers'[19] estates in East Prussia, it was not for us to decide whether Villarceaux should be sequestered or confiscated for the account of the French nation. Our only responsibility was to provide for its protection. The Civil Affairs program called for the maintenance of peace and order, irrespective of the title to property or its eventual disposition. To this effect all Civil Affairs officers, and, for that matter, every American soldier, were trustees of the property that came to their notice.

LOOTING BY GERMAN AND ALLIED TROOPS

Actual looting by our troops never reached any but the most meager proportions in the Paris region, but there were nonetheless some glaring cases of unnecessary wartime carelessness.[20] The total damage attributable to our troops at the 140 châteaux that I had scheduled for protection was far less than that done by the Germans. We maintained constant and unrelenting supervision of the thousands of our troops billeted in châteaux. In spite of our watchfulness, things had a way of disappearing. Several brass window handles from the Château de Wideville were appropriated. They were later tracked down and found in the possession of some of our soldiers. Three stained glass roundels,[21] objects more likely to attract the light-fingered, were stolen, and these were never recovered.

The owner of the château, comte Antoine de Chavagnac, had only recently returned from doing forced labor in Germany. He found his château despoiled of many of its treasures. The Germans had taken away a Rembrandt and other famous paintings, as well as valuable rugs and Louis XIII and XIV furniture. He agreed with me that there was little likelihood of further harm resulting from the use by a civil censorship detachment of the now-barren paneled rooms and their ornate ceilings and fireplaces.

We had been told that the Germans took only Jewish properties in France. This was not true, as we learned again and again. Though the property of Jews was taken more methodically, and suffered less on this account since it was usually handled by either experts or self-styled experts, many treasures were looted by individuals from more than 25 châteaux I could mention. These castles are among the hundred finest in the Île-de-France, and here none of the Nazi race theories could be applied. Such famous châteaux as those of Fleury-en-Bière, Chamarande, Courances, Champlâtreux, and Dampierre all suffered from looting while under German domination. Neuville, La Doutre at Ozoir-la-Ferrière, Voisins-le-Bretonneux, and other smaller châteaux were subjected to more thoroughgoing looting than the larger, better-known residences. Even the Château de Nemours with its public museum lost five of its seven tapestries under Kunstschutz observation. These small-scale but cumulative lootings are neither so well recorded nor so publicized as the removal of the Italian faiences, 59 cases of rare books, important paintings, and other objects from the colossal Château de Ferrières of Édouard de Rothschild.[22]

The confiscation of the Château de Ferrières was conducted under the observation of Dr. Zeitschel,[23] adviser to the German embassy in Paris, before the Einsatzstab Reichsleiter Rosenberg (ERR) was in full swing.[24]

It is doubtful there ever will be anything approaching a complete reckoning of these confiscations. Only in the instance of objects easily identifiable or of outstanding importance or value is there any hope of an accurate tabulation and accounting. Volume 2 alone of *Répertoire des*

ABOVE
Some 5,000 American troops on their way to the front were billeted in tents and farm buidings at the Château de Chamarande, which was designed by François Mansart. The castle itself was used as administration headquarters by the Allies.

RIGHT TOP
U.S. Army tents outside the Rothschilds' Château de Ferrières. In 1944 the GIs found it as cold as it is said to have been in Valley Forge during the Revolutionary War.

RIGHT BOTTOM
Inside the Rothschild mansion, after German troops had fled, U.S. Army officers decorated the 18th-century salon for Christmas, 1944. The sign on the wall announces: "Club will be vacated at 24:00 hours, by order of the Commanding Officer."

FOLLOWING SPREAD
After the war, the Rothschild mansion remained empty until it was reacquired and restored by members of the Rothschild family in 1959. After hosting friends and celebrity guests for a number of years, including Brigitte Bardot, Grace Kelly, and Audrey Hepburn, the family donated the property to the University of Paris. It now houses a cooking school and two restaurants.

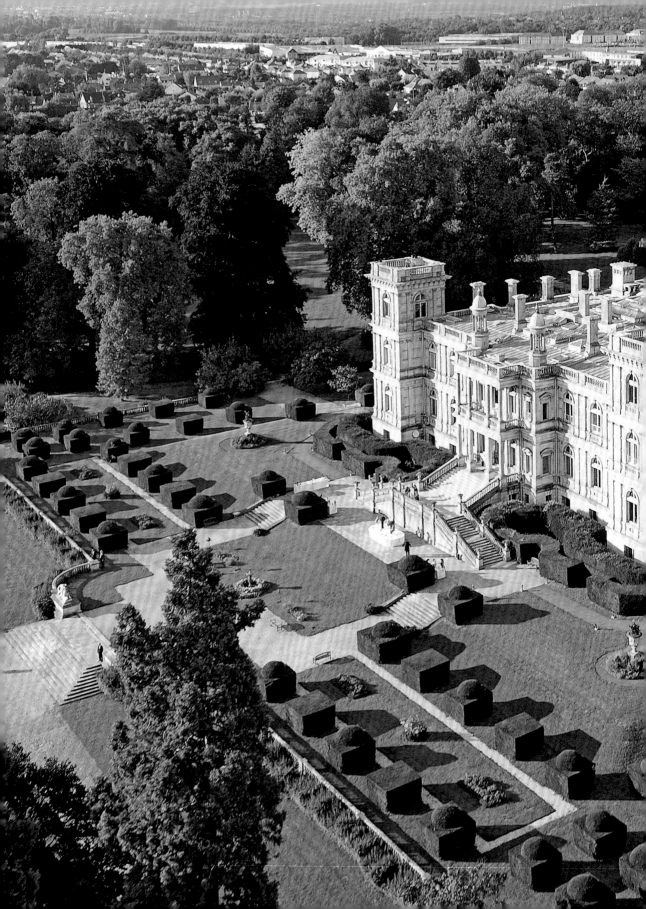

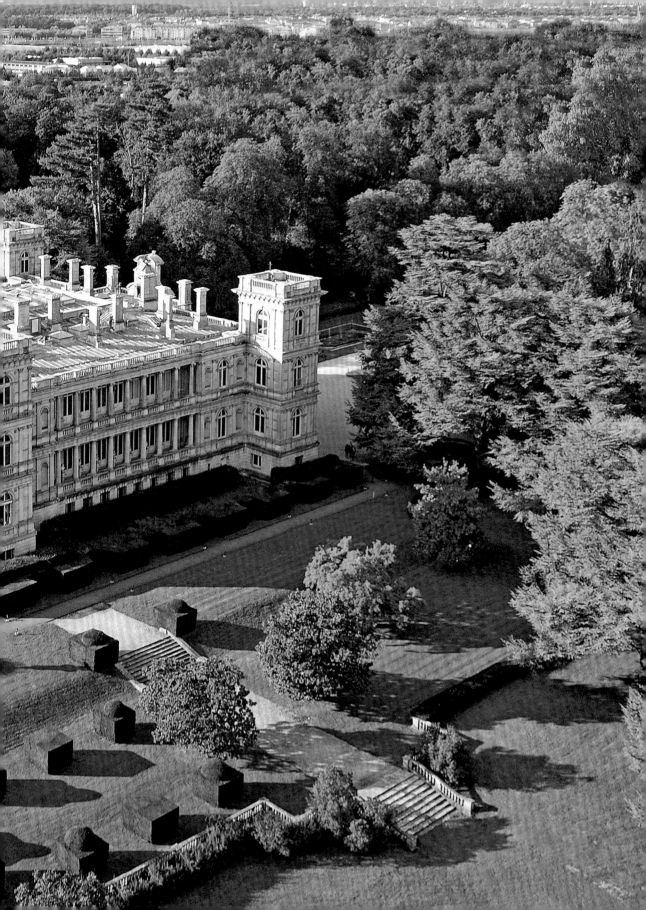

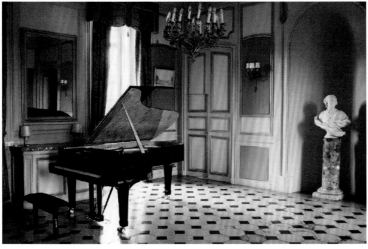

TOP AND RIGHT
When the Germans retreated from Château de Neuville, the castle of the Marquis de Labriffe, a GI trucking unit set up its kitchen in the dining room. To make room for the kitchen, GIs piled china and heirlooms in a closet.

ABOVE
The Château de Neuville has been restored by the descendants of the Marquis de Labriffe and functions today as an event venue.

biens spoliés en France durant la guerre, 1939–1945, published in four languages by the French army in Berlin in December 1947 (illustrated), lists 8,470 pictures and drawings, 423 tapestries, 634 marble sculptures, 1,096 bronzes, and other artworks not recovered by that time.

The Château de Frémigny

Only once did I see French property owners really incensed by the American use of a place that the Germans had previously occupied. M. and Mme André Homberg were the owners of the Château de Frémigny[25] at Bouray, which was used for billeting troops who kept coming and going in a vast stream. The owners said the Allied troops had done more damage to the château in two months than the Germans had done in four years. The local secretary at the mayor's office was convinced that their claims were exaggerated. We visited the château together. Unfortunately, there had been no exaggeration in the owners' claims of damage. The shutters, shelves from the bookcases in the library, doors, and other woodwork in this château, which had been built in 1803 for the later comte de Montholon, a Napoleonic general,[26] had been ripped out and burned for firewood. The fires had been so carelessly built that the fireplaces were damaged and the chimneys would have to be replaced. Paintings by Prud'hon[27] and some 18th-century Dutch paintings from King Louis of Holland were desecrated.

The Château de Dampierre

I reveal no confidences in writing of these matters. The French know them only too well and have made their justifiable claims. They recorded the results of German and Allied willful destruction, often with painstaking attention to even the most minute details. The secretary of the duc de Luynes gave me a copy of a 62-page report of German looting and vandalism at the Château de Dampierre, and the caretaker spent an entire evening giving me additional details. Dampierre, begun in 1550, was completed late in the 17th century by the son-in-law of Colbert,[28] Charles Honoré d'Albert de Luynes, duc de Chevreuse. Its fame as one of the most splendid examples of the work of Mansart, with gardens and park by Le Nôtre, had little if any meaning to most of the 300 men and officers of the two air corps trucking companies who had established themselves in the castle following the German example. The Germans had left the château in an atrocious condition. They had installed a bar in front of the celebrated Ingres *Golden Age* in the main salon. No other bar in history ever had a mural such as this for a background.[29]

Dampierre, one of the chief places on the Official List of Protected Monuments, had been occupied without proper authority. It was no place for a trucking company headquarters, or for that matter any other kind of army installation. Nails to support personal equipment had been driven into the rare paneled walls. The GI kitchen in particular disturbed me. It had been placed in the loggia underneath a wing of the castle where one of the most important libraries in France had been housed for generations. (The Germans had taken some of the Bossuet[30]

papers from the library and used them as field expedients to take the place of the softer, more affordable commercial product they lacked. The letters were salvaged and cleaned by the caretaker and returned to the library.) If a fire had ever broken out in the improvised kitchen, which was not unlikely, this timbered construction might well have been completely consumed. When the duc de Luynes returned from South America, he asked me if I could arrange for a "group of senior officers or some exclusive Allied unit to take possession of the château at Dampierre so as to protect the castle from the seething communism in the neighborhood." I referred the suggestion to the French authorities and advised that all the necessary precautions be taken to protect this shrine from future depredations. The Bibliothèque Nationale librarians agreed that the French historical records in the Dampierre library should come under more adequate government supervision than they had thus far. Our units were ordered to leave the premises. They were permitted to move into a more modern château, which, if it could not be expected to match Dampierre's luxurious artistic appointments, was far more comfortable.

The Château des Boulayes

An American quartermaster trucking company[31] with 7 officers, 140 men, and 20 German prisoners of war to do the chores pulled in late on a rain-soaked night at the 18th-century Château des Boulayes. The antique furniture was haphazardly stacked in one room and used as laundry racks. The old paneled rooms were converted into dormitories. The fine paintings and sculptures were charitably left in their places, but every variety of equipment was hung and stacked around them. Outdoors, the unit's enormous trucks and gasoline tankers sank deeper and deeper into the turf.

The Château de Chamerolles

I had hoped that the Château de Chamerolles, near Chilleurs-aux-Bois, a picturesque and well-known towered medieval castle, would profit from its remote location in a farming district of the Loiret Department. When I arrived there, M. and Mme Gaston Jessé Curély trudged wearily across the courtyard to inquire the purpose of my visit. These two old people had suffered. The Germans had dispossessed them in June 1940, driving them out of the home that for 30 years they had been gradually restoring to its original state.

The Curélys were too disheartened and tired to attempt the seeming impossibility of ever putting their home in order. They left undisturbed the emptied wine bottles and overturned furniture, the fragments of works of art, the battered furnishings, partly packed trunks, and German rations. They could well have used the rations, but they were too proud to touch them. They roamed the countryside seeking food. The Germans had carted off 1,700 paintings and drawings, 147 oriental rugs—some dating back to the 16th century—17th- and 18th-century tapestries, and untold amounts of rare silver. It seemed unthinkable that a former ambassador from France to other lands, who had rendered

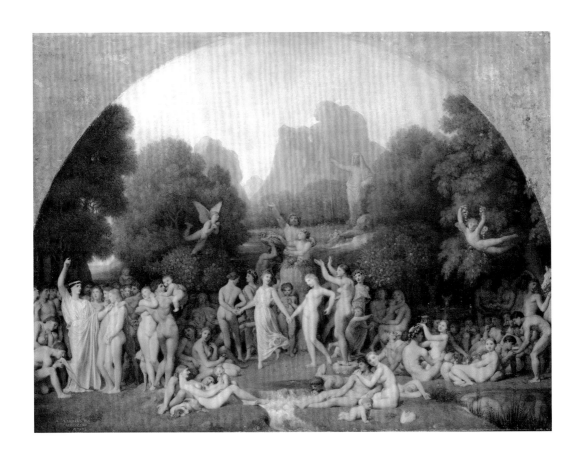

Jean-Auguste-
Dominique Ingres,
The Golden Age, 1862.
Harvard Art Museums/
Fogg Museum. The
original frescoes can be
seen today in the music
room of the Château
de Dampierre. This is a
smaller version, created
by Ingres, of the
original *Golden Age*
fresco; the figures are
in poses reminiscent
of Raphael's famous
frescoes in the Vatican.

his country and civilization distinguished service, should be living in this manner. It was within my power at least to record this destruction.[32]

Other Severely Damaged Châteaux

Other châteaux were similarly mistreated by the Germans, and their listing here would be repetitious. Many of our troops were careless; few had any appreciation of the value of their surroundings. But their conduct, however bad, did not have the characteristic brutality of the Germans. At Rentilly the Germans deliberately set fire to the great modern château of Jacques Meunier, the chocolate king. On the same day they burned a considerable portion of the neighboring Château de Crosissy-Beaubourg, which had been built in the 17th century for Colbert, the famed financier. Nothing remained of the paneled rooms and works of art.

Princess Murat had some four-year visitors who established themselves in her elegant Château de Rocquencourt, near Versailles. The farm buildings were thought to house a secret laboratory or some other restricted scientific works. When the Germans were about to leave on August 20, three huge explosions rocked the château. All of the shutters, windows, and window frames were either damaged or destroyed. The entrance walls collapsed, as well as the garden house where valuable furnishings had been stored. Thirty 18th-century clocks, fine furniture, candlesticks and candelabra, Greek vases, old prints, and a marble bust by Bartolini[33] were rescued by the caretaker and his wife, whose home across the street had been entirely wrecked.

This was not the end of Rocquencourt's mutilation. There were three or four pilfering expeditions from a Russian displaced persons camp in the district. I took photographs of the vandals taking remnants of woodwork from the neighboring Château de Beauregard. Putting the matter before the general heading the Russian mission to France netted me no satisfaction. "Not our Russians," he said, spreading his hands blandly.

The Germans used all the floors, the paneled walls, and most of the antique furniture in the handsome 18th-century Château de Pomponne for firewood. Only a few sticks of furniture that had been tossed into the stable gave evidence of the quality of what had been destroyed.[34]

There is no limit to the sad record that could be made of the wanton destruction perpetrated by the Germans, destruction that cannot be justified by any excuse of ignorance, necessity, or ambition. It was these same châteaux of the Île-de-France that Dr. Franz Albrecht Medicus[35] had in mind when he wrote the following in 1944 in his book *Schlösser in Frankreich* (*Castles in Germany*): "The historic monuments, that are holy to the French, stand near to the German heart. . . . The German soldier today stands before the French castles without bitterness, and is inspired with wonderment and awe by their strength, their individuality and their beauty."

TOP
The tranquil exterior of the château at Chamerolles gave no indication of the Nazi vandalism found in its sumptuous rooms.

BOTTOM
An interior room at Chamerolles after the Nazis fled.

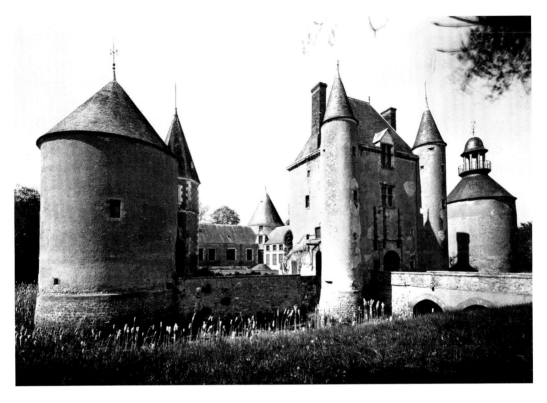

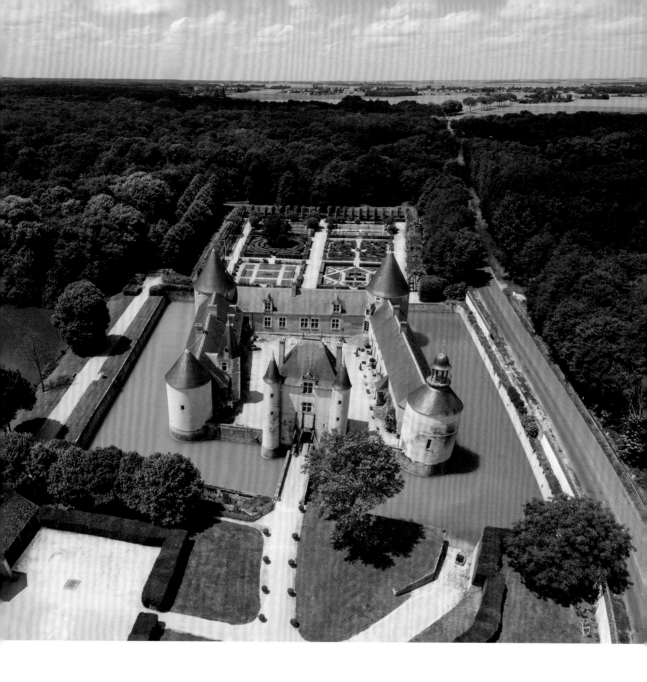

The château at
Chamerolles was
restored beginning
in 1988. Today it is
surrounded by elegant
Renaissance gardens
and houses a museum
dedicated to the
history of perfume.

NOTES

1 Twelfth U.S. Army Group, commanded by General Omar Bradley, was the largest U.S. Army formation ever to take the field. The group included the First U.S. Army, which formed the western wing of the Allied lines in Normandy. At the time in question Twelfth Army Group came under the overall command of General Dwight D. Eisenhower, as commander of Allied land forces in Europe.

2 Paul-Louis Weiller (1893–1993) was a French industrialist and philanthropist from an Alsatian Jewish family who had been arrested in 1940. He managed to escape to Canada, but his mother died in Auschwitz in 1944. He was one of the founders of the French airline that later became Air France.

3 The chief administrative officer in a town or city under military government.

4 Brigadier General Rogers was head of Seine Section, to which the author was attached.

5 General Benjamin "Yoo-Hoo" Lear (1879–1966) was a distinguished, long-serving career soldier, who was responsible for training large numbers of U.S. troops in World War II. Known as a strict disciplinarian, he became a nationally recognized figure in 1941 through the incident in which he earned his nickname. He had been playing golf outside the base near Memphis when soldiers in a truck convoy returning from the field spotted a group of women golfers. The men in the front trucks took to "yoo-hooing" and bantering with the ladies while jeering at the general, whom they failed to recognize in his golf knickers and kneesocks. When Lear ordered the entire convoy to return immediately to the field for a 15-mile march, his harsh discipline erupted into a national controversy. His commanding officer's call for his retirement fueled the controversy: his CO happened to have a cousin in Washington who was then senator, and later president, Harry S. Truman. Lear survived the controversy, but the nickname stuck.

6 La Demeure Historique is a French association responsible for private historic monuments.

7 Field Marshal Erwin Rommel (1891–1944) had used the Château de La Roche-Guyon as his headquarters in the German defense of Normandy. See also page 139.

8 Probably Gilbert de La Rochefoucauld, duc de La Roche-Guyon.

9 The author was perhaps remembering a plaque recording that the marquis de Lafayette was a witness to the celebrated nuptials of Sophie de Grouchy and Nicolas de Caritat, marquis de Condorcet, in the chapel of Château Villette. The château has since become available as a luxury vacation rental and was featured in the 2006 movie *The Da Vinci Code*.

10 Cécile Sorel (1873–1966) was a flamboyant, enduring comic actress, whose career extended between the world wars and beyond. She specialized in the stock part of the "grande coquette" at the Comédie Francaise and was known for her elaborate costumes.

11 The Château de Louveciennes originally lacked a view of the Seine. The separate pavilion was added in 1771 to afford such a view. By 1923, however, erosion of the riverbank had made it necessary for the architect to move the entire pavilion back a few yards, but evidently not far enough to avoid the blast from destruction of the bridge.

12 Madame du Barry, born Jeanne Bécu (1743–1793), was the last official mistress of King Louis XV. After his death she retired to Louveciennes but was later arrested and executed in 1793 during the French Revolution.

13 It has been reported that Crown Prince Mohammed bin Salman of Saudi Arabia rebuilt one of the grand homes near the pavilion at Louveciennes at a cost of $300 million in 2015. See Nicholas Kulish and Michael Forsythe, "World's Most Expensive Home? Another Bauble for a Saudi Prince," *New York Times*, December 16, 2017 (online edition).

14 The Château de Sully-sur-Loire has been partially restored and is now open to the public.

[15] Château de Gien was acquired by the French government and now houses a museum of hunting artifacts dating from the Middle Ages to the present.

[16] Mme Sommier (1881–1968) was born Germaine Casimir-Périer. She was the daughter of Jean (1847–1907) and Hélène (1854–1912) Casimir-Périer, who were briefly president and first lady of France in 1894–95.

[17] Descendants of the Sommiers continued to own Vaux-le-Vicomte after the war. Although privately owned, it has been designated a "monument historique" and is open to the public.

[18] Perhaps the most famous resident of the Domaine de Villarceaux was Françoise d'Aubigné (1635–1719), better known as Madame de Maintenon, who became the morganatic wife of Louis XIV of France around 1683 and grew to be a powerful figure at his court.

[19] Members of the nobility in Prussia, known as Junkers, owned vast estates across the region, mostly in the countryside. The most famous Junker was Chancellor Otto von Bismarck. After World War II, Junkers in the eastern provinces fled or were expelled from their land by the incoming Polish and Soviet regimes.

[20] In contrast, Chapter 9 documents extensive looting by both U.S. and German troops later in the war in Germany.

[21] Small round windows.

[22] See Chapter 6 for additional information about the fate of the Rothschild collections.

[23] Carltheo (Karl Theodor) Zeitschel (1893–1945?), a member of the Wehrmacht (armed forces) and SS. After the fall of Paris, he managed the Jewish Affairs desk at the German embassy, taking charge of many confiscated collections.

[24] The notorious Einsatzstab Reichsleiter Rosenberg (ERR) was dedicated to looting cultural property. See also Chapter 6 and page 46.

[25] The Château de Fromigny (today's preferred spelling is Frémigny) was fully renovated in 2012 and now serves as a corporate conference center.

[26] Charles Tristan, marquis de Montholon, was made a count in 1809 and was sent into exile with Napoleon Bonaparte on the island of St. Helena after serving as one of his generals in several campaigns. Some historians believe that he poisoned Napoleon with arsenic. See Ben Weider and Sten Forshufvud, *Assassination at St. Helena Revisited* (New York: John Wiley & Sons, 1995).

[27] Pierre-Paul Prud'hon (1758–1823) was a French painter of allegories and portraits who was particularly popular with the court of Napoleon.

[28] Jean-Baptiste Colbert served as minister of finance to Louis XIV from 1665 to 1683. He sought to develop the French economy by raising tariffs and encouraging public works. Although his measures have generally been considered effective by historians, they were not sufficient to keep up with the extravagant level of King Louis's military expenditures. Colbert is sometimes credited with the oft-quoted witticism that "the art of taxation consists in so plucking the goose as to obtain the largest amount of feathers with the least possible amount of hissing."

[29] The frescoes at the Château de Dampierre (before 1878) have survived and can be seen today in the music room of the château.

[30] Jacques-Benigne Bossuet (1627–1704) was court preacher to Louis XIV and was an eloquent supporter of the divine right of kings. He was considered one of the greatest orators of all time.

[31] The U.S. Army Quartermaster Corps is generally responsible for supplying food, transportation, and other necessities to troops on campaign.

[32] The Château de Chamerolles changed hands several times in the postwar period and

fell into serious disrepair. In 1987 the French government came to its rescue. It was elegantly restored as one of the nation's Monuments Historiques between 1988 and 1992. In addition to the castle and gardens, it now houses a museum dedicated to perfume.

[33] The Italian sculptor Lorenzo Bartolini (1777–1850), who produced several busts for the imperial house of Bonaparte. The last owner of the Château de Rocquencourt, Cécile Ney, Princess Murat, was distantly related to Napoleon: her ancestor, Joachim Murat, was one of Napoleon's generals and married the emperor's sister Caroline Bonaparte. The château has not been rebuilt.

[34] Partial walls and towers of the Château de Pomponne survive as a picturesque ruin.

[35] Medicus was a German lawyer who joined the SS early on. The SS (an abbreviation for Schutzstaffel or "Protection Squad") was the Nazis' primary security organization, which, among other activities, was directly involved with carrying out the Holocaust. Medicus held various administrative positions within the Nazi Party organization. In 1935 he co-authored the infamous Nuremberg Race Laws. In 1942 he served as a military official in the Paris region, where he controlled the disposition of properties seized by the Nazis. See Charles Glass, *Americans in Paris: Life and Death under Nazi Occupation* (New York: Penguin Books, 2010).

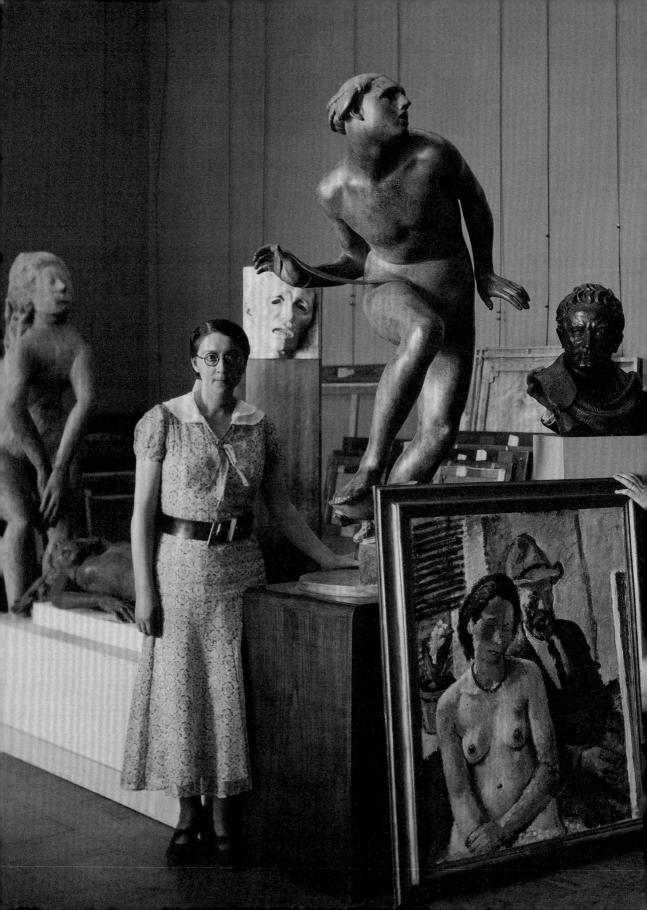

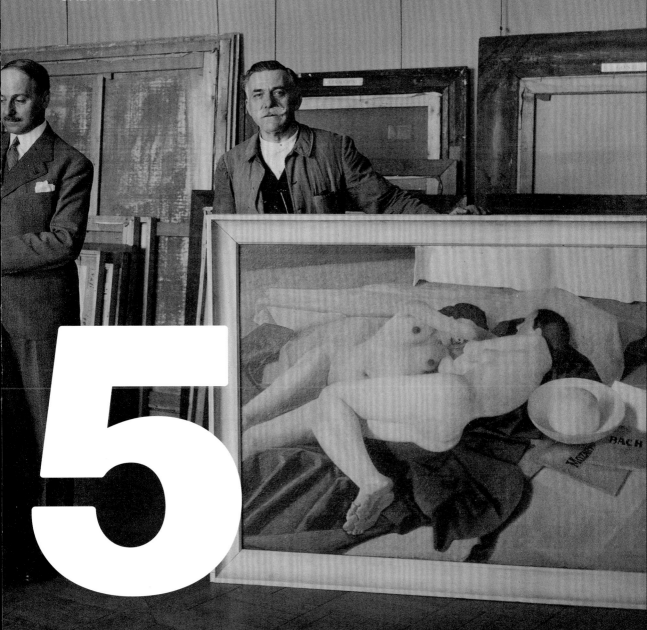

Art
Underground

TRACING STOLEN ART FROM PARIS TO THE
SALT MINES OF SOUTHERN GERMANY

5

MINES USED TO STORE ART, 1944–45

Area in Red is Territory Claimed by the Nazis

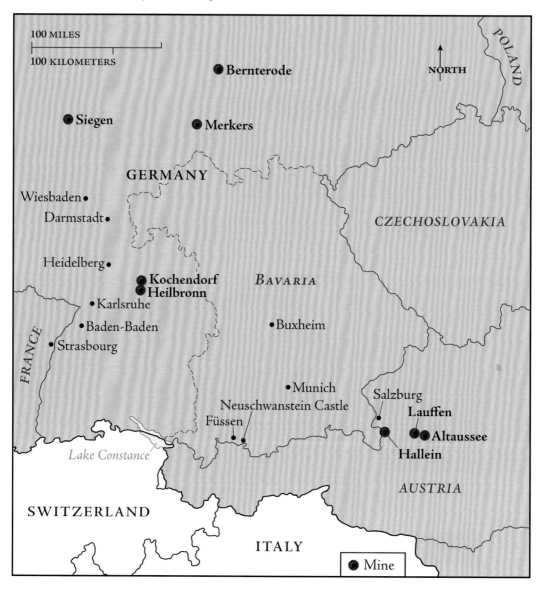

100 MILES

100 KILOMETERS

NORTH

POLAND

● Bernterode

● Siegen

● Merkers

GERMANY

Wiesbaden●

Darmstadt●

CZECHOSLOVAKIA

Heidelberg●

● Kochendorf
● Heilbronn

BAVARIA

● Karlsruhe

● Baden-Baden

● Buxheim

FRANCE

● Strasbourg

● Munich

Salzburg

Neuschwanstein Castle

Lauffen

Füssen ●

● ● Altaussee

Hallein

Lake Constance

SWITZERLAND

AUSTRIA

ITALY

● Mine

PREVIOUS SPREAD
Rose Valland with, it
is believed, André
Dézarrois (center),
then curator of the Jeu
de Paume, and a guard,
during installation of
works for the 1935
exhibition *Italian Art*.

Cue magazine (July 5, 1947) quoted the author, after he returned from the war, as saying, "We started out to preserve monuments and to promote better relations. We ended up catching thieves and their loot." This chapter documents the author's transition from cultural emissary to detective and follows his steps toward tracking down and preserving art stolen by the Nazis.

ROSE VALLAND

Although my main purpose in Paris was to preserve buildings and to protect them and their collections from further abuse, it became increasingly apparent that I was in a position to gather intelligence for future operations in Germany in the course of doing my job. The one person who, above all others, enabled us to track down the official Nazi art looters and to engage intelligently in that aspect of the whole picture was Mademoiselle Rose Valland, a rugged, painstaking, and deliberate scholar.

This young woman was an assistant at the Jeu de Paume when the Germans arrived and converted the building into the central clearinghouse for the finest of the confiscated works of art. She told me that judging from what she had observed, the Germans had taken one-third of the privately owned art from France. Throughout the war, and in the absence of the director, she stayed at her post in the museum. Time and time again the Germans tried to discourage her presence. She was led to the door with a frequency that bordered on the comic, but each time she disregarded their orders and returned to the museum. Her blind devotion to French art made no allowance for any thoughts of personal danger.

Valland's Reluctance to Share Her Records of German Looting
She had risked her life many times over as a member of the resistance to secure the information she possessed, and it was no easy matter now to win her confidence. She would trust no one with the data, including the French. Lieutenant Colonel McDonnell[1] and some of Rose Valland's French friends were beginning to mistrust her vague hintings of concealed knowledge and wonder if she really knew as much as she claimed. The president of the Commission de Récupération Artistique, however, was willing that I attempt to secure the information for the Allies that Rose Valland professed to possess. One of the enticing leads she dangled was her statement that she had recorded Goering's 20 visits to the Jeu de Paume to make selections of works of art for his private collection. She had, she claimed, much more information about the visits of other high-ranking Nazis.

Locating the Art Train
Early in August 1944, while the Germans were still in Paris and gathering up the last of their loot, Mlle Valland notified members of the resistance that 51 railway boxcars had been loaded for shipment to Germany. The train was shunted about from siding to siding on one pretext or another

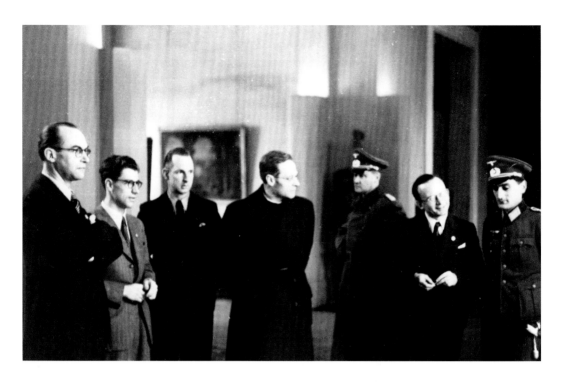

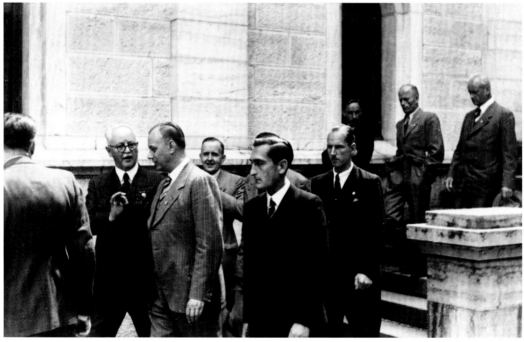

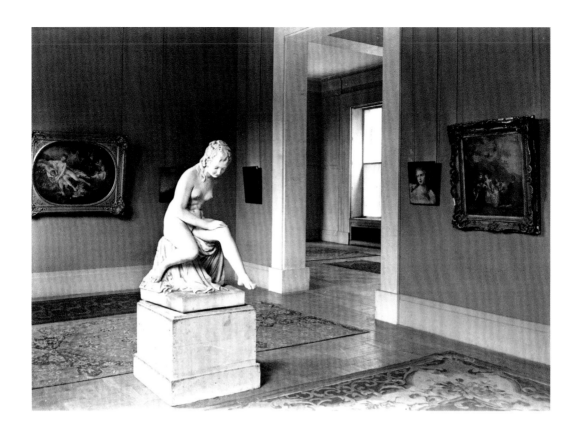

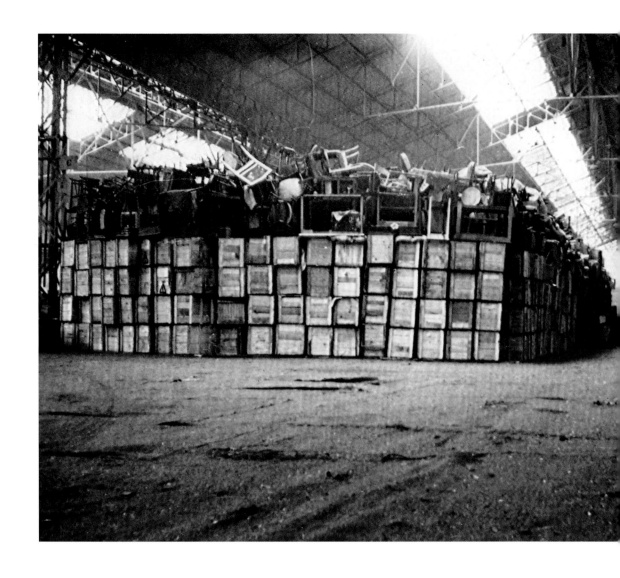

This photo, taken by
the author, shows
hundreds of crates
holding belongings that
had been confiscated
by the Nazis from
Jewish families. They
were found by Allies in
46 boxcars on a train
destined for Germany.

and never left the vicinity of Paris. The five cars that contained the best objects were unloaded in September, immediately after the liberation, and their contents were taken to the Jeu de Paume. Included were Picassos, Braque, and many other modern paintings—more than a thousand in all—as well as rugs, tapestries, furniture, sculpture, and rare books. When I heard that the other 46 cars were still standing unloaded in a freight yard, Rose Valland and I first started to work together.[2]

With the help of the stationmaster who had originally delayed the train, we followed its circuitous route from one small suburban station to another. After locating the train in a freight yard just outside of Paris, we checked the contents of the cars. They were mostly pots and pans, household furniture, and bric-a-brac. These were turned over to the Administration des Domaines, a section of the French Ministry of Finance.

Though this hunt had been time-consuming and unrewarding from an art standpoint, it was worthwhile in that it proved conclusively that Valland's records were accurate since she had known by number which of the cars contained the most valuable property. If she had similar information, gleaned during the Germans' stay at the Louvre and the Jeu de Paume, our task in Germany would be considerably simplified. But how could the information be extracted from Valland, unless she willingly handed it over?

A Bottle of Champagne

Just before Christmas I received a bottle of champagne from Mlle Valland. It was the first sign that there was a possibility that she might release to me the information we needed. We had many American friends in common, and she seemed to be gaining confidence in my expressed desire to help France. She wanted to appear a woman of shifting moods—at one moment difficult, scheming, making good use of all the feminine wiles and subterfuges—but at all times her absolute integrity and her devotion to France were only too obvious. She withheld her information because she feared that it might fall into the wrong hands, and she delayed turning it over to us on that account. When she agreed to come to my apartment a few nights later, I thought that I had at last convinced her that I would use her information only as she wished it used—in France's interest.[3]

In the best cloak-and-dagger tradition I uncorked the bottle of champagne and we drank a toast to the success of our mission. Valland became a little more expansive and told me how she had copied the Germans' lists of the treasures they had exported. At night she would sneak out the negatives that the Germans had developed during the day. She had prints made and then returned the negatives to the files the following morning.[4] With imprisonment in a concentration camp, or death, the penalty if she were caught, she had been fortunate. Even the watchman's logbook, which had the names of all the visitors to the Jeu de Paume for more than a four-year period, had come into her possession. She would not, however, show me the lists and the photographs. She was not convinced that I should be trusted with all her secrets.

One night she asked me to her apartment, and I wondered as I cycled along the cobbled streets past the Cluny Museum, the Sorbonne, and up the long hill to a part of Paris little known to most tourists, how this game of cat and mouse would finally end. The apartment building was near the Halles aux Vins, where there had been a serious fire on the night of August 26, when the Germans had bombed Paris. I locked my bicycle in the hallway, pressed the button on my flashlight, and started up the stairs. Rose had warned me that I would have to climb several flights. It was a lonely, secluded place, and if the Gestapo had had any idea that Rose was a member of the resistance it would have been very easy for them to cart her off at any time without anyone being the wiser.

There was a soft glow in the fireplace, and the only other light in the apartment was a dim one. There were a few flowers in a vase on the coffee table. Nearby there were a bottle of cognac, some small cakes she had just made, and a pack of American cigarettes. She had become a chain smoker since the occupation, and our arrival only increased her opportunity to secure more than her usual quota. Whenever I gave her a cigarette, she would smile, quote the fantastic price she had paid for her last pack, and say, "It's funny, James. I have no scruples when it comes to taking cigarettes. They're no good for me; they make me cough. I know it's a vice, but if I can smoke, nothing else except my work matters." Then she would shrug her shoulders, with the particular expressiveness that the French impart to this gesture.

We spoke about the American army and the fact that the British outranked us,[5] about the meanness and cupidity of certain small fry who had come to occupy positions of importance and trust in the new government, of the effect of the Nazi occupation on many of the French. She was a long time in getting to the main purpose of this meeting.

Suddenly, the pleasantries, if they can be called that, were finished. "You must go to Germany, James," she said. "I'll join you as soon as I can, but you must go right away."

I hadn't counted on this. What would I do with Rose Valland at the front if my assignment to Seventh Army, which was nebulous at best, did materialize?[6] And where did she learn that there was any possibility that I might be going? I later realized that if she did have some idea about the chance of my going to Germany, then she must have secured it from a British intelligence officer who came to stay with me for one night and lingered for two weeks more, like *The Man Who Came to Dinner*.[7] Rose had spoken to him on several occasions, and I suppose that I had mentioned to him that I might go to Germany.

I explained to her that the American, British, and French armies were under a unified command and that she must give her information to Supreme Headquarters through the Mission to France. Only in this way could any unit, when it arrived at a place where there was a target, be informed from the top down through channels.

"Channels?" she questioned heatedly. "I call it bureaucracy. It is nothing more than wheels within wheels. Inefficiency. One fellow is thickheaded and smug, and *poof* . . . nothing happens."

She went into her bedroom and came back a moment later with a stack of photographs and bundles of neatly arranged papers. She showed me photographs of Reichsleiter Alfred Rosenberg, the editor of the *Völkischer Beobachter*[8] in the 1920s and the powerful Nazi who was Hitler's selection as the man "to supervise the spiritual and philosophic training and education" of the Nazis. There were photographs of the Rosenberg officials—a rogues' gallery that came to life as she told me story after story of their private affairs, their public utterances, and their part in the confiscation of the French patrimony. I could not have had a better introduction to these people if I had met them at a social gathering.[9]

She delighted in telling about the vanity of the Nazis and the apple-polishing tactics of the official photographer, whose real job was to photograph the works of art in the process of being confiscated and not the high-ranking Nazis selecting them. In all his pictures the Nazis were carefully photographed; the art objects were props. I prevailed upon Rose to give copies of these photographs with appropriate descriptions to the SHAEF Mission to France so that the monuments officers with the armies could make use of them. Months later, after the cessation of hostilities, and after my real need for them had passed, I found the set prepared by the British in the SHAEF files at USFET.[10] Rose had been right all along to protect her records. Someone had ignored these invaluable pictures and simply filed them away.

Photographs of the confiscated French collections of works of art brought to the Jeu de Paume were among other valuable documents we pored over that night. There was one important question that remained unanswered: where had the works of art that were removed to Germany been secreted? Once more Rose went into the next room. She returned with photographs of the two castles near Füssen on the southern confines of Bavaria.

"In the castles of Neuschwanstein and Hohenschwangau," she said, "the Nazis have collected and catalogued their booty. There, and at Buxheim near Memmingen, will be all the records and all the works of art taken from France."

"How can you be so certain?" I asked. "You weren't in Germany."

"Trust me, James. What I tell you is based on more than a woman's intuition. Here, take these two photographs. They will show you where to find what you were asking about. I'll give this same information to SHAEF, but you must promise to go there yourself and save our treasures before the SS can destroy them."

WAITING FOR THE ALLIED ADVANCE INTO GERMANY

Staking Out the Lohse Building

Anxious as I was to get into Germany, for the moment there was little I could do to further that aim except perhaps to pray that our armies would be able to move quickly into Germany in the spring. But the trail of the Einsatzstab Reichsleiter Rosenberg (ERR) could be investigated

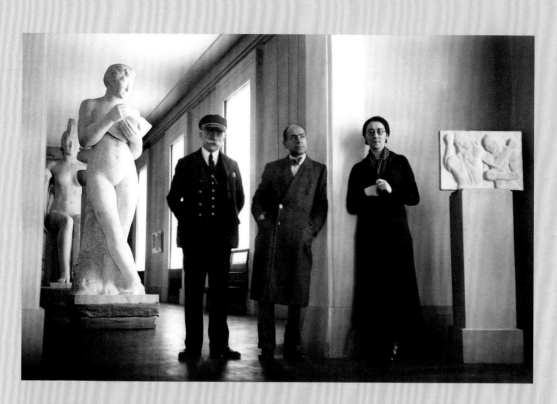

Dépôts de Füssen

Neuschwanstein à gauche.
Hohenschwangau à droite.

Souvenir amical
et nouveau assaut
Heidelberg 10 août 1945
R. Wallard

à ne pas publier.
R. Wallard

3/9/45.

Rose Valland as a student before the war.

UNDERCOVER AT THE JEU DE PAUME MUSEUM

Rose Valland joined the Jeu de Paume in Paris as a volunteer in 1932, having no idea she would eventually become the secret savior of French culture at the center of the ERR's looting operations in Paris. Throughout the Nazi occupation, she quietly observed the proceedings, reporting every few days to the director of the Louvre, Jacques Jaujard, on the confiscation, display, and disposition of the loot.

In her secret notebook, under February 8, 1944, she reveals the constant risk under which she labored and the fear that her subterfuge would be discovered: "Lengthy conversation with [Bruno] Lohse, who unfortunately surprised me in the act of trying to decipher an address. . . . Looking me straight in the eye, he announces that I could be shot. I calmly respond that anyone here would be stupid not to realize the risks he or she is facing."

Even during the days after the liberation of Paris, Valland barely escaped assault by a mob searching the museum building for Nazis and their French collaborators.

After the war, Valland devoted herself to restitution efforts in Germany, returning to Paris in 1954. She was eventually given a position at the Louvre to continue her restitution work, while also preparing plans for evacuation of artworks in the event of a future invasion. She passed away in 1980 and was laid to rest in the family vault beside her deceased partner, Dr. Joyce Helen Heer (1917–77).

Although Valland had been recognized for her valor early on when she received the French Legion of Honor in 1946, it was not until many years later that her contributions to French cultural heritage, at the daily risk of her own life, were widely acknowledged. In 2005 the French Ministry of Culture installed a commemorative plaque in her honor, which can be seen today at the Jeu de Paume.

During the war, German
art dealer Bruno Lohse
was engaged by Hermann
Goering to seek out art
for his personal collection.

further in Paris. Rose and I began inspecting the buildings that had been used by his crew. Bruno Lohse, assistant chief of staff and special Goering agent, had lived in a small apartment near the Rond-Point des Champs-Élysées.[11] When we arrived there, an FFI[12] colonel and his wife were living in the apartment. They had no information that would aid us, and the building agent, who just possibly might have known something, was painfully uncommunicative.

I had not realized before the untold ramifications of this looting business and how much easier it was to pretend ignorance of all German activities than to become involved, if one weren't already. The only lead we had was furnished by the concierge's wife, who told us that the Germans had left the building a few days before the liberation of Paris and had taken one or more truckloads of artworks with them.

That night, feeling a little bit foolish but hopeful that I might possibly turn up something of interest, I returned to the Lohse building and spent an hour in front of the entrance trying to repair my bicycle tire from which I had conveniently removed the air. No *Grand Hotel*[13] scene could have done justice to the characters who wandered in and out. In spite of this, I saw nothing that was helpful in any way. I finally gave it up as a waste of time and went back to my room.

Checking the Rosenberg Clearinghouse

Rosenberg had the clearinghouse for his paperwork in the home of Baroness Frieda von Seidlitz. The Gestapo, according to the concierge and the baroness's inscrutable secretary, had left this house on or about August 19. Now, two months later, we were apparently the first official Allied visitors. Looking for papers that might have been overlooked in the confusion of the last few hours of the ERR in Paris, I tapped 74 binders in one cabinet. All were empty except one. This binder contained a set of German High Command General Orders, which, according to SHAEF G-2 (Intelligence) Documents Section, was the first such set to come into Allied hands. They were complete up to August 24, 1944, but were not pertinent to Monuments, Fine Arts & Archives problems.

Checking Rosenberg's Staff Billets and Warehouses

In another house on this same street we visited the billets that had been occupied by members of the ERR staff. The fine works of art it had contained had been confiscated by the Nazis and the antique furniture replaced by modern pieces. The photographic laboratory was on the Place des États-Unis. A visit here was time wasted. At 54 Place d'Iéna, used by the Communication Zone's Machine Records Unit, few works of art remained in what had been a clearinghouse for the looters.

I inspected the two large garages used by the ERR for trucking and warehousing. They were empty, but in a third garage, on the Rue de Richelieu, some 10,000 books were in a pitiful state. The boxes in which they had been packed for shipment to Germany had been broken into and vandals were getting at their contents. This was now wholly a French affair. The Administration des Domaines had placed its poster

WHY DID NAZI OFFICIALS COLLECT ART?

Hitler's obsession with the purification and promotion of German culture, which came to concentrate on his grandiose plans for the Linz Museum, inspired a preoccupation with art collecting that permeated the hierarchy of the German government and the Nazi party, as well as the upper echelons of the military. The close-knit circle of officials surrounding the Führer used art to consolidate their status, indeed, many of them vied to impress him with their "good taste."

There is a myth, derived from comments by a roommate from his youth, that rejection of Hitler's drawings by a panel of Jewish judges at the Vienna Arts Academy frustrated his early attempts to become an artist. If such an event occurred, it might contribute to an understanding of the genesis of his anti-Semitic views and his later schemes to compensate for early failures. This explanation seems extraneous, given the prevailing level of anti-Semitism already existing in Germany at the end of World War I.

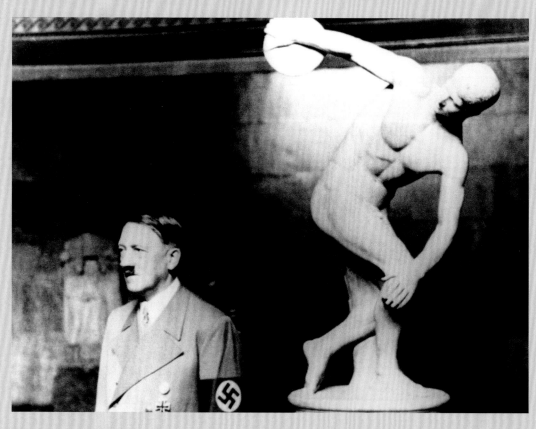

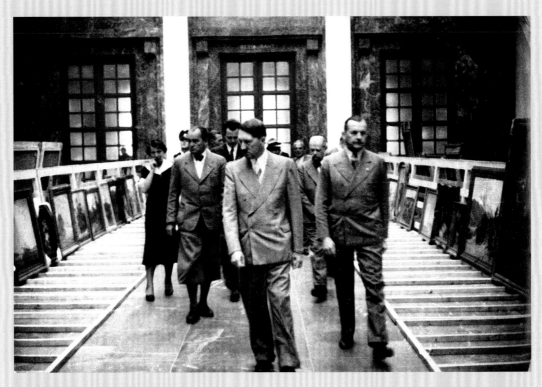

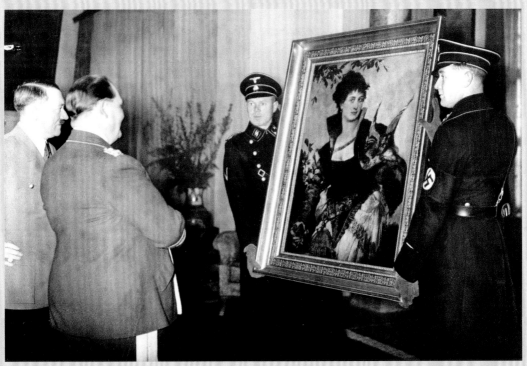

on the front of the building, the garage was being used by the Sécurité Militaire, the Ministry of War had authorized the removal of 250 pounds of books for military purposes, and the Production Industrielle claimed jurisdiction over the printed books. I bellowed and howled, to no avail, about the need for protecting these books. The best ones had been picked over by the Germans at the Library of the Alliance Israélite Universelle, where the Germans had confiscated 50,000 Jewish-owned books and documents and sent them to Frankfurt.

Still Waiting in Paris While the Allies Advance

I was impatient to follow these trails into Germany and to run down Valland's leads to the Nazi looters. We had waited in England before coming to the Continent, and in the Sarthe before forging ahead to Paris. Now that winter was at last coming to an end, I felt that the long wait for the push into Germany would be over.

By April 25, after the successful Allied crossings of the Rhine, the area under Twelfth Army Group covered almost 50,000 square miles. Only three monuments officers, with our First, Third, and Ninth Armies, were available for the staggering assignments given them. It was a challenge unique in the history of civilization to safeguard objects in this area, whether they were of German origin or they had been acquired under duress during the German occupation and would eventually have to be returned to the countries from which they had been removed by the Nazis. At the beginning of April, Seventh Army, under Sixth Army Group, did not have a monuments officer. SHAEF officials knew the Seventh Army was about to penetrate a region of Germany rich in cultural associations and containing some of the most important repositories of works of art.

AMERICAN SOLDIERS DISCOVER TREASURES IN THE MERKERS MINE

On April 7, 1945, while I was still in Paris, the news was broadcast throughout the world of the discovery of works of art, especially those that had been evacuated from the Kaiser Friedrich Museum in Berlin, in a chamber 2,100 feet below the surface in the Merkers salt mine in Thuringia, 90 miles west of Weimar. An estimated 100 tons of gold bullion valued at 84 million dollars, together with quantities of currency, were found at the same time and in the same place. It was believed that this was the bulk of the German gold reserve.

The chance character of the find added to an already breathtaking story. Apparently, a couple of German women in search of a midwife were halted by two American MPs near this salt mine. They released the women, and as they walked past the mine, one of the women said, "That's where the bullion is hidden." The gold and the artworks were then recovered.

Subsequent investigations revealed that three of the German officials in charge of the treasure were in Thuringia. Dr. Paul Ortwin Rave

A soldier, believed to be Corporal Donald Ornitz, later a photographer of celebrities in Hollywood, views *Wooded Path in Late Fall*, c. 1900, by Olof August Andreas Jernberg, that was hidden in the Kaiserode salt mine near Merkers, April 1945. The painting is now in the Alte Nationalgalerie, Berlin.

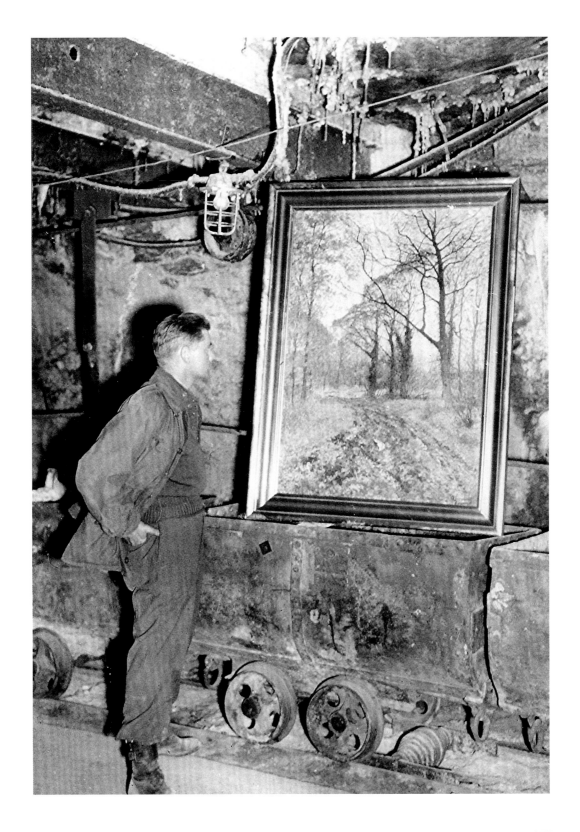

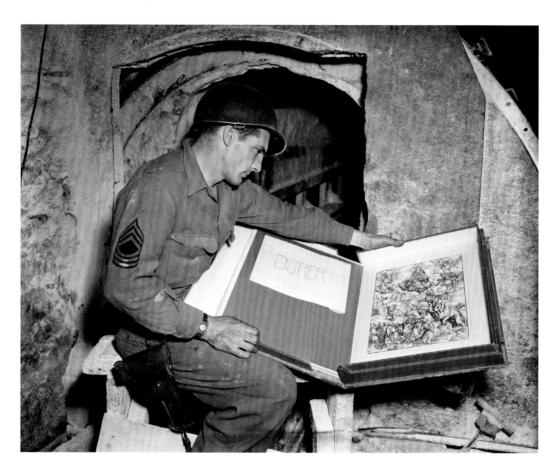

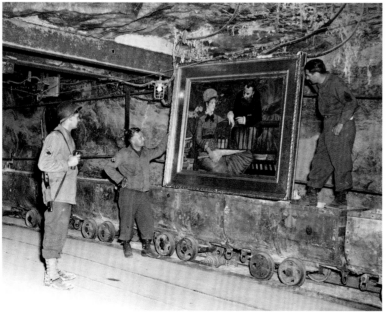

Albrecht Dürer, *The Beast with Two Horns Like a Lamb*, from the *Apocalypse* series, 1497-98. Metropolitan Museum of Art.

(1893–1962), assistant director of the Prussian State Museums, was one of the three. He stated that the gold had begun coming from Berlin on February 11, 1945, and the currency had come shortly thereafter. He also said that when he had been instructed by the minister of education, Bernhard Rust, to begin transferring art treasures from Berlin to Thuringia, he saw to it that Rust's library, tapestries, and furniture were in the first consignment.[14]

Seventh Army territory was soon to stretch from Darmstadt, Germany, in the north to Bad Ischl, Austria, in the south, a distance of some 280 miles. The average width of this area was 80 miles. Seventh Army had no monuments officer, and I was hopeful that I would be released from my Paris assignment, as had been planned in January. At the moment I was the only museum man available. Captain Walter J. Huchthausen of Ninth Army had been killed in the line of duty,[15] and several of the competent enlisted men sent over from the States had not yet been commissioned.

LEAVING PARIS

A few days after the Merkers find, which brought matters to a head, I was ordered to proceed to Seventh Army headquarters and to investigate a salt mine reported to be in Heilbronn. No one in Paris could tell me if Heilbronn had been captured or where, within a couple of hundred miles, Seventh Army had its headquarters. The railway transportation officer thought it might be in Lunéville, and he gave me a compartment on a train going in that direction. On the train moving eastward, an officer who had been in Germany just a few days before told me he had heard that the headquarters had already moved across the Rhine. This helpful, friendly lieutenant advised me to stay on the train to the end of the line at Sarrebourg, 50 miles to the east. If I clutched at straws it was because I had no alternative; there was no reliable information to be had.

Sarrebourg was the last place to which I should have gone. Not only was it the end of the line, it was a dead end as well. For several hours it appeared that I was going to end my army career sitting disconsolately in a railway car on a siding. The picture brightened when I was offered a ride in a 2 1/2-ton truck by a GI who had overheard the routing corporal telling me a little while before of the uncertainty of transportation. The driver was going to Worms, 150 miles nearer to my goal.

I didn't take any time to accept. I piled in and we were off on a nightmarish ride across battle-torn country. I eased myself out at Worms, glad to be back on steady ground. There followed a ride, a comparatively sedate one, to the military government headquarters. There, I was told with some assurance that army headquarters was south of Darmstadt, across the Rhine. The only transportation available was a charcoal-burning French truck that would leave for the area if the repairs it was undergoing could be completed before dark. The chance of spending the night rattling around in this broken-down vehicle had no appeal, and I refused the ride even though one of the military government officers,

who would have to provide quarters for me if I stayed, all but insisted that I leave with it. Not until 1:30 that morning did I find out why he had been so determined to get me on my way. A young Fräulein entered my room. She was startled to find me in the officer's twin bed.

I reached Darmstadt the next day. Lieutenant Colonel Joseph L. Canby, the G-5, told me that he had been expecting me since January, when he had concurred in a request from Sixth Army Group and SHAEF that I report to his headquarters. Canby had risen from a captain since I had seen him in England and was soon to be given the rank of full colonel. Here was a man who knew his own mind. He also knew what he expected of his small staff. Rapidly he outlined his policy concerning Monuments, Fine Arts & Archives operations with Seventh Army. Since the air corps had all but leveled Germany, and our hard-hitting ground forces were doing further damage to many already badly scarred cultural buildings in the attempt to nail down a quick victory, Canby felt that there was no point in my setting out to give first aid to these monuments. The practical move was to try to locate where the looted Allied works of art, as well as the Germans' own objects, had been stored.

THE HEILBRONN SALT MINE

Protecting the Strasbourg Stained Glass

I was particularly anxious to get to Heilbronn. We knew from captured German documents that Alsatian works of art had been sent there. An investigation conducted by marine captain Marvin Ross[16] at Strasbourg had disclosed that the stained glass windows from the Cathedral of Strasbourg had been safely stored in southern France at the outbreak of the war in the custody of the prefect of the Department of Dordogne. In May 1944, the Germans had insisted that the glass be returned to Strasbourg, so that they could prepare it for shipment to Germany in the event of an Allied victory. On November 22 of that year, two truckloads containing 73 cases of the choicest stained glass were consigned to the director of the City Salt Mines at Heilbronn.

There were other reports of large concentrations of artworks in at least two salt mines in Heilbronn's environs. The city was, at the moment, in our possession, but it had been retaken once by the Germans and the situation was still quite unsettled. Two Seventh Army military government officers had been waylaid on the Heilbronn road on the previous day. One had been shot resisting capture, and the other taken prisoner and then shot. Canby warned me that under no circumstances must I travel alone or be on the road after dark.

Devising Strategies to Protect German Materials

To promote military cooperation in France I had often used the argument that the good Franco-American relations had to be preserved, and that possible claims against our government, which might accrue from the unnecessary destruction by our troops of French monuments and

other cultural material, had to be avoided. In Germany this argument was useless. At this juncture I found little or no sympathy in the army for German works of art. The colonel suggested the line I would have to follow to secure cooperation in Germany when he told me that Third Army had come in for more than its share of publicity. It was time that Seventh Army had a salt mine or two and some caches of looted artworks to its credit.

Finding stolen objects was, of course, more spectacular, but it was of equal importance that the great German and German-owned works of art be protected. The value of works of art to civilization is not limited by national boundaries. The Strasbourg stained glass windows would have been my first priority even if they had been German owned.

The Merits of Salt Mines

Canby discussed with other staff officers at our headquarters and at corps the feasibility of my getting through to Heilbronn, and I was told to go ahead. I had obtained some information about salt mines in Paris, but it was sketchy at best and provided little insight into the problems involved in taking one over. Young François Carvallo, who was continuing his father's work of presiding over the Demeures Historiques, had told me that Dr. Hermann Bunjes of the Kunstschutz[17] had explained to him the use of salt mines for safeguarding works of art in Germany. The almost constant temperature and humidity, roughly 50 degrees and 60 to 65 percent, respectively, guaranteed that the deposited works of art would not suffer from sudden changes in atmospheric conditions.

German scientists had investigated the practicability of storing such objects in the mines for more than a year before they were used as repositories. Paintings and other objects were not affected by the moisture or action of the stable salt under the existing conditions. Iron was, of course, attacked by rust, but this could be prevented by thickly coating it with oil or grease. Thin films of salt dust deposited on works of art were not harmful and could be readily wiped off before the objects were removed from the mines. In the library of the Rosenberg headquarters in Paris I had found a volume dealing with the economy of Germany. In the section devoted to salt mining, I learned that before the war salt mines in Germany and Austria were producing about 10 percent of the world's supply. The exploitation of these mines was said to date back to prehistoric times.

Military Headquarters at Heilbronn

On the outskirts of Heilbronn I noticed the distant superstructure of a mine shaft and wondered if this could be the support for the elevator cables. I was anxious to make an immediate inspection of the mine but decided that I had better go first to the local military government headquarters for an appraisal of the military situation. Heilbronn was desolate and almost deserted. It had been a railroad center of strategic importance, and its chemical and other industrial plants had been expanded during recent years. Tens of thousands of German citizens had been killed in a 28-minute raid by our bombers and in the later artil-

lery bombardments. The stench of the unburied dead filled the town. The highest tower of St. Kilian's Church had been used for German machine-gun nests, which were built into concrete-reinforced cubicles. It was as battered as most of the other solidly built stone structures that had once been Heilbronn's glory.

I found Major Harry Montgomery, the commander of the military government detachment, in one of the few undamaged rooms in the post office. In spite of the fact that military and civilian demands were more onerous than in any other place I visited on the Continent, the major was interested in my assignment and cooperated in every way possible. We studied maps of salt mines at Heilbronn and of another at Kochendorf—the latter listed by SHAEF as a reported art repository of considerable importance—and discussed the important castles in the region. According to the latest reports, the castles and Kochendorf were still in enemy hands. On a detailed map of Heilbronn, the major showed me a route I could follow through the debris-filled streets where the engineers were clearing a road. He warned me against going out of the city in any direction but the one from which I had just come—the north. We decided that I might be able to secure further information from the newly appointed mayor, Herr Oberbürgermeister Beutingen. In the weeks to come I learned to trust the mayor implicitly. He was a sincere anti-Nazi and anxious to do all he could to help us. But although he had once been on the board of the salt mine, he could give me no information about recent activities there.

Evidence of Recent Fighting Near the Mine
Major Montgomery's instructions made it possible for my driver and me to find our way through the devastated areas until we located Salt Street, then Salt Works Square, and finally Salt Ground Street. There were people milling about, going in and out of the houses nearby, and I addressed several of them. I learned that they were Russian and Polish displaced persons who had been working in the mine as slave laborers, but language difficulties prevented my finding out anything further.

Military equipment, both German and American, littered the area. Some of the buildings were still smoldering and occasionally burst into flame. I found a few mine records, but the main office building had been totally destroyed by fire and the records of what was deposited in the mine had probably been consumed by the flames. I finally located a couple of weary and terrified German women in one of the houses that had formerly served as a gatehouse and residence for some of the mine employees. They said that the fighting in this area had been savage, and their statement was corroborated some weeks later when German prisoners of war dug out 35 bodies of American soldiers from the ruins of the office building. They answered my questions about the mine with no hesitation.

For many months the Germans had been bringing their most cherished possessions to the mine by the car- and truckload and placing them at the foot of the mine shaft. These women claimed that there was only one shaft giving access to the mine. I found this difficult to

ABOVE Nave of the Church of St. Kilian at Heilbronn, Germany, 1933. St. Kilian was an
Irish missionary who led a team of evangelists to Franconia, Germany, in the late seventh
century. After successfully converting the local duke, Kilian was obliged to inform him
that his marriage to his late brother's wife violated the teachings of the Christian church.
Upon hearing this news, the duke's wife had St. Kilian and two of his companions
beheaded. The relics of the martyrs are paraded through the streets of Wurzburg every
July 8, St. Kilian's Day.

RIGHT Bombed out interior of the Church of St. Kilian, 1945.

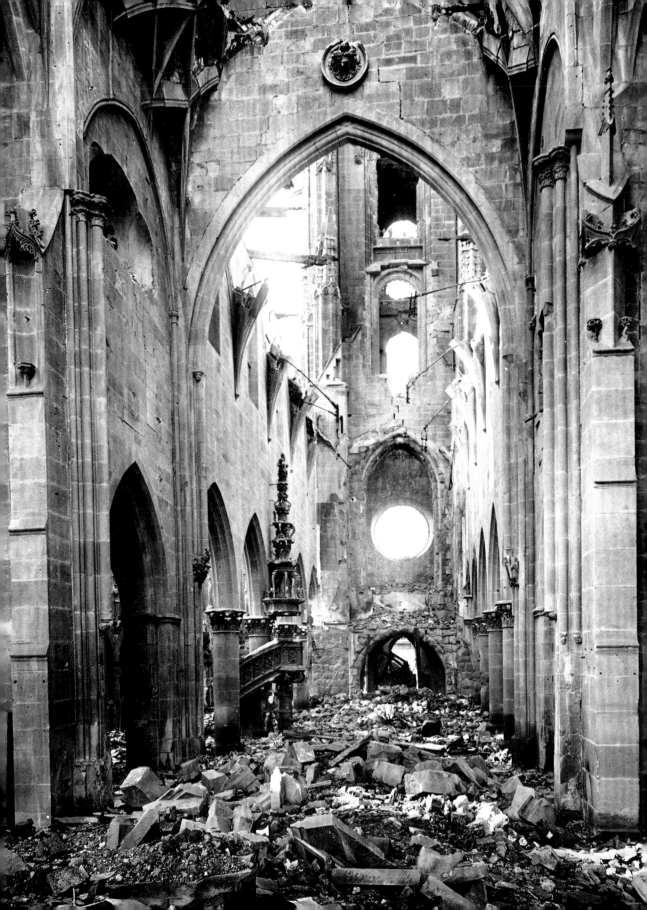

believe in view of the statistics they provided concerning the mine's area. The average depth of the salt deposits was 600 feet below the earth's surface. The removal of the salt had left storage spaces 300 feet long, 50 feet wide, and averaging 70 feet in height. The women had no idea how many of these places there were on the mine's two levels, but they had seen dozens of them. We found out later that some of these areas, of which 16 had been used for storage, were as high as 90 feet. The total area used covered approximately 10,000 square yards of the mine's floor. The real extent of the salt deposits had been only partially proven by test borings, but it was estimated that there were 20 square miles of minable salt at Heilbronn.

The women insisted that the miners had not carried out the Nazis' instructions to destroy the mine shaft. The German people could not survive without salt. The main concern of these women was the seepage from the Neckar River into the mine. It was necessary to pump this water from the mine for eight hours every day. Now that the pumps had stopped working with the failure of the electricity, they feared that the water would not only damage the things stored in the mine but would also destroy the shaft and machinery. I went back to town, picked up the mayor, and explained the situation to him in the jeep on the way to military government headquarters. Herr Beutingen and Major Montgomery both assured me of their fullest cooperation, but at the moment there was nothing to do but post a military guard at the entrance to the mine to prevent any possible sabotage. I returned to Darmstadt the next morning and requested the services of a qualified mining engineer from higher headquarters. My colonel told me with no mincing of words that the mine was my responsibility and that I should manage as best I could. There was no engineer available, and that was that. Lieutenant (USNR) Charles Kuhn (now head of Harvard University's art department)[18] met me in Darmstadt and offered to go back to Heilbronn with me in the event that he might be able to help.[19]

Plan to Dewater the Mine

A couple of days later I was back in Heilbronn with Kuhn. The mayor sent runners to neighboring towns to fetch Dr. Hans Bauer, the vice director of the city's salt mine, and Wilhelm Giegerich, the chief engineer. They confirmed the seriousness of the water seepage and the failure of the electricity, although they hoped that there might still be time to rescue some of the objects stored in the mine. The water would not reach the upper level for some time, and if the steam boiler could be transformed and fitted with hauling buckets to bring water out of the mine, the existing water pumps could then be put in order. Accomplishing all this would take time and workmen. They estimated that 70 of the former mine workers would be needed to reconstruct parts of the damaged plant.

At the time I didn't know that Bauer had been a student and biographer of Martin Luther or that his house would soon be razed by Nazi fanatics because he was cooperating with the American army. Although he seemed genuinely concerned over the fate of the cultural objects stored

in the mine, I had no idea how far he could be trusted. No lists had been left with the mine's directors, but complete inventories had in some cases been placed with the objects in the mine. Bauer recalled part of the mine's contents: Rembrandt's *St. Paul in Prison* from Heidelberg, most of the famous Heidelberg University Library (67 carloads), musical instruments and works of art from Mannheim, and other shipments from Karlsruhe, Schleswig, and elsewhere in Germany. I. G. Farben, the famous chemicals concern, had deposited measuring instruments and documents in the mine, as had Bosch and other concerns. Stained glass had come from Strasbourg. Bauer volunteered the information that a synthetic oil plant had been under construction in one section of the mine.

Kuhn, Bauer, and I went out to the mine and debated whether the need for determining the extent of damage to the mine warranted going down into the depths by way of the frail, perilous-looking 600-foot ladder. We were spared the necessity for making the decision when PFC Robert Steare, Co. B, 2826 Engineers, came out of the mine. Strictly on his own, this intrepid young GI had gone down with one of the mine's employees. Their report was ominous. The pumps were under 3 feet of water, and the water extended about 90 yards to the south and 60 yards to the east and had reached the storage spaces. Steare had seen the word "Strasbourg" written in chalk on one of the doors, but he had not attempted to enter any of the locked chambers.

Subject to Major Montgomery's approval, we evolved a plan for beginning operations. The continuing accumulation of water was of greater concern than the possibility of sabotage. The first move was to drain off the water. The problem of safeguarding cultural objects could be taken up next. Once the water had been removed and the art objects had been cared for, salt could again be mined. Under no circumstances were any persons other than trusted former mine workers to be permitted to enter the shaft.

Entering the Mine Shaft

On the last day of April, Dr. Bauer promised that the steam, for which there was now sufficient coal in reserve, would be running the elevator and the skips[20] within three days. With the removal of the water underway, I was free to work in Bavaria and Austria for several weeks. It was not until May 27 that I could return to the mines and end the suspense of worrying about their contents. The danger of collapsing salt had been overcome, and Major Montgomery and I decided to go into the mine. We climbed the mine superstructure and walked onto a platform measuring about 4 by 5 feet. The water had been drained out of the mine in a box built into the bottom of this platform. The box was lowered into the water; then, as it was brought out of the mine, torrents of water spilled out, and what was not carried off in skips gradually ran back into the shaft. The cables were rusted from this almost constant immersion, to the point where I feared that they might give way.

In spite of my fears, we came to a gentle stop at the bottom. A dozen men were working in a room that had been cut into the hard salt, which ranged in color from crystal to black. We were warned to step with cau-

tion. Large sections of salt had been washed away by the action of the water and we had to walk over loosely laid boards. The soluble salt pillars supporting the installations at the foot of the shaft had dissolved, and wood and brick reinforcements were being built, lest the entire structure collapse. The foundations of the pumps had already given way and were being renewed so that the water, coming in at the rate of 100,000 gallons a day, could be carried off as in normal times. It was estimated that 3 million gallons had collected before the removal began on May 4. As we moved away from the bottom of the shaft, sections of the salt wall along a 30-foot connecting passageway dropped as if pushed from behind by a bulldozer. After that, the assurance of the foreman that there was little danger of further serious mishap carried little weight.

We hurried on to the storage and workrooms. Water had entered only one of the lowest areas. Pharmaceutical supplies and badly needed medicines were beginning to dry out now that the water had been drawn off. Although the humidity in the room where the water had penetrated was 75 percent, everywhere else it was a constant 65. We left the mine shortly after; there was nothing further we could do until the elevator and other machinery were in good running order.

Locating the Mine's Storage Records

Now that we were to have easy access to the objects in the mine, we needed the storage records for purposes of identification. Some of the principals who had placed objects in the mine had yet to be located. I had visited Dr. Rudolph Schnellbach, general director of the museums of Baden. He had supervised the storing of many of the shipments in the Heilbronn salt mine and was particularly concerned about his own belongings, including his library and vital records, which had been placed there. As he had joined the Nazi Party in its early days (and now quite understandably regretted it exceedingly), he was disqualified from any active cooperation with us. However, his information did prove of value. He urged me to contact Dr. Kurt Martin, who knew all about the objects that had been brought from France to Heilbronn. I was told that he might be in Baden-Baden, where he had supposedly gone after Karlsruhe had been bombed. All the lists of the objects deposited in this mine and elsewhere were certain to be in the possession of Dr. Martin or his secretary.

Major Edward D'Arms,[21] on leave from the University of Colorado, had been the Monuments, Fine Arts & Archives education and religion documents officer for G-5, Sixth Army Group, stationed at Heidelberg. Acting on the information I had given him, he went to Baden-Baden at the end of April to hunt for Dr. Martin. He discovered that Martin and his wife had left for Lake Constance, probably at the order of the ministry. They had taken their household goods with them, but it was not known whether they had taken documents.

The name Kurt Martin has long been familiar to art historians, especially those who have studied problems in Rhenish art. He was well known, too, as the director of the Kunsthalle in Karlsruhe, where he had shown an enthusiasm for collecting and an understanding of the diverse

approaches to the intricacies of a local art museum desirous of widening its responsibilities in the community it served. Before I left France I had heard reports of Martin's indefatigable efforts to safeguard Alsatian art, particularly in the city of Strasbourg, where, under German domination, he had been made the director of the three museums previously built up under Hans Haug.

As the lists Dr. Martin purportedly had were apparently the only ones in existence, I made every effort to have them secured for Seventh Army. It was April when I learned that Dr. Martin had taken his lists with him and that he was residing in the French Zone near Lake Constance, but it was early September before I secured permission to go in person into the French Zone to find him.

Our administrative officer, Lieutenant (later Captain) Jack Stipe, my constant companion at headquarters, jumped at my invitation to come along on one of my "excursions," as he labeled them. Early Sunday morning we were joined by Dr. Schnellbach and set out for Pfullendorf, south of Sigmaringen, on the way to Lake Constance.

We found the art repository in what had once been the local jail. Fräulein Luise Vernickel, Martin's secretary, was in charge. She told us that the Martins were living in Bankholzen, that the doctor had been trying to contact me for weeks, and that he would wish to return to Pfullendorf with me to give me whatever information we sought. We found Dr. Martin and his wife in a small room of a peasant cottage. The belongings they had brought with them from Karlsruhe were modest and in good taste. These were not art treasures taken from the art centers of Europe for personal gain. I was willing to believe Dr. Martin's avowal that he had held on to the documents to prevent them from being destroyed or falling into unfriendly hands. Martin explained that he had heard about my work with Seventh Army and that he had decided to deliver the documents to no one but me in person.

The doctor returned to Pfullendorf with us, as Fräulein Vernickel had forecast, and the two worked all night preparing copies of the lists I wanted most. In the morning 50 typewritten pages were delivered to me; in the following weeks the others were delivered to me in Heidelberg. Using these annotated lists we were able to single out the boxes in the Heilbronn salt mines containing works of art from France and Holland, and other boxes containing scrupulously kept entries, bills of sale, and record books of all the art transactions, particularly confiscated Jewish works of art from Alsace and elsewhere. Martin had made praiseworthy efforts to preserve the objects, and the systematic records were evidence of his thoroughness and good intentions.

Though I had checked fairly extensively on Dr. Martin's activities, I sent to USFET for the services of Lieutenant Walter Horn, our monuments intelligence officer, who had been born in Heidelberg.[22] He spent ten days checking Martin's story in the French Zone and in Alsace. I went to Strasbourg and to Paris to look further into a record that appeared to be unimpeachable. Finally, I came back for Martin and took him to Strasbourg with me. He came through this intensive checking with no

marks against him. Following arrangements with the French officials, we planned his return to the American Zone in Baden, where his further services to the monuments officers proved most helpful and rewarding.

For the better part of a year, Lieutenant Dale V. Ford[23] and Corporal Harry L. Ettlinger[24] worked at separating the loot from the German-owned property at the Heilbronn mine and at the other mines at Kochendorf and Jagstfeld. Abstracts from their reports give some idea of what would have been lost to the world if there had not been such splendid teamwork.

THE KOCHENDORF SALT MINE

The Kochendorf salt mine, 5 miles north of Heilbronn, was a very important repository. I arrived there on April 20 after the area had been cleared of German troops. An intelligence task force was on the scene to investigate the important underground jet-propelled airplane motor plant ready for operation in one of the mine's chambers. Charles Lindbergh came with the hope of seeing the engines, but the descent machinery was not yet in working order and he was unable to go down into the mine. I had the impression after talking with him at breakfast that he had a broader view of German armaments than most investigators. His unassuming simplicity, so admired in his early career, seemed still to be natural and unaffected.[25] Later, when the mine machinery and shaft were operating, selected workmen built six engines under Allied supervision.

Works of art and cultural resources were safe from vandalism as it was still impossible to go down into the lower levels. As an added safeguard, the 100th Infantry Division was on guard at the premises.

Dr. Ing. Ernst Baur,[26] the head of the mine, assured me that the cultural objects he had stored there for many institutions would be safe indefinitely. Unlike the storage chambers at Heilbronn, those at Kochendorf were some 35 feet above the water level and there was no danger of seepage. Dr. Baur was under suspicion of having been a member of the Nazi Party. Just before my arrival, he had given two record books to Second Lieutenant Nicholas T. Stalikas of the 389th Infantry Regiment. These books contained the original and only inventories of the estimated 30,000 cases stored in the mine. I contacted the lieutenant's outfit and was told that he was on furlough. I sweated out his return and did a lot of needless worrying. The books were recovered undamaged.

The repair of the essential equipment proceeded too slowly for Major Montgomery, and he called in Hans Bauer from the Heilbronn mine to supervise both mines. Dr. Ing. Ernst Baur, in spite of the fact that his own library and works of art were stored in the mine, seemed to be in no appreciable hurry to get them out. He had expressed the belief that the Americans would confiscate all privately owned works of art, regardless of how they were acquired. This idea probably accounted to some extent for his seeming inability to get things done. With Hans Bauer in charge, progress was much more noticeable.

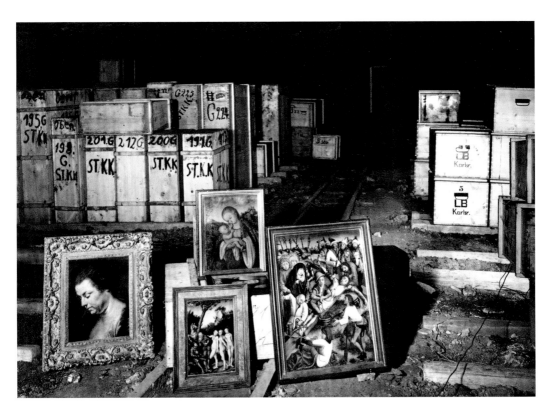

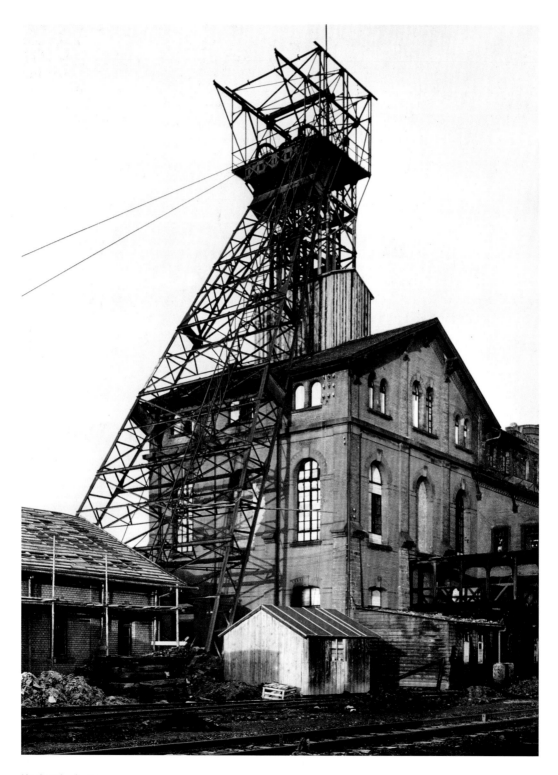

Kochendorf mine.

On July 9, John Nicholas Brown, Lieutenant General Clay's cultural adviser,[27] and Lieutenant Colonel Mason Hammond[28] of U.S. Group Control Council went down into the Kochendorf mine with me. We looked at some of the contents—the famous Grünewald painting of the Virgin from the church at Stuppach,[29] dozens of canvases from Stuttgart, and furniture from the palace at Ludwigsburg. Here at least the Germans had done an excellent job of safeguarding their own treasures and those confiscated during their occupation of foreign lands. We decided that the wisest course would be to leave everything right where it was. It was safer here than it would be in the hands of unqualified personnel.

SECURING THE LAUFEN MINE IN AUSTRIA

One of the most important salt mine repositories in "Greater Germany" was hidden in the Laufen mine near Bad Ischl containing the best objects from the state collections in Vienna—paintings, medieval objects, tapestries, prints, drawings, manuscripts, and ethnographical and natural history material. The humidity in the mine was at a low level, and except for slight dampness in one of the chambers, the conditions were said to be good. The objects sent here had been prepared for removal from Vienna in 1942, as the intensity of the air raids increased, and were placed in the mine in 1944. The number of world-famous objects exposed to these hazards was alarming. Eight sculptures, 728 unidentified cases, 278 map boxes, 1,408 paintings, and 122 sacks of tapestries were stored nearly 3 miles from the entrance of the mine.

Viennese Loot Looted Again by German Officers

A theft from the mine on May 4 subjected the best objects secreted there to incredible dangers. Under the pretext of saving the art treasures from the fast-approaching Russians, a contingent of German officers and soldiers, threatening the use of arms if opposed, drove off at 4:30 in the morning with two trucks shaking up the most important objects of the Vienna Kunsthistorisches Museum, the Österreichische Galerie Belvedere, and the Akademische Gemäldegalerie. The transport contained 184 paintings of the highest value—by Rembrandt, Titian, Velázquez, Bruegel, Dürer, etc.—49 sacks of tapestries, and 2 chests of smaller objects. The theft occurred just before the arrival of our troops. Dr. Victor Luithlen, the custodian of the repository for the Vienna Kunsthistorisches Museum, sent a letter to the American authorities on May 9, but it never arrived at our headquarters and it was never clear to whom it had been addressed. The theft did not come to my notice until May 18, when Lieutenant Kuhn and Lieutenant Colonel McDonnell of SHAEF returned to our headquarters on their way back from Austria. Warnings were wired at once to the troops in the area where the objects had last been seen.

A Tip Leads to the Golden Lion Inn

I shared my office at this time with the Seventh Army food and agriculture

RIGHT
Lt. Colonel Mason Hammond (left), the first monuments man, descended into the Kochendorf mineshaft with the author (right). John Nicholas Brown, Lt. General Clay's cultural adviser, went down into the mine with them.

BELOW
The *Stuppach Madonna* by Matthias Grünewald was found in the Kochendorf salt mine, it ranks with the Isenheim Altarpiece as one of Grünewald's greatest works. It has been returned to its home in the parish church of Stuppach, Germany.

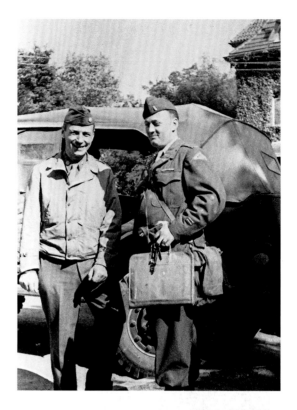

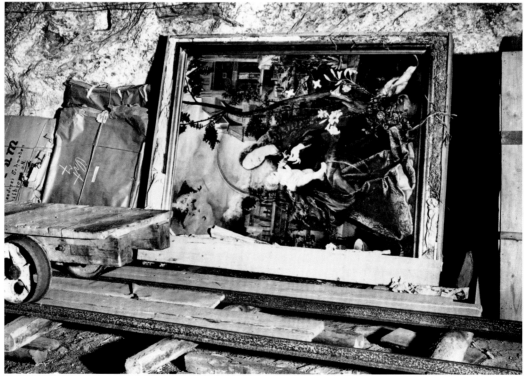

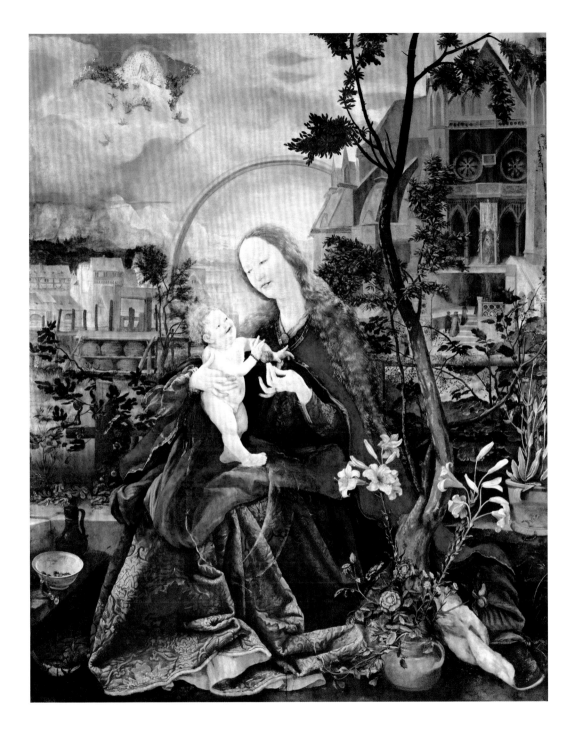

Mathias Grünewald,
Stuppach Madonna,
c. 1514–19. Pfarrkirche
Mariä Krönung,
Stuppach, Germany.

officer, and he had become cognizant of our art-rescue problems. While on a mission to feed the hundreds of thousands of surrendered soldiers of the German army, Southern Zone, he learned that an extraordinary cache of art objects was somewhere in their area. (He said it was the hope of the German commanding general to turn them over to the pope for safekeeping pending a peace treaty with the Allies!) Knowing we would want to follow up such information, he telephoned our headquarters immediately. I had already set out for Bad Ischl to seek clues for running down the Laufen theft and to provide the necessary security at the mine. Colonel Canby, on the receipt of this new intelligence at our headquarters, sent Lieutenant Hathaway to ferret out the whereabouts of the things reported by the food and agriculture officer. Lieutenant (later Captain) Calvin S. Hathaway had arrived from Versailles on May 26 to help me at Seventh Army following my urgent appeal for more help.[30]

Hathaway's quest led him to the Goldener Löwe (Golden Lion) Inn in Sankt Johann in Tirol. When confronted with Hathaway's interrogations, the innkeeper professed ignorance of the entire matter. A guest at the inn named God, a tall, paunchy gentleman approaching 50, volunteered help. He said the objects sought had been put in the cellar rooms of his house by men under the command of a Major Fabian. Major Fabian was described as a commander of remnants of the Grossdeutschland Regiment.[31] A Major Hay of the German First Army claimed to have brought the things there and said that fear of the approaching Russians had prompted Baldur von Schirach, Gauleiter[32] for Austria, to order their removal from the Laufen mine.

The responsibility thrust upon God had evidently been uncomfortable for him. He had had two visitations by SS officers and German First Army men who threatened him and attempted to obtain paintings for themselves. Hathaway followed God to the neighboring house. In two extremely damp cellars (one water-soaked) he found 32 uncrated paintings, 49 sacks of tapestries, and 9 wooden packing cases. Here were the things taken from the Laufen mine. Among the paintings were eight by Bruegel, five by Rembrandt, seven by Velázquez, and eight by Titian.

Hathaway and I would have liked nothing better than to have spent months looking over these objects, but all we could do was provide for the maximum security possible and give instructions about drying and warehousing the paintings and tapestries. Several of the unboxed pictures had developed mold, and I arranged that all of these works of art be taken immediately to Salzburg. Later when I asked Hathaway if the Cellini saltcellar was among the objects, he had to say he didn't know; time and help were so limited that he had had to deliver the sacks unchecked.[33]

CAPTAIN POSEY SECURES THE MINE AT ALTAUSSEE

Before we were aware of the importance of the Laufen mine we had come to Salzburg on May 7 to prepare an armed expedition to the mine at Altaussee. Hathaway and I had reported to Colonel Worthing, army

TOP
Rembrandt self-portrait and a portrait of his son, Titus, were among the renowned paintings that were rescued through monuments men action and returned to the Kunsthistorisches Museum, Vienna.

BOTTOM LEFT
Rembrandt, *Small Self-Portrait*, c. 1657. Kunsthistorisches Museum, Vienna.

BOTTOM RIGHT
Rembrandt, *Titus, Son of the Artist*, Reading, c. 1656-57. Kunsthistorisches Museum, Vienna.

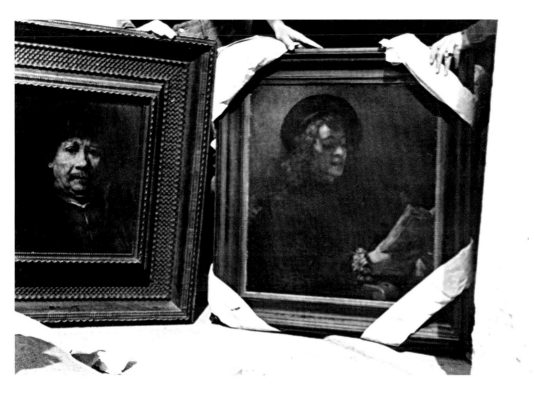

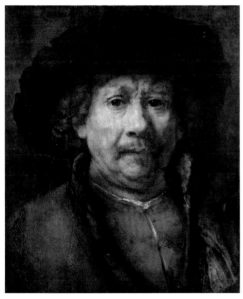

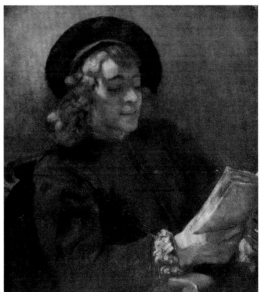

chief of staff, G-5, at XV Corps headquarters in Salzburg. The colonel told us that the winding up of most of the combat operations would be completed the following day and would soon be broadcast as the official announcement of V-E Day.[34] In the war room the latest reports on the area around Altaussee stated that the Nazis were not surrendering here as elsewhere and had ambushed a forward company of American troops, and that reinforcements were being sent in.

The Ghent Altarpiece

The situation was still tense, but it was important that the Americans arrive at Altaussee at the earliest possible moment. SHAEF lists indicated that the famous Van Eyck altarpiece, of the *Adoration of the Mystic Lamb* from Ghent, removed by the Nazis from the French repository in Pau, had been brought to this mine. Officials of the Einsatzstab Rosenberg had told me that this was the most important of the storage places for art looted by the Nazis. Just as we had decided that it would be prudent to await further information from this sector, an officer produced a larger-scale map revealing, to our chagrin—as we would have liked to have been the first at Altaussee—that the mine was in the Third Army area.

Coordination with Third Army

I communicated at once with Major Kanto, our operations officer at Seventh Army headquarters, who in turn called Third Army headquarters to give details of the situation. He said that we had captured many records showing the supreme importance of the Altaussee repository and that I had a map of the mine and its intricate storerooms. Many weeks later we learned that Captain Posey of Third Army had obtained intelligence about looted-art repositories from Count Wolff-Metternich's Paris co-worker, Dr. Bunjes, who later committed suicide.[35]

CONSULTATION ABOUT THE WOLFDIETRICH MINE ("HIMMLER'S CAVE")

It was not until two weeks after the Laufen incident and the capture of Altaussee by Major General McBride of Third Army that I had occasion to go there to talk with Captain Posey. I had only a few hours before having to return to our Augsburg headquarters five hours away. I did not see the contents of this astounding cache comprising thousands of paintings, sculptures, furniture, and art objects of all descriptions, including the *Ghent Altarpiece*, Dirk Bouts's altarpiece from Louvain, Michelangelo's statue of the Virgin and Child from Bruges, the Czernin Vermeer from Vienna, and other objects looted from Paris and Vienna. I had taken the technical director of Austrian Salt Mines and Dr. Luithlen with me. We wanted to talk with Posey about the various problems we had encountered in the mine repositories at Laufen and Hallein ("Himmler's Cave"),[36] both of which would soon come under Third Army jurisdiction.

Benvenuto Cellini,
Saliera, 1543.
Kunsthistorisches
Museum, Vienna. This
Saliera (or saltcellar)
was returned to the
Kunsthistorisches
Museum, Vienna, by
Captain Calvin
Hathaway. This object
was stolen again from
the museum in 2003
and recovered in 2006.

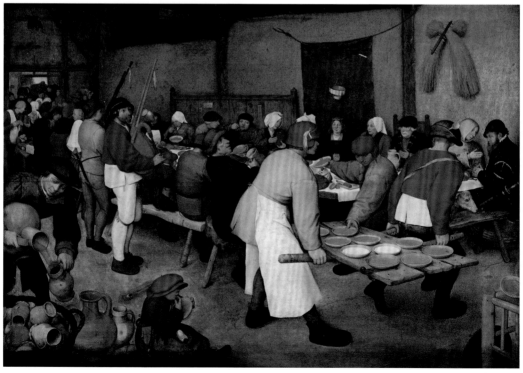

LEFT TOP
World famous *The Peasant Wedding*, c. 1568, by Peter Bruegel the Elder is now in the Kunsthistorisches Museum, Vienna. Army blankets like those seen here provided the only protection when art objects were transferred from places like damp cellars where they had been found by monuments men.

LEFT BOTTOM
Pieter Bruegel the Elder, *The Peasant Wedding*, c. 1568. Kunsthistorisches Museum, Vienna.

ABOVE
Bruegel's *Tower of Babel* was found at the same unidentified location as *The Peasant Wedding*.

BELOW
Pieter Bruegel the Elder, *Tower of Babel*, 1563. Kunsthistorisches Museum, Vienna.

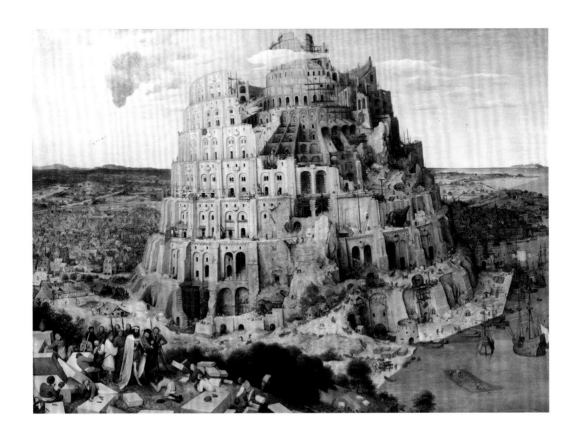

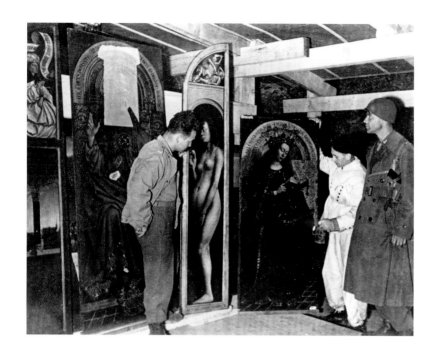

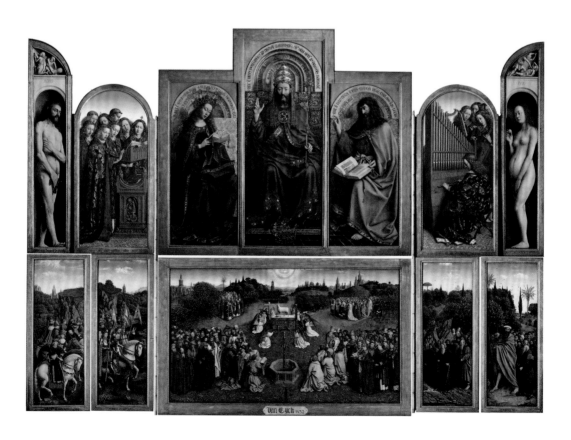

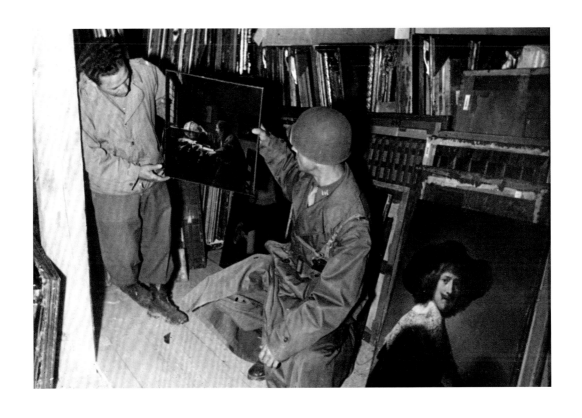

ABOVE
The Astronomer by
Johannes Vermeer
found at Altaussee mine.
According to some
sources, it was one of
Hitler's favorite paintings.

RIGHT
Johannes Vermeer,
The Astronomer, c. 1668.
Louvre Museum.

The Wolfdietrich mine in the mountains near Hallein was reported to contain Himmler's personal papers, put there when the SS commander saw defeat was inevitable. Books, works of art, and papers from the German Institute in Rome, from Salzburg, and from Hallein itself were concealed here. The technical director of Austrian Salt Mines told me later that stores of valuable radium were also hidden in the cave. At the approach of the Allies, the Germans had sealed or blasted shut the passageways and entrances.

Dr. Luithlen was responsible for the safekeeping of other Austrian cultural objects, which, to all appearances, had less security than those in the Laufen mine. He lived in a small inn about 4 miles from the mine. Behind it was an unguarded shed. He took me into it. Famous Albrecht Altdorfers (c. 1480–1538) from the Monastery of St. Florian near Linz and other superb paintings from Austrian monasteries and museums were piled one against the other.[37] The American guards stationed at the inn were carrying out instructions to check credentials of passersby, but they had no idea that anything was stored a few yards behind them.

THE HOLY CROWN OF ST. STEPHEN

Crown Not Found on the "Hungarian Gold Train"

We had to administer to objects of art in strange places. There wasn't time to inspect 20 carloads of art objects left on a railroad siding near Munich. I could only report their presence to our Munich office. In Werfen and the vicinity there were concentrations of German soldiers and ordnance equipment, including small arms and acres of broken-down trucks. On the railroad track were 52 boxcars, 20 of them containing miscellaneous loot from Hungary. In an effort to keep this cargo from the Russians, who had been advancing rapidly in the east, 42 Hungarian guards under compulsion from the Nazis accompanied a gruesome mixture of gold wedding rings (in cases too heavy for two men to lift), household furnishings, money, watches, diamonds, dress goods, building stone, carbon, boards, empty cans and rubbish, objects from the museum in Györ, and *people*.

Arpád Toldy, who had accompanied the shipment from Hungary, escaped with the inventories of the contents of the train before it fell into American hands. We did not envy Major Laughlin, the executive officer of the 15th Regiment, 3rd Division, XV Corps, who with the property control officer would have to decide how to handle these carloads of problems. I recommended that the material of artistic value be sent to collecting points being established in Salzburg and Munich.[38]

The Royal Crown of Hungary,[39] also known as the Holy Crown of St. Stephen, was not on this train as had been erroneously reported in an American newspaper. Its pursuit was complicated by conflicting statements and a general reluctance on the part of everyone concerned to reveal its whereabouts. As usual, rumors were plentiful. It seemed as though every Hungarian PW[40] had the crown safely secreted. Few objects of art in Europe could match the importance of this enameled

gold crown. It was the Hungarian coronation crown and without it no ceremony was considered constitutional. The Hungarians believe that as long as the crown is safe, Hungary is safe. According to scholars, Pope Sylvester II in the year 1000 sent a crown to St. Stephen of Hungary (r. c. 1000–1038), and another was sent by the Byzantine emperor, Michael VII Ducas (r. 1071–78), to Geza I of Hungary (r. 1074–77). In the 13th century, when the older crown was supposedly damaged and incomplete, the two crowns were combined into the present royal crown.

In the early part of June I sat on an iron strongbox in Major Paul Kubala's quarters at Augsburg. Kubala, who was in charge of the Seventh Army Interrogation Center, told me that he thought he knew the whereabouts of the crown. I had a feeling that I, too, knew where it was, and that it was no farther away from me than the interior of the strongbox on which I was sitting.

A few days later, my suspicions concerning the box still unsatisfied, I was ordered to Weilheim, south of Munich. Word had been received from Major Wills, the military government head there, that he had discovered the location of the crown. Major Wills had been told the location by a Hungarian officer from a nearby camp. I might have given more credence to his story if it had been the first of the many I had heard, or if I hadn't suspected that Major Kubala knew more about the circumstances than he had told me. I decided to return to headquarters and continue the search for the crown from that point. After continued inquiries from me and higher headquarters, Kubala turned in a report to headquarters in which he described his efforts to obtain the royal crown. His report follows:

> On or about 7 May 1945, an ancient box was delivered to the Seventh Army Interrogation Center by Colonel Pajtas and twelve guards of the Hungarian Army.
>
> Colonel Pajtas stated, upon delivery of the box to me, that the box contained the Holy Crown of St. Stephen of Hungary. The Colonel stated further that he must remain with the crown inasmuch as he was the official custodian and guardian. Upon being questioned as to the whereabouts of the keys of the box, the Colonel stated that originally the keys were distributed among three people, but that they had all been acquired by Prime Minister Szálasi.[41] I presented this picture to Colonel Quinn, the former AC of S, G-2,[42] Seventh Army, and was instructed to make every effort to obtain the keys. Second Lieutenant Granville of this organization was assigned the task of interrogating all Hungarian nationals that could have had knowledge as to their location. In the meantime I made several unsuccessful efforts to turn the box over to the proper authorities. [Lieutenant Colonel Rowe, our property control officer, and I had refused to take the box into custody until we were certain of its contents. Our seniors had ruled that this could not be done until the keys were found so that we could open the box without forcing the lid.]
>
> On or about 24 July, Lieutenant Granville succeeded in obtaining the keys and the box was opened in the presence of Lieutenant Granville and Captain Zoller, and was found to be empty. I immediately called for

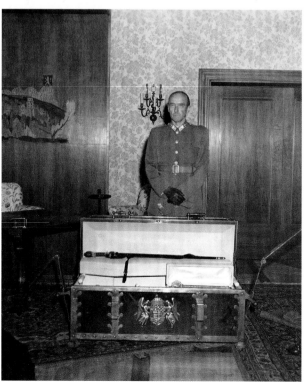

ABOVE
The side of a car in what became known as the Hungarian Gold Train, being held at Werfen, Austria, 1945. This train was filled with all manner of looted gold objects.

LEFT
Hungarian Colonel Erno Pajtas, commander of the crown guards, with the strongbox containing the Royal Coronation Regalia of Hungary, June 1945.

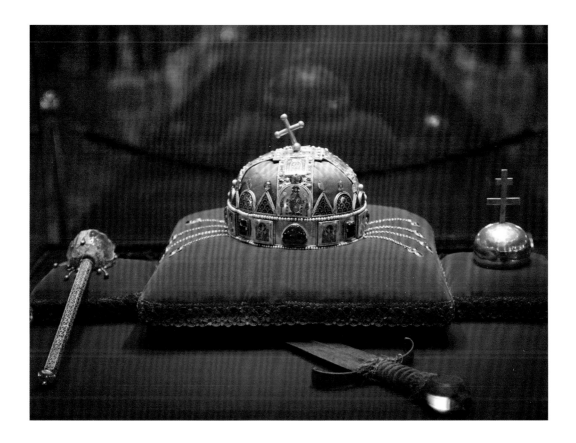

ABOVE
The Hungarian coronation crown now on display in the Hungarian Parliament Building in Budapest. After the war, the coronation regalia was held at Fort Knox in the U.S., owing to Cold War tensions between the U.S. and the Soviet Union; the crown was not returned to Hungary until 1978.

RIGHT
Edith Standen and Joe Kelleher with the Hungarian coronation regalia and other precious objects at the Wiesbaden Collecting Point, early 1946.

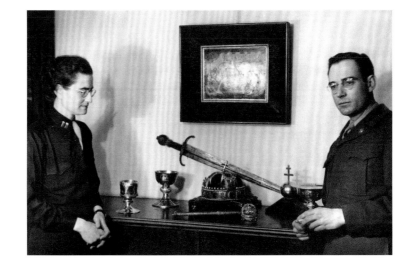

Colonel Pajtas and asked him for an explanation. Colonel Pajtas then explained to me that he knew that the box was empty all the time, having personally removed the crown, the scepter and the Holy Apple and buried them in accordance with instructions. I pointed out to the Colonel that he had placed me in an exceedingly difficult position inasmuch as the whole world knew that the box was in the possession of the Seventh Army. Whereupon Colonel Pajtas volunteered to go after the Crown at once.

In the meantime, Second Lieutenant Andrews of this organization, who had entered the room, volunteered to go with the Colonel. I agreed first to let them go, then changed my mind so that I might contact the AC of S, G-2, beforehand and therefore forbade Lieutenant Andrews and Colonel Pajtas to go. I made four efforts that night to contact Colonel Perry by phone. The following day about noon, as I was writing a letter to Colonel Perry, Lieutenant Andrews and Colonel Pajtas stepped into the room with the statement that they had left quietly the night before and now returned with the crown. [I have never been able to discover where the crown was buried.] An old mud-covered gasoline drum was brought into the room. The drum was then chiseled open by Colonel Pajtas and three very muddy and deteriorated leather-covered boxes removed therefrom. These boxes were falling apart. The crown, scepter and Holy Apple were then carried to my bathroom where all mud and dirt was washed off. This operation was performed by Colonel Pajtas and myself. We then placed the items on the floor to dry. After all the items were dried thoroughly, they were then placed into the original box. The sword of St. Stephen has never been removed but was in another container in the original box. The box has since this date not been opened.

On August 3, the strongbox containing the Holy Crown of St. Stephen, the scepter, the golden orb of state, the so-called St. Stephen's coronation sword, and an empty box for the Hungarian Signum Laudis[43] was opened again. In attendance were our acting commanding general, Major General Millburn, other interested officials, and representatives of the press. Following this showing, I packed the items carefully in the general's towels and sealed the box with sealing wax bearing the impression of the dog tags of our property control officer, Lieutenant Colonel Rowe. He took them with a military escort to the Reichsbank in Frankfurt, and later, when we made Wiesbaden our central collecting point, I transferred the box there, pending its return to Hungary.[44]

VON RIBBENTROP'S HOUSE IS FOUND EMPTY

At Fuschl I visited von Ribbentrop's house,[45] which he had taken over from Baron von Remnitz when the latter was sent to Dachau. There was nothing of artistic importance left in the house, but the von Ribbentrop family servant claimed that works of art had been farmed out to the local people. This information was passed on through normal army channels, but we assume that most of von Ribbentrop's paintings, like hundreds of others acquired by the Nazis, will be as elusive as Captain Kidd's treasure.

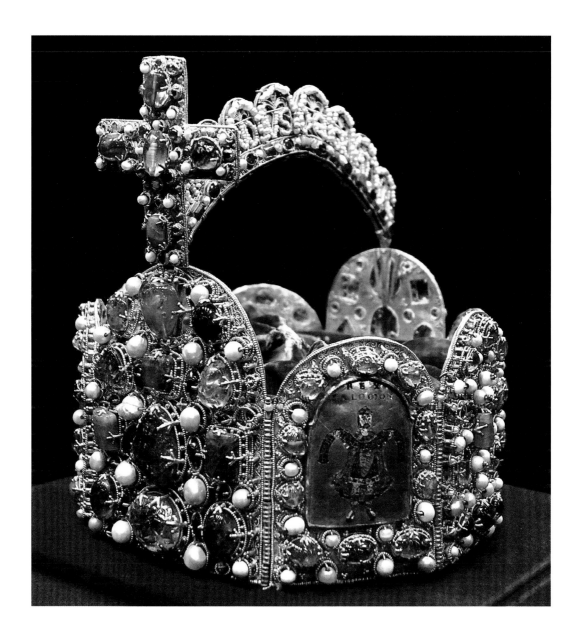

The Imperial Crown of the Holy Roman Empire, c. 1000. Imperial Treasury, Vienna. In 1938, Hitler transported this crown from Vienna to Nuremberg. As the Allies approached in early 1945, local officials, on orders from Heinrich Himmler, helped the SS remove the crown and its regalia from public display and walled them up in a bunker under the city. Monuments intelligence officer Walter Horn (see page 189) tracked down the culprits and convinced them to reveal the hiding place. The crown and regalia were returned to Vienna in early 1946.

NOTES

[1] Aeneas McDonnell served as a monuments officer with the British. See Chapter 3, note 29.

[2] The story of this train loaded with art looted by the Nazis was dramatized in the 1964 film *The Train*, starring Burt Lancaster, Paul Scofield, and Jeanne Moreau.

[3] The apartment was located at 160 Rue de l'Université. The author's brother-in-law, the violinist Samuel Dushkin, occupied the apartment before the war. During the occupation, German soldiers took over the apartment, but the author found it in reasonable condition, and Dushkin's piano was unharmed. See Chapter 3, note 25.

[4] Before digital photography, a photographer captured an image on light-sensitive film and then developed the image in a series of liquid chemical baths to produce a negative. The negative image captured on film had to be projected onto light-sensitive paper in a darkroom, and, when immersed in another series of chemical baths, it produced a positive of the image on paper.

[5] The British assigned officer ranking to their monuments officers that was commensurate with their civilian accomplishments, rather than their seniority in uniform.

[6] At this time, in the spring of 1945, the U.S. Seventh Army had not yet begun to fight its way across the Rhine into Germany on its way to capturing Munich and entering Austria.

[7] *The Man Who Came to Dinner*, a popular play by George S. Kaufman and Moss Hart that opened in 1939, recounts the exploits of a dinner guest who slips on the doorstep upon arrival and proceeds to cause all manner of mischief during his prolonged stay. The 1942 film version starred Monty Woolley, Bette Davis, and Ann Sheridan.

[8] The *Völkischer Beobachter* (*People's Observer*) was a Munich newspaper featuring anti-Semitic content that became the principal propaganda organ of the Nazi Party. At the height of Nazi power, it published editions not only for Munich and broader Bavaria but also in Berlin and Vienna. The term "Völkischer" has no single English translation, but implies a group of people defined by their ethnicity.

[9] Robert K. Wittman and David Kinney have documented Rosenberg's central role in Hitler's rise to power and the development of Hitler's racist views in *The Devil's Diary: Alfred Rosenberg and the Stolen Secrets of the Third Reich* (New York: HarperCollins, 2016).

[10] United States Forces, European Theater, the unit of the U.S. military previously known as European Theater of Operations, United States Army (ETOUSA).

[11] Lohse will appear again later in Chapter 6.

[12] Forces Françaises de l'Intérieur, or French Forces of the Interior, the designation used to refer to the French resistance in the later stages of the war.

[13] This wildly popular 1932 American film set in the Grand Hotel in Berlin and starring Greta Garbo was based on a 1929 book by the Austrian novelist Vicki Baum. The original book, entitled *Menschen im Hotel* (People at a Hotel) established the genre of the "hotel novel" and has inspired successors in multiple media, including later movies, plays, and musicals.

[14] As Hitler's minister of science, education, and national culture, Rust (1883–1945) was responsible for molding the German educational system to produce "ethnically aware" Germans.

[15] Captain Huchthausen (1904–1945) was trained as an architect at the University of Minnesota and Harvard. His accomplishments as a monuments officer included rescue of one of the oldest churches in northern Europe, the Cathedral at Aachen (commonly referred to as Aix-la-Chapelle), where Charlemagne's remains are kept. Huchthausen was killed by enemy fire when he and another monuments man, Sheldon Keck (1910–1993), unintentionally entered territory still under German control while on assignment near Aachen.

[16] Marvin C. Ross (1904–1977) was another monuments officer educated at Harvard and then New York University, the University of Berlin, and the Centro de Estudios Históricos in Madrid. After enlisting in the marines and seeing combat in the Pacific theater, he was transferred to SHAEF headquarters in London prior to the Normandy invasion. His military experience enabled him to direct field operations of other monuments officers effectively, while his art background enabled him to identify critical intelligence to be shared with field officers quickly.

[17] Jonathan Petropoulos, *The Faustian Bargain: The Art World in Nazi Germany* (New York: Oxford University Press, 2000), details the life of Hermann Bunjes (1911–1945), who, among other things, worked for Goering at the Jeu de Paume. Petropoulos also traces the deals made by several other German art professionals mentioned in this narrative. He describes Bunjes's career as "the gradual corruption of an art historian."

[18] Charles L. Kuhn (1901–1985), a native of Cincinnati, Ohio, was a museum curator and scholar of Germanic art at Harvard before the war. After serving first as a naval military intelligence interrogator and then as a monuments officer, he returned to Harvard, where he was director of the Busch-Reisinger Museum until 1968.

[19] The salt mines at Heilbronn are now open to the public.

[20] Skips are sturdy containers made of steel and other metals that are used to carry ore through mine shafts from deep underground to the earth's surface.

[21] Edward F. D'Arms (1904–1991) was a graduate of Princeton and a Rhodes Scholar who taught classics at Princeton and the Universities of Minnesota and Colorado before the war. He later became an executive at the Rockefeller (1947–57) and Ford (1957–69) Foundations. See http://www.nytimes.com/1991/05/03/obituaries/edward-f-d-arms-87-executive-and-teacher.html.

[22] Walter W. Horn (1908–1995) was a scholar of German art and architecture who had fled Germany in 1938. After becoming a U.S. citizen, he left the University of California at Berkeley to serve in U.S. Army intelligence. While interrogating German prisoners of war, he stumbled on the trail of the hidden regalia of the Holy Roman Empire, which had been confiscated by the Nazis. The story of his pursuit of the regalia is told in Sidney D. Kirkpatrick, *Hitler's Holy Relics: A True Story of Nazi Plunder and the Race to Recover the Crown Jewels of the Holy Roman Empire* (New York: Simon & Schuster, 2010).

[23] Dale V. Ford (1919–1979), trained as an architect at the University of Michigan, joined the other monuments men as officer in charge at the Heilbronn and Kochendorf salt mines in August 1945. His wide-ranging assignments earlier in the war included a central role in the scheme to fool the Germans into believing the Allied landings would take place at Calais rather than Normandy. After the war he returned to the Kendall School of Design in Grand Rapids, Michigan, to pursue a successful career in furniture design.

[24] Harry Ettlinger (1926–2018) was born to a family of department store owners in Karlsruhe, Germany, which he left the day after his bar mitzvah in 1938 to escape Nazi persecution. He was the author's jeep driver and translator during the war. He is mentioned again in Chapter 8 in connection with his successful efforts to recover his family's print collection confiscated by the Nazis. For additional information, see Robert M. Edsel with Bret Witter, *The Monuments Men* (New York: Hachette Book Group, 2009).

[25] After accomplishing the first solo flight across the Atlantic in 1927, Charles Lindbergh was widely criticized as a Nazi sympathizer before World War II. After Pearl Harbor he offered his services to the United States and flew numerous combat missions as a civilian in the Pacific theater.

[26] The title Dr. Ing. may be used by a holder of a German doctorate degree in engineering. It is an abbreviation for Doktor der Ingenieurwissenschaften.

[27] John Nicholas Brown II (1900–1979) was the heir to a financially successful family; his ancestors are best known today as the founders of Brown University. After training at Harvard and military service in both world wars, Brown enjoyed a long career as a philan-

thropist and advocate for cultural policy. His son, John Carter Brown (1934–2002), was director of the National Gallery of Art in Washington, D.C. from 1969 to 1992. Lucius D. Clay (1898–1978), deputy to General Eisenhower in 1945, went on to become military governor of the United States Zone in Germany in 1947–49; in that role, he orchestrated the Berlin Airlift in 1948–49 when the Soviets blockaded West Berlin.

[28] Mason Hammond (1903–2002), the first of the monuments officers. See also pages 18 and 332.

[29] *The Stuppach Madonna* (1516) by Matthias Grünewald (1470–1528) ranks with his *Isenheim Altarpiece* (1512–16) as one of the artist's great works. It has been returned to its home in the parish church of the Coronation of the Virgin in Stuppach, which is a district of Bad Mergentheim, Germany. The *Isenheim Altarpiece* was also looted and hidden in the cellar of the Alsatian Château du Haut-Koenigsbourg. Monuments officer Marvin Ross discovered it there. Today it is in the Musée Unterlinden in Colmar, France.

[30] In addition to extended collaboration with the author, Calvin Hathaway (1907–1974) participated in many other successful recoveries accomplished by the monuments men. Trained as an art historian at Harvard and New York University, he later returned to civilian life and retired as curator of decorative arts at the Philadelphia Museum of Art in 1973.

[31] The Grossdeutschland Regiment was an elite unit of the German army formed in 1921, which served primarily on the eastern front from 1939 until the end of the war.

[32] The term "Gauleiter" is roughly equivalent to district governor in the Nazi hierarchy.

[33] The author is referring to the golden saltcellar originally designed by Benvenuto Cellini for Cardinal Ippolito d'Este and later executed by Cellini in France for King Francis I. Known in Italian simply as the *Saliera*, it portrays intertwined figures of the god of the sea and the goddess of the earth set with precious stones. After its return to the Kunsthistorisches Museum in Vienna, it was stolen again in 2003 but was ultimately returned in 2006.

[34] Victory in Europe Day, which is celebrated in the United States on May 8, marked the end of the war in Europe in 1945.

[35] For more about Count Wolff-Metternich, see Chapter 3, note 11. For more about Bunjes, see note 17 above.

[36] Heinrich Himmler (1900–1945) was one of Hitler's senior officers. As head of the SS, he was among those directly responsible for the Holocaust. He looked to mysticism for support of his racist theories and founded the SS "institute" known as the Ahnenherbe, meaning "inheritance from the ancestors." Through this unit he pursued far-fetched theories intended to prove German racial superiority, including an expedition to Tibet led by the SS zoologist Ernst Schäfer in search of a lost Aryan tribe. See Bettina Arnold, "The Past as Propaganda: Totalitarian Archaeology in Nazi Germany," *Antiquity* 64, no. 244 (September 1990): 464–78; Heather Pringle, *The Master Plan: Himmler's Scholars and the Holocaust* (New York: Hyperion, 2006). Following his capture, Himmler committed suicide in May 1945 by swallowing a cyanide capsule.

[37] Among the finest German paintings of the Renaissance, the multiple panels of Altdorfer's *Sebastian Altar* (completed 1518) are now once again located in St. Florian's Priory near Linz, Austria, except for the parts sold by the monastery between the wars to the Kunsthistorisches Museum in Vienna.

[38] The Nazis had instructed Toldy to prepare and escort the Hungarian Gold Train, which contained huge quantities of property seized, in part, from Jews murdered in the Holocaust, primarily at Auschwitz-Birkenau. Although the valuables were in large part secured by the Allies, restitution became a subject of continuing litigation. Today, rumors continue to persist that another such "Gold Train" still lies hidden under a mountain in Poland.

[39] More than 50 kings of Hungary since the Byzantine era (c. 1000) were crowned with the Royal Crown of Hungary, also known as the Holy Crown of St. Stephen.

[40] The term "POW" is now more commonly used as an abbreviation for prisoner of war.

[41] Ferenc Szálasi, an ardent Hungarian fascist and leader of the Arrow Cross Party in Hungary, served as the Nazi-supported prime minister of Hungary for a short period at the end of the war. After escaping the Soviets, he was captured by the Allies, tried, and executed for war crimes in 1946. One theory holds that the elaborate charade described in this passage was part of a plot hatched by Szálasi to hide the jewels, with the help of Colonel Pajtas, pending his hoped-for return in glory to reclaim the leadership of Hungary after the war. See Kenneth D. Alford, *Nazi Plunder: Great Treasure Stories of World War II* (Cambridge, Mass.: Da Capo, 2001).

[42] Assistant chief of staff, Intelligence.

[43] The Signum Laudis (Sign of Praise) was originally a military decoration of the Austro-Hungarian Empire known as the Military Merit Medal. After World War I, upon adoption by Hungary, the medal displayed the Holy Crown of St. Stephen in lieu of the crown of the emperor.

[44] As it turned out, the crown enjoyed an extended stay in Fort Knox, Kentucky, home of the U.S. gold bullion depository, owing to Cold War tensions with the Soviet Union. The crown was finally returned to Hungary in 1978 after President Jimmy Carter negotiated appropriate safeguards. It is currently on display in the Hungarian Parliament Building in Budapest.

[45] Joachim von Ribbentrop (1893–1946) was Hitler's foreign minister. Ribbentrop's name is attached to the Molotov-Ribbentrop Pact, the notorious Soviet-German non-aggression pact of 1939, by which Hitler tricked Stalin into giving him a free hand in Poland, and much of the rest of Europe, until he turned to attack Russia less than two years later. Ribbentrop was tried at Nuremberg and executed in 1946. See William L. Shirer, *The Rise and Fall of the Third Reich: A History of Nazi Germany* (New York: Simon & Schuster, 1960).

Rosenberg Repositories

DISCOVERING THE HIDING PLACES OF
THE NAZIS' LOOTING TASK FORCE

AREA AROUND NEUSCHWANSTEIN CASTLE, 1944

Area in Red is Territory Claimed by the Nazis

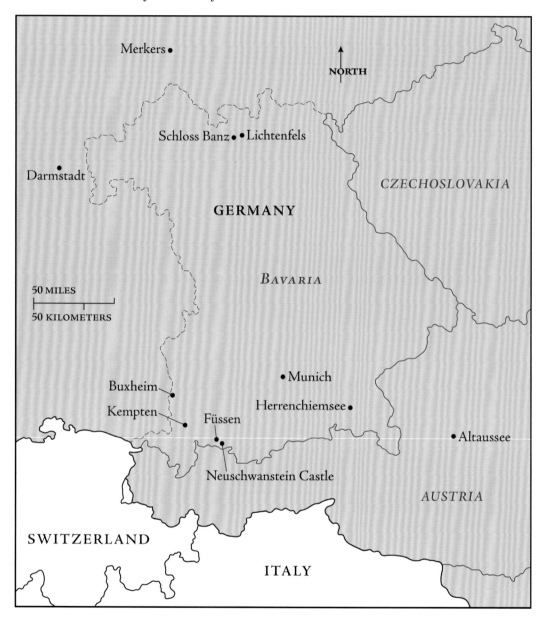

Merkers •

↑
NORTH

Schloss Banz • • Lichtenfels

• Darmstadt

CZECHOSLOVAKIA

GERMANY

BAVARIA

50 MILES

50 KILOMETERS

• Munich

Buxheim •

Herrenchiemsee •

Kempten • Füssen •

• Altaussee

Neuschwanstein Castle

AUSTRIA

SWITZERLAND

ITALY

PREVIOUS SPREAD
Neuschwanstein Castle,
c. mid-20th century.

The author describes his progress as the Allied armies worked their way south in Germany, through areas of continuing enemy resistance, toward the principal hiding and processing locations of Alfred Rosenberg's official Nazi looting operation at Neuschwanstein Castle and the other repositories near Füssen. Three factors lent a sense of urgency: the risk that retreating Germans (or, for that matter, friendly troops) would damage or steal surviving cultural property and records; the arrival of Soviet troops, who were approaching rapidly from the east, intent on vengeance and collecting reparations for the death and destruction so recently suffered at the hands of the Germans; and ongoing risks to bombed out and unprotected structures and artifacts from exposure to the elements.

THE SUICIDE OF BARON VON BEHR

While we were still near Darmstadt, a message came to our headquarters concerning Baron Kurt von Behr, the most despised of all the Germans implicated in the confiscation of works of art in France.[1] It stated that he was in the small town of Lichtenfels, north of Bamberg, and now American territory. Rose Valland and others in Paris had told us many things about this Goering satellite. He was the director of the Paris office of the Einsatzstab Rosenberg, as well as a Red Cross official. Members of his staff wore uniforms resembling those of the SS and frightened the French on many occasions.

Von Behr's vanity was much in the Goering manner. The Einsatzstab Rosenberg photographer took time off from photographing works of art to court favor by catching von Behr in various uniforms and from various angles, but even he became impatient at the continued insistence upon new poses. The camera did not spare the features of this overstuffed, dissipated, and haughty dandy, who led the Rosenberg gang with a determined hand.

We were shorthanded at Darmstadt and I was unable to get away to make the long trip to Lichtenfels. I sent a telegram to Supreme Headquarters at Versailles giving details and requesting that someone be sent to help handle the case. Some days later I learned that the telegram was being held at Sixth Army Group headquarters at Heidelberg, pending word from me as to whether I had originated it, and whether it should be forwarded "Routine" or "Priority." It was unnecessary to answer these momentous questions. By that time Baron von Behr and his wife had acted out their Wagnerian roles. They had drunk champagne—1928 vintage—liberally dosed with poison. Von Behr's was one of the first of these suicides that we encountered, and if it accomplished no other purpose it did put us on our guard lest there be others.

The baron had been living in his castle, the Schloss Banz, and thousands of books and documents were found stored in readily accessible parts of the castle's cellars. Others were discovered in a cement-covered steel vault five stories underground.[2]

WAITING FOR COMBAT OPERATIONS
TO CLEAR THE WAY

Rose Valland had assured me that Füssen, south of Augsburg near the Austrian border, was the center for the Einsatzstab Rosenberg activities in Germany. It was there that the great shipments from France were sent during the years from 1940 to 1943, and where the archives and inventories were assimilated and prepared. I visited the War Room in G-3 (Operations) daily and tried to determine the course of the battle. On April 28, *Stars and Stripes*[3] announced that troops under the Seventh Army had arrived at Kempten, 25 miles northeast of Füssen. No one in the various staff rooms could confirm the report, and the War Room was occupied at the moment by Lieutenant General Patch and his staff.[4] I telephoned ahead to Major Dickson, the G-5 (Intelligence) at VI Corps, and told him of the *Stars and Stripes* story. He told me that the information was incorrect. "But," I persisted, "if there's any truth to it at all, our troops ought to be in Füssen pretty soon." I went on to tell the major about the castles of Neuschwanstein and Hohenschwangau, which were reliably reported to contain invaluable caches of looted works of art from France and related documents. "I've been on the trail for months," I explained. "I must get there at the earliest possible time." Dickson promised to keep us informed of the tactical situation and to do what he could to check on this and subsequent reports.

Requests for Guidance Pour In

Interest in art, particularly looted art, was gradually increasing among officers and enlisted men of all ranks and echelons who saw the latest reports of every kind of captured enemy material. There were works of art everywhere, and information poured in faster than our limited personnel (my corporal and I) could handle it. The lure of discovering hidden art treasures, together with the desire for the sure-fire attendant publicity, appealed to many commands. For weeks we were swamped with requests for guidance in the handling of newly discovered works of art, and we had to choose among those requiring immediate action.

A Reconnaissance Expedition

A young corporal who kept the war map in G-4 (Supply) Operations, Captured Enemy War Material, showed me on one of my frequent visits how it might at last be possible to get through to Füssen. It was 300 miles away. According to the most recent reports from G-3 (Operations), it was now under American control, although the route to this forward position was still surrounded by German pockets that could easily cut off the road. A three-day reconnaissance from which I had just returned had taught me caution. It effectively dampened my ardor for being at places as soon as they came into Allied possession.

I had planned the trip so that we would reach the castle at Neuenstein before night.[5] When we reached the Kocher River we found that the bridges had all been destroyed. My driver had been sent back from

the front to recover from battle fatigue; but now, driving through territory that was at least partially in enemy hands and with night fast approaching, his nerves (and mine) were becoming increasingly jumpy. We were driving in circles through a thick forest and twice went through the same smoldering village. The few remaining inhabitants, huddled in a battered house, misdirected us back to the center of the woods. We came across a signpost at a crossroad, but the arrows pointed in five different directions and it was too dark to read any of them.

We set off in what I hoped was the direction we had come from that afternoon. A few miles down the road the U.S. Army fortunately put in an appearance. We found two GIs walking near an encampment. They put us up for the night, and the following morning we were directed to drive along the bank of the Kocher River until we found a spot where we could cross. We were mystified when the tracks we had been following suddenly gave out, but at that point a truck also bound for the other side of the river lumbered up and piloted us through the swiftly rushing waters.

Safeguarding Monuments at Rothenburg

Among other places, we visited Rothenburg, the most famous medieval walled city in Germany. Aside from the 16th-century town hall and the modern sections, the town was less damaged than any I had seen since crossing the Rhine, except Heidelberg. The military government officer there was wholehearted in his acceptance of my suggestions regarding the safeguarding of monuments. He returned to the church the great Riemenschneider altarpiece from the damp cellar in which it had been stored.[6] I derived a great deal of satisfaction from being able to report to the press that the destruction to this tourist mecca had been vastly exaggerated.

More Repositories on the Way to Füssen

Shortly afterward our command post was moved to Gmünd. There we were only 120 miles from Füssen. During the first 48 hours I made trips to a dozen repositories and brought back reports about many cultural objects needing attention.

On May 1 word came through that the castles at Füssen had been taken. And now, of all times, I was unable to get a vehicle. Our command expected to move momentarily to Augsburg, or perhaps even to Munich, and all conveyances would be required. In the absence of the chaplain, I unburdened myself to a Red Cross worker in an adjoining office. He told me that he had plenty of vehicles and could lend me a jeep. There was no regular driver available, but I wasn't going to let this little detail deter me. I did the necessary first-echelon maintenance checkup and prepared for the journey. My corporal, John Skilton, volunteered to go along.[7]

A STOPOVER AT BUXHEIM

Rose Valland had given me a notation that at Buxheim, in the vicinity of Memmingen, there were "two repositories activated in 1943 for stor-

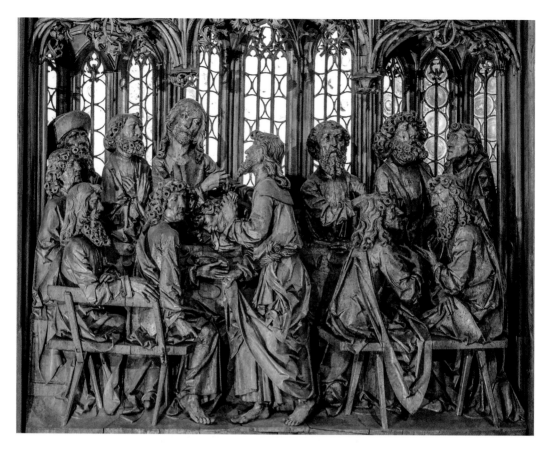

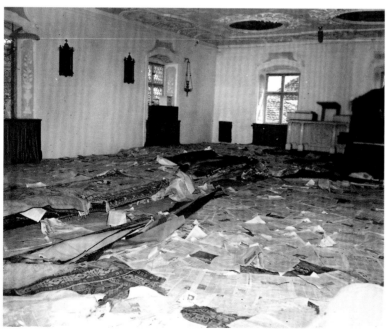

ABOVE
Central panel of the
Altar of the Holy Blood,
1499-1505, by Tilman
Riemenschneider in the
Church of St. James
(St. Jakobskirche),
Rothenburg, Germany.

LEFT
The chapel at Buxheim
in Germany was filled
with rugs, tapestries,
and Coptic textiles
taken from French
collections by the
Nazis, 1946.

ing the overflow from Füssen. A considerable number of paintings had been shipped to these repositories." Memmingen was on our route, and when we arrived there I spoke to the first deputized German policeman I saw. He told us with no hesitation that a couple of miles away, in the Carthusian monastery, the Nazis had carried on substantial activities in connection with shipments of works of art from France and other countries. We set out immediately for Buxheim.

At Buxheim the American guards and the military government authorities knew little about 72 packing cases in a room entered by a side door of the sprawling monastery. The room had been broken into by vandals, and the guards were intent on the security of some merchandise removed from French dry goods stores. Glancing about, I saw cases stamped with the symbol "D-W," representing the collection of Michel David-Weill, president of the Museums of France. One case had been opened, and well-known bronzes from the collection were standing about.

The main entrance to the monastery was in the courtyard behind closed gates and had not been noticed since the arrival of the Americans. I rang the bell. I had a long wait in the vestibule; then Max Scholz, the resident director of the monastery since 1938, appeared. He was obviously uncomfortable at having to deal with an American, and at the first opportunity he dashed off on the excuse of finding Otto Lentner, the superintendent of the repository. These two old men were reluctant to discuss the cases with French labels found in the building by our troops. After considerable prodding, we began the search for art treasures.

The corridors were stacked with Renaissance and 18th-century furniture—good, bad, and indifferent. Some of the objects were in cases; others were not packed. Ethnographical materials from Russian museums, Kiev in particular, were disappointing. A priest, 13 nuns, and bombed-out children had taken refuge in the monastery. A room used as a dormitory by the 22 refugee children, without regard for the choicest of furniture, was an appalling sight. Bric-a-brac, pottery, ornaments, paintings—everything imaginable—occupied other rooms. Some things were neatly placed on shelves; others had been stacked wherever there was room. The floor of the large chapel of the monastery was covered about 8 or 10 inches thick with rugs and tapestries. Among them were some of the Rothschild textiles taken from the walls and floors I had found denuded in their Paris and country homes.

Discovering the ERR's Conservation Workshop
Scholz and Lentner were uncommunicative, but they did lead us to Martha Klein, the restorer from Cologne. At first she was very excited and probably frightened. But after a few minutes of ordinary conversation, she began to speak with no sign of fear. She talked so rapidly that I was unable to put down all the places and names she mentioned. We accompanied her into a two-room suite where she was living with her child and other members of her family. Personal possessions, cameras, paintings, and restorer's equipment were spread around in a disorder scarcely equaled by the average Montmartre artist's atelier. There were two large vats in the

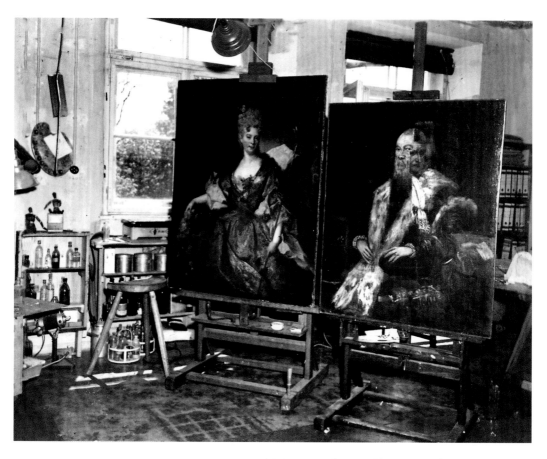

LEFT, TOP AND BOTTOM, AND BELOW Art restoration workrooms of the ERR at the Buxheim Monastery, c. 1946. In photo opposite top, at left is *Portrait of a Woman as Astrea*, c. 1710–12, by Nicolas de Largillière, today in the Montreal Museum of Fine Arts; the painting at right is by Tintoretto, c. 1518–94, which was painted over another painting said to be by "Passeri." In photo below, the Tintoretto is in the corner.

RIGHT This Rembrandt was protected from fire while inside a Munich bank vault where it had been hidden by Nazis. It was later transferred to the ERR restoration workrooms at Buxheim.

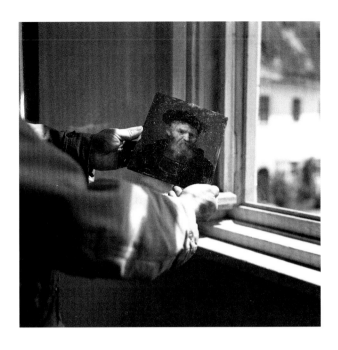

room containing the milk used for relining canvases.[8] This was the main restoration center for the ERR. Martha's husband, Otto Klein, was in the Elizabeth Hospital at Memmingen, but it seemed that the only reason for his being there at this time was his inability to get through because of the roadblocks. His wife was continuing as best she could with the restorations. A small painting lying carelessly on one of the tables seemed particularly good. Frau Klein explained that this was a Rembrandt brought from Munich after the great fire. She had no record of its actual source, but she believed that it had been found in a bank vault. I told her that restoration would have to cease at once; first aid to paintings could be continued. The Allies could assume no responsibility for turning Tintorettos into Titians, or satyrs into harmless beasts of the forest. I asked to see the records of the paintings brought to Buxheim for restoration. Martha Klein handed me two binders with listings of all the paintings that had come to their workshop. Those no longer there had been tallied out. Only the best of the looted paintings were being restored by the Kleins.

There are few museums in the world that could boast a collection such as the one we found here. Works of art could no longer be thought of in ordinary terms—a roomful, a carload, a castle full were the quantities we had to reckon with. The following list, though incomplete, gives some idea of the importance of the 158 paintings remaining at Buxheim.[9]

3 Largillières
4 15th-century paintings (3 Italian, 1 German)
1 Cuyp
1 Van Loo
6 Bouchers
1 Nattier
4 Watteaus and School of Watteau
7 Fragonards
1 Vlaminck
2 Delacroix
2 Goyas
4 Davids
3 Hubert Roberts
2 Le Bruns
1 ter Borch
1 Metsu
1 Palma Vecchio
2 Joshua Reynolds
2 Gainsboroughs
2 Lancrets
1 Guardi
1 Greuze
1 Murillo
1 Massys
3 Teniers
2 Renoirs

Later that day I saw Otto Klein in the hospital. His wife, somehow passing the roadblock, arrived by bicycle and was in the courtyard when I came. They confirmed previous information I had about Füssen and other ERR repositories and told me that the salt mine at Altaussee was the richest of the deposits of looted art. I picked up Major Eugene P. Walters of Los Angeles, commanding the military government detachment, and we returned to Buxheim to establish security for the objects there. The military guard was increased and all civilians except those we specifically authorized to live there were cleared out. Major Walters had not previously been to the monastery, and he was now as excited by the discovery of the ERR cache and the need for its supervision as I was.

Lieutenant Colonel Rowe, our property control officer, arrived at Memmingen with Majors Cartier and Ryan of Sixth Army Group to investigate the financial structure of this and other communities. That evening we discussed my opposition to having the works of art in the monastery removed at once without adequate personnel in the manner of the Merkers salt mine. At the moment, I assured them, security was all that was required. The next morning these officers looked over the works of art and they agreed to the measures I had suggested and also to my plea that no publicity be given this find until I had had the opportunity to investigate other ERR leads.

PROCEEDING TO FÜSSEN AND THE CASTLE AT NEUSCHWANSTEIN

This delay had been necessary, if not unavoidable, but I was now determined that nothing should prevent my getting to Füssen at the earliest possible moment. I did not take the time at Kempten, which also was on our route, to investigate the reputed Nazi archival repository at Miesbach. We stopped just long enough to give the local military government detachment the information I had received from SHAEF.

The fairy-like castle of Neuschwanstein near Füssen had been built in a fantastic pseudo-Gothic style by the "Mad King" Ludwig of Bavaria.[10] As we approached it from the north through an open valley, it looked in its mountain setting like a prototype of all storybook castles. It was a castle in the air come to life for egocentric and mad thirsters after power, a picturesque, romantic, and remote setting for a gangster crowd to carry on its art-looting activities.

We drove on to Füssen, where we were joined by the public safety officer of the local military government detachment and Major Duncan of the 20th Armored Infantry Division, and then continued on our way to the castle. At the entrance to the castle there were two cannons mounted on armored cars on either side of the great iron doors. The sergeant of the guard reported that the castle had not been fortified by the Germans and that we had taken it without difficulty. A couple of shotguns, which appeared to be the extent of Neuschwanstein's armament, had been surrendered to our troops. As the result of the telephone

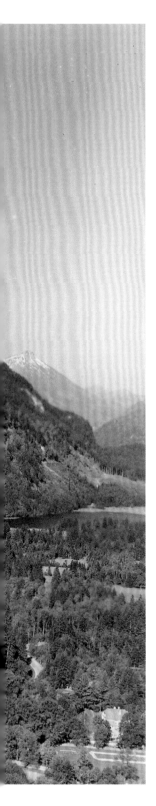

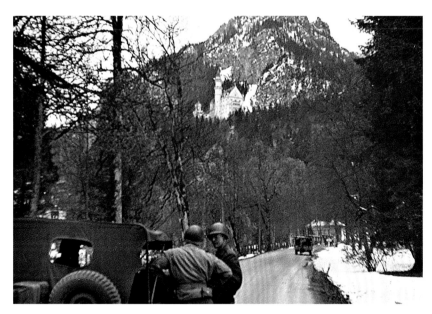

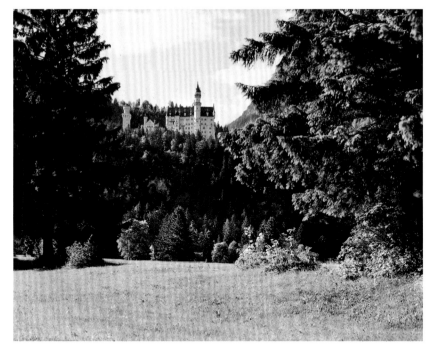

LEFT
The town of Füssen, Germany, where Neuschwanstein Castle is located, c. mid-20th century.

TOP AND ABOVE
American GIs and jeeps on the road to Neuschwanstein, c. 1945. The author took both photos on his first approach to the castle.

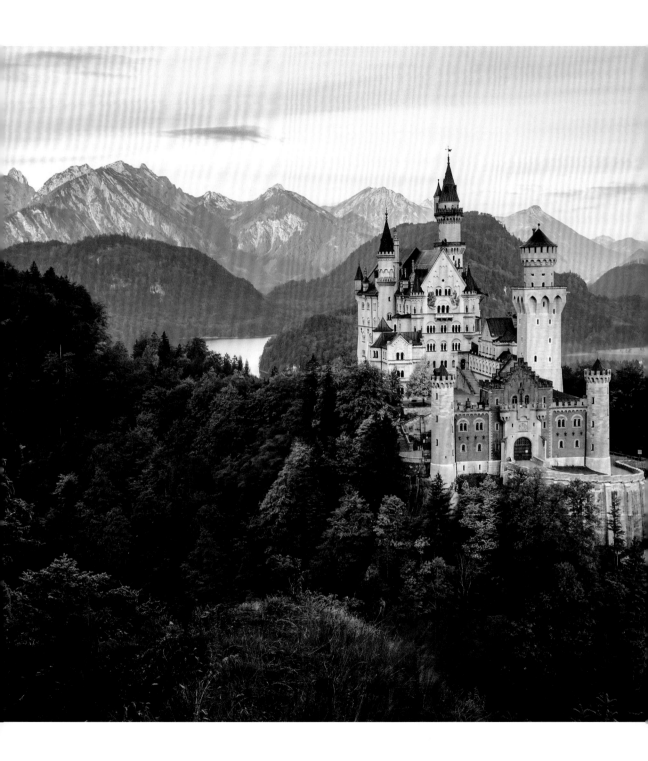

Neuschwanstein Castle.

call I had put through to VI Corps, the castle had been placed off-limits, and orders had been issued that no one, regardless of rank, was to enter until I arrived.

Apparently the Nazis had found it expedient to trust one of the God-fearing old retainers for housekeeping and internal security; one of their own men would have required constant Gestapo supervision. Christoph Wiesend, the acting chief custodian, had been at the castle since 1931 as an employee of the Administration of Bavarian Castles.[11] The alarms and other protective equipment were kept in splendid condition by a squad of men stationed in the castle, and the guards went their appointed ways seemingly unmoved by the changes in the world outside.

FIRST REVIEW AT NEUSCHWANSTEIN CASTLE

Wiesend acted as our guide. Skilton, a group of representative military government and security troops, and I started off to explore the castle. From the lower court, where American guards were on duty, we climbed a long flight of steps to a second court surrounded on three sides by the wings of the complicated structure. The verticality of the surrounding mountains was repeated in the structure of the castle, so that in going from one series of rooms to another, one had the feeling of climbing up the mountainside. When we reached the second level, one of the watchmen produced the usual large cluster of keys, unlocked a door, and we proceeded upward. At the end of this flight of exterior steps,[12] we came to a room stacked to the ceiling with boxes and crates. Observing security procedures suitable for a safe deposit vault, one of Wiesend's men locked the door behind us. The boxes were stenciled with the telltale "ERR" and other letters and numbers. I wouldn't have wanted to have been alone; the thick walls with their tiny windowed apertures closed in around us.

The Storage Rooms
We continued our climb up the next winding spiral staircase, and at the top still another door was opened and locked behind us. Except for the throne room and a few other rooms in the state apartments, all available space was used. Works of art were everywhere, most of them marked with Paris ciphers. Confusion indicated that this repository was being emptied when the Nazis had vanished a short time before the arrival of our troops. Here, and on the floors below, racks and specially prepared rooms recently plastered had been partly filled with paintings, rare furniture, tapestries, and other treasures confiscated from France.

In addition, there were 1,300 paintings that had been sent here by the Administration of Bavarian Castles. These were from the Munich museums and the Residenz and the private collections of the royal Bavarian Wittelsbach family, and had been deposited here before the place was used by the ERR. In several of the rooms we found the art libraries of Paris collectors. Thrown behind and between the books were rare

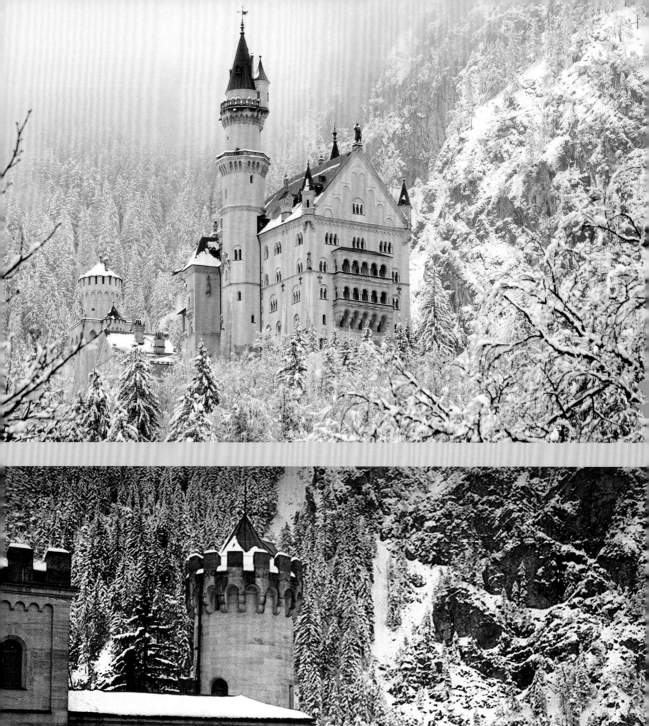

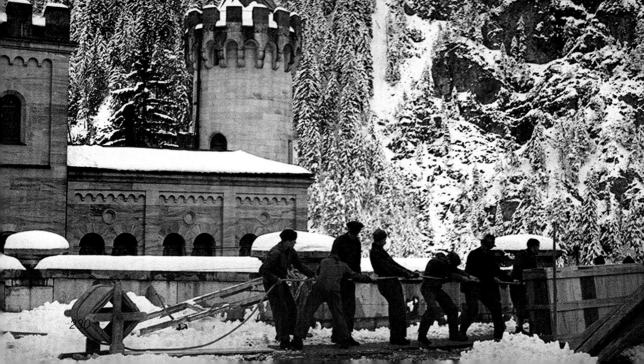

NEUSCHWANSTEIN CASTLE

Neuschwanstein Castle was used by the Nazis as a major collecting point for stolen art. By the time the author arrived at the castle in 1945, it was absolutely stuffed full of art, decorative objects, furniture, and countless other valuables. Almost as important were the card files and other records created by the Einsatzstab Reichsleiter Rosenberg (ERR), which Rose Valland told the author he would find there. By saving these records from destruction by Nazis in retreat, the monuments team laid the foundation for the immediate work of assembling and repatriating much of the looted property to the original individuals and institutions from whom it had been stolen.

In the decades since the ERR records were discovered at Neuschwanstein, the field of provenance research has expanded significantly. However, it would take many decades before modern developments and the implementation of laws in the 1990s made it possible for survivors and their families to claim Holocaust-era assets, followed soon afterward by broad international adoption of the Washington Conference Principles on Nazi-confiscated Art.

By the end of the 1990s, heirs to seized collections had successfully asserted claims against several museums where looted property was discovered. In due course, the fabulous sums brought by auction sales of liberated artworks inspired a variety of art-world players to join the hunt. The ongoing digitization of provenance records has facilitated the progress of these efforts. The ERR file cards are now part of a single portal of international Holocaust research resources in the U.S. National Archives.

ABOVE
Art being moved down castle steps on a wooden skid.

TOP
Neuschwanstein Castle was built by Ludwig II, King of Bavaria, in the late 19th century to resemble the fantasy castle of a medieval knight (probably Parsifal, the knight of the Holy Grail in Arthurian legend). *Parsifal* was the last opera by Richard Wagner, whom Hitler greatly admired and with whom Ludwig II had a friendship.

BOTTOM
Monuments men and other workers used a system of pulleys and wooden skids to lower crates of artworks down the steps of the castle.

ABOVE LEFT AND RIGHT
Besides works of art, the monuments men recovered highly detailed files and registers of 40,000 objects confiscated by the ERR in France and Belgium. These records were critical in the process of locating the individuals and institutions from whom the artworks had been stolen.

BELOW
An inventory card from the ERR files for the middle painting being carried down the steps of Neuschwanstein in the photo on page 236. On the card, the initials "M.W." in the box at upper right indicate that it came from the collection of Max Wasserman.

RIGHT, TOP LEFT
Silver and other precious objects found at Neuschwanstein. They had been confiscated from the David-Weill Collection.

RIGHT, TOP RIGHT
Neuschwanstein contained some of the rarest tapestry fire screens stolen from the homes of the Rothschilds in Paris.

RIGHT, BOTTOM
Adriaen Brouwer, *Peasants Playing Cards in a Tavern*, c. 1635. Alte Pinakothek, Munich. This painting is similar to, if not the same as, the Brouwer from the Wasserman collection seen on page 236 (middle) that was returned to France and restituted on November 13, 1945.

LEICA-PHOTO	KÜNSTLER	HERKUNFTSLAND	DATIERUNG		INVENTAR-NR.	
	Adriaen Brouwer				M.W. 45	
	LEBENSZEIT	geb. 1605 in 06 in Oudenaarde				
		gest. 1638 in Antwerpen				
FILM-NR.	GROSSFOTO	AUFBEWAHRUNGSORT	WERT	INV. NR. ALTE SLG.		AUS KISTE NR.
BILD-NR.						

THEMA BZW. GEGENSTAND	
BESCHREIBUNG	Kartenspielende Bauern in einem Wirtshaus. Auf dem Tisch ein grünes Tuch. Durch die geöffnete Tür Ausblick in eine flämische Landschaft. Rechts an einem Kamin Mann und Frau in Unterhaltung.

MATERIAL	GRÖSSE	GERAHMT FASSUNG	BEZEICHNET SIGNATUR	VERBLEIB
Öl auf Holz 32,3 x 42,6 cm parkettiert			unbezeichnet	

ZUGANGSTAG	STANDORTWECHSEL	ZUSTAND BEHANDLUNG (AUCH UMSEITIG)	BEMERKUNG
IN PARIS : 20.3.41			HERKUNFT SCHRIFTTUM (UMSEITIG)
IM REICH :			

EINSATZSTAB RR, Sonderstab Bildende Kunst, Berlin W 9, Bellevuestr. 3

233

engravings, drawings, and paintings. There was no time to look closely at any individual works of art; there were too many extraordinary objects of cultural value.

Behind the Steel Door

We were guided to a hidden, thick steel door, this one locked with two keys. Inside there were two large chests of world-famous Rothschild jewels and box upon box of jewel-encrusted metalwork. There were also rare manuscripts and more than a thousand pieces of silver from the David-Weill Collection and other collections.

In April 1941, 30 special baggage cars of art objects, and in October of the same year 23 carloads more, had been brought here from France. One shipment alone of these objects back to France required 36 freight cars for 1,221 crates containing 6,000 objects. I passed through the rooms as if in a trance, hoping that the Germans had lived up to their reputation for being methodical and had photographs, catalogues, and records of all these things. Without them it would take 20 years to identify the agglomeration of loot.

Securing Two Special Rooms

From here we were taken to the Kemenate,[13] a two-storied wing of the castle with its own entrance. In two coal stoves there were remains of a Nazi uniform and charred documents, one bearing Hitler's signature. Rubber stamps with ciphers used for marking shipments to the other repositories had not been consumed and were helpful in locating additional information. In one room there was the photographic laboratory of the Einsatzstab Rosenberg. The ERR catalogues and individual records of the 203 private collections from France were in filing cabinets. The private catalogues of the individual collections, often the only record of their art possession, had been taken with the collections. Three books gave the details of the shipments to the other Rosenberg repositories. And what colossal shipments they were! Even the *Ghent Altarpiece* had been sent via Neuschwanstein.

This first day's survey was necessarily brief, and it was not until the following day that I recognized the 8,000 negatives and individual catalogue cards for the 21,903 recorded confiscations. We could take no chances on any harm coming to these irreplaceable records. We decided that neither the German nor the American guards could be permitted to enter these two rooms under any circumstances. Toward that end we nailed down the trapdoor in the floor, which connected with secret escape ladders, and covered it with a heavy steel trunk. We locked the doors behind us, and as a field expedient I took one of the antique Rothschild seals—"SEMPER FIDELIS"—and sealed the doors with sealing wax and cord.[14] I retained the seal but gave the key to the American sergeant of the guard. With these precautions any forced entry would not be long undiscovered. The German guards were all instructed to check the seals on their periodic rounds.

TOP
In addition to loot, the castle held some of the great Munich collections that Nazis deposited there for protection from Allied bombing raids, including the work at left by Anthony Van Dyck, *The Marquis of Mirabel*, date unknown. Alte Pinakothek, Munich.

BOTTOM
The author and Sergeant Anthony T. Valim examine some of the Renaissance jewelry and 18th-century snuff boxes from the Meurice de Rothschild collection. In the foreground is a silver tureen from the David-Weill Collection, May 1945.

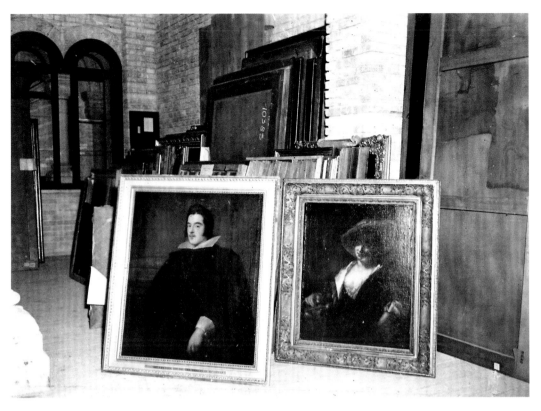

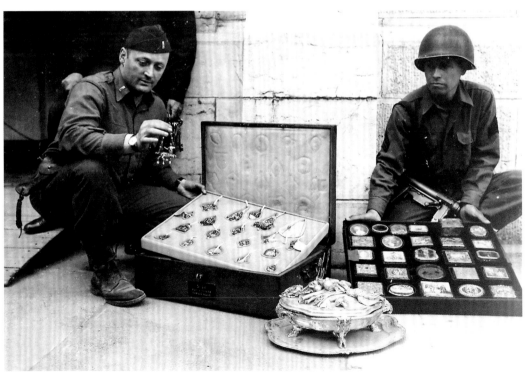

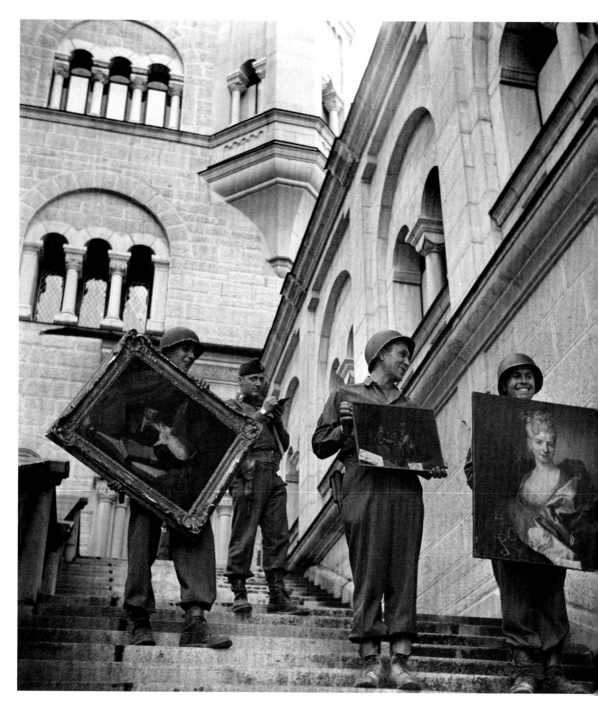

The author (on top step) overseeing the removal and eventual restitution of art at Neuschwanstein Castle, May 1945. Here he is posing with unidentified soldiers and three paintings: at far left is one by Jean-Baptiste-Siméon Chardin(?); at center is *Peasants Playing Cards in a Tavern* by Adriaen Brouwer, c. 1635; and at far right is a painting by Nicolas de Largillière.

Finding Lohse and Schiedlausky

Downstairs, I stopped to look through the register used by the Germans, hoping I would come across some familiar names. I had memories of Rose Valland's descriptions of some of these people, notably Dr. Günther Schiedlausky and Dr. Bruno Lohse. As I looked over the lists I overheard a gray-haired German peasant, who had arrived to go on his guard shift, remark that he had seen "the doctor in the village last evening." The doctor could mean Schiedlausky, whose name headed the register. If my hunch were right, here was direct evidence that Dr. Schiedlausky had been in the neighborhood less than 24 hours before. Under direct questioning, the guard admitted that the doctor might still be staying in the Bethanian nursing home in the village of Hohenschwangau at the foot of the mountain. There were thousands of Nazis living in the crowed hotels and chalets taken over by the German Red Cross and other organizations during the war. I decided to enlist the services of a "practical" CIC (Counter Intelligence Corps) agent to help me locate Dr. Schiedlausky and to minimize the possibility that he would take the same way out as had von Behr.

In approaching darkness, we drove down the steeply winding narrow road to the village. At the first house in a group that had been taken over by the Bethanian sisters I talked with the Mother in charge. She told me that Schiedlausky and Bruno Lohse had insisted on living in her home. She warned me about Lohse just as Rose Valland had. In Paris I had been told that Lohse was a most untrustworthy, double-crossing scoundrel, who would ingratiate himself with great personal charm and then turn traitor. In appearance he was the strictly Nordic type. He was moody and emphatic. As von Behr's deputy, and at the same time Goering's personal agent, he had occupied a unique position in Paris and had used his Goering connections and influence freely. He succeeded von Behr as chief of staff of the Western Division of the Einsatzstab Rosenberg.

Lohse and Schiedlausky were in another room of the house. The CIC agent and the Füssen military government public safety officer accompanied me into the room. Our approach was the normal one for the situation. We were American soldiers questioning the enemy. I made no mention of their looting activities for the moment. Both men assured me that they had already reported to the military government authorities in accordance with Allied regulations for German soldiers who had not yet been taken as prisoners of war although technically still under orders on active duty. Lohse signed his papers as a corporal in the Luftwaffe—which he actually was. He made no mention of Goering or Rosenberg affiliations in the attempt to disassociate himself from his real wartime activities.

As it turned out, we might just as well have spared ourselves the time and effort. For all we learned by our devious approach, we would have been just as well off confronting them immediately with our information. With all that I had heard about Lohse, I felt that it would be a good idea to place him in custody until I could obtain instructions from higher headquarters. It was not until June 3, almost a month after we had arrested him, that the Seventh Army received a telegram prepared

by the Office of Strategic Services (OSS)[15] in Washington instructing that Lohse was wanted, among others we subsequently apprehended.

Self-righteous, serious, and unyielding, Schiedlausky appealed to me on the grounds that he had been transferred to the Rosenberg service as a soldier ordered to do so by the commanding authorities of the Kunst-schutz. He explained that he was a scholar, serious in his desire to see that the works of art were carefully handled and catalogued. He seemed to be completely lacking in warmth until he mentioned that he wanted to marry one of the staff of the ERR. But even this sudden spark was short-lived. I told him that I knew he had behaved better than his compatriots in Paris, where he had been an appraiser for the Rosenberg loot. I gambled on his future cooperation and told him that he would be allowed to remain at liberty, with ready access to his friends. I did not even search his baggage or the premises. He was far too clever to leave anything of importance where we could find it. I warned him to be careful. A more ardent ERR member might also foresee Schiedlausky's possible coopera-tion with the Allies and end the threat. I felt certain that he would not attempt to get away; he was too well disciplined. Even if I were wrong on every count, it was not too desperate a chance I was taking. The road-blocks were preventing Germans from going any great distances.

Interviews with Schiedlausky

Lieutenant (USNR) Charles Kuhn of SHAEF and Lieutenant Colonel McDonnell of the SHAEF Mission to France returned with me on my next visit to Füssen the following week. McDonnell wanted to take back to the officials in Paris firsthand information about the progress of our discoveries. They talked with Lohse and Schiedlausky. Lohse com-plained about the miserable condition of his kidneys and the uncomfort-able life he was leading in the local jail. I discovered that Schiedlausky had been communicating with him by means of hand-processed letters and received some idea of the unpleasantness of confinement.

A few minutes later I was alone with Schiedlausky, and finally my considerate treatment of him was rewarded. As I started to leave he handed me 31 of the most extraordinary documents ever to come into my possession. In themselves they were worth my work in Germany. These papers constituted the report with summaries of the Rosenberg activities in France and elsewhere, complete as of July of that year. There were originals and some copies of letters and orders from Hitler, Goering, Rosenberg, and others. They had been carefully collected and brought from the repository at Kogl by Lohse.[16] Schiedlausky would not reveal how he had obtained them.

I could not sleep that night. I lay awake reading for hours. Then when I tried to sleep, any fatigue I should have felt was erased by my mount-ing excitement over these papers. I couldn't stop jumping from bed and referring to them. That morning I took the papers to army headquarters and sent part of their contents to Washington by radio photo. Fifty pages of mimeographed translations were sent to all interested agencies. Lieu-tenant (USNR) James Plaut,[17] an old friend who turned up in Germany

as director of the Art Looting Investigation Unit of the OSS, told me that he discussed them with Major General Bill Donovan, head of the OSS.[18] Donovan considered them the most damning evidence about Nazi looting that had been acquired. I was later consulted about them for the Nuremberg trials. Lohse and Schiedlausky were among those taken for intensive interrogation and cross-examination by Plaut's OSS unit, whose mission it was "to collect and disseminate such information bearing on looting, confiscation, and transfer by the enemy of art properties in Europe, and on individuals or organizations involved in such operations and transactions, as will be of aid to the United States agencies empowered to effect restitution of such properties and the prosecution of war criminals."[19]

Rose Valland Is Barred from Neuschwanstein

As soon as I could find the time I left on a short mission to Austria. As luck would have it, Rose Valland came to the castle of Neuschwanstein during my absence and, ironically, was not permitted to enter. The instruction I had left with the guards was that no one should be permitted to enter the castle. I was desperately sorry that I had missed her.[20]

Well-Hidden Treasures

Shortly after my return, 30 reporters and newsreel men representing the world's press came to the castle to catch a glimpse of the phenomenal treasure house. I had not attempted a search for individual works of art. As far as I was concerned, this was an intelligence and security operation until such time as the bulk of the things could be returned to the French nation.

I would have liked nothing better than to take the time to study all of these objects. It would have been particularly rewarding to go through part of the Munich Schatzkammer (Treasury) that had been brought to Neuschwanstein for safekeeping by the Administration of Bavarian Castles. I doubt if the ERR knew it was there. One of the old Bavarian keepers of the castle had confided to me that access to these treasures was hidden behind the stove in the kitchen.[21]

For the moment a few of the items—Rubens's *Three Graces* from the Meurice de Rothschild Collection and other paintings, drawings, jewels, and furniture—provided sufficient evidence for the press and various visiting firemen from higher headquarters and from the States of the need for safeguarding the castle. A Cook's tour[22] of the castle gave them an idea how great would be the task of segregating its contents. We had also returned loads of objects from the nearby area to the castle. John Nicholas Brown, sent by the War Department as adviser on cultural affairs to U.S. Group Control Council,[23] approved my suggestion that the unopened works of art remain in their cases and be returned to France as soon as restitution could be arranged.

In February of the following year, long after the Third Army had taken over the responsibility for Neuschwanstein and other Bavarian repositories captured by the Seventh Army, Lieutenant (USNR) Charles Parkhurst[25] wrote me about the Schatzkammer: "The Neuschwanstein deal on hidden treasures was even more devious, mysterious and clever

than we knew." Only some of the objects were located behind the stove. Evidently the crafty keeper had moved others to one of the labyrinthine cellars, and these objects were not found until evacuation of works of art from the castle had been undertaken.

In the 1920s I had seen these objects at the Munich Residenz, where representatives of the church, the state, and the Wittelsbach family each came ceremoniously with a key to open the doors to the room where they were kept.[25] My old friend Dr. Adolph Feulner, the onetime director of the Residenz, had been with me. He committed suicide soon after the fall of Germany.

Another Palace of Ludwig II's

On May 7, between visits to Füssen, Hathaway and I set out for the other fabulous palace of "the Mad Ludwig" of Bavaria, at Herrenchiemsee. Lieutenant Colonel Samuel S. Morse was in charge of the island, with its Versailles-like palace. There were no ERR employees there. At the castle we were shown furniture, tapestries, woodwork, and other art objects brought from the Residenz in Munich after the devastating fire that destroyed so much of the unique structure and its collections.[26]

The colonel and Hathaway wondered what magic password I used when the overseer, Köck, caretaker of the palace since 1911 for the Wittelsbach family, volunteered to show us the 300 packing cases marked ERR that had been brought here and whose existence had not yet been revealed to our troops. I had simply told the old man that I knew he had no connection with the ERR but was a paid employee of the Bavarian royal family. I brought him greetings from the economic adviser of the Wittelsbachs at Hohenschwangau. I also told him that his anti-Nazi crown prince, Ruprecht, had been liberated by the Americans from an Italian prison camp and would soon be returning as a friend of the Allies. The cases that Köck showed us contained objects of great value from Russia and Paris. In due course the contents of the boxes were carefully inventoried by Lieutenant Colonel Morse. Our troops were permitted to visit the castle, except for those rooms storing the ERR cases.

The great Altaussee repository, where Hitler accumulated many of the ERR treasures, has been discussed with the story of the salt mines.[27] The swift and dramatic piecing together and corroborating of intelligence items made it possible to locate and protect those works of art that Hitler and Goering, through their henchman Rosenberg, had intended placing in great museums for the edification of the Nazi race and the glorification of their own names.

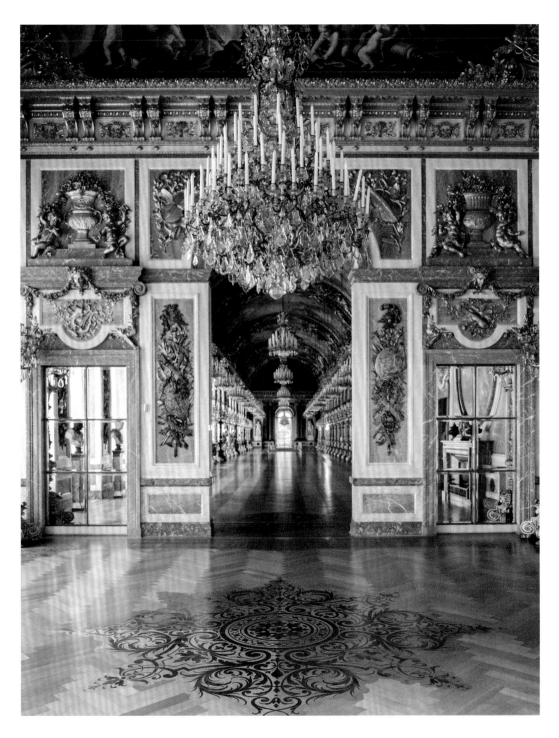

The Hall of Mirrors at Herrenchiemsee Palace. In 1878 King Ludwig II of Bavaria, builder of Neuschwanstein Castle, set out to construct yet another extravagant palace, this one based on Versailles, and located on an island in Chiemsee Lake, southeast of Munich. It was not completed until after Ludwig's death. Beautifully restored and open to the public today, its hall of mirrors is even larger than the original at Versailles.

NOTES

[1] Colonel Baron Kurt von Behr (1890–1945) was Alfred Rosenberg's deputy director in Paris. Petropoulos, *Faustian Bargain*, includes a full account of von Behr's activities in Paris. See also Hector Feliciano, *The Lost Museum: The Nazi Conspiracy to Steal the World's Greatest Works of Art* (New York: Harper Collins, 1997).

[2] This former Benedictine monastery in Bavaria survives today and offers tours of the grounds with limited access to its chapel.

[3] *Stars and Stripes* is the daily newspaper of the U.S. military. It continues to publish news relevant to the U.S. armed forces under the supervision of the Department of Defense, but with First Amendment freedoms overseen by the U.S. Congress.

[4] General Alexander "Sandy" M. Patch was a senior U.S. Army officer who served in both world wars. His son, Captain Alexander M. Patch III (1920–1944), had been killed in action the previous October. The general died of pneumonia just over a year later, in November 1945, at age 56.

[5] The castle at Neuenstein, in Baden-Württemberg, should not be confused with the better-known castle of Neuschwanstein, see note 12. Neuenstein is still standing and open to visitors.

[6] *The Holy Blood Altarpiece* (1499–1505) carved in wood by Tilman Riemenschneider, c. 1460–1531, can be seen today in St. James Church in Rothenburg.

[7] John D. Skilton Jr. (1909–1992) was an art historian trained at Yale as well as in Paris and New York. After assisting the author for two months, he finally received his commission as second lieutenant to become a monuments officer. He then took charge of the salvage of monuments in Würzburg. British bombers had very recently destroyed the historic city when the retreating Gauleiter refused to surrender. Skilton's 1948 memoir, not published in full in English until 2008, contains a remarkable account of how he won the trust of the community and achieved significant results under especially difficult circumstances. His memoir also further documents his collaboration with the author described in this chapter. John D. Skilton Jr., *Memoirs of a Monuments Officer: Protecting European Artworks* (Portland, Ore.: Inkwater, 2008). After the war, he returned to civilian life and worked for many years at Parke-Bernet Galleries (now Sotheby's) in New York City.

[8] The reference is evidently to casein, a milk derivative used in art restoration.

[9] The author did not encounter the famous 17th-century woodcarvings by the Tyrolean sculptor and woodcarver Ignaz Waibl (1661–1733), which can be seen today at the Buxheim Charterhouse. At the time of the narrative, these carvings were not located at Buxheim. They were at St. Saviour's Hospital in London, having been sold by the monastery in 1880. After multiple relocations, the carvings were ultimately returned to Buxheim in the 1980s.

[10] In the past, Ludwig II of Bavaria (1845–1886) was frequently referred to as "mad." More recent historical and medical analyses have largely dispelled the notions supporting this assertion.

[11] Now known as the Bavarian Administration of State-Owned Palaces, Gardens, and Lakes, or the Bavarian Palace Administration, this unit of the Department of Finance of the State of Bavaria continues to manage Neuschwanstein and about 45 other Bavarian castles.

[12] Neuschwanstein Castle is today a popular tourist attraction, but these particular stairs are not generally open to the public.

[13] *Kemenate* is a German term referring to the living and working rooms of a castle heated by fireplaces or stoves. The term is sometimes translated as the "women's heated apartments."

[14] Although better known as the motto of the U.S. Marine Corps, "Semper Fidelis" has been used for centuries on the crests of numerous European families and institutions.

[15] See notes 18 and 19 below and Chapter 1, note 25, for more information about the OSS.

[16] The ERR used Schloss Kogl, near Salzburg, Austria, as another one of its art repositories. The castle was fully restored in 2000 and is now open to the public for rental by the week.

[17] James Plaut (1912–1996), a native of Cincinnati, Ohio, studied art history at Harvard. After the war he resumed his position as director of the Institute of Contemporary Art in Boston.

[18] William J. "Wild Bill" Donovan (1883–1959) was the first chief of the Office of Strategic Services (OSS), which later became the Central Intelligence Agency (CIA). He is said to have complained about his nickname, which he earned in World War I, when soldiers under his command were amazed by his remarkable level of endurance and enthusiasm for battle.

[19] The Art Looting Investigation Unit was created under the OSS inter-branch directive dated November 21, 1944. The 1945–46 reports of the ALIU have been compiled by the National Archives and Records Administration, Washington, D.C.

[20] Notwithstanding this temporary setback, Valland pursued a long career in the field. See page 171 and Corinne Bouchoux, *Rose Valland: Resistance at the Museum*, English ed. (Dallas: Laurel, 2013). She remained in touch with the author throughout their postwar careers.

[21] The jewels from the Munich Treasury may be seen today at the Munich Residenz, the former royal palace of the ruling Wittelsbach family of Bavaria. See note 26 below.

[22] The term "Cook's tour" refers to any fast overview of multiple tourist attractions. The term is derived from the worldwide tours arranged by Thomas Cook & Son, a travel agency that got its start in 1841 when its founder arranged a special train to convey passengers from Leicester, England, to a temperance meeting in the nearby town of Loughborough. The company declared bankruptcy in 2019 after 178 years in business.

[23] For more on Brown, see Chapter 5, note 27.

[24] Another prominent art historian from Ohio, Charles P. Parkhurst (1913–2008) served with the author as one of the monuments men until 1946. After the war he had a long and illustrious career as a popular art educator and museum director, first at the Allen Memorial Art Museum and subsequently at the Baltimore Museum of Art. He became assistant director and chief curator at the National Gallery of Art in Washington, D.C., until his retirement in 1983. See also Chapter 8, pages 295, 301, and 314.

[25] At the beginning of Chapter 8 the author describes his first visit to Munich with his father, in 1921. At the time he would have been about 16.

[26] For several centuries the Residenz palace complex served as the seat of government of the kings of Bavaria. In 1729 substantial portions of the Residenz were destroyed by fire. Allied bombing destroyed it again in World War II. Portions of it were rebuilt in the 1980s. Today, the Residenz, along with its fabulous Treasury referred to in this chapter, are major tourist attractions in the center of Munich.

[27] See Chapter 5.

Berchtesgaden: The Goering Story

**LOCATING GOERING'S PERSONAL ART COLLECTION
IN THE MOUNTAINS NEAR SALZBURG**

7

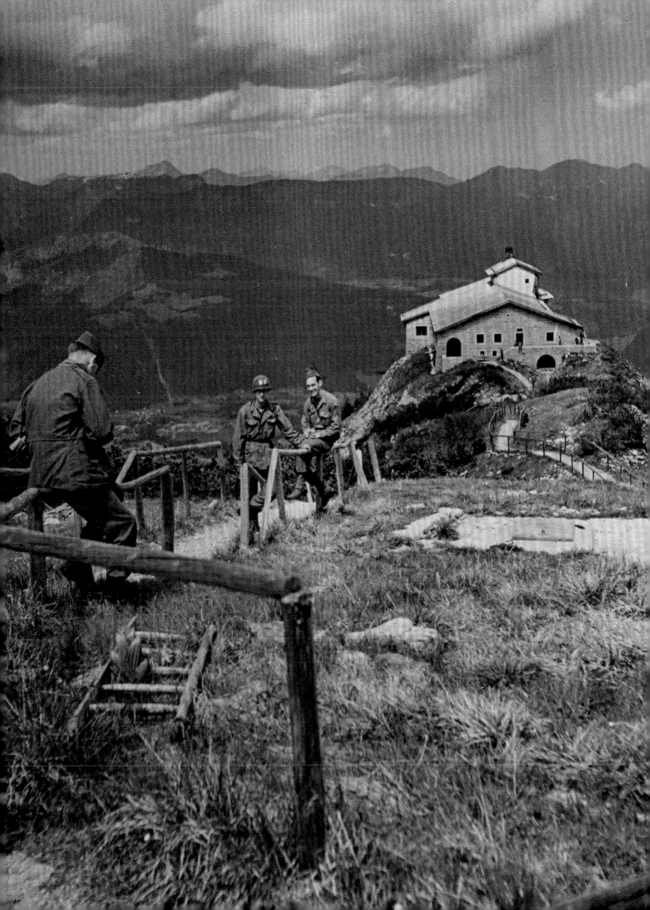

ROUTES OF HERMANN GOERING'S ART TRAINS, EARLY 1945

Area in Red is Territory Claimed by the Nazis

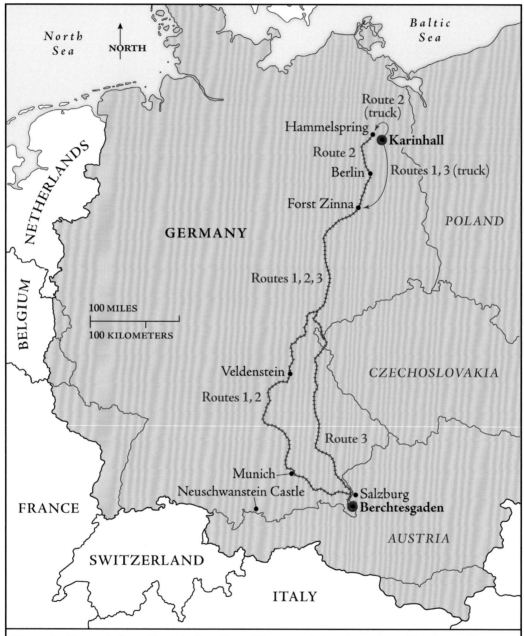

Route 1 By truck from Karinhall to Forst Zinna, and then by train to Berchtesgaden
Route 2 By truck from Karinhall to Hammelspring, and then by train to Berchtesgaden
Route 3 By truck from Karinhall to Forst Zinna, and then by train to Berchtesgaden

This chapter concerns events that occurred in the Obersalzberg region in Bavaria in the spring of 1945, at the very end of the war. The area features picturesque Alpine peaks and clear lakes and is just north of Salzburg. Given Hitler's birth in the town of Braunau, on the border between Austria and Germany; his youth in Linz, Austria; and the birth of the Nazi movement in Munich, it is not surprising that this area became both the playground and final redoubt of the Nazi High Command.

During his rise to power and throughout the war, Hitler maintained a vacation home in the Obersalzberg, in the resort town of Berchtesgaden. Known as the "Berghof," this house began as a modest cottage but expanded over time, eventually becoming the focal point for a complex of buildings and tunnels that housed quarters for senior party members and military officials. At the onset of the war, the Nazis constructed still more underground bunkers and housing for security forces, including crews to man newly built anti-aircraft defenses.

In 1937–39, Martin Bormann (1900–1945), Hitler's powerful private secretary, commissioned the construction of the Eagle's Nest (or the Kehlsteinhaus*) high on a nearby rocky outcrop known as the* Kehlstein*. Hitler never actually spent much time there because he feared the possibility of lightning strikes. He also worried about the elevator, which served as the only access to the Eagle's Nest, ascending the final 400 feet through solid rock to the top of the Kehlstein. Although Bormann intended the Eagle's Nest to be used for diplomatic receptions, Hitler's companion, Eva Braun, used it more regularly as a sunny getaway for relaxation with friends and family.[1] Today the Eagle's Nest offers tourists a restaurant and beer garden.*

At the time of the Allied invasion, Hitler rejected advice from Bormann to move to the Eagle's Nest and insisted on remaining in his Berlin bunker. As it turned out, the anti-aircraft batteries surrounding the complex were unable to train their weapons on British bombers, which flew in very low over the mountaintops, destroying the buildings aboveground in a matter of hours.

Meanwhile, as Allied forces closed in on the region around Berlin to the north, Hermann Goering fled south with his trains loaded with art.

AT THE EAGLE'S NEST

PREVIOUS SPREAD
A view of Eagle's Nest, Hitler's compound high in the mountains near Berchtesgaden, after Nazi surrender, June, 1945. Seen here are unidentified Allied soldiers.

Originally it had been agreed that 12 tanks from the French Second Armored Division were to precede our infantry in taking Berchtesgaden, playground of Nazidom. The French general in charge of the operation had used 33 tanks with an end in view that became obvious when the last tank in the column conveniently broke down in a narrow pass, thus forestalling the immediate entry of our mechanized infantry coming up from the rear.[2] The French raised their flag on the top of Hitler's Eagle's Nest, a fantastic structure on the summit of the highest crag of the Kehlstein. Here, in rooms so high up that clouds drifted through the windows, Hitler had communed with his spiritual self and his closest followers.

The French also took possession of the administrative building and the barracks for 800 SS troops adjoining the Berghof, Hitler's home, and were tasting what it was like to see nothing but ruin where once this boastful conqueror had lived. A colonel from the War Department who had been in Berchtesgaden told me in Salzburg of the unprecedented French looting and of vandalism out of control, but we could understand it. The colonel said that he had seen empty picture frames of every description in the tunnels under the homes of the Nazi leaders in Obersalzberg.

TOP AND BOTTOM
Hitler entertains
Nazi officials and
companions
at the Eagle's Nest,
July 19, 1939.

CLUES POINT TO HOFER

Rose Valland and others had provided reliable clues in the search for the Rosenberg repositories, but looking for the Goering collection was quite a different matter. Disconnected statements to the effect that Goering had "bought" many Cranachs, or other specifically named paintings, for his prospective museum at Karinhall,[3] north of Berlin, gave us no idea of the actual quantity of his acquisitions. But the 20 occasions on which Goering had made selections at the Jeu de Paume, and the letters that Schiedlausky provided me, made clear the part Goering had played personally in the wholesale looting of private collections in France. His accumulation of art treasures through purchases also attested to the importance of his collection. Bruno Lohse told me that Goering had confided the secret hiding place for his collections to no one, unless possibly to his agent, dealer, and adviser, Walther Andreas Hofer. The name Hofer meant nothing to me at the time, but the knowledge that he was Goering's agent made me determined to find him.

PRELIMINARY INVESTIGATIONS

I had but a vague notion that Berchtesgaden might be the place where the Reichsmarschall had sent his collection; it was a surmise based on the importance Berchtesgaden had played in Nazidom, together with the sketchy information about the Salzburg region in the SHAEF list of repositories. It was listed in such general terms that it was impossible to determine from maps or guidebooks where to look for the hidden caches. Baedeker[4] described a salt mine on the Salzburg road about three-quarters of a mile east of Berchtesgaden, but speculating on the picturesque countryside seemed about as fruitless as trying to guess in which vault in all of New York's banks one could expect to find a batch of stolen securities.

In the last days of hostilities troops from everywhere converged on this center of the Nazi hierarchy. Hathaway and I arrived on V-E Day. Berchtesgaden was a noted mountain resort, but above all else it had become the symbol of Nazi invulnerability. The party men who had won favor had built homes in the region in order to be readily available to accede to the whims and orders of their Führer. Hitler, Goering, and

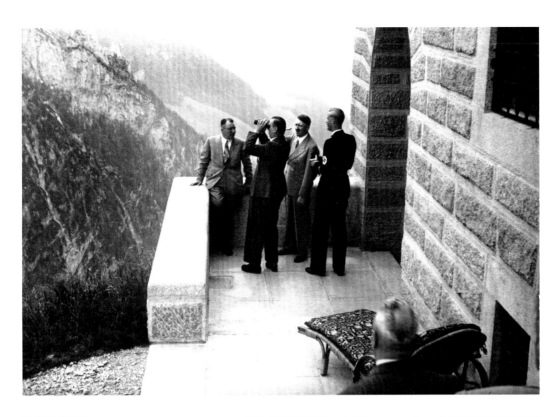

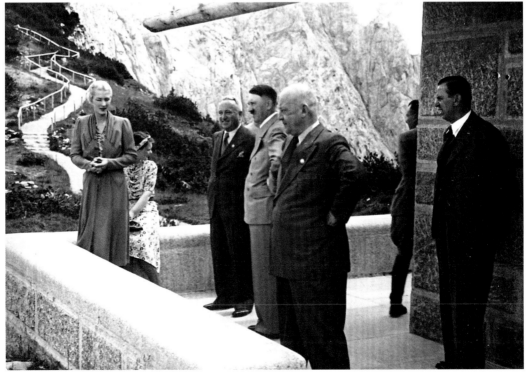

THE CAREER AND COLLECTIONS
OF HERMANN GOERING

"After all, I'm a Renaissance type," Goering declared to his U.S. Army interrogator, Major Paul Kubala, after his capture near Berchtesgaden on May 8, 1945.

Goering spent much of his youth in the home of his godfather, Herman von Epenstein, at Veldenstein Castle in Bavaria, near Nuremberg. In World War I, serving as a combat aviator, he succeeded the Red Baron as squadron leader after his predecessor was killed in the skies over France in 1918.

After World War I, like so many demobilized German troops, Goering found himself at loose ends and fell in with Hitler in Munich, where he took part in the Beer Hall Putsch in 1923. As one of Hitler's earliest henchmen, he rose to power, eventually being named head of the German Luftwaffe. In 1936 he was appointed Plenipotentiary of the Four Year Plan, designed to revive the German economy. This unique lever of power enabled him to extract endless personal concessions that made him supremely wealthy.

As early as 1940, however, Goering's glory began to fade. His vaunted Luftwaffe failed to overcome the British Royal Air Force in the Battle of Britain, where British defenses, bolstered by the invention of radar, kept the Luftwaffe at bay. These events left Goering time to pursue his favorite hobbies: hunting, model trains, and collecting art. His expanding hunting lodge at Karinhall became the ideal facility for all three pastimes.

Goering's art curator at Karinhall was Andreas Walther Hofer, who advised Goering as he amassed his collection. Making some 20 trips to the Jeu de Paume in Paris, among other destinations, Goering was able to lay claim to his preferred pieces even before Hitler, whose agents were collecting primarily for the proposed Linz museum. Nevertheless, the contents of Goering's collection led some contemporary experts to question his self-proclaimed Renaissance taste. As one prominent art collector put it at the time, Goering had "rather peculiar taste in art, scorning religious pictures and being interested mainly in nudes."

TOP LEFT
Reichsmarschall Hermann Goering from a postcard found on one of Goering's trains. His Field Marshall's baton was transferred to American General Alexander Patch after Goering's surrender in 1945 and later presented by Patch to President Truman. It is now on display at the West Point Military Museum.

TOP RIGHT
One of Goering's bookplates was found by Allies in the disorder of one of his abandoned trains.

BOTTOM
Hitler was best man at Goering's wedding to his second wife, Emmy, on April 10, 1935.

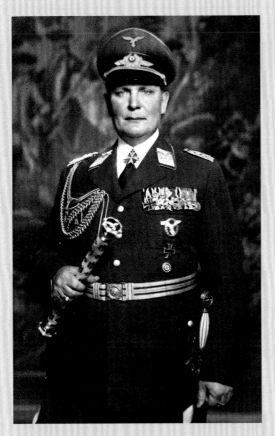

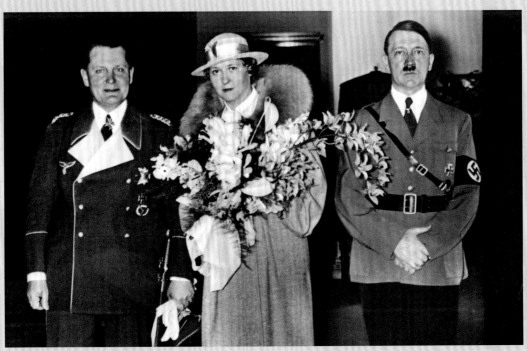

LEFT TOP
Italian dictator Benito
Mussolini (center front)
visits Emmy (left)
and Hermann Goering
(right) at Karinhall,
their hunting lodge in
the Schorfheide Forest
near Berlin.

LEFT BOTTOM
Goering as Reich
Master of the Hunt,
1936.

ABOVE LEFT
Goering (cane on arm)
shopping for jewelry in
Amsterdam, 1940.

ABOVE RIGHT
Goering and his nephew,
Klaus Rigele, playing
with an electric train set
in the attic of Karinhall,
1938. Goering, who
loved trains, had an
enormous train set at
Karinhall.

RIGHT
Goering (left) guides a
visitor through his art
collection at Karinhall,
c. 1939.

Bormann had their homes here, halfway up the mountain to the Eagle's Nest, and the SS had an extensive school here as well. The Platterhof, the hotel for official guests, was extravagant in its proportions and appointments, and its large garage was on a scale comparable to that of the livery stables and carriage collections of an earlier era.

The devastation above ground resulting from Allied precision bombing was widespread and thorough. The underground fortifications, however, with their series of machine-gun nests and the subterranean passageways, complete with air-conditioned living quarters and vast storage spaces, had to a great extent withstood the pounding from the air. When we arrived, wholesale looting and vandalism were still in progress, and everywhere there was a mad scramble to liberate everything movable. Thousands of reels of valuable Nazi motion picture film, by the hundreds of thousands of feet, were strewn all over the place. Our troops were being kept out of the area as far as possible, and the French were loading their tanks and trucks, in preparation for leaving that afternoon with their accumulated loot.

Scrambling over piles of debris and burned furnishings, we made a thorough search of the ruins of the houses of Hitler, Bormann, and Goering. We could go from one to the other through the interminable connection passageways.

The only works of art that remained were some relatively unimportant decorative pieces in Goering's house. The SS had apparently followed up the bombings of Hitler's house with fires of their own making. In the small, garage-like structure behind the house we found large boxes that had been used for shipping paintings here. We opened them with the aid of some sightseeing GIs but to our chagrin found nothing.

At the entrance to one of the tunnels there were two glazed terracotta tondos,[5] good examples of original Della Robbia work, which had been abandoned by looters whose craving was evidently larger than their capacity for carrying these heavy pieces. The CIC agent accompanying us on this inspection tour felt that they were copies and not of the period. Collectors had paid thousands of dollars for similar works of art, and these were the best objects we had seen so far at Berchtesgaden. I insisted that he would have to trust my opinion and maintained that these objects must be protected. Whatever the correct estimate of their value, it was only common sense to see that no harm came to them.

In Obersalzberg[6] we continued searching in vain for important works of art and for the Goering collection. The Reichsmarschall himself was said to have been taken as a prisoner to Styria by SS troops on Bormann's order.[7] Before the French left I checked with their commander, Major Dronne, a capable, fiery, and most accommodating officer. He knew nothing of the Goering collection and during the two- or three-day French occupation had not picked up any information he thought might be pertinent. He was as disturbed by the looting as we were and promised that somewhere on the road back to France he would, as he put it, "shake down" his officers and men.

I wanted to continue searching the neighborhood for the Goering collection, but there were other repositories requiring immediate attention and I decided to return to headquarters. I asked the military government officers and CIC agents to get in touch with me if anything should turn up. The 101st Airborne Division was moving into Berchtesgaden that day, and they were to be notified to be on the lookout for Goering's collection in the various tunnels and other places reported in SHAEF repository lists as having been used for the storage of art.

THE ALLIES CAPTURE GOERING

Two days went by. On May 10 I heard that Goering had been captured and brought to the Seventh Army Interrogation Center near Augsburg.[8] I feared that it would be no simple matter for a monuments officer to get permission to question so eminent a captive as Goering. But the G-2, Colonel Quinn, and his executive officer, Colonel Perry, paved the way without hesitation. I prepared the questions I wanted answered, and it was decided that they were proper and important. Goering was being given his favorite drugs in gradually smaller doses and was being subjected to as little grilling as possible.

I was particularly anxious to get to him before the press. Once the location of his art objects was made public it would make the problem of providing protection much more difficult. I primed Captain Albert Zoller, a French officer from the headquarters of the Défense Nationale, for his informal talks with Goering. He did not know when he would find his moody, drugged subject in an expansive frame of mind, nor how he would react to being questioned about his art objects.[9]

Zoller and Goering drank together until one in the morning on May 14. That morning I had a verbal message from Goering that sent me back to Berchtesgaden as fast as I could get there. I left without waiting for the written record. It would be on my desk when I returned. The message stated that on April 15 Goering had left for Berchtesgaden in his special train with many cars loaded with his works of art.[10] On April 23 he had been taken into custody by the SS. The cars, when he had last known about them, were in the railway tunnels between Berchtesgaden and Königssee. We were to discover that there were eight carloads of works of art in the tunnel near Unterstein,[11] another car with Renaissance furniture on the main tracks at the Berchtesgaden railway station, and the working and living compartments of the train a few hundred yards away in one of the other tunnels. Many of the best objects from the cars had been unloaded by the Germans at Berchtesgaden, where the trains had been temporarily halted en route to Unterstein.

This is the record of the interrogation of May 13–14, given in full as it was prepared by Captain Zoller based on my questionnaire. My questions were:

> *(1) Where are the works of art which you selected at the Jeu de Paume in Paris and at other places? Their preservation from the elements and postwar conditions is a matter of concern to the Allied armies.*

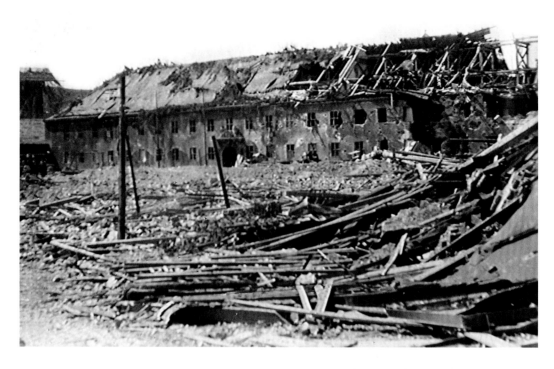

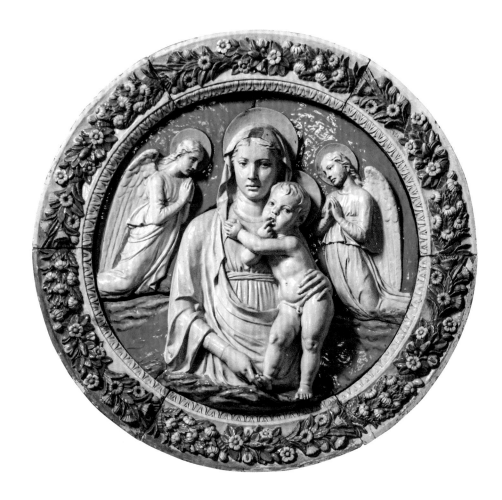

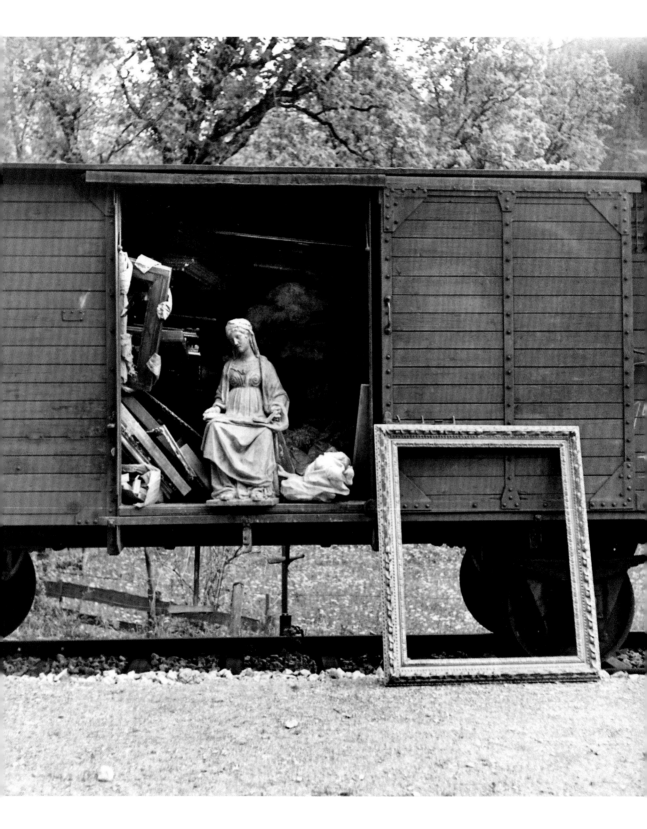

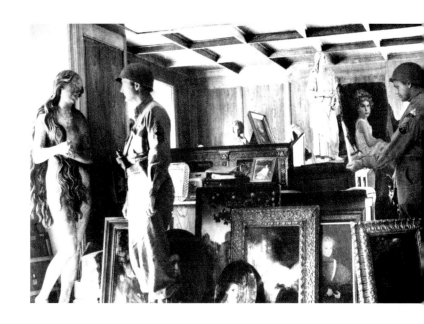

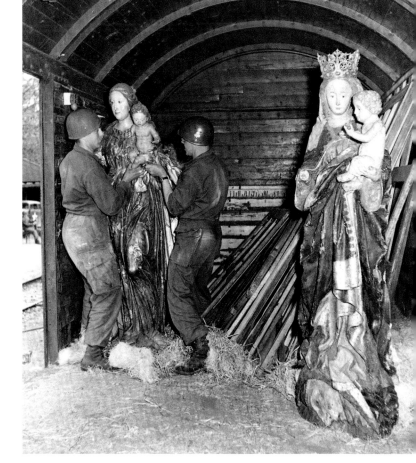

LEFT
A boxcar loaded with art taken by the Nazis, discovered by Allies near Berchtesgaden, 1945.

ABOVE RIGHT
An American soldier (left) studies the 16th-century statue from the Louvre Museum, known as *La Belle Allemande* that was particularly admired by Goering. The soldier at right holds a portrait of Goering's daughter, Edda, by Boleslaw von Szankowsky, 1941.

RIGHT
Another Nazi-abandoned train car filled with art at Berchtesgaden.

(2) Were works of art of world importance left at Berchtesgaden and other well-known places?

(3) Other party leaders had great art collections. Do you know where they are kept—either in Germany or abroad?

(4) Is there anyone who can give complete information about works of art brought to Germany from other countries since 1939? Information as to the Einsatzstab Rosenberg repositories is known to the Allies.

Captain Zoller's report on his Goering interview ran as follows:

Although he had been depicted in many news reports as being half mad, Goering gives the impression of being a highly intelligent and cunning man, with charming manners and a certain knowledge of art. He is very talkative, and once he has started to develop a favorite theme he can hardly be stopped.

He insists that he has no desire to conceal anything about the works of art which he obtained in foreign countries. He explains his tremendous accumulation of treasure by claiming to be a great lover of artistic works, and by stating that it was his intention to transform Karinhall into a national museum. He says, "Ich bin nun mal ein Renaissancetyp." ("After all, I'm a Renaissance type.") Goering also states that the low prices of jewelry and works of art in the occupied countries provided an incentive to buy them wholesale. He adds that he was astounded by the cheapness of diamonds at Cartier's in Paris in 1940. From 1942 onwards, the prices of antiques and artistic works rose enormously, and he had to exercise all his cleverness and every ruse in order to avoid being "stung" by the dealers.

The source states that in addition to the treasures which he bought, others were sent to him as gifts by Party members and units of the GAF,[12] and that he also exchanged articles with dealers and other collectors, as a stamp collector swaps stamps. He claims that only about one percent of his collection comes from France.

Goering states that no works of art were taken away from the French national museums. He claims to have been very helpful to the directors of the French museums in providing safe repositories for their treasures in a specially constructed air-raid shelter. He states that he exchanged two statues and a couple of paintings for one wooden statuette and one painting which he was very fond of at the Louvre.[13] The negotiations, he states, were long and difficult, but there was no exercise of pressure on his part.

The Jewish properties were exhibited in the Salle des Jeux [sic] de Paume, under the supervision of French and German officials. The most valuable of these were sent, on Hitler's orders, to the royal castles of Neuschwanstein and Hohenschwangau, Bavaria, to the shelters of the Führerbauten in Munich and of the Chancellery in Berlin, and to Obersalzberg. Their ultimate destination was the new National Museum at Linz. Although he admits that some of those treasures were sent elsewhere, Goering pretends to have no knowledge of their whereabouts.

The remaining works of art exhibited at the Salle des Jeux de Paume were sold at public auction. PW [the prisoner of war] bought some paintings, statues, antique furniture, and Gobelins tapestries. In those deals Goering was advised by a French expert, a museum official, and his bids never exceeded the evaluation set by his adviser. The only jewelry which he bought was antique. French and German antique dealers were also authorized to take part in these auctions. PW claims that the Führer demanded photographs of all works of art bought by other amateurs, and that the latter often had to turn over their purchases to Hitler's representative, for eventual shipment to the Linz museum.

Goering states that he bought certain items direct from dealers in Paris, like any private collector. Also, he occasionally made purchases from châteaux and private collections through an intermediary. . . .

This report was accompanied by the following declaration by Goering:

I hereby declare:

(1) That I am ready to return art treasures (exhibited in Jeux de Paume) which I acquired and bought at auctions of requisitioned property.

(2) That I will do my utmost to find out about the location of these articles and that I will give all the pertinent information possible.

(3) That the greater part of these articles and of my total property of art treasures are packed in several freight cars in Berchtesgaden. The storing of these articles in air-raid shelters did not occur because of my imprisonment by Hitler the day after my arrival there.

(4) That I informed the French liaison officer in charge about several other places where there could be some less important works of art.

(5) That I am convinced that a conference with my former art custodian Hofer in the presence of Allied officers will lead to a speedy and extensive clarification of all questions.

(signed) Hermann Goering,
Reichsmarschall

RETURNING TO BERCHTESGADEN

Hathaway again accompanied me to Berchtesgaden. Captain Bryant, in charge of the military government detachment, told us that the Della Robbia tondos I had previously pointed out at the entrance to one of the tunnels at Obersalzberg had been broken and battered since our first visit a week before. He had not had the time to do anything about them. I was disgusted to think that we had been unable to master the

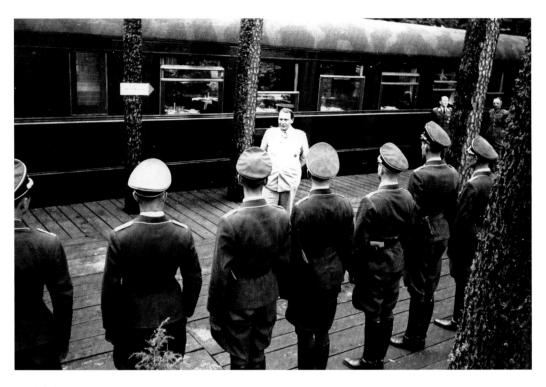

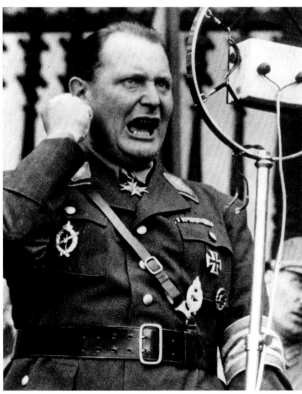

ABOVE
Goering speaks to elite
troops after the Battle
of Crete in front of
his Sonderzug (special
train), July 1941.
Goering's attack on
Crete inspired the
establishment of
American airborne units
that later played key
roles in the Allied
invasion of Europe.

LEFT
Goering at a rally,
c. 1935.

situation and that really important works of art were suffering from the lack of means to deal with them. But I knew well that conflicting orders and instructions of the day, not to mention the hordes of visitors, were making time- and personnel-consuming demands on the few military government officials. Similarly, there was work here for a dozen monuments specialist officers, and only Hathaway and I were available. Some of the higher-ups were demanding skis, Tyrolean costumes, fishing tackle, and other equally vital paraphernalia from the military government, and these items had to be obtained.

On the next morning I gathered the fragments of the Della Robbias and put them in our command car for delivery later to a storage place where they could be safeguarded. After that Hathaway and I sought out Major (later Lieutenant Colonel) Robert S. Smith, the G-5 for the 101st Airborne Division. As chief of the monuments section at Seventh Army, I explained to him Lieutenant General Patch's concern for the Goering collection. Smith was trained in military government principles and he had a well-integrated staff. He informed me that one of his officers, Captain Anderson, was— among his other duties—hard at work salvaging some of the collection.

Captain Anderson turned out to be Harry Anderson, a friend of the family's with whom I had traveled to Williamsburg, Virginia, for art meetings a few years before.[14] We had seen each other last in Paris, just before the Bulge.[15] He had been trying to concentrate on preparing a collecting point at Unterstein, near Königssee, for the Goering material, but he was constantly being given other jobs and could not devote his energies exclusively to Monuments, Fine Arts & Archives. Anderson had requested that Major General Taylor send a message to SHAEF asking that I come to Berchtesgaden at once. The message joined a long list of other requests that I never received.

The seemingly frank statements made by Goering when questioned by Captain Zoller did not reveal the location of a large part of his collection. A two-storied, cave-like cement structure had been built in a remote wooded area near Berchtesgaden. It was still incomplete when Goering was taken away on instructions from Bormann. Before the arrival of the Allies, the Germans had moved some of the artworks from the trains to this hiding place. It was damp and unsuitable, and it was fortunate that an intelligence agent, when questioning prisoners of war, extracted the information about the building and its location from the engineer who had built it, and reported it at once. Forty men from an American company of engineers helped take these objects, dripping with moisture, from the cave to the Unterstein collection point.

On May 16 the young Colonel von Brauchitsch,[16] son of the famous general and adjutant to Goering, was sent to Berchtesgaden by General Patch to show me the location of this cave. By that time Anderson, Hathaway, and I had already spent two and a half days unscrambling the Berchtesgaden activities of Goering and his followers and had recovered art and documents secreted in half a dozen different places. There was nothing the colonel could add to what we already knew. Nevertheless, I found it interesting to talk to this Nazi who had been stamped so completely from

the party mold. He was impetuous, irascible, and curiously immature for all his worldliness. The ten years he had devoted to Goering had imbued him with the characteristic theories of world conquest and German superiority. He brooded over the completeness of the German defeat by the despised Allies and addressed us with haughty scorn. His loyalty to Goering was the result of ten years of idolizing the all-powerful Reichsmarschall, but his estimate of some of the others in the Goering entourage was not colored by a similar blind devotion. From this talk was sensed the jealousies, hatreds, insecurities, malice, and favoritisms among the Goering satellites. Of Lohse, von Brauchitsch spoke with utter contempt.

GETTING TO KNOW THE HOFERS

In the interrogation Goering had said that a conference with his former art custodian, Walther Andreas Hofer, would lead to a clarification of all our questions.[17] Harry Anderson had discovered Hofer's usefulness and was working with him when we arrived. He had not been taken into custody, however, and was going about unhampered and free to communicate with anyone. Hofer had spent ten years as Goering's art adviser, pursuing a career in the international art market, which had taken him to Switzerland, Holland, and France. He knew everything and everyone, and he had managed to maintain his dual role of independent art dealer and Goering adviser. Every facility for travel and for the conduct of sometimes intricate negotiations had always been put at his disposal. His own well-appointed compartment on Goering's ultra-deluxe private train smoothed his travels. He would often return from his foraging expeditions with one or more baggage cars filled with loot. All the paintings acquired by the Reichsmarschall were passed on by Hofer, and many of these transactions brought him handsome personal rewards. He was not a mere tool; he earnestly directed these acquisitions. Goering's choice in decorative arts was usually the result of vulgar and untutored judgment. But, with Hofer's well-trained, keen eye many of Goering's acquisitions were sound and intelligent. Hofer's wife, Beatrice Fritsch, was the restorer for the Goering acquisitions.

I first met the Hofers when I was standing on the main street of Berchtesgaden with Harry Anderson. They approached us cheerfully and affably. They were eager to establish friendly relations and almost immediately asked about mutual American acquaintances. Frau Hofer spoke of having worked for the late Stephen Pichetto[18] in New York and emphasized having occasionally restored a painting for the Metropolitan Museum of Art. Hofer stressed that he was the brother-in-law of another international art dealer of note, Kurt Walter Bachstitz of The Hague. He mentioned this connection in the hope that his alliance with a man who had been unacceptable to the Nazis would strengthen his position. He did not mention that in the early 1920s he had been a salesman in his brother-in-law's firm and had made the most of the situation to develop his own commerce.[19]

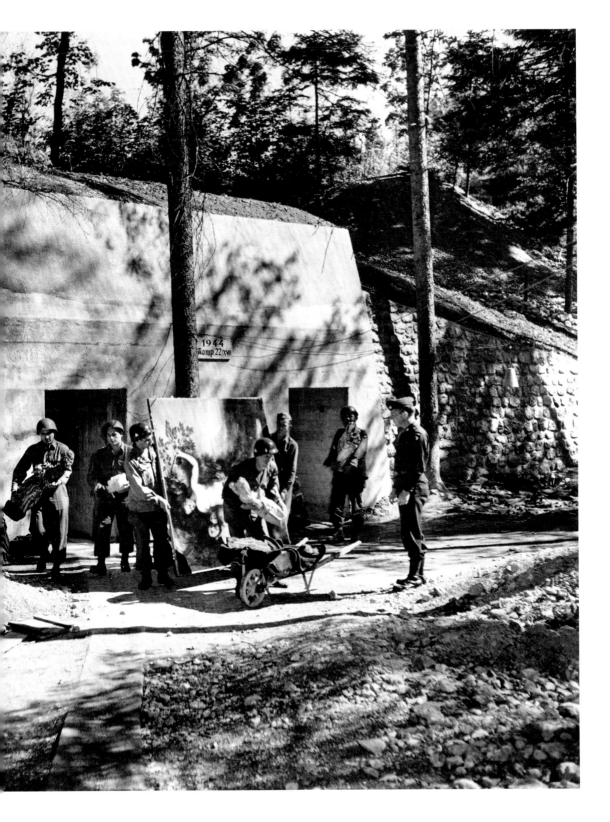

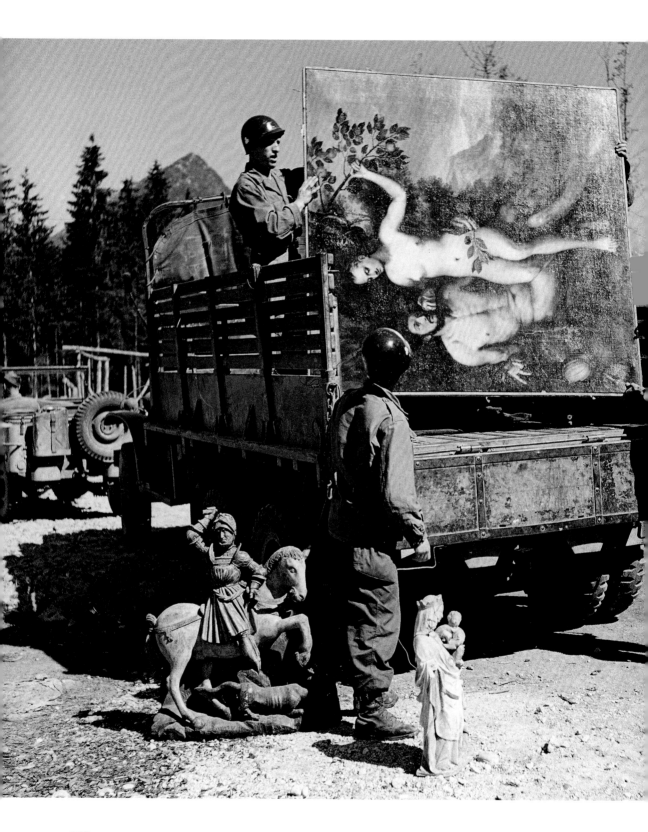

PREVIOUS SPREAD
This bunker was used by Allies to store some of the works of art removed from Goering's train.

LEFT
U.S. troops load a truck with paintings and sculptures discovered on one of Goering's trains.

BELOW
The painting being loaded onto the truck (left) is a copy by Sebastiano Ricci of an original *Adam and Eve* by Frans Floris the Elder (below) that is in the collection of the Pitti Palace in Florence. The copy by Ricci is in the Museum of the Palazzo Vecchio in Florence.

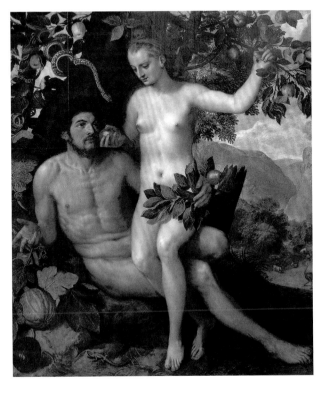

Beatrice Fritsch Hofer, who was a highly accomplished art conservator and the wife of Walther Andreas Hofer, Goering's art expert, is giving "first aid" to *Infanta Margaret-Teresa*, by Diego Velázquez, 1654–55. Before confiscation by the Nazis, the portrait was in the collection of Alexandrine de Rothschild; it was returned to Paris in 1946.

Walther Andreas Hofer presenting Lucas Cranach the Elder's *Rest on the Flight into Egypt*, 1509, to the press at the Unterstein Collecting Point, c. 1945. Behind Hofer is *Venus* by Lucas Cranach the Elder, c. 1518, today in the National Gallery of Canada, Ottawa. The large painting next to Hofer is *Christ at Gethsemane* by the Master of the Sterzinger (or Sterzing) Altarpiece, a German artist active in Ulm around 1460–70. Mussolini presented this work to Goering on January 12, 1942, as a birthday gift. Today it is in the Museo Civico, Vipiteno, Italy.

Hofer had a phenomenal memory for detail and he was anxious to help assemble the scattered Goering material. Under his guidance I spent the remainder of that morning going about Berchtesgaden. He spoke all the while of his art deals and the Goering collection. I followed up a chance remark of one of the trainmen, and in a barnlike garage adjoining Haus Winkler, opposite the main station at Berchtesgaden, we discovered bundles of tapestries, about 100 of the best Goering pictures, and some miscellaneous sculptures and other objects. They had been left there by Dr. Gornnat, who was in charge of Politische und Wirtschaftliche Sachen (Political and Economic Matters). Gornnat had disappeared. The people living in the Winkler house knew nothing of the works of art, except that they had been entrusted with the key. They were relieved when I told them that the objects would be removed that very day.

I was reluctant to move these delicate pieces in open army trucks, with blankets as their only protection, but I was more apprehensive about leaving them where they were. If it should become known that Goering's objects were in the Winkler barn right near the road, the looters and vandals who had been active in the area would most certainly concentrate their efforts here. No highly organized monuments teams had as yet been made available for this kind of work, but I felt that it would be dangerous to take the time to make inventories or to wait until adequate packing facilities and personnel could be secured.

THE UNTERSTEIN COLLECTING POINT

Harry Anderson had chosen an excellent temporary collecting point, the small, modern Bavarian Hotel at Unterstein, until recently a rest center for the Luftwaffe. Untrained servicemen, without proper supervision, unloaded a 2 1/2-ton truck with a vigor and dispatch that terrified me. I cautioned them to handle the objects with more care and tried to impress them with the nature and importance of their cargoes.

These works of art were unloaded into a hodgepodge of Rembrandts leaning against Hubert Roberts[20] and tapestries padding sculptures. This house could not easily be put in order. Though the few tapestries I unrolled were not of the best quality and the sculptures were not particularly distinguished, some of the paintings were admirable. There were two Bouchers from Paris acquired through Dr. Wendland and originally the property of Mme de Pompadour, a Tintoretto and a Masolino from the Contini Collection in Florence, a van Ostade from the Cook Collection acquired in Amsterdam, a David from the Pinakothek in Munich, the Richelieu Collection Rubens from the Koenigs Collection in Holland, and the Cook Rembrandt, dated 1633, acquired from Katz in Amsterdam. I recognized the 16th-century nude statue of the Magdalen clothed in her hair, known as *La Belle Allemande*, which Goering had acquired from the Louvre on a barter basis. Marcel Aubert had shown me photographs of it a few months before and had described how Goering had fondled it with his fat hands.[21] I also saw a Memling from the Renders Collection.

A Summons to Meet with the Major General

Before I could complete my inspection of the objects in the Bavarian Hotel, I received word that Major General Taylor wanted me to come to his headquarters with his G-5, Major Smith, for a complete discussion of the Goering art matters. I reviewed the looting and the lack of security, stressing the Della Robbia incident as typical. I told him of recovering a painting of the Watteau school from one of the CIC agents that very morning. This agent had found it in the Berchtesgaden home of Colonel General Bruno Lörzer and thought that it might be a nice souvenir. Mrs. Hofer identified the painting as one formerly at Karinhall that she had restored before Goering gave it to Lörzer as a Christmas present.[22]

General Taylor assigned some of the troops from the 101st Airborne Division to us for security duties, and he relieved Captain Anderson of other military government responsibilities so that he would be able to devote his full time to supervising the assembly of the works of art that had still to be taken to Unterstein. He wanted me to take the Goering collection from his area as soon as possible but recognized that it would not be advisable until we had a central collecting point, which I told him I hoped to establish in Munich. The general also arranged for us to take Hofer and his wife into protective custody at Unterstein, where they could be watched continually and could begin putting the objects into some order and making an inventory. Hofer was the one person available who knew the collection, and Mrs. Hofer could protect the canvases that had been damaged by ill treatment. She was instructed to administer first aid but not to repaint or otherwise restore missing parts.[23]

In Search of the Goering Documents

As soon as Hofer's belongings were piled into a truck, and his wife with them, he and I started our search for Goering's documents. We spent several hours going through the dozen cars of the commodious train which, as Goering had thought in his interview, remained in three places near the Berchtesgaden station. The cars with the sleeping quarters, dining rooms, offices, and recreation rooms had been thoroughly ransacked by German, French, and American looters. The rejected material lay scattered about the floor. In the communications rooms given over to the headquarters of the Luftwaffe there remained maps, drawings, and other intelligence material that had not yet been exploited by the task force. We found the Renaissance furniture that had been brought from Karinhall in one of the unguarded cars on a siding a few hundred yards away. Finally, we located the car where Hofer had last seen the records of his own art dealings and those of the Goering collection. Hofer claimed that 200 cases of books and papers belonging to him and to Goering were in the car when it left Karinhall en route for Veldenstein. In time, 11,000 books and pamphlets were recovered.

This car, like the others, had been wantonly looted. Papers, books, photographs, bills of sales—records of all kinds—were strewn about. Some of the papers had been thrown out of the windows and were being

Allied soldiers at the entrance to a building at Unterstein where stolen art collected by Goering was displayed by the 101st Airborne Division, 1945.

industriously burned by our troops, who had been instructed by their unit commanders to "police the area."[24] I requested that guards be placed on this car immediately. Weeks later, other documents came back from Paris, where they had been sent by French intelligence operatives.

Securing the Records in the Boxcar

That night, without the proffered help of Hofer, Hathaway and I searched the car. Hofer's life history and questionable dealings were recorded in these papers, and I had no intention of permitting him access to them. Lieutenant Hathaway and four guards spent two days gathering what remained, and we placed all pertinent documents in a steel filing cabinet equipped with a lock. Without our efforts these papers would certainly have been lost, yet the 101st Airborne Division now refused permission for Hathaway to take them to our headquarters.

I asked Hathaway to make his complaint to Captain Nussbaum of G-2 (Intelligence) Documents on his return to Augsburg. The wheels were set in motion: Nussbaum relayed the complaint to Colonel Perry, the executive officer of the G-2 Section. Colonel Perry passed it on to Colonel Quinn, the G-2. Quinn then went to the chief of staff. Finally, the entire group involved appeared before Lieutenant General Patch,

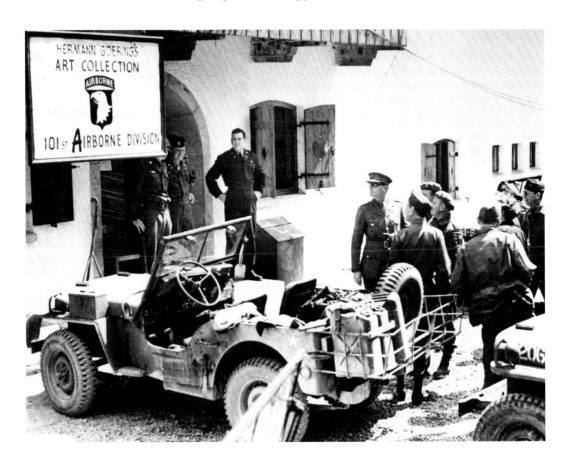

commanding general of the Seventh Army. The general telephoned Major General Taylor and instructed him to deliver all Goering papers to me on my next trip to Berchtesgaden.

Another Summons from the Major General

I was in Berchtesgaden on a Saturday evening with Major Smith, sitting on the veranda of his chalet looking out over the snowcapped mountains and the forest in the valley below. The incomparable beauty of the view was spoiled for me by a telephone call from Colonel Moore, who passed on General Taylor's request that I appear before him on the following morning with my credentials. I rejected the possibility of another Mont Saint-Michel arrest for mistaken identity, but I was ill at ease inasmuch as I had no written authority to take away the Goering papers, which we had locked in the office downstairs. General Patch had arranged their release with General Taylor over the telephone.

On the carpet the next morning I found out that all Taylor wanted to know was what Patch had requested of him. He hadn't been able to hear him clearly on the phone but, in good army etiquette, had said, "Yes, General," without knowing the request.

By June 5 Hathaway, aided by his sergeant, James Cook (who helped us considerably during our weeks of work together), had completed analyzing the Goering papers, and I had communicated the results to higher headquarters. The documents were later turned over to Lieutenants (USNR) James Plaut and Theodore Rousseau of the OSS[25] and to the Munich Collecting Point, to which the Goering collection was later sent. Among these papers were cards for Goering's libraries in Veldenstein and Rominten,[26] worksheets for a catalogue of paintings, photographs of tapestries and stained glass, other photographs of objects presumably offered for purchase, lists of Goering's collection alphabetically arranged by artist, records of gifts received by Goering on birthdays, objects purchased by Hofer (usually in Paris), parts of various inventories, and revealing correspondence. One of the 1923 letters from Hitler to Goering authorized him to proceed to England and later to Italy to collect funds for the Nazi Party.

THE CASE OF THE MISSING MEMLING

A small Memling painting (Rothschild 86) of the Virgin and Child had disappeared from the castle at Zell am See where Goering's wife was residing.[27] The 101st Airborne Division complained about the painting's removal. It had vanished, according to the account, when Goering's valet was permitted entry to get some shirts and personal belongings desired by the Reichsmarschall. I telephoned Major Kubala of the Seventh Army Interrogation Center, who was noted for his intelligence work. When I explained the situation, the major was irate. "Young man," he said, his well-known temper flaring, "you call Colonel Quinn and he'll teach you the facts of life."

I went to Colonel Quinn and he took me to General Patch's office. En route he explained that the Memling had been sent for in order to test the veracity of Goering's statements. He recommended that I tell the 101st Airborne not to be so lax as to permit such unchallenged entries and departures in the future.

The Memling was on the general's desk. Colonel Quinn said that I could have it as soon as it was photographed for the record. "As a matter of curiosity," said Colonel Quinn, "what do you think that painting is worth?" Although Hofer later valued it at 400,000 dollars, I estimated conservatively that if it were not so well known and could be sold on the art market, it would bring at least 40,000 dollars, with a top range of 70,000 dollars. The colonel whistled and gingerly handed me the picture. "Take it," he said. "I won't have this lying around. Not even on the general's desk." He wouldn't think of having it photographed. A few days later when I returned the picture to the 101st Airborne Division for inclusion in the Unterstein Collecting Point, I photographed it in the hands of Major Smith and Captain Anderson.[28]

Hofer had informed me that Frau Goering still had four additional paintings at Zell am See. I was curious to meet the Reichsmarschall's wife, but I was involved in other matters and arranged for Hathaway to go to see Frau Emmy. Hathaway succumbed to the persuasions of Anderson, who particularly wanted to go. Harry set out to recover Stephan Lochner's *Birth of Christ,* a Memling from the Renders Collection,[29] Rogier van der Weyden's *Madonna and Child*, and Vermeer's *Christ and the Sinner.*

In spite of the fact that this last painting was one of the now-famous forgeries painted by Han van Meegeren, it was greatly valued by the Goerings. The Reichsmarschall had told his wife that this should be the last of her possessions with which she should part, thinking that its intrinsic value would be an assured source of money for her. At first Frau Goering denied any knowledge of the painting, but finally she brought it from its hiding place—wrapped around a stovepipe. It has since been reported that Goering gave this painting not to his wife but to her nurse. In any event, it was not worth the 150 or so paintings that Hofer claimed Goering had given in exchange for it, the aggregate value of which was estimated at 1,600,000 Dutch guilders.[30]

ARRANGEMENTS AT UNTERSTEIN

We arranged to show the Goering collection to the press, and I went to Unterstein to check conditions before representatives of the world's news sources would arrive from their camp at Rosenheim. Although all arrangements had been handled through our army public relations officer, *Life* magazine photographers had already been permitted by the 101st Airborne Division to see the collection before the announced press view day. I had purposely put off this day until some semblance of order and security could be established. It was unfortunate that many of the published pictures showed conditions in the hotel repository that revealed careless handling.

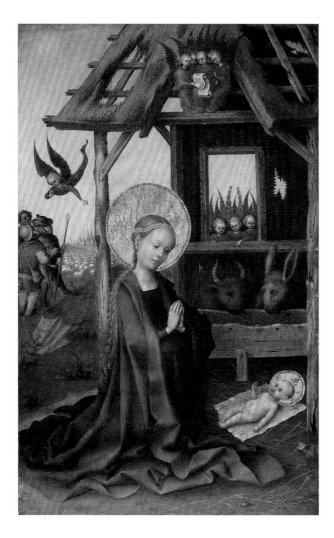

One of four paintings
retrieved by Captains
Hathaway and Harry
Anderson from Emmy
Goering: Stephan
Lochner, *Birth of Christ
(Adoration)*, 1445, now
in the Alte Pinakothek,
Munich.

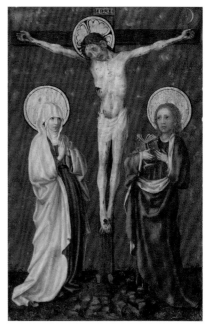

On the verso of the
panel shown above
is this painting by
Stephan Lochner:
Crucifixion of Christ,
1445. Alte Pinakothek,
Munich.

I asked that Hofer, who was under arrest, not be permitted to talk to the press, but the G-2 of the 101st Airborne could see no harm in having him talk freely and disallowed my request. Twenty-four hours later Supreme Headquarters clamped down on any such interviews. The intelligence angles obviously could not be handled if arrestees gave out information without adequate supervision. When Hofer tossed about a fine Rembrandt and leaned it carelessly against a Masolino (dazzling the eager-eyed press), I called him aside to caution him. "If Herr Lieutenant will forgive me," he said, "I will be responsible for the Goering treasures. Nothing will happen to them."

"Herr Lieutenant will do no such thing," I insisted. "The collection is our responsibility, not yours."

Before the arrival of the press we had attempted to concentrate the best works of art in one large room. The collecting point was no place for sightseers, and I protested any further exhibition of the collection. The objects had been temporarily placed wherever room could be found for them: one great painting stood on a washstand; another leaned against the wall in an insecure position. An added hazard was the impossibility of adequate security at this time. I soon learned that there had been several thefts: two of the four Memling Angels, one small portrait by Cranach from the Philips Collection, and two small landscapes by Van Goyen. The Cranach was seized a couple of years later by U.S. government officials and brought to the Metropolitan.[31] As a result of these thefts, the 101st Airborne made the ill-constituted compromise of closing the building to all visiting troops under the rank of colonel.

There were supposed to be 1,375 paintings in the Goering collection at one time or another. At Unterstein I noted, among others, the following paintings:

> 5 Barthel Bruyns
> 15 François Bouchers
> 6 Pieter Bruegels
> 2 Clouets
> 19 Cranachs
> 3 from the School of Cranach
> 10 Van Dycks
> 7 Fragonards
> 3 Memlings
> 7 Paters
> 9 Rembrandts
> 2 Hubert Roberts
> 4 Renoirs
> 4 Veroneses

The Goering collection had been valued at 200 million dollars. Actually, it is impossible to estimate the value of art objects that in normal times could not be bought at any price.

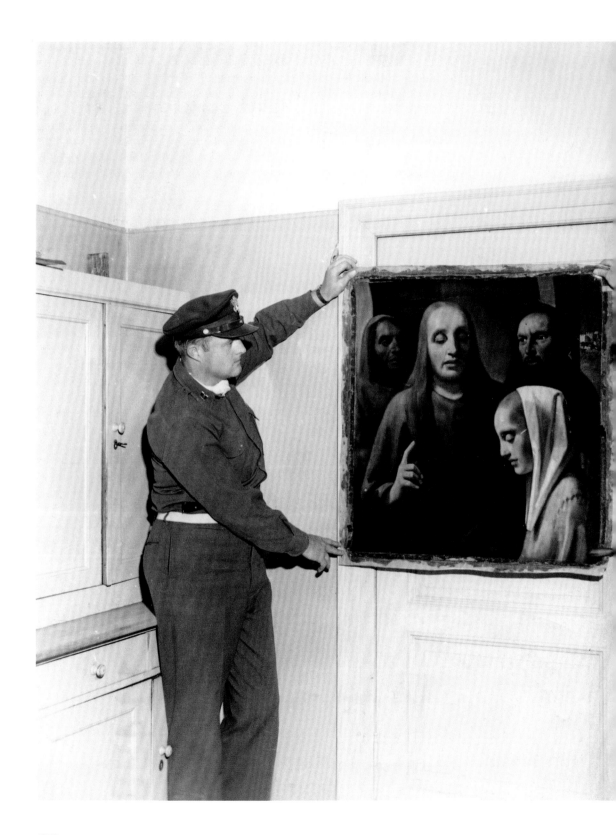

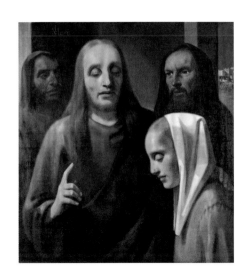

The objects collected at Unterstein were removed in August under the supervision of Lieutenants Thomas Howe (USNR), Lamont Moore, and Stephen Kovalyak.[32] In 13 days they took 31 truckloads to the Munich Collecting Point. There were 70 cases of books and pamphlets, comprising 11,000 in all. Howe stated that the first shipment consisted of four truckloads and included 308 pieces of glassware, 1,135 of porcelains, and 415 of gold and silver plates.

Regrets about the confusion that resulted in the improper handling of the works of art might have been avoided if Goering had not tried to keep his collections with him up to the very last minute of the war. Had we known sooner that special trains loaded with his treasures had left Veldenstein and started toward Seventh Army territory, we could have notified the field units to be on the alert for them. This procedure had worked at Neuschwanstein and in the case of the stolen works of art from Laufen. That someone was aware that the trains had "started south toward Austria" was later revealed by a clipping from the *New York Times* released by Third Army on May 1 and dated May 2.[33]

The works of art were taken to the Munich Collecting Point for safekeeping and for return to their owners. Goering has met his fate and Hofer, after a spell behind bars during the Nuremberg trials, is probably, like many another Nazi, once again pursuing his normal occupation.[34]

NOTES

1 Reported in the documentary "The Eagle's Nest," *Nazi Mega Weapons*, season 3, National Geographic/PBS.

2 The French general was Leclerc, who was the first to enter Paris upon its liberation by the Second Armored Division. See Chapter 3, note 24.

3 Karinhall, originally a hunting lodge named after Goering's deceased first wife, grew into a rambling repository for his looted art. See Nancy H. Yeide, *Beyond the Dreams of Avarice: The Hermann Goering Collection* (Dallas: Laurel, 2009).

4 See page 44. It appears that the author kept his copy of a Baedeker guidebook at hand during the war.

5 A tondo is a large, round painting or sculpture. Luca Della Robbia (1399/1400–1482) and his nephew, Andrea (1435–1525), were leading Florentine Renaissance sculptors who worked primarily in terra-cotta.

6 The name Obersalzberg, meaning "mountain above the salt," refers generally to the resort area above the town of Berchtesgaden.

7 In this notorious incident during the last days of the Reich, Goering had offered by telegram from Berchtesgaden to take command of the Reich due to Hitler's being "incapacitated" because he was encircled by Allied troops in the Berlin bunker. Hitler had reacted to the telegram with fury, and Martin Bormann, Hitler's chief of staff, arranged to have Goering arrested for treason. The incident is referenced in Goering's signed declaration on page 261.

8 Augsburg is northwest of Munich, roughly 145 miles from Berchtesgaden. Goering and his second wife, Emma, were captured while on the way to what he hoped would be a personal meeting with General Eisenhower at Schloss Fischorn at the Austrian border. See Nicholas, *Rape of Europa*, p. 343.

9 Norman Ohler's *Blitzed: Drugs in Nazi Germany* (London: Penguin, 2016) documents the extensive use of drugs in the Third Reich.

10 Goering tried to save his art collection from capture by the Soviet army as it approached Karinhall (see note 3 above), which was located north of Berlin, by sending the bulk of it south in his personal trains. See map page 246. At least two of the trains unloaded at his family castle in Veldenstein and later reloaded for shipment to Berchtesgaden. Accounts of the train routes differ in their details, however, and the actual routes remain uncertain. See National Archives and Records Administration (NARA), *WWII OSS Art Looting Investigation Reports*, CIR 2, *The Goering Collection*, September 15, 1945, pp. 170–73, https://www.fold3.com/image/232000614; and NARA, Records Concerning the Central Collecting Points ("Ardelia Hall Collection"): Munich Central Collecting Point Restitution Research Records, *Berchtesgaden: Göring Train*, report of a field trip of September 1, 1947, https://www.fold3.com/image/270038356

11 A village below Berchtesgaden on the Königsseer Ache, a river formed at the northern outlet of the Königssee, a lake still noted for its clear, clean water.

12 Captain Zoller's use of the abbreviation "GAF" presumably refers to the German air force, which was known as the Luftwaffe in Nazi military parlance. Goering had become well known as a fighter pilot in World War I. As the first commander in chief of the Luftwaffe under Hitler, he was largely responsible for the clandestine buildup of Germany's air force (in violation of the Treaty of Versailles) between the wars.

13 This exchange of statues and paintings, one of many complex barter transactions perpetrated by Goering, is also mentioned in Chapter 3, note 7.

14 Both before and after the war, Harry V. Anderson (1902–1983) was a recognized authority in the field of interior design. The author, whose family had been in the interior design business, may have known him before the war through this connection.

[15] The Battle of the Bulge (December 1944 through January 1945), named for the bulge appearing on the map in the Allied front line, was Germany's last major offensive in World War II. The U.S. Army reportedly incurred almost 90,000 casualties (including soldiers killed, injured, captured, and missing in action) during the fierce fighting.

[16] Berndt von Brauchitsch (1911–1974) was the son of Field Marshal Walther von Brauchitsch (1881–1948), who served as one of Hitler's leading generals until Hitler blamed him for the army's failure to capture Moscow in 1941. The younger von Brauchitsch, after testifying at the Nuremberg trials, later became a steel and chemical company executive.

[17] For a comprehensive review of the careers of Hofer and some of the other Nazi personalities mentioned in this section, see Petropoulos, *Faustian Bargain*.

[18] Stephen S. Pichetto (1887–1949) was a prolific American restorer who rose to prominence as the favorite restorer of the famous art dealer Joseph Duveen. At the time of his death, Pichetto employed a team of 12 technicians in his New York studio. He had worked as a "consultant restorer" for the Metropolitan Museum starting in 1928 and, thanks to Duveen, as conservator of the extensive and well-known Kress Collection, now in the National Gallery of Art in Washington, D.C. See S. N. Behrman, *Duveen* (New York: Random House, 1951).

[19] An important figure in the international art scene before the war, Kurt Walter Bachstitz (1882–1949) fled from occupied Holland in 1944 on account of his Jewish heritage. It has been reported that his family's efforts to recover his art continue.

[20] Hubert Robert (1733–1808), a French painter active in the latter half of the 18th century, is best known for his imaginative, picturesque paintings of landscapes with ruins.

[21] Marcel Aubert (1884–1962) was a renowned French art historian, a curator of medieval, Renaissance, and modern sculpture at the Louvre, as well as curator of French National Museums. *La Belle Allemande*, also known as the *Mary Magdalene* by Gregor Erhart (1470?–1540), is also mentioned in Chapter 3, note 7. In due course, the sculpture was returned to the Louvre.

[22] Bruno Lörzer (1891–1960), a senior Luftwaffe commander, had been a close friend and colleague of Goering's since they flew together during World War I. The painting in question appears to be the *Gallant Party* from the school of Jean-Antoine Watteau (1684–1721). See Yeide, *Beyond the Dreams of Avarice*, no. 977.

[23] Maxwell D. Taylor, commander of the 101st Airborne Division at Berchtesgaden, went on to an illustrious military career after the war, serving first as superintendent of West Point and later as an advisor to President John F. Kennedy. As chairman of the Joint Chiefs of Staff in the 1960s, a time of growing popular disillusionment with the conflict in Vietnam, he was heavily criticized for advocating unrestrained assault on North Vietnam to put an end to the seemingly endless "limited" war. See John M. Taylor, *General Maxwell Taylor: The Sword and the Pen*, Doubleday, New York, 1989.

[24] In military parlance "policing an area" means cleaning up the trash, as in policing cigarette butts on the parade ground or policing your spent brass after a session at the firing range.

[25] An expert in French medieval art trained at Harvard, Theodore Rousseau (along with Plaut) handled many of the key interviews with Nazi prisoners about missing art for the Art Looting Investigation Unit of the OSS. See Chapter 6, note 19. After the war, Rousseau and the author continued to work as colleagues at the Metropolitan Museum for many years. There Rousseau had a long and distinguished career as curator of paintings and later became its deputy director until 1973.

[26] Goering maintained another hunting lodge at Rominten, which was located in a historic hunting forest near the Baltic coast. Goering built it when Kaiser Wilhelm II refused to let him use his original lodge nearby. Goering's lodge was destroyed at the end of the war, but parts of the Kaiser's lodge survived and were moved to the Russian city of Kaliningrad, formerly the German city of Königsberg. The remnants of Kaiser Wilhelm's lodge today

serve as the administrative headquarters for the Central Park of Kaliningrad. Goering's plan to name his Rominten lodge "Emmyhall" after his second wife, to match Karinhall, was never fully realized.

[27] The reference is to Goering's second wife, Emma "Emmy" Goering (1893–1973). She lived many years after his suicide while in Allied custody and has told her story in an autobiography entitled *My Life with Goering* (London: David Bruce and Watson, 1972). Zell am See is an Austrian resort town near Salzburg, about 50 miles south of Berchtesgaden.

[28] A detailed account of the so-called missing Memling, complicated by the probable confusion between two similar but different works of the same period, appears in listing No. A960 of Yeide's treatise, *Beyond the Dreams of Avarice*.

[29] The author may here be confusing the Renders Memling with another painting by the same artist that was also in the Goering collection.

[30] For an authoritative account of the Vermeer forgeries, see Lopez, *The Man Who Made Vermeers*.

[31] Recent scholarship suggests that the Cranach seized by the government and brought to the Metropolitan was actually a different work by the same artist. See Yeide, No. A1166. The reference is undoubtedly to the famous art collection of Frederik Jacques "Frits" Philips, son of one of the founders of Philips, the Dutch electronics company.

[32] Thomas C. Howe (1904–1994) joined the team of monuments officers in May 1945 after two years of naval service. He had studied with Paul Sachs at Harvard, where he had earned undergraduate and master's degrees in art history. In addition to his work at Unterstein, Howe was involved in a variety of other recovery and restitution efforts in Europe. During this period the publisher Bobbs-Merrill approached him to write a book about the work of the Monuments, Fine Arts & Archives Section, which appeared in 1946 as *Salt Mines and Castles: The Discovery and Restitution of Looted European Art* and was republished in 2014 as part of the *Uncommon Valor* series. After the war Howe resumed his position as director of the Palace of the Legion of Honor in San Francisco, which is now part of the Fine Arts Museums of San Francisco. Lamont Moore (1909–1988) was trained as an art historian, educator, and conservator at Lafayette College and the Newark Museum of Art and Science. Before and after the war he pursued a multifaceted career, concluding as director of the Yale University Art Gallery. During the war, both on his own and as a member of the three-person Special Evacuation Team with Howe and Kovalyak, he participated in several of the most critical salvage operations conducted by the monuments team. Stephen Kovalyak (1915–1997), although trained as a teacher, not an art historian, lent his knowledge of Slavic languages and his notable physical strength to the three-person team. After the war he had a long and successful career as an administrator and inspector in the Pennsylvania Department of Education.

[33] Gene Currivan, "Goering Hoarding Art for Life's Sake: Shipped Looted Treasure in Air-Conditioned Cars for Use as Clemency Bait," *New York Times*, May 2, 1945, https://timesmachine.nytimes.com/timesmachine/1945/05/02/313694012.html?pageNumber=4

[34] Petropoulos, *Faustian Bargain* and *Goering's Man in Paris: The Story of a Nazi Art Plunderer and His World* (New Haven, Conn.: Yale University Press, 2021), document the fulfillment of this conjecture.

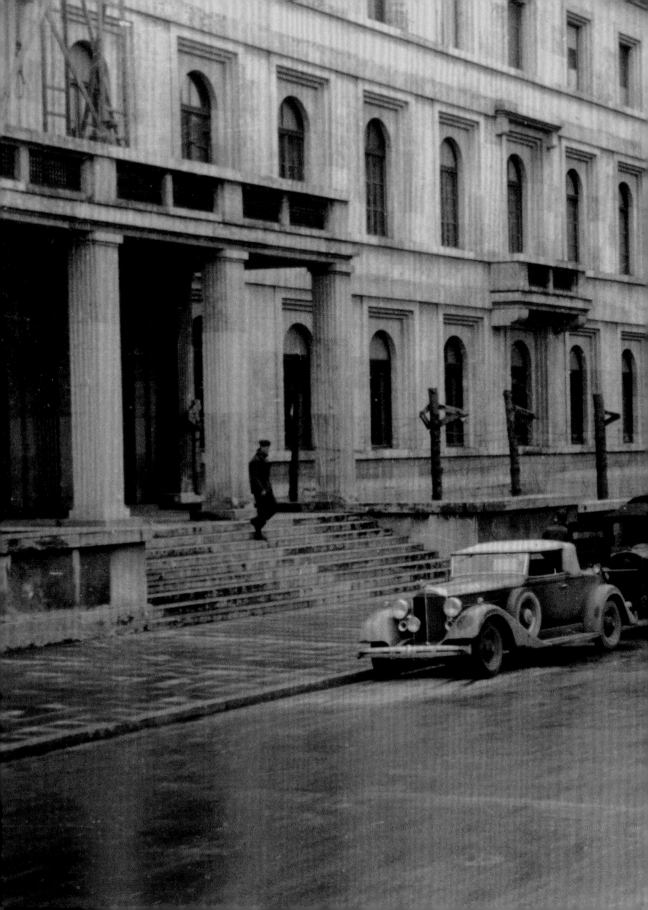

Restitution

THE WORK OF THE COLLECTING POINTS

8

ART COLLECTING POINTS IN THE AMERICAN ZONE, 1945

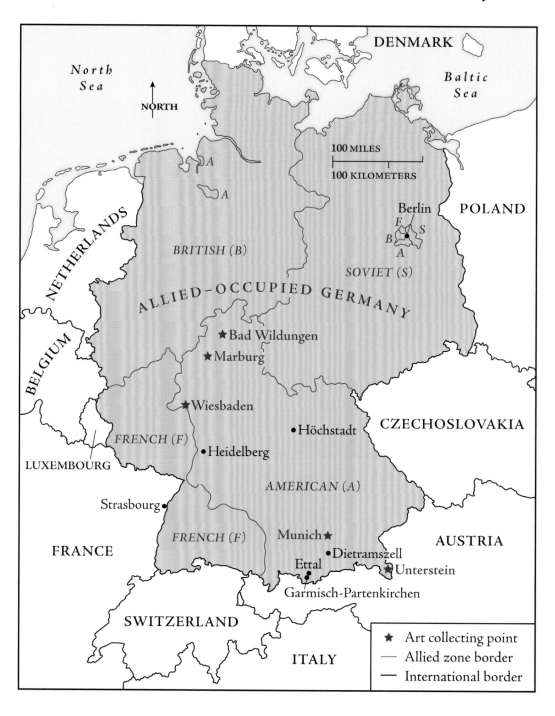

This chapter describes the early stages of the effort to salvage and return the scattered works of art discovered in salt mines, castles, bunkers, and other hiding places in Germany and Austria. The core strategy was to establish a limited number of collecting points, including primary centers in Munich, Wiesbaden, and Marburg. The monuments men, aided by fresh expert personnel from the United States and other Allied nations, plus scholars cautiously recruited from Germany, used these locations to assemble, safeguard, and inventory not only property confiscated by Nazi forces during their occupation of France (and other countries in Europe) but also property hidden away by German and Austrian state institutions to protect them from Allied bombing.

A critical role was played by U.S. military government under Law No. 52. This law imposed a complete freeze on transfers of works of art in the occupied territories. Any physical or legal transfer without proper authorization, whether by military or civilian personnel on either side, was punishable by fines and imprisonment. This provision both deterred trafficking in artworks pending identification and restitution and helped to build confidence among the local populace regarding the Allies' intentions toward cultural property. The relevant section of Law No. 52 is below:

> *Law No. 52, Prohibiting Trafficking in Works of Art:*
>
> *No person shall import, acquire, or receive, deal in, sell, lease, transfer, export, hypothecate, or otherwise dispose of, destroy, or surrender possession, custody, or control of any property . . . which is a work of art or cultural material of value or importance, regardless of the ownership or control thereof.*
>
> *Laws of the U.S. Military Government for Germany*

REFLECTING ON A FIRST VISIT TO MUNICH

It was in the summer of 1921 that I first visited Munich with my father, who had been there in the 1890s, like many other Americans, to continue his education.[1] He knew the city intimately and he loved its people and their way of life. Association with Bavarian friends and institutions afforded him something of the understanding that broadens the vision and opens the mind to an appreciation of other peoples' culture. Visiting my father's old haunts and meeting the friends who had colored his youthful studies left me with a feeling of lasting warmth. This first visit and a half dozen subsequent ones gave me an appreciation of Munich's gardens, museums of science and industry, and food and beer, all of which offered pleasant foils to long hours spent in art museums and galleries rivaling those in Berlin.

PREVIOUS SPREAD
The Allied Central Collecting Point for artworks in Munich, 1945.

Nazi troops and storm
troopers parading in the
Königsplatz in Munich,
during celebrations on
November 10, 1936, for
the 13th anniversary
of the Beer Hall Putsch
of 1923.

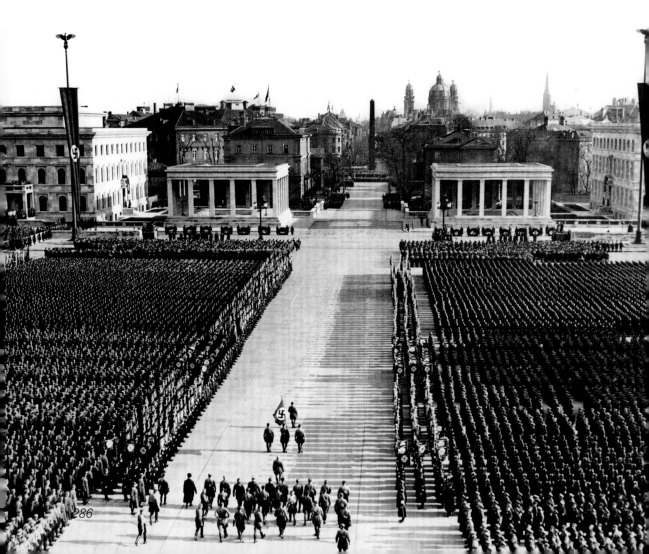

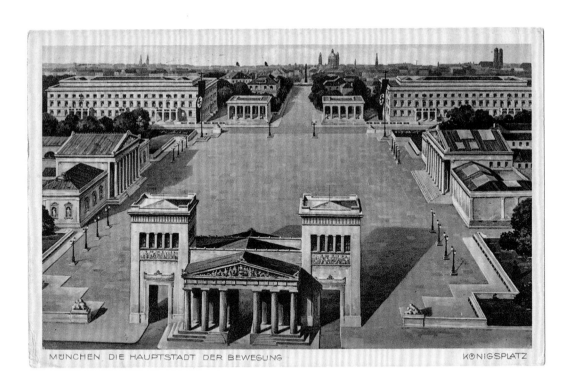

MÜNCHEN DIE HAUPTSTADT DER BEWEGUNG KÖNIGSPLATZ

A 1938 postcard, which shows the entire Königsplatz in Munich. The Führerbau (leader's building) and Verwaltungsbau (administration building), appear across the top portion of the card. The two smaller structures in between are the so-called honor temples, where Nazi party members who died in the putsch were entombed. The temples were removed in 1947 during de-Nazification. The legend in the lower left margin of the card proclaims Munich as "The birthplace of the [Nazi] movement."

Hitler's Munich headquarters—the Führerbau—before the arrival of the Allies. This building became the Monuments, Fine Arts & Archives Central Collecting Point for Art in Bavaria. Note the eagle, adopted by the Nazis as a symbol of empire, above the portico in the foreground.

RIGHT TOP
An early color photograph by Hugo Jaeger of Hitler's grandiose office in the Führerbau, which was the setting for the signing of the notorious Munich Agreement.

RIGHT BOTTOM
The 1938 signing of the Munich Agreement. By signing this document, Neville Chamberlain (far left), prewar prime minister of Great Britain, acquiesced to Hitler's seizure of the Sudetenland, a strategically critical region of Czechoslovakia, without military opposition. Although President Roosevelt initially approved of Chamberlain's strategy to promote "peace in our time" by appeasing Hitler, Churchill staunchly opposed the agreement. Also shown: Edouard Daladier (left of Hitler) and Benito Mussolini (right of Hitler), the prime ministers of France and Italy, and Italian foreign minister Galeazzo Ciano (far right).

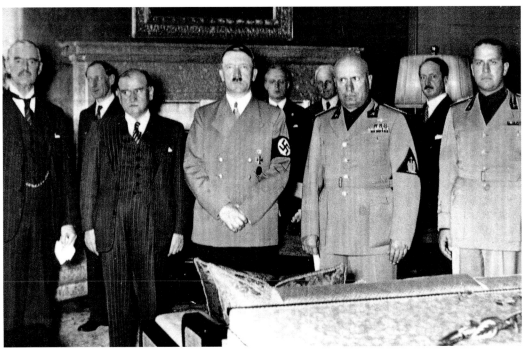

MUNICH AT THE END OF THE WAR

The Munich to which I returned on May 7, 1945, a few days after its capture by the Seventh Army, held few reminders for me. The familiar green-topped towers of the Frauenkirche looked down on almost complete destruction. There was no longer any individuality; the rubble, the debris, and the almost-complete ruin had a dreadful encompassing similarity. The Residenz, formerly the Bavarian Royal Palace, incorporating four centuries of celebrated architecture with grandiose interiors and housing artistic treasures of great distinction, was badly burned and shattered. Floors had collapsed and works of art that had not been moved to safekeeping were completely destroyed or in almost hopeless condition. The complex of buildings spread over a large devastated area would have required days for a thorough search. Along the streets lay bric-a-brac and miscellaneous trophies from the Armeemuseum.[2] In the Glyptothek, one of Europe's most important museums of Greek and Roman sculpture, the sculptures too heavy to take to safety were so calcinated by heat that they were in danger of crumbling if moved.

The Deutsches Museum, which once contained installations showing scientific accomplishments, was open to the skies following the bombings. The Old and New Pinakotheks, which had housed fabulous painting collections, stood ghostlike and disembodied. Some of the newer structures, like the pseudo-medieval city hall, had survived air raids concentrated on the central railroad stations and tracks. The official Nazi buildings, notably the Führerbau and the Verwaltungsbau, had suffered less because of elaborate camouflage systems and adequately manned firefighting equipment.

The Führerbau was on the list Rose Valland had given me of repositories in Germany containing French art. This was Hitler's Munich headquarters. The connecting building was the Nazi Party administration building, the Verwaltungsbau der NSDAP.[3] It was here that Hitler had made his selections, and it was the interim storehouse for objects to be deposited in the mine at Altaussee, pending their eventual placement in his prospective museum in Linz. Valland had referred to these buildings as "two museums containing paintings confiscated from Jewish collections, as well as paintings bought in France on the order of Hitler." The looting in the first hours after the Nazis fled these buildings was attributed to Russian and Polish displaced persons, but I suspect that the residents of Munich were far from blameless. And it may well be that a good many of the Nazi mementos we continue to read about, such as the silver tea and coffee set once owned by Hitler and described in our newspapers as a souvenir obtained by a task force captain, may have come from these buildings.[4]

Continuing Havoc at the Site

Repeatedly for four or five weeks I visited the premises with property control officers from the army, province, and city levels, and in all this time

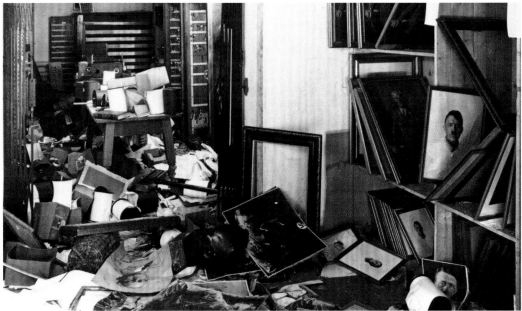

TOP AND ABOVE
Rooms in the Führerbau
when Allied troops
arrived. One of them
(bottom) contained some
of Hitler's press and
propaganda material.

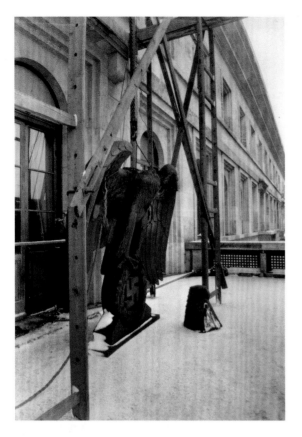

LEFT
American soldiers
removing the eagles,
a favorite Nazi
symbol of power,
from the Führerbau.

ABOVE, BELOW, AND RIGHT
Three views of the
Führerbau after Allies
converted it to the Mu-
nich Collecting Point.

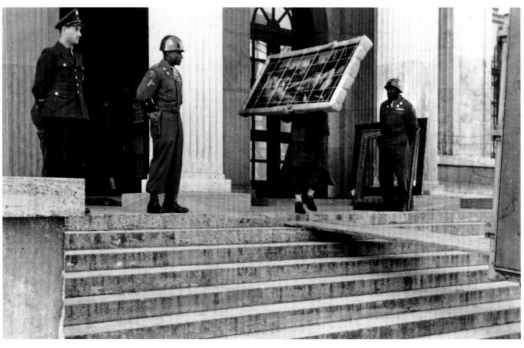

the situation was uncontrolled. I asked one major in charge of security troops billeted in the Führerbau and on guard in the Verwaltungsbau why 40 German prisoners of war were burning records without adequate supervision. His answer was that the higher headquarters task force had released the premises as an intelligence target and that from this he supposed that the records were of no value. It struck me that burning these valuable papers and records of party membership was considered the most convenient way of putting them in order. The major told me of blocking up a passageway by detonating a hand grenade in its opening.

At the end of one of the corridors I found a room that had not yet been entered. It was still carefully stored with Hitler's personal belongings—his library, a collection of photographs by his famous personal photographer, Heinrich Hoffmann, and other things of interest. On the door was a notice stating that this room was reserved for possessions from Hitler's home. I asked that the cases containing his library be moved at once to a place of safety. For the next three days I was occupied elsewhere. When I returned I found that many of the items had disappeared from the room. It seemed inconceivable that this material could have been looted with the main entrance under guard, until I checked the back entrances, which were wide open to prowlers. Cellars full of household equipment, paintings, and photographic records of works of art were prey to marauders. The photographs, floating in water from broken pipes, and several hundred paintings were taken to a temporary storage room on the first floor.

ESTABLISHING THE MUNICH COLLECTING POINT

I recommended the use of the Führerbau and the Verwaltungsbau as a central collecting point for the works of art looted by the Nazis and requested that a monuments officer be sent to take charge. There were no other buildings in Bavaria so well suited to housing the Goering collection, the Rosenberg and Hitler confiscations, and other looted items. Lieutenant (USNR) Craig Smyth arrived in Munich shortly thereafter, on June 4, to take charge of the buildings and the myriad details that attended such an operation. I had known Smyth before the war, and it was a relief to have so able and serious an officer build up the Munich Collecting Point.[5] By October this extremely well-run central collecting point housed books, documents, and 13,619 cases and uncrated works of art.

CONTINUING INSPECTIONS OF THE NAZI ART REPOSITORIES

By June 3, 175 repositories had been reported in our area. Hathaway and I inspected as many of these repositories as we could. The inspections, although necessarily brief, enabled us to determine which were the most important locations and to arrange for security wherever it was lacking. Previously, by the end of May, we had caught up with Franz Dehler,

who was a colonel in the SS and had been president of the Bavarian Administration of State-Owned Palaces, Gardens, and Lakes.[6] Papers were found in his hotel room at Herrenchiemsee that gave details of many additional repositories belonging to the Reich and to various agencies of the SS not under the control of the Bavarian Administration of State-Owned Castles. These were in addition to extensive secret lists found in a safe at Nymphenburg providing information about 197 repositories. In the period from April 15 to July 15, 1945, I visited dozens of repositories and Hathaway went to visit many others. Later Lieutenant (Junior Grade) (USNR) Charles Parkhurst, who succeeded Hathaway, took over his duties and continued to help most ably with our inspection tours. We had firsthand information about more than 180 places where works of art and cultural objects were stored.

The Castle of Dietramszell

The entrance to the castle of Dietramszell[7] adjoins extensive monastic buildings surrounding a cloister. The American guard posted there told me that his instructions permitted all officers access to the building. Curiously, his interpretation included German officers as well as ours. A German from a nearby prisoner-of-war camp, where thousands of soldiers were subject to the orders of their own officers, had been permitted to visit the wife of the owner of the castle. The woman's husband was a prisoner of war in the United States, and the family was said to have been anti-Nazi. Friendly visit or not, this incident pointed up the laxness of the instructions to the guard. I left the castle with a package of books and documents under my arm. Another guard was on duty and he made no attempt to stop me. He had had no instructions forbidding removals from this treasure-laden repository.

Objects deposited in the cellar vaults of the castle were all in good condition: Raphael's *Holy Family* and other great paintings and works of art from the Old and New Pinakotheks, from the Glyptothek, and from the Ethnological Museum, paintings from Schleissheim, and books from the State Library. In one of the vaults I came across paintings by Martin Schongauer:[8] *St. George and the Dragon*, *Christ Preaching*, *The Virgin and Child*, and *Anthony Abbot with Donor*. It had been reported that the Germans had not removed any works of art from the Colmar repositories, but these paintings had come from the Unterlinden Museum at Colmar. I had seen them in the museum and I knew that they belonged to France. The Germans "explained" that these famous paintings had been brought to Dietramszell so that they could be studied in preparation for a Schongauer publication.

This find enlarged my already active suspicion that my guides—Herr Lobe, the chief restorer of the Pinakothek in Munich; Fräulein Brandt of the Munich State Gallery; and Frau Schiessel, the secretary of the Administration of Bavarian Castles—could provide further information. I asked to see all the records of the works of art at Dietramszell. From a safe in one of the cloister walks they removed the original accession books for several Munich museums.

In the pages devoted to Pinakothek acquisitions since the Nazis came into power, I noted at random a Tyrolese painting of the year 1470. It was entered as coming from a "Jew." No name was given. The agent was Helbing, and the sale and purchase price was only 250 marks. Among other vendors were Weinmüller, a Munich picture dealer, and the Kunstgewerbe and Schnütgen Museums in Cologne. These accession books provided us with valuable information in locating looted objects acquired officially by Dr. Buchner, the director of the Pinakothek, and other Nazis. Dr. Buchner had also been involved in the removal of the *Ghent Altarpiece* from France. I sent a message to headquarters requesting that he be apprehended.

There was another list here that I found more interesting than the Munich accession books. It contained the names of 235 private collectors from Munich who had stored their collections in ten repositories under the auspices of the Pinakothek. I forwarded a copy of this list to other investigators. Dr. Buchner had 100 paintings deposited in five of the listed repositories.[9] There were such entries as "Almas-Dietrich Galerie,"[10] which was connected with the international looting gangs who had acquired works of art under duress for the Nazi officials; Haberstock,[11] long associated with Hitler's collecting, who had bought four paintings "through Böhler"; one of the Hanfstaengls,[12] who had sent 33 paintings; Professor Fritz Meder,[13] who had 139 listed opposite his name; and so it went.

Heinrich Hoffmann[14] had 107 pictures at Dietramszell, including two that Hitler had painted.[15] I took his catalogue with 276 photographs of his paintings so that I could use it in interrogating him about the source of his collection. I decided to follow up the Hoffmann lead in the hope that the intimacy of his association with Hitler might now result in our getting some useful information.

FOLLOWING THE TRAIL TO HOFFMANN

Many agents were sending in reports about Hoffmann, and I decided to visit his home in Gufflham near Altötting. In the middle of May I arrived there with Lieutenant Colonel J. H. Harrison of the 501st Field Artillery Battalion of the 14th Armored Division. Our American security was so good that we had difficulty in gaining access to Hoffmann's home. It was a small house, comfortable and modern, with white walls in the Beverly Hills or Florida manner. There were dozens of paintings and a small but good collection of Nazi motion picture films showing official and intimate views of Nazi bigwigs and their favorites. I photographed a Bruegel genre painting said to have come from the Hohenzollern's Sigmaringen Collection[16] and took a copy of the lists of works of art and furnishings, which had been prepared by a friend of the Hoffmann family living in the house. She was an actress from Berlin who had sought shelter here following the first Berlin raids. She thought that Hoffmann had hidden works of art with friends in the vicinity.

Interviews with Hoffmann

Hoffmann himself was, of course, in jail. Up to this time he had refused to talk to other investigators. I tried to draw him out. He breathed heavily, nervously, tired from the recent strain and the uncertainty of his position as a great friend of Hitler. I brought him cigarettes, arranged for him to have daily walks in the courtyard of the jail, and talked to him as though he had led a blameless existence. We had our sessions in German. Hoffmann knew English but he was too excited to speak anything but his mother tongue. After his initial refusal to talk, he became garrulous and with some pride gave me an outline of his life.

He had been with Keystone-International in London[17] when Hitler was still comparatively unknown. He had been assigned to get a picture of Adolf. As a result of their meeting he and Hitler became very good friends, and Hoffmann greatly influenced the art activities of the Führer. He became wealthy under this patronage and by the end of the war had 65 agencies handling his publications and branches in Berlin, Munich, Prague, Paris, Strasbourg, Riga, Posen, Warsaw, and Vienna. He was inordinately proud of his assiduousness in promoting German taste. He claimed to have acquired many works of art for reproduction purposes only, and that he had owned his most important pictures long before the war.

On one of my visits with Hoffmann I brought Private Ettlinger with me. He was German-born and wanted us to help him recover his grandfather's large print collection, which the Germans had taken to one of the repositories near Baden-Baden. Ettlinger spent many hours getting as much of the history of Hoffmann's paintings as the prisoner could remember. Several of them had been seized by an SCI (Special Counter-Intelligence) agent in the house of Lola Schmidt.[18] Hoffmann provided additional information about paintings he had placed in a hotel at Waldmünchen. Included in this group were four Hubert Roberts[19] he had acquired in 1942. These works were vastly superior to some of the romantic scenes that he and Hitler both admired fervently and encouraged by their patronage.

Hoffmann gave me a statement he had written in English, which is indicative of the attitude of the Nazi captive toward his American captor:

> *Investigation about my pictures can be allowed. The most and the first pictures I attained before the war at the time when Hitler was in power. My money comes from my art house, which shows great sales exchange. The biggest part of my pictures belongs to the stores of reproductions. Therefore the collection from my sales of my art dealings are not high. I have never acquired pictures from museums or galleries, but instead bought or exchanged them from famous dealers. A number of pictures belong to my wife, who brought them with her at my marriage, or are gifts from acquaintances.*

HANS FRANK, THE BUTCHER OF POLAND

Hans Frank (1900–1946) was originally Hitler's personal lawyer and rose within the Nazi Party to become the Hitler appointed head of the General Government of Poland, where his role in organizing the transport and extermination of the populace earned him the nickname "Butcher of Poland."

While in Poland, Frank installed himself and his family in the Royal Castle in Kraków, which he decorated lavishly with confiscated works of art. When Frank fled to escape advancing Soviet troops, he took three world-famous paintings with him to his Bavarian villa on the Schliersee: Leonardo da Vinci's *Lady with an Ermine* (c. 1490) and Rembrandt's *Landscape with the Good Samaritan* (1638), which were returned to their owners, the Czartoryski family of Poland. They now hang in the Czartoryski Museum in Kraków. The third painting, Raphael's *Portrait of a Young Man* (1514), has never been found.

Frank was tried for genocide and crimes against humanity at Nuremberg and executed in 1946.

BELOW
Polish art historian Karol Estreicher returns Leonardo da Vinci's *Lady with an Ermine*, 1946. Flanking him are, from left, monuments men Everett Parker Lesley Jr., Frank P. Albright, and Jose D. Espinosa.

RIGHT
Leonardo da Vinci, *Lady with an Ermine*, 1489–91. Czartoryski Museum, Kraków, Poland.

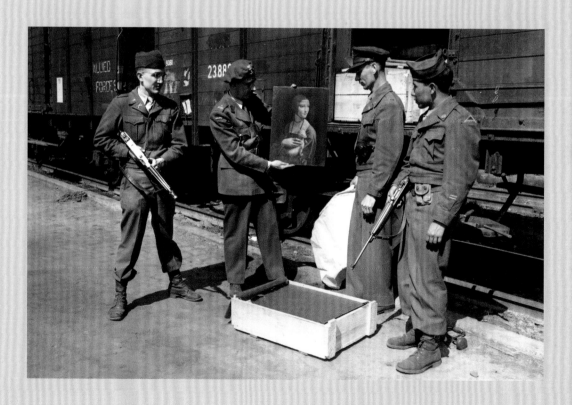

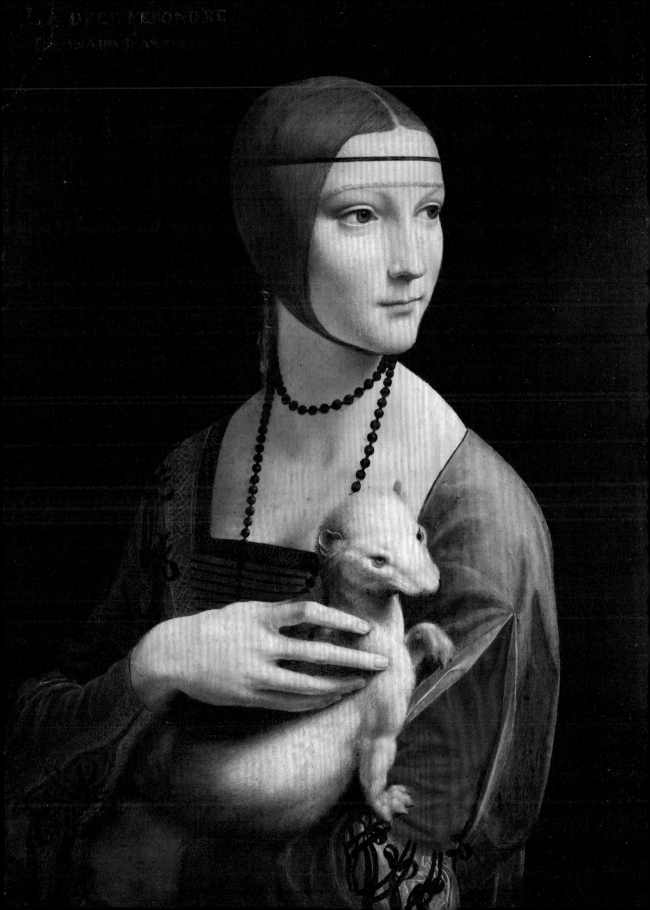

THE MONASTERY AT ETTAL

One of the other principal Munich repositories I was able to inspect was the famous Baroque monastery at Ettal near Garmisch-Partenkirchen.[20] Here, superb selections of objects from the Pinakothek, the State Library, the Print Collection, and other things sent by the Landesamt für Denkmalpflege[21] were in supposedly air-conditioned vaults. When I checked the relative humidity I found it at 75 percent. This excessive humidity explained the mold growth attacking these masterpieces, which had been saved from the Munich air raids and fires. The custodian and his son, who had been released from the Wehrmacht, were not competent to handle these objects. The Pinakothek at one time boasted 84 pictures by Rubens alone in its collections. The custodian and his son had dusted off the mold growth when it became unsightly, but they did not understand how to use the dehumidifying apparatus that had been installed by other Munich officials. It took but a short time to get these devices working. There were not enough of them, but the few that were available did considerable good.

Discovery of the Bernheimer Collection

The famous monastery had a few windows broken during a raid on a nearby airplane factory, but fortunately that was the extent of the damage it suffered. Father Kupfer, the abbot at Ettal, said that he was anti-Nazi and had done much during the war to help save works of art, including furniture, rugs, and other objects from the firm of L. Bernheimer in Munich.[22] In his reception room there were many prices tagged "not for sale," although they bore the name of the dealer Bernheimer. The abbot said that these objects had been brought to the monastery by another anti-Nazi, D. Joseph Egger, working on behalf of Otto Bernheimer, who was in Venezuela.

A few days later a letter relative to the Bernheimers came to my desk in Heidelberg. It was a paraphrase of a letter written by a U.S. Army lieutenant who had entered Munich shortly after its fall. As a friend of the Bernheimers he wrote to one of them in Venezuela. A Bernheimer letter to an art dealer in California was intercepted and sent to my office in Heidelberg. The letter read: "Bernheimer's stock on hand is now larger than it was in 1938 and none of the old stock has been touched. This was due to the fact that the firm was able to carry on business with newly purchased merchandise. All the most valuable objects of art are still in stock. The stock was evacuated to ten safe repositories in castles and cloisters in Upper Bavaria in 64 large furniture vans." The letter had been picked up by our alert intelligence system and was sent back to Germany to help in our monuments program. Fortunately for the lieutenant, it was held that security had not been violated.

Also at Ettal were a large Tiepolo salvaged from the Residenz in Munich and case upon case from institutions and private sources, including many boxes from the Bruckmann Verlag, a press known worldwide for its art publications.[23]

THE SCHLIERSEE AND HÖCHSTÄDT

From Dr. Hans Frank's castle on the Schliersee near Munich, an American task force recovered paintings he had acquired when he was Gauleiter of Poland.[24] Details of the Nazi's deliberate obliteration of Poland and all Polish culture by theft, fire, and murder are too familiar and too extensive for more than a mere mention here. The task of tracing and identifying objects stolen by the Germans from Poland was only one of myriad problems besetting the monuments officers. At one collecting point alone we held 635 vessels carefully selected by the Nazis from Polish churches.

At Höchstädt, looted Egyptian and Scythian ethnographical and prehistory collections from Russian and Polish museums were catalogued and studied by the Einsatzstab Rosenberg officials who had removed them for "safekeeping." A footnote to one of the captured lists stated: "All the museum objects evacuated for safety from battle harm should be returned at conclusion of hostilities." In one list there were 2,018 separate cases and 628 packages. Lieutenant Parkhurst wrote a 34-page report on this material. I gave a copy of the report, together with other information, to the Third Army, which on June 15 took over the task of continuing the work we had started in southern Bavaria.

CONSOLIDATING GAINS OF THE MONUMENTS MEN

With the cessation of the war, the army and navy could release other men for monuments specialist work, and an organization with some continuity could be set up for bringing together and returning art objects. Major L. Bancel La Farge, chief of the Monuments, Fine Arts & Archives Section of United States Forces, European Theater, had requested the establishment of collecting points in what were to become Eastern (Third Army) and Western (Seventh Army) Military Districts. In the Eastern Military District, I had selected Munich, which came under Third Army jurisdiction on June 15. With the advice of Bancel, I chose Wiesbaden and Marburg for the Western Military District. These became the principal collecting points for the other repositories. By the end of 1945, 384 repositories, not including those turned over to the Third Army, were reported in the Seventh Army area. Of these, 296 were inspected and 86 were evacuated. This enterprise was manned by an average of 26 fine arts specialists. Representatives from Allied governments came to help identify their looted objects: Rose Valland from France, Captain H. L. C. Jaffé from Holland, and Lieutenant Colonel Raymond Hocart from Strasbourg.

In all, 123 denazified[25] civilian specialists contributed to the task of cataloguing and caring for cultural objects. We were grateful for the services of such outstanding scholars as Professors Richard Hamann and Gers von Merhart of Marburg, Professor Ernst Holzinger of Frankfurt, Professor Otto Schmitt of Stuttgart, and Kurt Martin of Karlsruhe.[26]

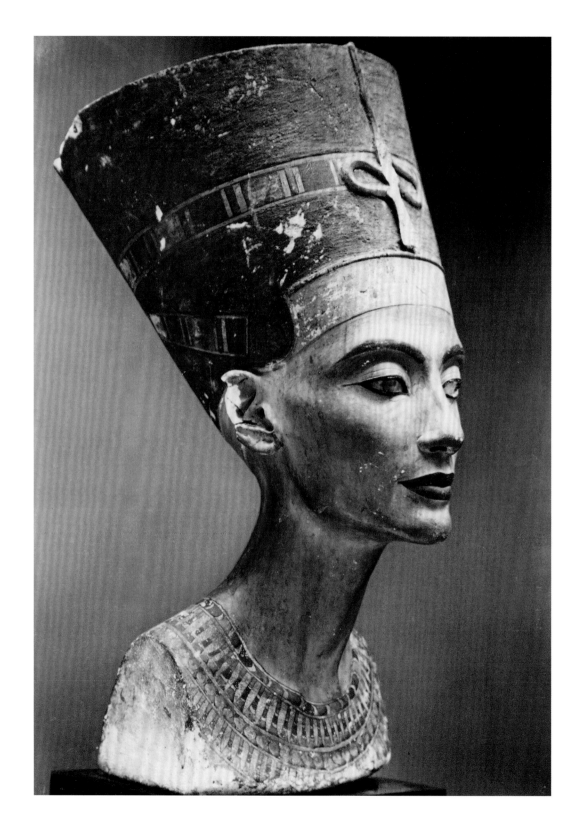

LEFT
Nefertiti, c. 1345 BCE, now at the Neues Museum, Berlin, Germany. It was discovered by Allies in the Merkers salt mine.

RIGHT
Walter Farmer with *Nefertiti* at the Wiesbaden Collecting Point. The bust was returned to the Berlin museum, notwithstanding the Egyptian government's request to return it to Egypt.

BELOW
Edith Standen (far right), Rose Valland, and Joe Kelleher at the Wiesbaden Collecting Point, c. 1946.

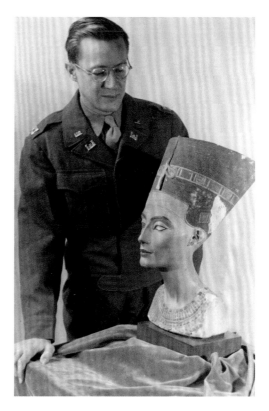

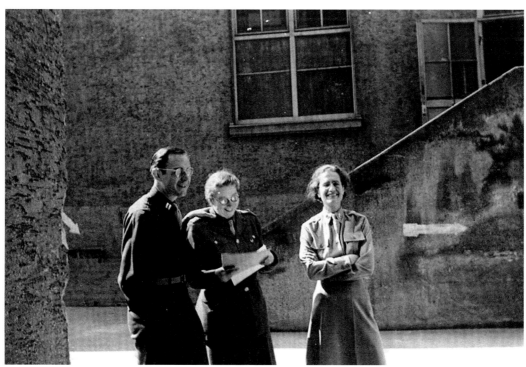

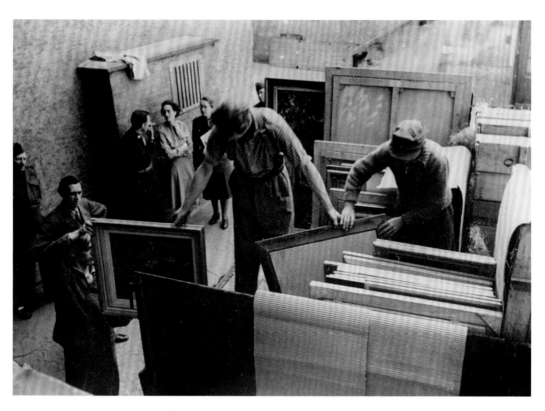

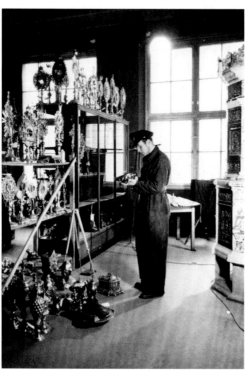

ABOVE
Rose Valland (far right), Edith Standen, and Joe Kelleher converse while paintings are organized for transportation at Wiesbaden, c. 1946.

LEFT
Some of the 635 gold and silver objects the Nazis took from the churches of Poland.

RIGHT
Twelfth-century chalice from Tremessen in Poland, one of the greatest but little-known examples of the art of medieval goldsmiths. The vessel is in the Gniezno Archdiocese Museum, Poland.

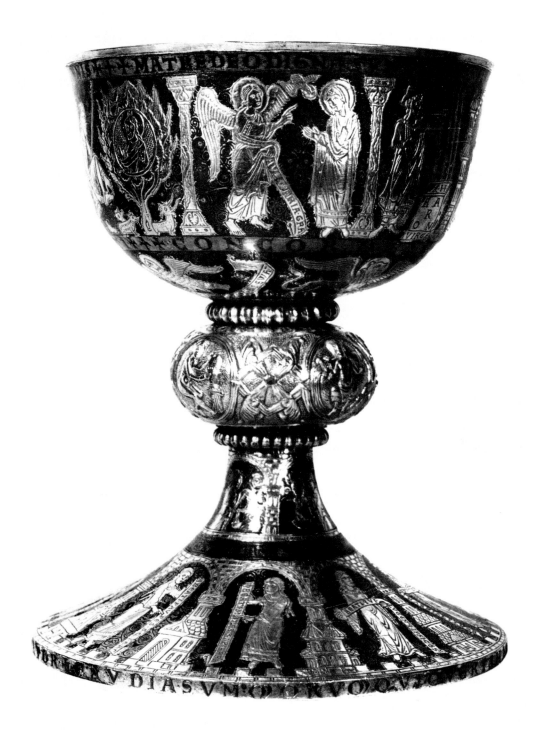

Wiesbaden became the Seventh Army's most important collecting point for German-owned objects. It was a large building—300 rooms—built to house a number of museums. It had not been seriously damaged by bombings. Captain Walter Farmer, who knew how to get things accomplished after serving with the engineers, prepared the building for the reception of the works of art.[27] It was not an easy task to clear the premises of troop units, have the roofs repaired, and replace 30 tons of shattered glass. A description of the works of art that we brought to the Wiesbaden Collecting Point might begin with the Egyptian bust of Queen Nefertiti, all of the Guelph Treasure[28] remaining in Europe, the Lüneburg Treasure,[29] and the 635 liturgical vessels mentioned previously, taken by the Germans from Poland. From their temporary shelter in the cellars of the Frankfurt bank we brought the cultural objects from 14 of the most important museums in Berlin, which had been found in the Merkers mine.

A subsidiary collecting point was set up in the modern archives building of Marburg University. It was one of the few buildings in Marburg to suffer from bombing, but as it was the second-largest institution of its kind before the war and was fireproof, we eventually arranged to concentrate 3,457 works of art here. Captain Walker Hancock,[30] in charge of the collecting point in its early phases (succeeded by Lieutenant Sheldon W. Keck[31]), wrote, "Even the problem of getting a broom with which to make a start required days of patience and plotting." Among the objects in the Marbug Collecting Point were paintings from the Folkwang Museum in Essen, the Suermondt Museum in Aachen, and the Wallraf-Richartz Museum in Cologne.

The most famous objects of medieval art gathered from the rich church treasuries by the Germans for safekeeping presented an incomparable array of hundreds of objects such as will probably never be seen together again. A total of 766 objects representing the finest paintings, sculptures, and decorative arts from the Rhineland were evacuated to Marburg from the copper mine in Siegen. When Captain Hancock had visited the mine in April as the First Army's monuments officer, he had found it dripping with moisture and crowded with civilians seeking refuge from the air raids. Mold had developed on paintings and sculptures, and there was nothing to counteract the humidity. The technical difficulties in evacuating this mine were surmounted by Hancock and by Lieutenant Lamont Moore (a Ninth Army monuments officer).

IMPLEMENTATION OF U.S. MILITARY LAWS

Military Government Law No. 52 defined the Allied policy on cultural objects in war areas, and there was a genuine desire on the part of the army to implement this law. When scientists and their equipment were evacuated from Thuringia before that region was formally annexed to the Russian Zone, we received word that by direction of the president of the United States no "indigenous" works of art were to be moved to

our zone. I interpreted the cable to mean that objects that had been in Thuringia before the Nazis came to power were to be left behind for the Russians to administer as they saw fit.

I went by plane to Weimar to see that the instructions were carried out, as there had been previous general instructions to place cultural objects in safekeeping within the limits of our eventual zone. The suspicions of the Russians had been aroused following the evacuation of the Merkers mine, but if they had worked with the American monuments officers, as did the French and British officials, they would have known to what extent every effort was made to avoid giving cause for alarm. If collections had been placed in Thuringia by German institutions and individuals from outside of Thuringia, for safekeeping during the war, it was obviously efficient and proper that they should be placed in the American Zone to facilitate their protection and return to their legal owners. The famous Goethe Collection of Herr Kippenberg was evacuated from Weimar on the basis that this was private property. If Herr Kippenberg wanted to work at this collection in Marburg rather than in the Russian Zone, we could see no reason for insisting that his collection remain in Weimar.[32]

Kurt Thöne Shares Information

While in Marburg at the end of July, I learned that a fire had broken out in the Heimboldshausen potassium mine. Placed here by the Germans were costumes and scores from the State Opera in Berlin, but most serious of all, 1.5 million books from the State Library. We were horrified to learn from Kurt Thöne, who had supervised the removal to the mine, that the fire had broken out in April. The public safety officer at Marburg had reported the fire to the regional military government office in Kassel. They reported it to the provincial military government office, also in Marburg. It took nine days for this information to cross the street.[33]

Kurt Thöne had been adjutant to Bernhard Rust, the German minister of education. He was completely imbued with theories on the greatness of Germany and the German people and had the greatest admiration for the Nazi ideology. According to Thöne, the Nazi officials were dumbfounded that the Allied bombings could do so much damage. So as not to alarm the public, they steadily refused to acknowledge the need for evacuating art objects from Berlin. When they eventually decided to send them to hiding places, there were the obstacles of insufficient personnel (women students did a great part of the packing), insufficient equipment and transportation, and inadequate repositories.

Kurt Thöne gave us particulars about Otto Kümmel (1874–1952), general director of the State Museums in Berlin since 1934. Kümmel's reputation as an art historian dates back to 1901, when he was a voluntary assistant in a museum in Hamburg following a student career in the Universities of Freiburg, Bonn, and Paris. He was especially noted for his studies in Far Eastern art and had published standard books. Before the war his was a name respected in learned circles. By 1937 to 1939 his publications were indicative of expansionist tendencies. Thöne

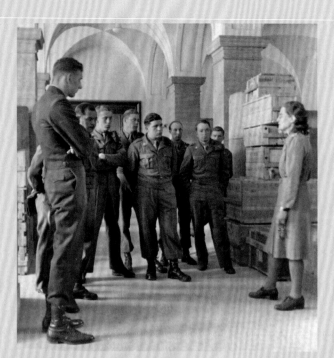

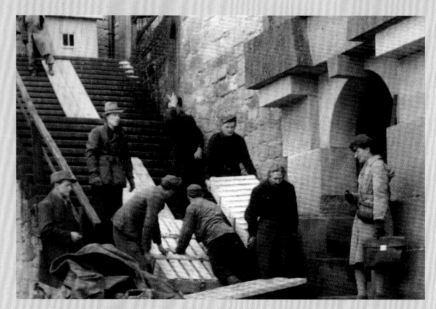

EDITH A. STANDEN

Captain Edith A. Standen succeeded Walter Farmer as head of the Wiesbaden art collecting point in Germany, serving as temporary officer in charge from March 1946 to August 1947. In her role as officer in charge at Wiesbaden, she worked closely with Rose Valland and supervised the restitution of huge numbers of artworks, including the collections of 16 Berlin state museums. She earned the U.S. Army Bronze Star for her service.

Born in Canada to British parents in 1905, Standen grew up in England and Ireland and earned her undergraduate degree from Somerville College, then one of two women's colleges at Oxford University. In 1928 Standen moved to Boston, Massachusetts. While volunteering at the Fogg Art Museum, she came to the attention of Paul Sachs and joined his museum course. She then took a job as secretary of the vast art collection of industrialist Peter A. B. Widener at Lynnewood Hall, his mansion outside Philadelphia, until the collection was donated to the National Gallery shortly before World War II.

In 1943 she enlisted in the U.S. Army Women's Auxiliary Corps, later known as the Women's Army Corps (WAC), and was eventually posted to work with Mason Hammond as a member of the monuments team, where her first assignment was inspection of art objects in the Reichsbank in Frankfurt, Germany.

After the war, Standen returned to the U.S., where Francis Henry Taylor, then director of the Metropolitan Museum of Art, hired her as curator of European tapestries. She continued at the Metropolitan Museum for more than 20 years, until retirement in 1970. She continued to work for another 18 years as a researcher and consultant. She died in New York City in 1998.

TOP LEFT
Standen briefs soldiers assigned to serve as guards at the Wiesbaden Collecting Point, c. 1946.

TOP RIGHT
Captain Standen (left) and Rose Valland pose next to a medieval suit of armor awaiting restitution, c. 1946.

BOTTOM
Standen (far right) supervises staff at Neuschwanstein Castle, c. 1946.

insisted that the "Herr Generaldirektor did not like the business of confiscating works of art in Germany and in the occupied countries and rarely cooperated with Rosenberg."

To Professor Kümmel was given the task of recapitulating the story of "works of art and historically important objects that have come into foreign possession since 1500, against our will and through doubtful transactions," and formulating the Führer's theories on the conditions of their postwar restoration to Germany. A copy of Kümmel's book, found by intelligence agent Albrecht near Hitler's home in Obersalzberg, has been turned over to the Department of State for such use as it may have for future problems of restitution and reparations. A photostatic copy is in the library of the Metropolitan Museum of Art.[34]

Goering had prepared two repositories in Bad Wildungen.[35] They were two concrete buildings ("bunkers") without windows. These we took over and supervised as a subsidiary collecting point. When the Allies arrived, Dr. Bleibaum, the Landeskonservator for Hessen-Nassau, was completing his inventory and photographs of the paintings deposited there. There were 388 paintings from Kassel, 110 from Hanover, 127 from Mainz, and others from Aachen. Stained glass, altars, and other ecclesiastical objects of importance had been assembled here by the Nazis from many German churches. Private property included 1,343 paintings, 63 pieces of furniture, and 23 sculptures. At Bad Wildungen I found the carefully concealed, massive accession books of the Frankfurt museums. A first survey revealed 140 items collected by the Nazis in France and 7 in Holland.

Gradually the implications of Law No. 52 were becoming clear to the Germans. They began to realize that our intentions were sincere and that there was no ulterior motive behind our efforts to help rebuild their culture. An exhibition of 30 masterpieces of European paintings that was organized by the Marburg Collecting Point for two weeks in November 1945 proved that some Germans hungered for the peaceful arts. Of the 2,800 visitors to the exhibition, all but 200 were Germans, although 14,000 Americans were being redeployed through the Marburg Reinforcement Depot.

Monuments Officers Oppose American Threat to Law No. 52

In November a directive arrived from Washington ordering the immediate preparations for the shipment to the United States of selected German-owned works of art for their "more adequate protection." It came at a particularly unfortunate moment in view of our efforts to secure the confidence of the German people, who looked upon this order with suspicion. John Nicholas Brown, Lieutenant Colonel Mason Hammond, and Lieutenant Commander Charles L. Kuhn had already returned to the United States after their exhortations had not been heeded at higher headquarters. Neither we nor the Germans knew of President Truman's promise to return the paintings when they could be more adequately housed in German museums. The directive was hotly protested by other monuments officers in Germany.[36] Owing in large part to this opposition, the only shipment of German-owned paintings to the United States con-

sisted of 202 pictures from the Berlin museums stored at the Wiesbaden Collecting Point. After three years in America, involving a stay at the National Gallery of Art in Washington and later a grand tour of other American museums, the paintings were all safely returned to Germany.

Any attempt to write the complete story of restitution and the Allied recovery of works of art confiscated by the Nazis from all of Europe would require a thorough study of all existing records collected by many individuals over a period of years. Rose Valland wrote from Berlin in the summer of 1948: "Now that the task of large-scale restitution is terminated, I have been named the chief of France's Fine Arts Section in Berlin, and I am trying to do a little diplomatic work with our neighbors in the East. . . . But in that direction there are still many things to recover, and you know that I am insatiable."[37]

Similarly, any attempt to give the complete story of the work of the enthusiastic, able, and hardworking specialist officers at the collecting points, and to tell the complete story of monuments work in Germany, would require another book. Bearing in mind the hundreds of repositories in Seventh Army territory, one can recognize the possibility of hundreds of narratives and thousands of sagas on the reunion of lost masterpieces and their legal owners.

Even though our numbers were few,[38] sincerity and humanity of purpose helped preserve for posterity the evidences of man's cultural past that had been shunted about in boxcars, buried in mines, sealed in caves, and stored in barns and in castles. The contributions of the Monuments, Fine Arts & Archives officers should give lasting credit to the policies of a country whose supreme military commander could tell the vanquished: "Despite all hardships, you need not face the future without hope. You can redeem yourselves, both at home and in the eyes of the world, through your own efforts. It lies in your power to build a healthy, democratic life in Germany and to rejoin the family of nations."[39] Nothing could contribute more to this peaceful way of life than restoring their cultural heritage to the Germans and giving encouragement and confidence in the rebuilding of non-militaristic educational institutions.

RETURN OF THE STRASBOURG CATHEDRAL STAINED GLASS

In the summer of 1945, Eisenhower ordered the return of the *Ghent Altarpiece*, found at the Altaussee salt mine, to Belgium, and the stained glass rose window, as well as many other windows, which were discovered by Americans hidden away in 73 cases in the Heilbronn salt mine, to the great cathedral in Strasbourg, capital of Alsace. Fearing destruction from bombing raids and gunfire, the French had originally removed the stained glass from the famous medieval cathedral and taken it to southern France for safekeeping, but the Nazis found it and in June 1944 trucked it across the Rhine to the mine at Heilbronn.

Strasbourg cathedral, having been under construction off and on for a couple of hundred years, was finally completed in 1439. Along with Notre Dame and Sainte Chapelle, the Strasbourg cathedral is a masterpiece of Rayonnant Gothic architecture, a style that is highly decorative and characterized by large windows filled with stained glass, allowing copious rays of light to enter the space. The rose window at Strasbourg is a particularly magnificent example of this style.

With the fall of France in 1940 and Hitler's triumphal visit to the cathedral in the same year, its reclamation became a cause célèbre of the Free French Forces led by Charles de Gaulle and Colonel Philippe Leclerc. After the first major victory of the French over the Italians at Kufra in North Africa, on March 2, 1941, Leclerc famously swore before his troops that they would never lay down their arms until the French colors again "flew over the cathedral at Strasbourg." This became known as the Oath of Kufra. On November 23, 1944, Leclerc led his 2nd Armored Division through the Saverne gap in the Vosges mountains to liberate Strasbourg. The city was almost retaken by a German counterattack, but the French garrison held them back. These dramatic events made returning Strasbourg's stained glass a potent symbolic gesture for the Americans. As the author puts it in his chronicle of the event: "The desire for appropriate ceremonies in connection with these official restitutions was recognized as a rare opportunity to stimulate good will and to make the world aware of our intentions and actions in righting wrongs committed by the Nazis."

The author being awarded the French Legion of Honor at Strasbourg by Lieutenant General Jean-Louis-Alain Touzet du Vigier upon the return of the stained-glass windows to the cathedral of Strasbourg, November 4, 1945.

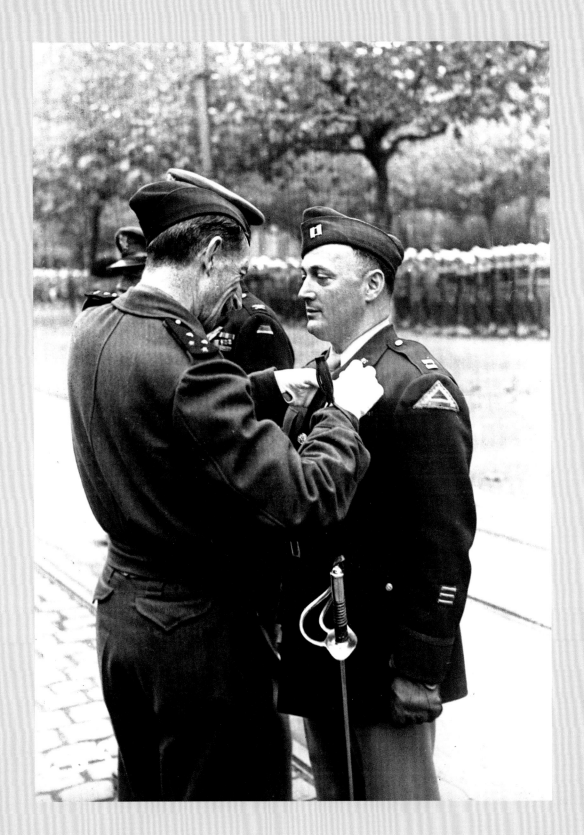

A team under the supervision of monument offi-
cers Dale Ford and Charles Parkhurst, along with the
author's driver and assistant, Harry Ettlinger, were as-
signed to extract the stained glass from the Heilbronn
mine and deliver it to the cathedral. On November
4, 1945, the day of the official ceremony, the author
joined a cavalcade of officials as they crossed the
Rhine into the city. The author, in an unpublished text,
described the scene at the ceremony: "Thousands of
people lined the square. There was restrained gaiety
with music. I could think only how different was the
scene at battle-torn Heilbronn when I had arrived
there six months earlier to recover the Strasbourg
glass. This historic occasion was indeed a fitting cul-
mination to the series of events which followed the
capture of Heilbronn, the scene of some of the bitter-

Strasbourg Cathedral
with the stained-glass
windows that the
French had removed for
safekeeping, but which
the Nazis seized and
relocated to the
Heilbronn salt mine.
They were among the
first objects of art to
be returned to an Allied
country.

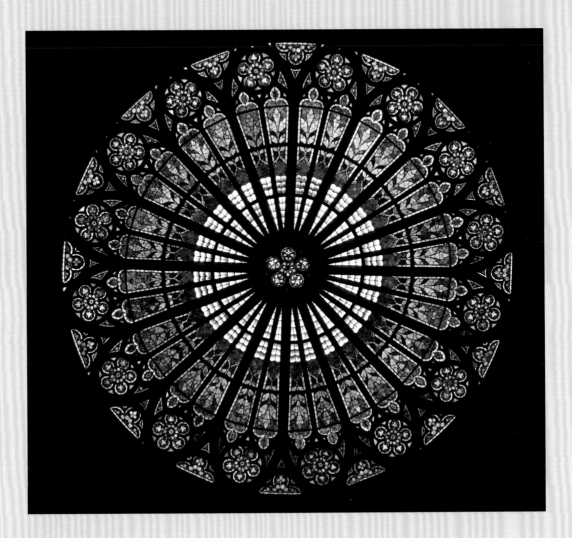

The spectacular rose window in Strasbourg Cathedral.

est fighting of the war. . . . I was thinking of my fellow Americans, thirty-five of them killed in battle near the entrance to the Heilbronn salt mine. Lieutenant General du Vigier . . . decorated me with the medal of the Legion of Honor. . . . I thanked General du Vigier and said, "This is one of the happiest moments of my life."

The author, who had been unaware until the last minute that he was to receive the honor, discovered later that Rose Valland had hand-carried the papers authorizing the award to General de Gaulle for his signature the day before, just in time to reach Strasbourg for the occasion. For the rest of his life, the author wore a small rosette in his lapel as a reminder of this momentous day.

NOTES

1 As a young man in the 1890s, the author's father, Louis Rorimer (1872–1939), who later became a prominent interior designer in Cleveland, Ohio, had studied at the Kunstgewerbeschule in Munich. See Piña, *Louis Rorimer*. Louis had his last name legally changed from Rohrheimer to Rorimer in 1917 to forestall the influence on his business of anti-German sentiment in the United States during World War I.

2 The Museum of Armaments was not restored to its original configuration. The building was partially restored in the 1980s and now serves as administrative offices for the Free State of Bavaria.

3 The author is describing two large, almost identical buildings on Munich's Königsplatz, which were connected by an underground tunnel. The complex used to include two smaller structures housing memorials displaying sarcophagi with the remains of Hitler's Munich partisans who died in the failed Beer Hall Putsch of 1923. These so-called honor temples, which used to be situated between the two buildings, were removed under denazification. See Janet Flanner, "Annals of Crime: The Beautiful Spoils, Part III—Monuments Men," *New Yorker*, March 8, 1947. The historical novel *Munich*, by Robert Harris (New York: Knopf, 2017), includes dramatic descriptions of the newly constructed Führerbau and other features of the Königsplatz as they appeared at the time of the Munich Conference of 1938. Today, the former of the large twin buildings houses a school of music and theater, and the latter serves as the administrative offices of several Bavarian cultural institutions.

4 Chapter 2 of Alford, *Nazi Plunder*, entitled "The Plundering of Munich," describes a secret task force of the U.S. Sixth Army designated "T Force," which was assigned to the recovery of German technology in Munich and was joined by other army units that participated in the looting. The stolen items included a "vast collection" of silverware mailed home to the United States, along with other booty.

5 Craig Hugh Smyth (1915–2006) was trained at Princeton and worked at the National Gallery of Art in Washington before the war. After the war he played a key role as officer in charge of the Munich Collecting Point until 1946 and continued as a friend and colleague of the author and his family. Among other roles, he served for many years as the director of the Institute of Fine Arts at New York University and later as director of Harvard's Villa I Tatti, its center for Italian Renaissance studies in Florence, Italy. See Craig Hugh Smyth, *Repatriation of Art from the Collecting Point in Munich after World War II* (Maarssen/The Hague: G. Schwarts/SDU, 1988). The organization and operations of the Munich Collecting Point are chronicled extensively in Iris Lauterbach, *The Central Collecting Point in Munich: A New Beginning for the Restitution and Protection of Art* (Los Angeles: Getty Research Institute, 2018).

6 See Chapter 6, note 11.

7 The monastery at Dietramszell today includes a beautifully restored Baroque church and also houses a Montessori school.

8 Martin Schongauer (c. 1445?–1491) was a leading Alsatian painter and engraver, probably the best-known predecessor to Albrecht Dürer.

9 For additional information about Ernst Buchner (1892–1962), see Petropoulos, *Faustian Bargain*.

10 The art dealer Maria Almas-Dietrich (1891–1971) is said to have gained access to Hitler's inner circle through her daughter's friendship with Eva Braun (1912–1945), his personal secretary and, in the end, his wife. Dietrich was reputed to have started out as the owner of a small gallery of antiques in Munich and became remarkably successful, though owing to her lack of experience, often unwittingly trading in forgeries. After the war, she again set up shop with her daughter in Munich, where a brass plaque with the name "Galerie Almas" hung in the building entrance until 2001. See Nicholas, *Rape of Europa, p. 32*. See Petropoulos, *Göring's Man in Paris*, pp. 151–52.

11 See Petropoulos, *Faustian Bargain*, for a full account of Haberstock's career.

[12] This reference undoubtedly relates to the German art publishing family of Ernst "Putzi" Hanfstaengl (1887–1975). Putzi (meaning "little fellow," a name that stuck with him from childhood despite his imposing stature) was a colorful early member of Hitler's inner circle. He had attended Harvard in the United States but was later excluded from the family business in Munich, where he fell in with Hitler in the 1920s. After more than a decade as Hitler's companion and foreign press chief, in 1937 he fell out of favor and fled, eventually resurfacing as a propaganda adviser to President Franklin D. Roosevelt, under guard in the United States. His son, Egon (1921–2007), also attended Harvard and served in the U.S. Army in the Pacific. Putzi is often referred to as "Hitler's piano player" or "the Harvard Nazi." See Peter Conradi, *Hitler's Piano Player: The Rise and Fall of Ernst Hanfstaengl, Confidant of Hitler, Ally of FDR* (London: Duckworth, 2005). His flamboyant character appears several times in the 2011 account of the U.S. ambassador's travails in prewar Berlin. See Erik Larson, *In the Garden of Beasts: Love, Terror, and an American Family in Hitler's Berlin* (New York: Crown, 2011). The Hanfstaengl family was prominent, both before and after the war, in art publishing, art dealing, and museum management. Eberhard Hanfstaengl (1886–1973), a cousin of Putzi's, was a German art historian who played a leading role in the return and repatriation of looted art at the Munich Collecting Point. Eberhard's daughter, Erika Hanfstaengl (1912–2003), also worked at the collecting point and pursued a long career as an art historian. In accordance with family tradition, all the Hanfstaengls were given names beginning with E.

[13] Meder's name, along with those of other German art intermediaries mentioned here, appears on the list of Red Flag names assembled by the Art Looting Intelligence Unit.

[14] Heinrich Hoffmann was not only Hitler's personal photographer but also his art dealer and confidant. See page 17.

[15] A number of watercolor paintings by Hitler are in storage at the U.S. Army Center of Military History in Washington, D.C. Other works come up for auction from time to time. Four Hitler watercolors owned by Hoffmann, along with his large collection of photographs, which were confiscated by the United States at the end of the war, were the subject of litigation that continued for more than 15 years, ending in 2004 with denial of review by the U.S. Supreme Court; Hoffmann v. United States, 543 U.S 1002 (2004).

[16] A branch of the ruling Hohenzollern family maintained Castle Sigmaringen, in the Baden-Württemberg region, nearby. For a brief period near the end of the war, Hitler ousted the family and relocated the Vichy government of France to that location. The castle is now open to the public.

[17] The reference is undoubtedly to the Keystone Press Agency, which was founded in London in the early 1900s. It manages an extensive global collection of images and remains in business today.

[18] Aloisia (Lola) Schmidt (1905–1997) was a cousin by marriage of Adolf Hitler. She was the wife of Johann Schmidt (1894–1945), who was Hitler's first cousin through his mother, Adolf's maternal aunt Theresia Schmidt, née Pölzl (1868–1938).

[19] For Hubert Robert, see Chapter 7, note 20.

[20] This popular Benedictine abbey in Bavaria is open to the public.

[21] The State Office for the Preservation of Monuments.

[22] Long before the war, Lehmann Bernheimer (1841–1918) founded a prestigious art and antiques dealership in Munich. His son, Otto Bernheimer (1877–1960), inherited the prosperous business, but after the organized attacks on Jews that occurred on Kristallnacht in 1938, he was interned at Dachau. He managed to get out by agreeing to purchase a rundown coffee plantation owned by Goering's niece in Venezuela. Bernheimer resumed the family business in Munich after the war. It seems likely that the author was personally familiar with the Bernheimers, owing to his previous visits to Munich with his father, who founded a decorating and design business in Cleveland. For a recent account of the Bernheimer family history by Lehman's grandson, see Konrad O. Bernheimer, *Great Masters and Unicorns: From the Life of an Art Dealer Dynasty* (Ostfildern, Germany: Hatje Cantz, 2015).

[23] The company is still active in publishing.

[24] See Page 298. An account of his career and its dénouement appears in Philippe Sands, *East West Street: On the Origins of "Genocide" and "Crimes against Humanity"* (New York: Knopf, 2016). *Lady with an Ermine* was purchased by the Polish government as part of the Czartoryski Collection and is today in the Czartoryski Museum in Kraków.

[25] The Allies established, but never fully implemented, an elaborate system for purging German and Austrian society of Nazi influence after the war. It included methods for classification of former Nazis according to their degree of culpability, which in theory allowed those with less involvement to assume or continue positions of public trust.

[26] Kurt Martin is mentioned in the author's discussion of the Heilbronn mine; see pages 188 and 189. In addition, an unpublished chapter omitted from the first edition of *Survival*, entitled "Our German Colleagues," includes specific information about Hamann, von Merhart, and one other cooperating German art historian, Friedrich Bleibaum, all of whom the author refers to as the "patriarchs" of German art history. Richard Hamann (1897–1961) was an influential professor of art history at the university in Marburg. In addition to innovative scholarship, he established a groundbreaking photographic archive, which continued in operation throughout the war and, by the time this narrative was written, contained 180,000 negatives. Today the photograph collection numbers 1.7 million. The collection is online at https://www.bildindex.de/). Gers von Merhart (1886–1959) was director of the Archaeological Seminar at Marburg and had reconstructed the history of ancient invasions in Europe, before the 8th century. He lost his post during the war as a result of Nazi influence but survived to supply the Allies with invaluable insights into both his colleagues and cultural objects. Friedrich Bleibaum (1885–1974) was the Landeskonservator (provincial curator) for Hessen-Nassau in central Germany. For years before the war he had built up a staff of architects and archaeologists who evacuated churches and protected other cultural objects before the bombings, reaching out even beyond his designated provincial jurisdiction. The Allies initially dismissed him from his post owing to service during the war in a neighborhood watch group, but the protests of the monuments men resulted in his reappointment.

[27] Walter I. Farmer (1911–1977) was another monuments man from Ohio. His posthumously published memoir recounting tales of his work with the 373rd Regiment of the U.S. Army Corps of Engineers, and later at the Wiesbaden Collecting Point, is titled *The Safekeepers: A Memoir of the Arts at the End of World War II* (Berlin: Walter de Gruyter, 2000). It includes fascinating firsthand accounts of his activities in Wiesbaden, including the return of the bust of Nefertiti to Berlin, notwithstanding the Egyptian prime minister's request to the U.S. Department of State to send it back to Egypt.

[28] The Guelph Treasure, known in Germany as the Welfenschatz, consisted of gold and jeweled liturgical art, such as crosses, liturgical vessels, and reliquaries, assembled by members of the House of Brunswick-Lüneberg. Taking its name from the House of Guelph, the source of multiple German and English monarchs, the Guelph Treasure was originally housed at the cathedral of St. Blaise in Braunschweig (Brunswick), Germany. In 1671 the treasure passed into the hands of the Duke of Brunswick-Lüneberg. The treasure was dispersed in the 20th century. Portions purchased by the Cleveland Museum of Art in 1930 and 1931 are on display there. Other portions, which passed through the Goering collection, are now at the Bode Museum in Berlin. Portions of the treasure transferred during the Nazi period have been the subject of extensive litigation. This case went to the U.S. Supreme Court, see Federal Republic of Germany v. Philipp et al., 141 S. Ct. 703 (2021).

[29] The Lüneberg Council Silver was collected between the 15th and early 17th centuries with revenues from salt mining. Portions of this magnificent collection are on display in the Berlin Museum of Decorative Arts.

[30] Walker Hancock (1901–1998) was born in St. Louis and studied sculpture at the Pennsylvania Academy of Fine Arts in Philadelphia. During the war he served as a monuments man in both France and Germany. After the war Hancock executed many noted public commissions and continued to work as a sculptor in Gloucester, Massachusetts, until his death. See Walker Hancock, with Edward Connery Lathem, *A Sculptor's Fortunes*

(Gloucester, Mass.: Cape Ann Historical Association, 1997).

[31] Sheldon Keck was trained in the nascent field of art conservation at Harvard under George Stout but was unable to begin fieldwork as a monuments man until February 1945 owing to army red tape. Shortly after arrival he was on a mission near Aachen with Walter Huchthausen when their jeep came under enemy fire and "Hutch" was killed. Keck went on to complete important conservation work in Europe, including the assignment in Marburg noted here. After the war he and his wife, Caroline Keck, enjoyed noteworthy careers in art conservation and education, including the establishment (with Craig Hugh Smyth) of the first graduate program in art conservation at the Institute of Fine Arts, New York University.

[32] This collection of original manuscripts and other Goethe materials was eventually recovered by Anton Kippenberg (1874–1950). His heirs later donated it to a foundation that has placed them on display at the Goethe-Museum in Düsseldorf.

[33] This anecdote is one of several included in this narrative to illustrate the difficulty experienced by the monuments men in communicating effectively through an extended military chain of command.

[34] Hitler commissioned Professor Kümmel's report in part to provide a justification for rounding up works of art with any plausible connection to Germany from all over Europe. In particular, Kümmel's compendium listed the German works of art carried home by Napoleon or removed from Germany as reparations under the Treaty of Versailles at the end of World War I.

[35] Goering planned to establish a headquarters for the Luftwaffe in the spa town of Bad Wildungen. Although many of the buildings were completed, the planned headquarters was never fully implemented. Today, many of the remaining bunkers and other military buildings have been adapted for civilian use.

[36] See Farmer, *Safekeepers*, for a detailed description of the monuments officers' protest document, known as the Wiesbaden Manifesto. It is examined in Bell and Nelson, *The Berlin Masterpieces in America: Paintings, Politics, and the Monuments Men* (2020).

[37] For additional description of Valland's diligent, but ultimately unsuccessful, efforts to recover works of art from the Soviet Union, see Bouchoux, *Rose Valland*.

[38] Although the total list of monuments men in both the European and Pacific theaters has been recorded by the Monuments Men Foundation to have added up over time to more than 350, a contemporary journalistic source estimated that the average number of monuments officers active on the ground in Europe at any one time was about 15. See Flanner, "Annals of Crime," p. 39.

[39] "Message from General Eisenhower," *Military Government Weekly Information Bulletin* 3 (August 6, 1945), pp. 3-4, at p. 4.

Education Begins at Home

ADDRESSING THE SCOURGE OF LOOTING AND
DESTRUCTION BY U.S. TROOPS

9

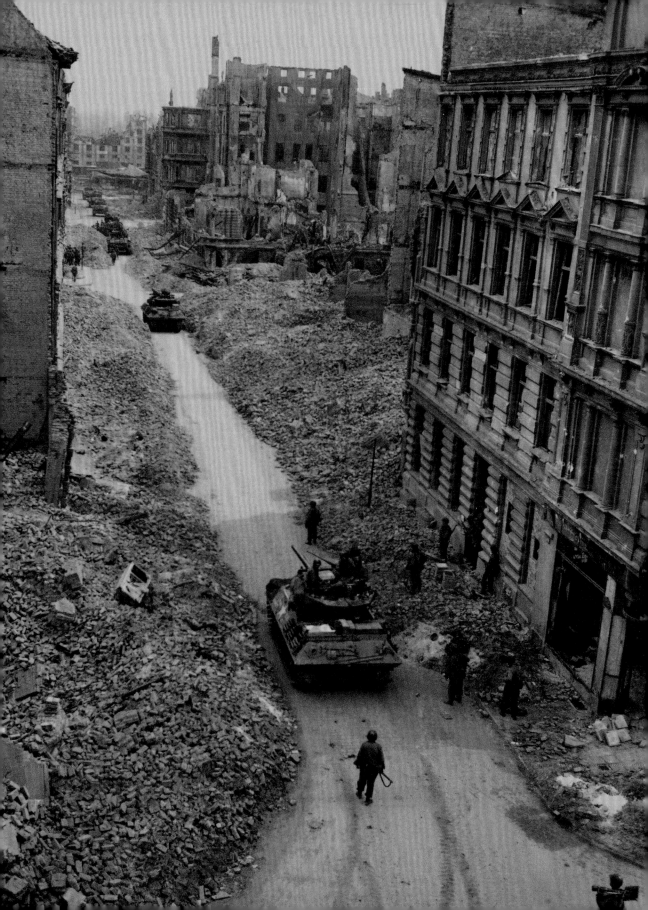

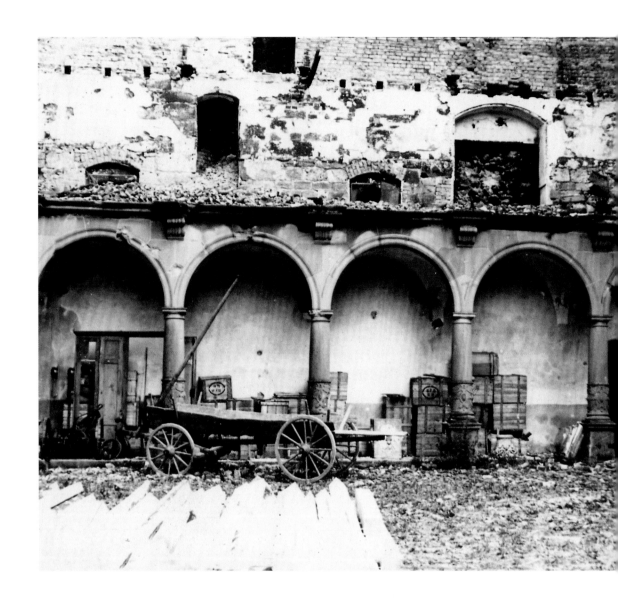

Most of the instances of American license in Germany did not have the front-page appeal of the theft of the Hesse jewels implicating a colonel and a WAC captain,[1] but none is an incident of which we can feel proud. They are indications of thoughtlessness and lack of discipline that had reverberations in Nazi Germany, where it was our earnest intention to set an example to a people who had become degenerate through their own excesses and those of their leaders.

The American soldier may blame his actions in foreign lands on wartime conditions, and excuse himself and his compatriots on that account, but it is not without implications that a callout in *Stars and Stripes* on April 21, 1945, stated:

> *Souvenir-hunting soldiers are unwittingly impeding the work of Army intelligence officers seeking information in captured Gestapo and army headquarters in Germany, officials said today (April 21).*
>
> *Vital files have been lost or destroyed by rummaging soldiers who didn't realize their importance. In one case intelligence officers had to search for three days through a pile of rubble in a back yard of a Gestapo headquarters to find badly needed lists thrown out of the windows by soldiers.*

You cannot teach the need for such care in basic training, any more than you can preach the desirability of respecting private property when you brief a bomber crew or send men into battle to destroy the enemy. There is a fundamental difference between destroying what you have captured and the destruction pursuant to carrying out a mission. This difference should have been impressed upon our soldiers long before they reached the Continent.[2]

Soldiers looking for liquor, arms, ammunition, or foodstuffs in a captured building should have been able to tell the difference between these items and cases of ceramics from the Frankfurt Museum stored in the barns and in the cave of the Leiningen Castle at Ernsttal.[3] Greek vases and pots from the ethnological collections in no way resembled the tens of thousands of bottles stored on open shelves and in neatly stacked packing cases very differently marked from those containing art objects. SS troops were reported lurking in the Ernsttal neighborhood when I arrived at this remote repository in the mountainous countryside. Most of our men were out on patrol, and I could not determine who had broken into some dozens of cases and strewn the art objects they had contained about the floor. German refugees who had come here after being bombed out of the industrial centers eagerly suggested that these cases must have been opened by the liberated Poles and Russians who had been imported by the Nazis to do forced labor in the fields.

There I also witnessed the wanton destruction of the Greek vases in the museum of the University of Würzburg. Following the capture of the town, the occupation troops needlessly smashed vase after vase, and little remained of one of the ten greatest collections of its kind in Europe.

At the castle of Count Erbach-Fürstenau at Michelstadt several troop units had come and gone. The archives, books, and family silver had been thrown from the shelves of the storage rooms and heaped on the

floor. To go from one room to another it was necessary to climb over these stacked possessions. The captain in charge of the infantry unit occupying the premises assured me that his troops had been cleaning up the place. There was work here for a company of archivists, not for men without training in the handling of cultural objects. I was able to close off the wing of the castle that contained the archives and to discontinue billeting in that area, but valuable pieces had unfortunately already been looted.

A few miles from Michelstadt the more important castle and collections at Erbach, also belonging to the count, were in danger of similar abuses. I feared particularly that the fine armory with its historical arms and armor would be looted or despoiled. All kinds of weapons, including some historic pieces, were being collected by German police officials so that they could be destroyed by military government officials in their sweeping search for dangerous implements of war.

In the castles of Prince Hohenlohe[4] at Oehringen and Neuenstein, the bivouacked troops created such disorder that Lieutenant General Patch, hearing about it on his way to his advance headquarters, personally placed the castles off-limits and had guards posted. At Oehringen I met the charming Princess Hohenlohe. Her husband called my attention to the need for going at once to Neuenstein, where he had valuable possessions. He was especially concerned over the safety of the Württemberg battle flags. Months later the archives that had been sent to Oehringen before the war were removed, contrary to our instructions, and carelessly stored in another part of the castle.

An American colonel who found it convenient to live in the castle of Princess Hohenlohe after her Nazi husband had been taken into custody thought that one of our investigating monuments officers was interfering with his private life and became unreasonable on two occasions. His references to the persistence of a junior officer's not minding his own business were soon set straight. The colonel was reminded that the commanding general of the Seventh Army[5] had himself indicated that this castle was not to be used, owing to its historic character and the nature of the collections and material stored there.

The damage done at Neuenstein, a massive walled castle with a large moat, was serious. Some of the cases containing Stuttgart Museum ceramics from the 16th, 17th, and 18th centuries had been broken into and their contents scattered about, along with fine linens from the Hohenlohe cupboards, a Titian, a Schäufelein, a Strigel,[6] a Bellini, and a great altarpiece of the year 1490. The Hohenlohe armory was a shambles. The scene was hardly improved by the overturned cans of apple butter, empty ration boxes, and indescribable filth. I appealed to August Stortz, the Hohenlohe caretaker, whom I felt I could depend on. He had served as Oberwachtmeister of the Stuttgart police for 15 years until he was dismissed by the Nazis in 1933. He had sought a haven in the castle and was permitted to remain as a Hohenlohe employee during the years Neuenstein had served as a German naval hospital supply base. Unlike our own troops, the Germans in this instance had respected the wings of the castle where the works of art were stored. After I made arrange-

ments for Stortz to put the castle in order, the intelligence corps jailed him on some trumped-up charges submitted by another German.

Fortunately for the works of art, his record was such that his incarceration lasted only a few days. I took over Neuenstein as an interim collecting point, and Stortz made the place immaculate. He had confidence in us and showed us the secret hiding places for the gold and silver plates of the Hohenlohes. These pieces were examined by the colonel in charge of local security and left in place, but the currency found at Oehringen was seized as the dubious property of a high Nazi official. Before the end of the summer, the Hohenlohe Museum at Neuenstein had again been put in order and guided tours were arranged for the troops.[7]

The important castle of Kleinheubach, near Miltenberg, suffered seriously when it was used as a displaced persons camp. The SS had established the camp to spite the Catholic owner of the property. The possessions of Prince Löwenstein-Wertheim-Rosenberg, and the furniture and decorative arts from the Städel Art Institute[8] and other museums in Frankfurt were stored there. This was the dirtiest, most disreputable installation I saw in Europe. There were no adequate plumbing facilities and men and women were living under intolerable conditions. They had not been able to organize themselves when their SS guards vanished upon the arrival of the American troops.

They celebrated their release by giving a dance in one of the splendid halls of the palatial castle. These Russians and Poles, unused to fine works of art and furnishings, had crammed the neatly stored objects from Frankfurt in one of the large, stately rooms of the castle so as to clear the floors of the adjoining room for their unfortunate, however well-deserved, merrymaking. Many a fine museum object was broken or badly marred. When I arrived at Kleinheubach, the emptied beer barrels and bottles were still on the marble floors. It must have required several weeks to clean this repository. I was told that the castle continued to be used as a displaced persons camp.[9]

At the castle in Ellwangen, owned by the city, the security troops reported that previous occupants had burned letters of Marie-Antoinette and Napoleon. The museum in the chapel had been desecrated, glass cases had been broken into, paintings from the walls were on the floor, and the collections were thrown about. Whether the damage was caused by previous troops from one of our own divisions, which had a poor reputation for taking care of properties (though their combat record was magnificent), we will never know. A corporal from this division typed my report on Ellwangen. His own stories of his comrades' vandalism in combat made me question my acceptance of the account of Alois Eiberger, for seven years the caretaker at Ellwangen, who believed that the SS who occupied the castle for four weeks were largely responsible for the damage.

The executive officer of the unit occupying the castle could not understand why I insisted that rooms laden with books and archives should not be used as offices and sleeping quarters. Had not their own general liberated a book on Napoleon from the shelves? It was this same general who in other places had failed to protect cultural resources. (cont. on page 334)

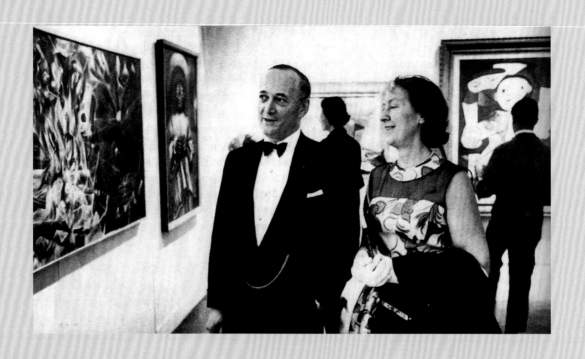

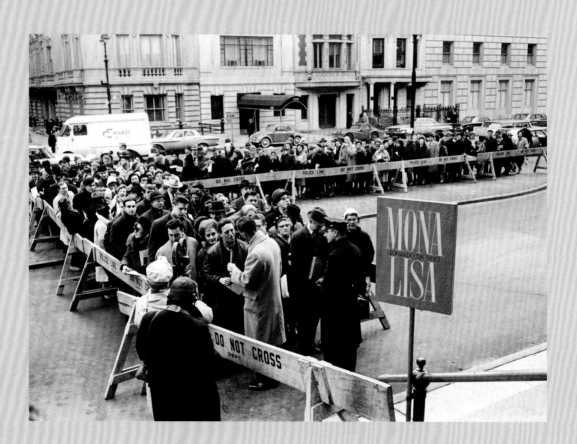

ABOVE
Letter from Rose
Valland to the author
congratulating him
upon his appointment
as director of the
Metropolitan Museum
of Art in 1955.
Translation below by
Lorenzo Pericolo.

Dear James
I've learned about your
brilliant appointment
with some delay. Allow
me to congratulate you
with my whole heart!
The news causes me an
intense joy, not only
because it concerns you,
my dear "captain," but
also because this title
and position were due
to you. A little bit of
justice on this earth
does not harm anyone.
And now, my dear
James, do not become
too intimidating and
remain always assured
of my faithful and most
sincere friendship.
Rose Valland

AFTER THE WAR

After the war, the author rejoined the Metropolitan Museum of Art in New York City, where he served as curator of medieval art and director of the Cloisters. He became director of the museum in 1955, a position he held until his death in 1966. Among his many post-war accomplishments were adding the Fuentidueña apse (c. 1175–1200) to the Cloisters; developing the museum's education department; renovating and expanding the galleries; and participating in major acquisitions, including the 15th-century *Mérode Altarpiece* (c. 1427–32) and Rembrandt's *Aristotle Contemplating the Bust of Homer* (1653). In the early 1960s, Rorimer, with the assistance of Jacqueline Kennedy, helped increase public visitation to the Metropolitan Museum of Art by bringing the *Mona Lisa* to the museum; at the time, it was the equivalent of a blockbuster.

The author's wife, Katherine S. Rorimer, remained active in museum circles until her death in 2000, supporting her husband's legacy and keeping in touch with many of the monuments men. Among various projects, she served as director of the New York National Headquarters of the Committee to Rescue Italian Art, which was formed in 1966 to salvage works of art and other cultural materials damaged by flooding of the Arno River in Florence, Italy.

OPPOSITE TOP
The author with his
wife, Katherine,
attending an opening at
the Metropolitan
Museum of Art in New
York after the war.

OPPOSITE BOTTOM
A crowd waiting in
line outside the
Metropolitan Museum
of Art to view the
Mona Lisa, 1963.
Jacqueline Kennedy
was instrumental in
helping the author bring
the painting to the U.S.

FOLLOWING SPREAD
The author as director
of the museum in the
paintings galleries of the
Metropolitan Museum
of Art, January 8, 1956.

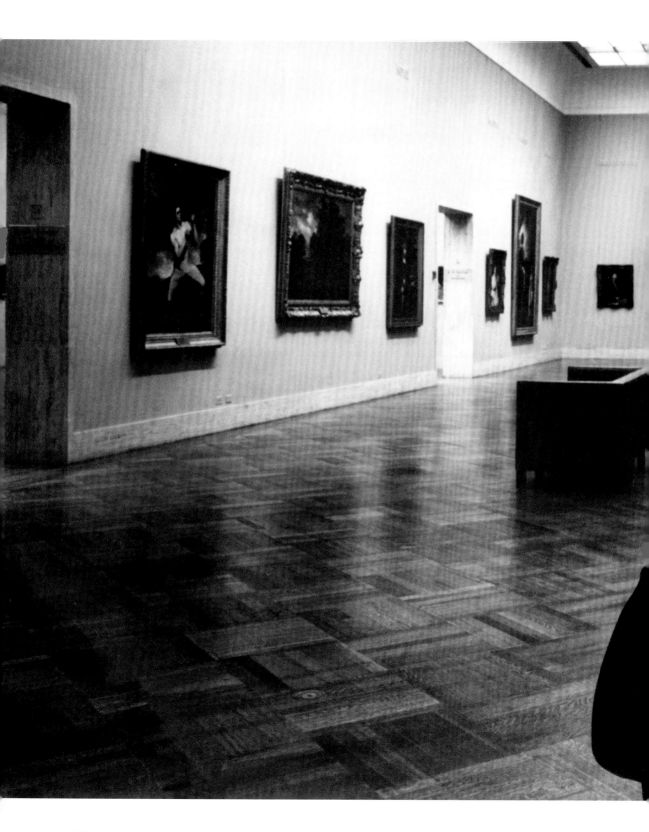

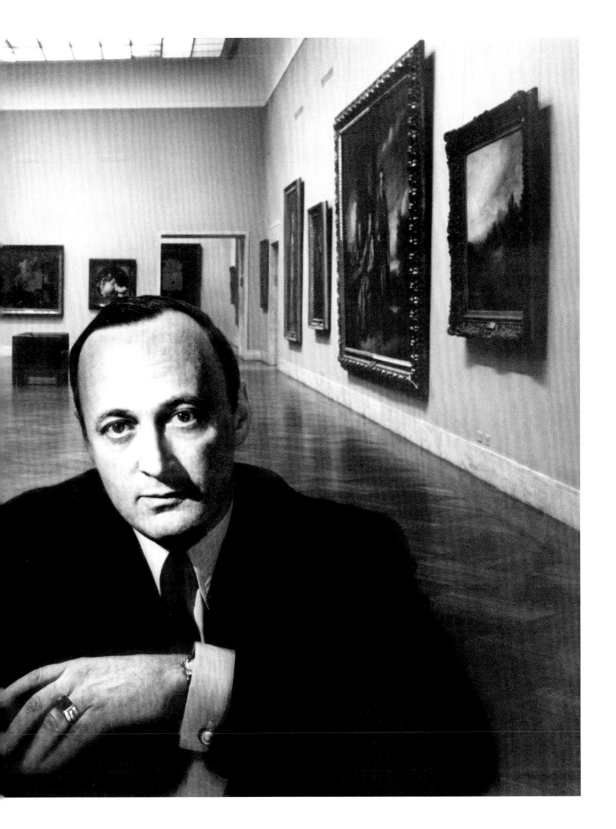

THE MONUMENTS MEN, 2014

In February 2014 Sony Pictures released the major motion picture *The Monuments Men*, a film directed by and starring George Clooney alongside an all-star cast in roles based on the real-life monuments men of World War II. The film is derived from Robert Edsel's 2009 book of the same name and features Matt Damon playing James Granger, a curator from the Metropolitan Museum of Art whose character is based on the author.

Cate Blanchett plays Claire Simone, the heroic assistant at the Jeu de Paume, whose character is based on Rose Valland. As in the real story between the author and Valland, she is highly suspicious of Granger at first, but eventually comes to trust him. The movie counterpart for Bruno Lohse is Viktor Stahl, Goering's sycophantic enabler, played by Justus von Dohnányi.

While much of Clooney's film is based on true events, he also took a few liberties and endowed Granger and other characters with imagined traits. For example, Granger's French is terrible, and he repeatedly attempts to use it, often to humorous effect, however the author spoke fluent French.

UPPER LEFT
James Granger (Matt Damon) and Claire Simone (Cate Blanchett) investigate crates of confiscated Jewish household articles. Damon's character was based on the author and Blanchett's role was based on Rose Valland.

BOTTOM
In a scene that was ultimately cut from the film, the monuments men find a clue to the location of the *Ghent Altarpiece* in Nazi records at Neuschwanstein Castle. Left to right: actor Dimitri Leonidas as Sam Epstein, a character based on the real-life Harry Ettlinger; John Goodman as Walter Garfield, based on Walker Hancock; George Clooney as Frank Stokes, based on George Stout; Matt Damon as James Granger, based on the author; and Bob Balaban as Preston Savitz, based on Lincoln Kirstein, a prominent figure in American theater and ballet.

RIGHT
The Monuments Men movie poster, 2014.

GEORGE CLOONEY
MATT DAMON
BILL MURRAY
JOHN GOODMAN
JEAN DUJARDIN
BOB BALABAN
HUGH BONNEVILLE
AND CATE BLANCHETT

IT WAS THE GREATEST ART HEIST IN HISTORY

THE
MONUMENTS
MEN

BASED ON A TRUE STORY

IN CINEMAS FEB 2014
MonumentsMenUK

THE NEW MONUMENTS MEN AND WOMEN

In October 2019, the U.S. Army entered into a partner-ship with the Smithsonian Institution with the goal of building a new cadre of army monuments officers. It was the first time deliberate efforts had been made in this direction since World War II. This collaboration with the Smithsonian Cultural Rescue Initiative is one of several key institutional partnerships in the U.S. and overseas, which are part of the army's broader com-mitment to cultural heritage protection, spearheaded by the U.S. Civil Affairs and Psychological Operations Command (Airborne).

The army project addresses recent events in the Middle East and around the world, most notably the notorious pillaging of the Baghdad Museum during the U.S. invasion of Iraq in 2003. The project is also a di-rect response to recent U.S. legislative developments, such as adoption of the Protect and Preserve Interna-tional Cultural Property Act in 2016 and adoption of the Hague Convention for the Protection of Cultural Property in 2019.

The army aims to assemble a full spectrum of heri-tage and preservation specialists from diverse fields through recruitment from reservists and civilians alike. They range from archaeologists to experts in remote geospatial analysis. The army's activities have included pre-deployment training during both conflict and peacetime.

BELOW
Mason Hammond, the first monuments man in the field, training soldiers in Algiers, 1942.

TOP RIGHT
Today, Hermes Knauer (in black), Metropolitan Museum conservator emeritus, instructs civil affairs soldiers on how to become modern-day guardians of history.

BOTTOM RIGHT
U.S. military personnel participating in a cultural property training course as part of the 2009 Bright Star War Game in Saqqara, Egypt.

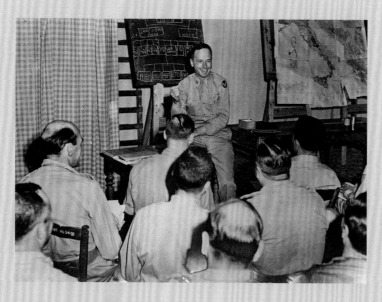

(cont. from page 325) In the house of Baron Carl von Adelsheim soldiers drank in the cellars, then opened cases of works of art on the first floor and ran knives through some of the paintings, which had been sent here for protection. In another house in Adelsheim, belonging to Katherina von Adelsheim, there were boxes containing works of art from the Kunsthalle in Karlsruhe. I requested that the stove fire in this room be put out at once, lest serious damage occur from continued overheating. There was a glass case of bibelots and arms handed down by generations of Adelsheims. I pasted an appropriate military government poster on the front of the case, which at this point was all the security I could provide.

Two months later all of the objects had disappeared. The baroness had returned and felt that the Americans had behaved badly. I tried to reason with this gentle old lady, whom the community had respected for her charity and neighborly spirit for many years. I did not tell her about the loss of her china, which had come about in this manner. Following the capture of the town, I was dining with some of the officers who were living in her home. A sergeant arrived from the general's headquarters and started to gather up some of the china. He explained that the general was giving a dinner for another important visiting general, and that he had been given instructions to get some of these objects to decorate the table. He promised to return them after dinner. I set aside certain of the finer porcelains, museum objects of considerable quality and value, and the sergeant left these behind. Many weeks later I returned to Adelsheim to investigate other repositories there, but I couldn't locate the borrowed objects.

In my notebook on April 24, 1945, I made the following entry: "Castle Warsberg at Neckarsteinach. The first American company broke into this castle on April 7. Hampe, a civilian architect who had helped us in the early days in the Heidelberg area, is tracking information. Cases from Mannheim Kunsthalle have been rifled. Furnishings and paintings from Heidelberg have been placed in jeopardy. Baroness Elizabeth Warsberg (according to her own account to me) was forced at the point of a rifle by a sergeant to deliver keys to a safe, and he took two Wouwerman paintings[10] and jewelry."

Having seen the condition of the castle, I believed that this account might well be true. A couple of antique pieces of pewter were at the side of a jeep in the courtyard. Several times I requested one of our officers, later relieved of his post, to investigate further and to report what had happened. But it was not until November 16, 1945, that Hampe's letter, dated May 15, arrived at my desk. It was addressed "To the G-5 Monuments Officer—Seventh Army." It had been received on May 18 and it was found in the desk of this officer, who was drinking his way through the war, by the officer who relieved him. The letter listed one diamond bracelet, one square-cut diamond ring, one row of 145 pearls, two round-cut diamond rings, and the two Wouwerman landscapes. The Bürgermeister had given the name of the American lieutenant and the unit that had first occupied Warsberg Castle. In part the letter stated: "Unfortunately by the use for soldier's billeting further damage is done to the furniture, of which nearly all are precious historical possessions of the old Austrian family."

It went on to request, as I myself had of the commanding officer, that the valued possessions be segregated for safekeeping. Upon receipt of this letter, I gave the facts to the Criminal Investigation Division (CID) of the provost marshal's section, but so far as I know, and would venture to guess, probably nothing further came of the case.

The CID, unfortunately, was occupied with more serious problems. This was one of the main reasons why it did not follow up on more of these cases. And, in addition, even when a monuments officer prepared a case, it was apt to be dependent upon allegations that could not be proved, the "corpus delicti" rarely being available,[11] and more often than not it was substantiated by the testimony of Germans who were held to be prejudiced. The redeployment to the Pacific before V-J Day,[12] and later to the States, made difficult at best the satisfactory investigation of many of these cases. The prospects for ever settling most of them are practically nonexistent.

There is one such case that should be made a matter of public knowledge. In 1945 a thick dossier was forwarded to highest American headquarters. It had the approval of our commanding general, or at least of his chief of staff, and the recommendation that this case be returned to the Zone of the Interior[13] for further investigation. The following is an excerpt from the letter that was prepared and distributed by its German originators:

> I herewith wish to lodge a protest against the looting of my house at Reutti by a company of . . . soldiers under the command of a Captain E . . . who were billeted there in order to lay out a military cemetery. . . . At 2:30 p.m. on April 27 a Lieutenant E . . . arrived and told my wife—I was not at Reutti at the time—that the house was taken for military purposes. . . . The ladies, were . . . told that they might return the next day to fetch some more things. . . . When our lodger, Frau Brunner . . . arrived on the scene next morning, she was appalled to see a bonfire ablaze in the yard, made up, among things of great personal value, of priceless books of the 15th to 18th centuries. . . . this bonfire was seen to burn for a full week more, being made up not only of a beautiful 18th-century cupboard and other objects of art, but also of clothes and things irreplaceable in Germany under present conditions. At the same time, antiques and other furniture, that in the opinion of the officer in charge were superfluous, were thrown out of the first-floor windows and smashed or, at best, thrown into a shed in a heap.

The people who made this report may never have any material satisfaction. But they must know that it is inconceivable that such acts are approved in responsible quarters. In my own report of the inspection I included further evidence of the damage to drawings, sculpture, and furniture from the Ulm Museum. The custodian, whom I had known before the war, reported that some 400 drawings and watercolors had disappeared. He showed me many damaged sculptures and other museum pieces. I myself discovered a packing case with a painting of value used as packing material for an antique mirror, and I was ready to believe,

as claimed, that one of the famous 16th-century cabinets from the Ulm Museum had been cut to make a packing box for shipping 17th- and 18th-century porcelains. A PFC left a couple of packed cases with labels giving his name and the address of his unit, as well as the name of the addressee. The unit censorship stamp had been applied, but it had not yet been signed by an officer. These labels and a medicine bottle with the name of one of the officers gave sufficient pertinent facts for taking immediate action. We traced the officer as far as Marseille. From there he had shipped out, probably to the Pacific. Our pursuit ended there.

There are many other disgraceful accounts of American disregard for cultural objects. These instances prove the inability of an army, however well-intentioned its higher policy, to cope with such conditions during a period of disorder. No one officer—no group of officers—can discipline the men under battle conditions and in the early months following combat. With the constantly shifting commands and relocation of troops, it is impossible to ensure the kind of order to which we are accustomed in our well-run cities. We did not have sufficient monuments officers to protect many of the most important repositories. The defeated Germans were completely disorganized and could not protect cultural objects in the buildings from which they were evicted by military personnel.

Our own basic lack of training in simple good manners and human values has resulted in this outrageous behavior in foreign lands. Until fundamentals of civilized living are inculcated into all of our people, they will go abroad as poor ambassadors of a nation working so that others may not starve, caring for the sick and the underprivileged, and protecting treasures and cultural objects as a heritage for future generations.

NOTES

1 In 1946 the army made headlines when it recovered part of the Hesse family crown jewels stolen by U.S. troops from their hiding place at Kronberg, near Frankfurt. The Hesse family had buried the jewels under the basement floor in their castle before fleeing the Nazis. The victorious Allies converted the castle into an officers' club, where U.S. troops clandestinely dug them up and started selling them. The army apprehended a colonel and a Women's Army Corps (WAC) captain in Chicago, where they had gone to fence the jewels. See Nicholas, *Rape of Europa*, pp. 354–55.

2 The author's point is that teaching soldiers to respect cultural property cannot be effective in the context of the physical stress of basic training or the focus on the mission before a battle. For further analysis of military training lessons learned from the work of the monuments men, see Laurie W. Rush, "Cultural Property Protection as a Force Multiplier in Stability Operations: World War II Monuments Officers Lessons Learned," *Military Review* (March–April 2012). For a broader collection of articles on this topic, see Laurie Rush, ed., *Archaeology, Cultural Property, and the Military* (Woodbridge, U.K.: Boydell Press, 2010).

3 Now known as Waldleiningen Castle in Baden-Württemburg, it houses a private psychosomatic clinic operated by the Leiningen family.

4 The Hohenlohes are an old German princely family whose seat of power was at Oehringen.

5 The reference is to General Patch; see page 17.

6 The German painter and printmaker Hans Schäufelein (1480/85–1540) was one of Albrecht Dürer's most talented students. His patrons included the Holy Roman Emperor Maximilian I. In 1515 he became the municipal painter for the German city of Nördlingen. The Strigel family of Memmingen (Bavaria) included several artists in the 15th and early 16th centuries. The most successful was Bernhard Strigel (1460–1528), who also worked for Maximilian I.

7 Schloss Neuenstein and its museum, down the road from Oehringen, remain open to the public.

8 The Städelsches Kunstinstitut und Städtische Galerie, today known simply as the Städel, one of Germany's leading museums, located in Frankfurt.

9 For additional information about the destruction at Kleinheubach, see Skilton, *Memoirs of a Monuments Officer*, pp. 132–34. The House of Löwenstein today maintains its affiliation with the family seat, now known as Schloss Kleinheubach Palace. Today the property includes a hotel and the Löwenstein family wine estate.

10 The Wouwermans were a family of 17th-century Dutch painters, primarily of landscapes.

11 The Latin legal term "corpus delicti" has been defined as the substantial fact that a crime has been committed, including the corpse of a murdered person. https://thelawdictionary.org/corpus-delicti/. In this context it can refer to the evidence relating both to the cultural property that has been removed and to the individuals responsible.

12 In the U.S. "Victory over Japan Day" is celebrated on September 2, the day in 1945 when the Instrument of Surrender was signed on the USS *Missouri*.

13 The reference is one of the army's various administrative units that were established during the war to carry out specified functions of military government in both Europe and the United States.

BIBLIOGRAPHY

PRIMARY SOURCES

Eisenhower, Dwight D. Gen. Dwight D. Eisenhower, Allied Force Headquarters, to All Commanders. Subject: Historic Monuments, December 29, 1943. File: CAD 000.4 (3-25-43) (1), Sec. 2, Security Classified General Correspondence, 1943-July 1949, General Records, Civil Affairs Division, Records of the War Department General and Special Staffs, RG 165. https://text-message.blogs.archives.gov/2014/02/10/general-dwight-d-eisenhower-and-the-protection-of-cultural-property/

———. Dwight D. Eisenhower to G. O. C. in Chief, 21st Army Group; Commanding General, 1st US Army Group; Allied Naval Commander, Expeditionary Force; Air C-in-C, Allied Expeditionary Force, May 26, 1944. https://www.eisenhowerlibrary.gov/sites/default/files/research/online-documents/monuments-men/033-006.pdf

———. "Message from General Eisenhower," *Military Government Weekly Information Bulletin 3*, (August 6, 1945): 3-4. https://archive.org/details/MilitaryGovernmentWeeklyInformationBulletin0121.o/page/n71/mode/2up

Farmer, Walter I. *The Safekeepers: A Memoir of the Arts at the End of World War II.* Berlin: Walter de Gruyter, 2000.

Goering, Emmy. *My Life with Goering.* London: David Bruce and Watson, 1972.

Hancock, Walker, with Edward Connery Lathem. *A Sculptor's Fortunes.* Gloucester, MA: Cape Ann Historical Association, 1997.

Hartt, Frederick. *Florentine Art Under Fire.* Princeton, NJ: Princeton University Press, 1949.

Hitler, Adolf. *Mein Kampf.* Munich: Franz Eher Nachfolger, 1925.

Howe, Thomas Carr. *Salt Mines and Castles: The Discovery and Restitution of Looted European Art.* Indianapolis, IN: Bobbs-Merrill Company, 1946.

LaFarge, Henry. *Lost Treasures of Europe: 427 Photographs.* New York: Pantheon, 1946.

National Archives and Records Administration (NARA), Washington, DC. Record Group 239. Records of the American Commission for the Protection and Salvage of Artistic and Historic Monuments in War Areas. Consolidated Interrogation Report (CIR) No. 2: The Goering Collection, September 1945. https://catalog.archives.gov/id/148373866

———. Record Group 260. Records of U.S. Occupation Headquarters, World War II. Restitution Research Records, 1945-1950. Berchtesgaden: Göring Train. https://catalog.archives.gov/id/34789264

Rorimer, James J., with Gilbert Rabin. *Survival: The Salvage and Protection of Art in War.* New York: Abelard Press, 1950.

Skilton, John D., Jr. *Memoirs of a Monuments Officer: Protecting European Artworks.* Portland, OR: Inkwater Press, 2008.

Smyth, Craig Hugh. *Repatriation of Art from the Collecting Point in Munich after World War II.* Maarssen/The Hague: G. Schwartz/SDU; Montclair, NJ: Abner Schram, 1988.

United States Government Historical Reports on War Administration. *Report of the American Commission for the Protection and Salvage of Artistic and Historic Monuments in War Areas.* Washington, DC, 1946.

SECONDARY SOURCES

Alford, Kenneth. *Nazi Plunder: Great Treasure Stories of World War II.* Cambridge, MA: Da Capo Press, 2001.

Ambrose, Stephen. *Band of Brothers: E Company, 506th Regiment, 101st Airborne; From Normandy to Hitler's Eagle's Nest.* New York: Simon & Schuster, 1992.

Arnold, Bettina. "The Past as Propaganda: Totalitarian Archaeology in Nazi Germany." *Antiquity* 64, no. 244 (September 1990): 464–78.

Assante di Panzillo, Maryline. "The Dispersal of the Vollard Collection." In *Cézanne to Picasso: Ambroise Vollard, Patron of the Avant-Garde*, edited by Rebecca Rabinow, 259–62. New York: Metropolitan Museum of Art Art/ New Haven: Yale University Press, 2006.

Baum, Vicki. *Menschen im Hotel; ein Kolportageroman mit Hintergründen.* Berlin: Ullstein, 1929.

Behrman, Samuel N. *Duveen.* New York: Random House, 1951.

Bell, Peter Jonathan, and Kristi A. Nelson. *The Berlin Masterpieces in America: Paintings, Politics, and the Monuments Men.* Cincinnati: Cincinnati Art Museum; Lewes, U.K.: Giles, 2020.

Bernheimer, Konrad O. *Great Masters and Unicorns: From the Life of an Art Dealer Dynasty.* Ostfildern, Germany: Hatje Cantz, 2015.

Bouchoux, Corrine. *Rose Valland: Resistance at the Museum.* Translated by Yves and Arlette Quervel. Dallas: Laurel Publishing, 2013.

Chanel, Gerri. *Saving Mona Lisa: The Battle to Protect the Louvre & Its Treasures During World War II.* Poughkeepsie, NY: Heliopa Press, 2014.

Charney, Noah. *Stealing the Mystic Lamb: The True Story of the World's Most Coveted Masterpiece.* New York: Public Affairs, 2010.

Coleridge, Samuel Taylor. *The Rime of the Ancient Mariner.* London: Chatto and Windus, 1978.

Collins, Larry, and Dominique Lapierre. *Is Paris Burning?* New York: Simon and Schuster, 1965.

Conradi, Peter. *Hitler's Piano Player: The Rise and Fall of Ernst Hanfstaengl, Confidant of Hitler, Ally of FDR.* London: Duckworth, 2005

Corn, Geoffrey S. "'Snipers in the Minaret—What is the Rule?' The Law of War and the Protection of Cultural Property: A Complex Equation." *The Army Lawyer* (July 2005): 28-40.

Cue: The Weekly Magazine of New York Life, July 5, 1947.

Currivan, Gene. "Goering Hoarding Art for Life's Sake: Shipped Looted Treasure in Air-Conditioned Cars for Use as Clemency Bait," *New York Times*, May 2, 1945. https://www.nytimes.com/1945/05/02/archives/goering-hoarding-art-for-lifes-sake-shipped-looted-treasure-in.html

de Margerie, Laure. "Fountain of the Observatory." In *The Passions of Jean-Baptiste Carpeaux*, edited by James David Draper and Edouard Papet, 156–67. New York: Metropolitan Museum of Art/New Haven: Yale University Press, 2014.

Doerr, Anthony. *All the Light We Cannot See.* New York: Scribner, 2014.

Duncan, Sally Anne, and Andrew McClellan. *The Art of Curating: Paul J. Sachs and the Museum Course at Harvard.* Los Angeles: The Getty Research Institute, 2018.

Edsel, Robert M. *Rescuing Da Vinci: Hitler and the Nazis Stole Europe's Great Art, America and Her Allies Recovered It.* Dallas: Laurel, 2006.

Edsel, Robert M., with Bret Witter. *The Monuments Men.* New York: Hachette Book Group, 2009.

Feliciano, Hector. *The Lost Museum: The Nazi Conspiracy to Steal the World's Greatest Works of Art.* New York: HarperCollins, 1997.

Flanner, Janet. "Annals of Crime: The Beautiful Spoils, Part III—Monuments Men," *New Yorker,* March 8, 1947.

Glass, Charles. *Americans in Paris: Life and Death under Nazi Occupation.* New York: Penguin Books, 2010.

Greenhouse, Emily. "The Last of the Monuments Men." *New Yorker*, February 19, 2014. https://www.newyorker.com/culture/culture-desk/the-last-of-the-monuments-men

Harris, Robert. *Munich.* New York: Knopf, 2018.

Kaufman, George S., and Moss Hart. *The Man Who Came to Dinner.* New York: Random House, 1939.

Kentish, Benjamin "Nazi Gold Train Search Abandoned—But Brings in £150 Million for Polish Town," *Independent*, August 25, 2016. https://www.independent.co.uk/news/world/europe/nazi-gold-train-update-dig-poland-latest-news-walbrzych-hitler-wwii-mystery-search-a7209811.html

Kirkpatrick, Sidney. *Hitler's Holy Relics: A True Story of Nazi Plunder and the Race to Recover the Crown Jewels of the Holy Roman Empire.* New York: Simon & Schuster, 2010.

Kulish, Nicholas and Michael Forsythe, "World's Most Expensive Home? Another Bauble for a Saudi Prince," *New York Times*, December 16, 2017, https://www.nytimes.com/2017/12/16/world/middleeast/saudi-prince-chateau.html

Larson, Erik. *In the Garden of Beasts: Love, Terror, and an American Family in Hitler's Berlin.* New York: Crown, 2011.

Lauterbach, Iris. *The Central Collecting Point in Munich: A New Beginning for the Restitution and Protection of Art.* Translated by Fiona Elliott. Los Angeles: Getty Research Institute, 2018.

Lopez, Jonathan. *The Man Who Made Vermeers: Unvarnishing the Legend of Master Forger Han Van Meegeren.* Orlando: Houghton Mifflin Harcourt, 2008.

Maltby, Clive, and Bill Thomas, dirs. *Nazi Mega Weapons.* Season 3, episode 1, "The Eagle's Nest." National Geographic/PBS, aired January 10, 2017, on WVIZ, Cleveland.

Monuments Men Foundation. "Monuments Men and Women." https://www.monuments-menfoundation.org/monuments-men-and-women

New York Times. "Edward F. D'Arms, Executive and Teacher," May 2, 1991. https://www.nytimes.com/1991/05/02/obituaries/edward-f-d-arms-87-executive-and-teacher.html

Nicholas, Lynn H. *The Rape of Europa.* New York: Vintage Books, 1995.

O'Donnell, Nicholas, "Court of Appeals Upholds Claims to Renowned Guelph Treasure Sold Under Duress to Nazi Agents." *Art Law Report* (blog). *Sullivan & Worcester*, July 10, 2018. https://blog.sullivanlaw.com/artlawreport/court-of-appeals-upholds-claims-to-renowned-guelph-treasure-sold-under-duress-to-nazi-agents

Ohler, Norman. *Blitzed: Drugs in Nazi Germany.* Translated by Shaun Whiteside. London: Penguin, 2016.

Petropoulos, Jonathan. *The Faustian Bargain: The Art World in Nazi Germany.* New York: Oxford University Press, 2000.

———. *Göring's Man in Paris: The Story of a Nazi Art Plunderer and His World.* New Haven: Yale University Press, 2021.

Piña, Leslie. *Louis Rorimer: A Man of Style.* Kent, Ohio: Kent State University Press, 1990.

Pringle, Heather. *The Master Plan: Himmler's Scholars and the Holocaust.* New York: Hyperion, 2006.

Rorimer, James. *Mediaeval Monuments at The Cloisters, As They Were and As They Are.* New York: The Metropolitan Museum of Art, 1941.

Rush, Laurie W. "Cultural Property Protection as a Force Multiplier in Stability Operations: World War II Monuments Officers Lessons Learned." *Military Review* (March–April 2012): 36-43.

———, ed. *Archaeology, Cultural Property, and the Military.* Woodbridge, U.K.: Boydell Press, 2010.

Sands, Philippe. *East West Street: On the Origins of "Genocide" and "Crimes Against Humanity."* London: Weidenfeld & Nicolson, 2017.

Shirer, William L. *The Rise and Fall of the Third Reich: A History of Nazi Germany.* New York: Simon & Schuster, 1960.

Taylor, John M. *General Maxwell Taylor: The Sword and the Pen.* New York: Doubleday, 1989.

Weider, Ben, and Sten Forshufvud, *Assassination at St. Helena Revisited.* New York: John Wiley & Sons, 1995.

Wittman, Robert K., and David Kinney. *The Devil's Diary: Alfred Rosenberg and the Stolen Secrets of the Third Reich.* New York: HarperCollins, 2016.

Yeide, Nancy H. *Beyond the Dreams of Avarice: The Hermann Goering Collection.* Dallas: Laurel, 2009.

FURTHER READING

Art Looting and Recovery

Brey, Ilaria Dagnini. *The Venus Fixers: The Remarkable Story of the Allied Soldiers who Saved Italy's Art During World War II.* New York: Farrar, Straus and Giroux, 2009. (Documents the work of monuments officers in Italy).

Edsel, Robert M. *Saving Italy: The Race to Rescue a Nation's Treasures from the Nazis.* New York: W. W. Norton & Company, 2013. (Documents the work of monuments officers Deane Keller and Frederick Hartt.)

Hickley, Catherine. *The Munich Art Hoard: Hitler's Dealer and His Secret Legacy.* London: Thames & Hudson, 2015. (Recounts the story of Hitler's chief art buyer in occupied Paris, Hildebrand Gurlitt, and of the international sensation that ensued in 2013 when a trove of Nazi-era looted art was discovered in the Munich apartment of his son, Cornelius.)

Miles, Margaret M. *Art as Plunder: The Ancient Origins of Debate about Cultural Property.* New York: Cambridge University Press, 2008. (An authoritative study of the history of art as objects of plunder, focusing on Cicero's Verrine orations, c. 70 BCE, with an epilogue updating the topic though 2008.)

Ronald, Susan. *Hitler's Art Thief: Hildebrand Gurlitt, the Nazis, and the Looting of Europe's Treasures.* New York: St. Martin's Press, 2015. (The first book-length account in English of the Gurlitt story.)

Simpson, Elizabeth, ed. *The Spoils of War: World War II and Its Aftermath; The Loss, Reappearance, and Recovery of Cultural Property.* New York: H.N. Abrams / The Bard Graduate Center for Studies in the Decorative Arts, 1997. (Proceedings of an international symposium at the Bard Graduate Center in 1995, at which U.S. and Russian monuments men and women met for the first time.)

Stories of Recovery, Repatriation, and Restitution

De Waal, Edmund. *The Hare with Amber Eyes: A Family's Century of Art and Loss.* New York: Farrar, Straus and Giroux, 2010. (A personal account of recovering one family's illustrious history and some of its most meaningful possessions: a collection of Japanese netsuke.)

Goodman, Simon. *The Orpheus Clock: The Search for my Family's Art Treasures Stolen by the Nazis.* New York: Scribner, 2015. (A poignant account of the successful recovery of family treasures.)

Morelli, Laura. *The Night Portrait: A Novel of World War II and Da Vinci's Italy.* New York: William Morrow, 2020. (A novel that imagines the parallel lives of Cecilia Gallerani, the presumed subject of Leonardo da Vinci's *Lady with an Ermine*, and the fictional 20th century conservator and monuments men who recovered the painting from Nazi looters.)

O'Connor, Anne-Marie. *The Lady in Gold: The Extraordinary Tale of Gustav Klimt's Masterpiece, Portrait of Adele Bloch-Bauer.* New York: Vintage Books, 2015. (The true story behind the painting and its theft by the Nazis with extensive historical and social context and a family tree. The film *Woman in Gold* was inspired by this book and stars Helen Mirren and Ryan Reynolds.)

Sinclair, Anne. *My Grandfather's Gallery: A Family Memoir of Art and War.* Translated by Shaun Whiteside. New York: Farrar, Straus and Giroux, 2014. (The prominent French journalist Anne Sinclair, granddaughter of Parisian gallerist Paul Rosenberg (no connection to Alfred Rosenberg), recounts the journey to recover her family heritage, including paintings by many of the 20th century's best-known painters.)

Trienens, Howard J. *Landscape with Smokestacks: The Case of the Allegedly Plundered Degas.* Evanston, IL: Northwestern University Press, 2000. (Written by the lawyer who defended an American collector whose possession of a Degas landscape came under challenge, this account confronts the legal and factual complexities that face the parties in Holocaust restitution cases.)

Yetmen, C. F. *The Roses Underneath: A World War II Mystery.* Austin, TX: Ypsilon Press, 2014. (The first novel in a trilogy based on the true story of the author's German grandmother, who rescued her displaced family by serving as a translator at the Wiesbaden Collecting Point in 1945. The character based on her becomes the indispensible colleague of a fictional monuments man. Two subsequent novels, *What Is Forgiven* (2017), and *That Which Remains* (2021), continue the heroine's adventures.)

PHOTO CREDITS

Glenn Harper / robertharding; p. 145 bottom: © Archives Charmet / Bridgeman Images; pp. 148-149: Hemis / Alamy Stock Photo; p. 150 bottom left: Courtesy Château de Neuville; p. 153: Photo © President and Fellows of Harvard College; p. 156: Hervé Lenain / hemis.fr; pp. 160-161: © Archives Nationales (France) / Carole Bauer, 20144707/289; pp. 164 top, 164 bottom, 165, 172: Collection of Anne and Louis Rorimer. Photograph: ERR; pp. 170 bottom left, 170 bottom right, 207 bottom, 215, 302: Thomas Carr Howe papers, 1932-1984. Archives of American Art, Smithsonian Institution; pp. 174, 289 top: INTERFOTO / Alamy Stock Photo; pp. 175 top, 249 top, 249 bottom, 262 top: bpk Bildagentur / Bayerische Staatsbibliothek, Munich, Germany /Heinrich Hoffmann / Art Resource, NY; pp. 175 bottom, 253 top right: © akg-images / ullstein-bild; pp. 177, 251 bottom: © akg-images; p. 178 top: National Archives and Records Administration, College Park, MD (111-SC-374661); p. 178 bottom: National Archives and Records Administration, College Park, MD (111-SC-203453-5); pp. 191 top, 194 bottom: Collection of Anne and Louis Rorimer. Photograph: Helga Glassner; p. 191 bottom right: Prometheus / Wikimedia Commons; p. 195: Fokus GmbH Leipzig, via blicklokal.de / Wikimedia Commons; pp. 197 top, 200 top: Collection of Anne and Louis Rorimer. Photograph: Captain Calvin S. Hathaway; p. 197 bottom left: gallerix.ru / Wikimedia Commons; p. 199: Photo © Jononmac46 / Wikimedia Commons / CC BY-SA 4.0; p. 202 top: Charles De Jeagar / TopFoto; p. 203 top: Salt Mines and Castles: lecture, by Lamont Moore, 1983 October 11 / Archives of American Art, Smithsonian Institution; p. 206 bottom: National Archives and Records Administration, College Park, MD (111-SC-210340); p. 207 top: Wolfgang Kaehler / Alamy Stock Photo; p. 209: Photo © Bede735c / Wikimedia Commons / CC BY-SA 3.0; p. 220 top: Photograph: Dr. Volkmar Rudolph; p. 223 top: National Archives and Records Administration, College Park, MD (111-SC-374664); pp. 228-229: VOJTa Herout / Shutterstock; p. 230 top: Courtesy www.wallpaperflare.com; p. 230 bottom: National Gallery of Art, Washington, DC, Gallery Archives. 28MFAA-A, Edward E. Adams Papers; p. 232 bottom: Item M.W. 45; Entry A1 549 – Einsatzstab Reichsleiter Rosenberg (ERR) Card Files, Box 23; Records of United States Occupation Headquarters, World War II (Record Group 260); National Archives at College Park, College Park, MD; p. 235 bottom: National Gallery of Art, Washington, DC, Gallery Archives. 28MFAA-F, Charles Parkhurst Papers; pp. 236-237: Keystone-France / Gamma-Rapho via Getty Images; p. 241: Antoine Bonin; pp. 245, 258-259, 259 bottom, 264-265, 266-267, 268 top, 268 bottom: William Vandivert / The LIFE Picture Collection / Shutterstock; p. 252 top: AP / Shutterstock; p. 253 top left: Library of Congress, Prints and Photographs Division, [LC-USZ62-136158]; p. 253 bottom: Rosemarie Clausen / ullstein-bild via Getty Images; p. 257: B.O'Kane / Alamy Stock Photo; p. 259 top: Topfoto; p. 262 bottom: Three Lions / Getty Images; p. 267: Photo © Soprintendenza Speciale per il Patrimonio Storico, Artistico ed Etnoantropologico e per il Polo Museale della città di Firenze; p. 271: Granger; p. 274 bottom: bpk Bildagentur / Alte Pinakothek / Art Resource, NY; pp. 276-277: National Archives and Records Administration, College Park, MD (111-SC-374666); p. 277: Museum de Fundatie (long-term loan from the Cultural Heritage Agency), Zwolle and Heino/Wijhe; pp. 282-283: Courtesy of the University of Illinois Archives; pp. 286, 289 bottom: Sueddeutsche Zeitung Photo / Alamy Stock Photo; p. 288: Collection of Anne and Louis Rorimer. Photograph: Hitler's files; pp. 291 top, 291 bottom, 292 top left, 292 top right, 308 bottom: Lynn Nicholas Collection; p. 298: National Archives and Records Administration, College Park, MD (111-SC-238878); p. 303 top: National Gallery of Art, Washington, DC, Gallery Archives. Walter I. Farmer Papers; p. 304 bottom: Collection of Anne and Louis Rorimer. Photograph: Wiesbaden Collecting Point; p. 314: olrat / Alamy Stock Photo; p. 315: © Claude Divoux / Wikimedia Commons / CC-BY-SA 3.0. ; p. 321: Science History Images / Alamy Stock Photo; p. 326 top: © Ben Martin; p. 327 top: Metropolitan Museum of Art Archives; pp. 328-329: © Arnold Newman Estate / Getty Images. Courtesy Metropolitan Museum Archives; pp. 330 top, 330 bottom, 331: Photofest, Inc.; p. 333 top: U.S. Army; p. 333 bottom: Courtesy Dr. Laurie W. Rush

COLLECTION CREDITS

p. 50: Gift of John D. Rockefeller, Jr., 1937. 37.80.6.; p. 121: The Mr. and Mrs. Henry Ittleson Jr. Purchase Fund, 1959. 59.142.; p. 122: Gift of André and Clara Mertens, in memory of her mother, Jenny Pulitzer Steiner, 1964. 64.148.; p. 153: Bequest of Grenville L. Winthrop. 1943.247; p. 179: Gift of Mrs. Felix M. Warburg, 1940. 40.139.6(13); p. 327 bottom: The Cloisters Collection, 1956. 56.70a-cp

INDEX

Note: Page numbers in *italics* indicate illustrations.

INDEX

INDEX

ACKNOWLEDGMENTS

Monuments Man is the war story that our father, James J. Rorimer, never fully told us. Not that he was reluctant to talk about the war. We knew he was proud of the role he had played as a monuments officer in the Monuments, Fine Arts & Archives Section in France, Germany, and Austria. But he had written this book shortly after returning from Europe. By the time we, his children, were coming of age, both world wars were rapidly receding into history, and he was too fully occupied with directing the Metropolitan Museum of Art to dwell on the recent past.

Not until Robert M. Edsel brought the story of the monuments men to a broader public, with the publication in 2009 of his book *The Monuments Men*, did we take the time to read our father's 1950 memoir, originally entitled *Survival: The Salvage and Protection of Art in War*. Robert's dedication and encouragement inspired us to dust off our few remaining copies of *Survival*, unearth our father's wartime letters, and finally acquaint ourselves with the scope of his legacy. These relatively recent developments, along with many requests for copies of *Survival* over the years, inspired our effort to reissue his book. In the course of our work, we came to realize (initially, at the suggestion of Henry Adams at Case Western Reserve University) that the long-unheralded work of the monuments men marked a historic turning point in the development, not only of national responsibility for preservation of art in war, but also more broadly in recognition of the rights of all cultures to their unique patrimonies.

This has been a project for the whole family. The author's grandson, also named James, supervised the digitization and initial editing of the text, with the help of his wife, Yougeng Yin-Rorimer, and friend Will Bostwick. His sister, Sarah Rorimer Chen, contributed research and material from her 2014 travel blog, "Monuments Girl." Her husband, Peter Chen, guided our introduction to military histories of World War II in Europe. Louis's wife, H. Savery Fitz-Gerald Rorimer, kept the family farm in operation and the home fires burning whenever the rest of us were otherwise engaged.

Others also played active editorial roles in the early stages of the project: Constance Rosenblum and Barbara J. Bradley deployed their many years of editorial experience to shape the initial contours of the manuscript. The hawk-eyed fact checking of the manuscript by Suzy Ford played a major role in the research carried out to supplement the 1950 version of the book.

Of utmost importance to carrying out an expanded version of the original book, we cannot adequately express our indebtedness to the many people who participated in their respective areas of expertise to provide crucial photographic, archival, and/or cartographic information: Kate Blackmer, Blackmer Maps, Custom Cartography; Marisa Bourgoin, Chief of Reference Services, Archives of American Art, Washington, D.C.; Gerri Chanel, author of *Saving Mona Lisa: The Battle to Save the Louvre and Its Treasures from the Nazis* (2014); Maygene Daniels, former Chief Archivist, National Gallery of Art, Washington, D.C.; Ruth Ehler, granddaughter of Ralph Hammett and daughter of Dorothy Hammett

Allen; Emily Hindin, Assistant Director of Digital Collections, National WWII Museum, Washington, D.C.; Anstiss Krueck, daughter of Mason Hammond; Elizabeth Llewellyn, daughter of Mason Hammond; James Moske, Managing Archivist, Museum Archives, The Metropolitan Museum of Art, New York; Al Mallette, freelance photographer (whose touch-up work revitalized old photographs); Lynn Nicholas, author of *The Rape of Europa: The Fate of Europe's Treasures in the Third Reich and the Second World War* (1994); Jonathan Petropoulos, author of *Goering's Man in Paris: The Story of a Nazi Art Plunderer and His World* (2021); Laurie Rush, Cultural Resources Manager and Army Archeologist, Fort Drum, NY; Casey Shelton, Senior Researcher, Monuments Men Foundation for the Preservation of Art; Christine Vernay, CEO at the Association La Mémoire de Rose Valland, Paris; Corine Wegener, Director, Smithsonian Cultural Rescue Initiative (SCRI); Michele Willens, Archivist, National Gallery of Art, Washington, D.C.; Nancy H. Yeide, author of *Beyond the Dreams of Avarice: The Hermann Goering Collection* (2009) and head of Department of Curatorial Records, National Gallery of Art, Washington, D.C., 1990-2017.

We are grateful to the many other friends and professional colleagues, including several members of other families of monuments officers, who have generously assisted us in diverse ways from the early days of the project until the last minute, including: Philip Anderson; Louis V. Andrean; Dennis and Kathy Barrie; Charles A. Bittenbender; Christine Brennan; Abigail Angell Canfield; Pey-Yi Chu; Bev Chubat; Robert Citino; Elizabeth Cropper; John Briand Davidson; Andria Derstine; Gail Feigenbaum; Elizabeth Glassman; Victoria Sears Goldman; Gloria Groom; Ron Gordon; June Hargrove; Paul B. Jaskot; Josh Knerly; Charles T. Little; Griffith Mann; Tom Mayer; Suzanne Folds McCullagh; Annie Morse; Dale A. Nance; Jenifer Neils; Christine Newman; Faith Pleasanton; Maggie Popkin; Andrea Wolf Rager; Victoria Reed; Cora Rosevear; Susan F. Rossen; Catherine B. Scallen; Kathryn Leigh Scott; George Shackelford; Lucian Simmons; Ann Sindelar; Laurie A. Stein; Steven Szilagyi; Katherine Fischer Taylor; Hugh Van Dusen; John Vinci; Lawrence Waldman; Jayne Warman; Mike Weaver; Carl U. Weitman; Chuck and Lucy Weller; and Canan Yetmen.

This book has come to fruition thanks to the dedicated staff of Rizzoli Electa. We have had the good fortune and privilege to work with Andrea Danese, senior editor, who brought her unique vision and keen judgment to realization of the endeavor, in coordination with her colleagues Charles Miers, publisher; Margaret Rennolds Chace, associate publisher; John Deen, sales manager; Richard Slovak, copyeditor; Natalie Danford, proofreader; and Alyn Evans, production manager.

We also would like to express our thanks to Elisa Frohlich Gallagher, our thorough and imaginative photo researcher, and to our designer, David Heasty, of Triboro, who rounded out the creative team.

Louis Rorimer Anne Rorimer
Cleveland, Ohio Chicago, Illinois

September 2021

First published in the United States of America in 2022 by
Rizzoli Electa, A Division of
Rizzoli International Publications, Inc.
300 Park Avenue South
New York, NY 10010
www.rizzoliusa.com

Copyright © 2022 by Louis and Anne Rorimer
Foreword by Lynn H. Nicholas

For Rizzoli Electa
Publisher: Charles Miers
Associate publisher: Margaret Rennolds Chace
Senior editor: Andrea Danese
Designer: Triboro
Production manager: Alyn Evans

Printed in Italy

2022 2023 2024 2025 / 10 9 8 7 6 5 4 3 2 1

ISBN: 978-0-8478-7123-0

Library of Congress Control Number: 2021953307

Visit us online:
Facebook.com/RizzoliNewYork
Twitter: @Rizzoli_Books
Instagram.com/RizzoliBooks
Pinterest.com/RizzoliBooks
Youtube.com/user/RizzoliNY
Issuu.com/Rizzoli